Occupation and Communism in Eastern European Museums

Occupation and Communism in Eastern European Museums

Re-Visualizing the Recent Past

Edited by
Constantin Iordachi and Péter Apor

BLOOMSBURY ACADEMIC
LONDON • NEW YORK • OXFORD • NEW DELHI • SYDNEY

BLOOMSBURY ACADEMIC
Bloomsbury Publishing Plc
50 Bedford Square, London, WC1B 3DP, UK
1385 Broadway, New York, NY 10018, USA
29 Earlsfort Terrace, Dublin 2, Ireland

BLOOMSBURY, BLOOMSBURY ACADEMIC and the Diana logo
are trademarks of Bloomsbury Publishing Plc

First published in Great Britain 2021

A catalogue record for this book is available from the British Library.

A catalog record for this book is available from the Library of Congress.

ISBN: HB: 978-1-3501-0370-2
 ePDF: 978-1-3501-0371-9
 eBook: 978-1-3501-0372-6

Typeset by Integra Software Services Pvt. Ltd.

To find out more about our authors and books visit www.bloomsbury.com
and sign up for our newsletters.

Contents

Figures

Studying Museums of Communism: Recent Trends and Perspectives

Constantin Iordachi and Péter Apor

The current volume explores, by way of a sum of case studies, the multiple ways in which the history of the Second World War and of communist regimes in Eastern Europe has been represented in local, national, and European museums in post-1989 Eastern Europe. Our approach is based on the premise that the remembrance of the recent past is necessarily multifaceted, reflecting the multiple and contradictory aspects of communist regimes in the region, their longevity, and their peculiar features. Due to the great differences in the outlook of communist regimes in various Eastern European countries and the numerous stages in their internal evolution, the communist past has been displayed in a bewildering number of ways, a situation that resulted in a fragmented and kaleidoscope-like memory landscape. To arrive at a thorough understanding of practices of social remembrance, it is therefore important to understand who is remembering, when (s)he is remembering, and for what purpose.

Studying museums: Trends and perspectives

In the last decades, the history, main features, and sociopolitical impact of museums have been under intense scholarly scrutiny. By and large, scholarship has focused on four main issues: (1) the relationship of museum exhibitions to the rise of nationalism and the process of nation-building; (2) the impact of museum narratives and practices on shaping collective memories; (3) museums as institutions of knowledge production; and (4) the commodification of museums as tourist, mass-consumption enterprises. Conventional views in the field regarded museums as value-free institutions devoted to collecting, preserving, and exhibiting scientific knowledge, a definition museum staff have also tended to adhere to. More recently, new works in the field of museum studies have argued that the foundation of professional museums was closely linked to the emergence of modern European (nation-)states. To illustrate this view, they pointed out, for example, that the most famous European museums of art, history, and

ethnography in Western Europe during the nineteenth century were shaped by the way cultural-political elites imagined their own nations and their national identities.[1]

To avoid one-sided interpretations of museums as mere dissemination outlets, recent critical works have highlighted the importance of studying museums as institutions of knowledge production, as well. They pointed out that museums are crucial to the social construction of the anthropological notions of time, space, or "the Other" in a given society. Early modernist scholars studying the genesis of collecting and exhibiting practices in the Renaissance or the Enlightenment period have explored the epistemology of museum representations.[2] Other works have shown that museums served as key institutions of liberal modernity that rendered the idea of evolution and "civilization" tangible.[3] Museums of ethnography are particularly relevant in this respect, as their subject matter and approach reveal the fundaments of organizing difference and identity.[4]

The two main approaches described above argue that the creation of monolithic notions of political communities was a legacy of nineteenth-century modernist museums. Since the early 1980s, such legacies have been intensively criticized. Museums have been called on to reflect more explicitly on the polyphonic composition of, and diversity within, their societies. Typically, this multivalence is mostly defined in terms of memory and various cultural heritages that constitute a nation. Following Pierre Nora, numerous scholars regard museums as *lieux de mémoire*: these cultural sites do not possess an organic, natural, or "taken-for-granted" relationship to the past but are shaped by the relatively contingent and biased cultural codes of their producers.[5]

The concept of memory has been critically employed to undermine the authority of dominant historical narratives and to expose their close relationship to ideologically driven claims of political legitimacy. Scholars working in the field of memory studies argue that multiple historical interpretations of the past may be equally valid and that the historical representations employed in museums reflect the predominant values and norms of a given community.[6] From this perspective, museums appear as reflecting broader memory cultures: as institutions of memory they represent, disseminate but also shape communal identities and values. These theoretical perspectives turn the focus of analysis toward the politicized condition of museums: they are not innocent repositories of memory but institutions that disseminate particular elite interpretations of the past concerning the nation or other cultures.[7]

Instead of being seen as representations of an immutable temporal identity that links past, present, and future together, museums are now understood as cultural landmarks that make cultural ruptures between past and present visible. Museums, hence, are turned into repositories of "heritage" as David Lowenthal calls them, to be used by "inheritors" in the present. In this context, museum studies have also turned their attention toward the ways in which tourism impacts current museum practices.[8] Museums, in this perspective, are more pertinently used as fragmented but polyphonic places of cultural construction than as institutions that create compelling master narratives.[9] Museums are thus regarded as *agoras* where values and identities are publicly expressed, contested, and constantly renegotiated.[10]

Such approaches have prompted scholars to consider museums as physical spaces, as well. The cultural meanings museums attach to the past are intrinsically linked

to the symbolism of their location, their physical and urban surrounding, and the architectural texture of the building. As James E. Young pointed out in his reflection on monuments, "A stainless steel obelisk situated in an empty field, for example, generates different meanings from that situated in a neighbourhood shopping mall."[11] It is therefore important to take into account the fact that museum buildings have their own histories as pieces of architecture or spaces of exhibition, which shape the cultural meanings visitors deduce from subsequent performances.[12] A similar point was underscored by Michel Foucault's comment on heterotopias: "We do not live in a homogenous and empty space."[13] Such insights have inspired a broader material turn in the social analysis and critique of museums. Sociologists, in particular, have explored the way in which the physical qualities of spaces, material, and technological conditions shape knowledge production in museums, more broadly, and the way we understand "the social."[14] Museums, from this perspective, are part of an extended urban space, which favors the individualized study of objects and artifacts, and mediates—via technological nexuses—access to public knowledge.[15] Such concerns have only very recently informed museum studies. This volume, accordingly, addresses the complexities of architecture and material conditions in the museums of communism: see, for instance, the implications of using classic buildings of national museums for exhibiting the horrors of the twentieth century as opposed to employing privatized spaces for organizing popular "unofficial" museums of communism.

Memory studies have devoted particular attention to museums of communism.[16] When the first museums of communism or, more broadly, of the twentieth century, were established in East-Central Europe in the late 1990s and early 2000s, creators and commentators focused mostly on their impact on collective memory. The leadership, intellectuals, and politicians behind these initiatives defined museums as important vehicles of regaining those parts of the societal memories forcefully suppressed under communist regimes and of disseminating new post-communist identity narratives. These endeavors had palpable results: recent studies have pointed out that museums of communism have effectively impacted collective memory by offering images of the past that have resonated with their societies in psychological outlook, cultural canons, and narrative identities.[17] They have exposed the close and intricate relationships between museum representations of the recent past and ongoing changes in the historical "imagination" of a given nation. Critically minded analysts have also pointed out the failure of some of these museums to promote democratic values for their respective political communities.[18]

Debates over national identity has been another chief aspect in the study of museums of communism. This analytical focus has been largely confined, however, to the realm of national history. Even regional studies of this issue have concentrated on museums as attempts to construct ideologized nationalist readings of the recent past in various national contexts.[19] Only recently has the academic literature begun to emphasize the broader transnational context of these museums and their communalities. New comparative perspectives have opened up innovative ways to study museums of communism as part of a more global process of building new political identities through commemorating atrocities.[20] They have also explored the broader historical legacies that museums of communism sometimes unintentionally mobilize.[21]

What are the academic trends and prospects of studying museums of the recent past in Eastern Europe? While the historiographical picture is by now rather dense, it is clear, however, that there are both significant gaps as well as many promising avenues for further comparative work in the field.

First, there is no systematic exploration of the way in which experiences of mass violence and dictatorship has been represented in Eastern European museums. Paul Williams and, more recently, Amy Sodaro have addressed the emergence of new types of museums commemorating victims of atrocities and their implications for museum practices worldwide.[22] However, Williams focused chiefly on the Holocaust, the Second World War, and genocide museums, and touched upon examples of museums of communism in Eastern Europe only occasionally. Sodaro explored the global turn to remember past violence, yet her research only referred to the House of Terror in Budapest as one post-communist Eastern European example, beside other museums of atrocities in Africa, Latin America and North America.[23] A more focused collective volume, *Der Kommunismus im Museum*, grouped essays by curators and art critics,[24] but its intention is to provide a general introduction to the history of these museums rather than a systematic critical reflection on the topic. Finally, the collective volume *Past for the Eyes*,[25] tackled patterns of representation of contemporary history in post-communist Eastern Europe, yet its focus was not on museum practices but on visual patterns of representation, in general.

Second, due to the fact that museums in Eastern Europe are in a continuous flux, the existing partial overviews of museums of communism are rapidly outdated. In the last few years in particular, several museums have thoroughly refurbished their exhibitions in connection with the broader sociopolitical transformations that have occurred in their respective memory cultures, thus necessitating new comprehensive overviews. This is true particularly for the Baltic States, Romania, Bulgaria, and Poland.[26]

Third, the wealth of case studies and regional treatments of museums of communism in Eastern Europe, as well as the expansion of this field of studies at European and global level, open up new transnational research perspectives on the evolution of museums of the recent past in the twenty-first century.

In order to fill this research gap, the current volume employs a kaleidoscopic approach to the study of museums of the recent past in post-communist Eastern Europe. We treat museums as complex public fora in which narratives of historical experiences are continuously shaped and reshaped through the uneven interaction of a variety of state and non-state agents, such as political elites, various institutions, museum curators, and other types of collective actors, at international, national, and local levels. We also emphasize the fact that historical representations are conveyed through, but also mediated by, a variety of exhibition display techniques and methods, employing audiovisual media, historical objects and images, and textual documents. Integrating, in a single approach, the diversity of agents and the multifarious genres of representation helps us bridge museum studies with a detailed analysis of particular national and regional cultures of museums in Eastern Europe, two research fields that, although interlinked, do not often communicate with each other. By focusing on the nexus of institutional, professional, political, and cultural processes at work

in the field of museums of the recent past, we hope to highlight the relevance of the concrete sociopolitical contexts that shape museums and, thus, to pursue comparative inquiries of factors of differentiation. The kaleidoscopic approach brings out the historical originality of post-communist Eastern Europe, a unique area of the world that experience various forms of totalitarian and authoritarian regimes during the short twentieth century (1918–1989). While identifying regional patterns of post-communist memory in Eastern Europe, we also underscore the fact that individual societies responded to and 'translated' transnational experiences according to their own national traditions and contexts.

Content and organization of the volume

The current volume employs a comparative approach to the history of museums of occupation and communism in Eastern Europe. In order to identify similarities and differences and to account for transnational patterns of remembrance at national, regional, and European levels, the contributors focus on a wide variety of case studies in over twelve countries, such as the Vabamu Museum of Occupations and Freedom, **Estonia**; the Ninth Fort Museum and the Museum for Resistance and Deportations in Kaunas, the Museum of Victims of Genocide and the *Exhibition of Socialist Art* at the National Art Gallery, the section for deportations at the Open Air Museum, and Grūtas Statue Park, in Vilnius, **Lithuania**; the National History Museum of Moldova, Chișinău, **Republic of Moldova**; the Museum of the Solidarity Movement in Gdańsk and the Warsaw Rising Museum in Warsaw, **Poland**; the GDR Museum (DDR Museum) in Berlin, and the Documentation Centre on Everyday Life in the GDR (Dokumentationszentrum Alltagskultur der DDR) in Eisenhüttenstadt, **Germany**; the House of Terror Museum, in **Hungary**; the Museum of Crimes and Victims of Communism, Bratislava, **Slovakia**; the Museum of Communism, Prague, **Czech Republic**; the Sighet Memorial Museum, the Romanian National Peasant Museum, the National History Museum, and the Museum of the Socialist Republic of Romania in Podari, **Romania**; the Jasenovac Memorial Museum, Tito's museums in Kumrovec, and Brijuni, and the camp on the Goli otok island in **Croatia**; the Museum of Yugoslav History, Belgrade, **Serbia**; the Museum of Socialism in Garvan village, the Red attic of a librarian in Veliko Turnovo, Museums in Skrebatno and Vrabevo, in **Bulgaria**; and the National Museum of China, Beijing, **China**. These museums differ in their nature and character: some of these museums were established under communism and were refurbished after 1989; others have been established after the fall of communism, at various stages. Some of them are state-owned and state-sponsored, others are private museums or are run by local communities. Moreover, some of these museums are traditional in their style and presentation, while others are experimental multimedia institutions. Last but not least, some museums serve official propaganda purposes, others have a declared civic educational purpose, while a few are private mercantile enterprises commercializing nostalgia.

To capture this diversity, the volume focuses on patterns on the "musealization" of the recent past in Eastern Europe at both official and grassroots levels. At the official level, we analyze dominant master narratives over the communist past and the way they are implemented and "institutionalized" in museums of the Second World War and of communism (covering roughly the period 1939 to 1989–1991), as part of more general governmental campaigns on "politics of history" in post-communist Eastern Europe. Concerning museum policies in the region, we point out that in certain countries, most notably in Germany, authorities developed a comprehensive concept for the commemoration of contemporary history that framed long-term patterns of representing the communist regime. In other countries, however, rival political parties have developed their own divergent discourses about the past, resulting in competing museum representations of the communist era. Finally, in countries where there has been a conspicuous lack of consensus on how the communist period should be exhibited, "official" museums of communism are still missing.

In addition to museum politics, the volume focuses on the "musealization" of communism *from below*, exploring the efforts of local communities and private individuals to establish their "own" private museums of communism, outside the system of national and regional museums. So far, such initiatives have been largely ignored, being generally discarded as random and disjointed, due to their small scale, lack of professional curators, proper buildings, adequate resources, and clear legal status. The volume takes these private initiatives seriously. We argue that such initiatives are worth studying both in their own terms but also in comparison with official patterns of representation, since they illustrate grassroots attempts to come to terms with the socialist past. Approaches "from below" thus go hand in hand with approaches "from above," interpreted through the prism of reception of—and reaction to—central, top-down policies and discourses. These two approaches are instrumental in elucidating how a particular dominant policy or discourse on the past has been negotiated, redefined, twisted, domesticated, or subverted at the local level. On this basis, we argue that museum exhibitions should not be studied as one-way, top-down disseminations of a predetermined ideological narrative but as complex processes of multiple translations of objects and material settings. To document these features, the authors employ a wide set of primary and secondary sources ranging from works of history, public and parliamentary speeches, to field research in museums and interviews with professional curators, amateur curators, and ordinary people. One of our aims is to understand the way the life experience of ordinary people who lived under communism affects their self-identification with, or rejection of, the communist regime, and the way they react to the official representations of the regime's legacy.

Structure and organization of the volume

The volume is organized in four thematic parts, focusing on (1) comparative perspectives on history, memory, and politics; (2) museums of occupation; (3) museums of communism; and (4) practices of representation in museums of recent history.

In this introduction, we evaluate critically the state of the art in the field of museum and memory studies in Eastern Europe and define the aims of the volume and our comparative approach. In Chapter 2—"'Remembering' versus 'Condemning' Communism: Politics of History and 'Wars on Memory' in East European Museums"— Constantin Iordachi provides an overview of museums politics in Eastern Europe and their intricate relationship to politics, in comparison with other regions of the world. Iordachi argues that, if in the 1990s museum politics were dominated by civic-liberal attitudes, there has recently been a political offensive meant to refurbish museums of communism from a conservative-nationalist perspective. On the basis of his comparative analysis, Iordachi aims at identifying strategies of overcoming the methodological cleavage between discourses on communism as a "totalitarian regime" versus discourses on communism as a "lived experience." In historiographic terms, one such strategy is to depart from rigid and static "abstract" models of communist regimes and to instead promote interdisciplinary, sociocultural approaches to the communist past that account both for repression and the complex realities of everyday life.

Ene Kõresaar and Kirsti Jõesalu address a critical shift in the museum representation of the recent past in Estonia, in Chapter 3—"From Museum as Memorial to Memory Museum: On the Transformation of the Estonian Museum of Occupations." The current refurbishment of the former Museum of Occupations represents an important change in the narrative on the Second World War and the Soviet period. Previously, museum narratives focused on repression and victimization and were reluctant to address the involvement of the nation in ideological violence. The new exhibition went a step further in professionalizing the representation of the recent past: its change in generational narratives offers a more nuanced image of the war and of the communist past by placing the experiences of everyday life at the very center of the investigation.

In Chapter 4—"Institutionalized Narratives of Communism in Slovakia: Substituting the Nonexistence of the Official Museum of Communism"—Martin Kovanič compares the development of museums of communism to the campaigns of transitory justice. He emphasizes that, given the failure of a state-sponsored official museum to come into being in Slovakia, the issue of the memory and legacy of the communist regime has been a terrain of confrontation of multiple actors, closely linked to the political power. Although there is no museum of communism in Slovakia, there are nevertheless other cultural policies in place about the past, driven by institutions such as the Nation's Memory Institute and other private organizations. Kovanič highlights that the narratives these institutions promote are embedded in various ideologies of political anti-communism. These elite groups advertised their histories as truly national; however, they failed to grow into national institutions and turned into private, non-museum spaces.

In Chapter 5—"(Re)constructing the Past: Museums in Post-Communist Croatia"—Vjeran Pavlaković argues that in Croatia, the post-communist transition was intimately linked with its War of Independence (1991–1995), profoundly affecting memory politics in the last two decades. Unlike in other post-socialist countries, in

Croatia the new forms of cultural memory did not merely challenge the ideology—communism—of the former regime but emphasized the appropriate ethno-national identity of the newly independent nation state. In addition to cultural policies, the Croatian state sought to enforce the authoritative narratives through the country's historical museums and memory parks. This chapter critically examines several museums in Croatia that deal with the Second World War (Jasenovac Memorial Museum), Tito's legacy (Kumrovec, Brijuni), and sites of memory that could serve as future museums of communism (Goli otok). Pavlaković concludes that, while other countries in the region have established museums that address the communist period (for example the House of Terror Museum in Budapest, the Museum of Genocide Victims in Vilnius, or the GDR Museum in Berlin), Croatia still lacks a permanent exhibit in the Croatian History Museum to address the communist past.

In Chapter 6—"The 'Display' of Communism in Germany"—Irmgard Zündorf focuses on the representation of communism in museums and memorials in Germany, particularly in the former GDR. The chapter seeks to understand how a national concept of commemoration has been forged in Germany. It explores the diversity of agency and genres in this process such as museums financed by the federal government; memorials based in former Soviet special camps, in former prisons of the GDR State Security (Stasi), or at the former German–German border; museums financed partially by the federal government and partially by the state government; and private GDR museums that often do not follow national policy recommendations. The chapter concludes that, thirty years after the end of the SED regime, the legacy of communism is still subject to a "battlefield of memory." One can distinguish at least three different categories of memories that shape the image of the GDR: "memory of dictatorship," which highlights the repressive nature of the SED system; "memory of arrangement," which refers to the connection between political developments and everyday life; and the "memory of progress," which still maintains that the GDR was a legitimate alternative to the capitalist order. Along similar lines, Martin Sabrow discusses critically the prevailing patterns of memorializing the GDR, in Chapter 7—"Remembering the GDR." He concludes that the image of the GDR that emerges from a flood of accumulated remnants and experiences is not cohesive but, rather, fragmented. Like a kaleidoscope, it presents the East German state and its society in ever new variations.

Olga Manojlović-Pintar and Aleksandar Ignjatović explore interpretations of communism in socialist Yugoslavia and in present-day Serbia, in Chapter 8—"Discussing the Past, or Airing the Depots: Refashioning Exhibitions of Socialism in Serbia." They focus, in particular, on museum practices and the idea of communism in the Museum of Yugoslav History. This museum's public events and exhibitions are placed into two interrelated contexts. One is created by various museological institutions and another is dealing with wider public perception and production of historical narratives (various artistic and non-institutionalized projects). The two authors present the diversity of interpretations and hypothesis ranging from that of socialism and communism as the negative "Other" to a rather affirmative image used to construct a new leftist theory based on a critical attitude toward the present. These strategies can be understood only by taking into account the specificities of the Yugoslav socialist experience: the

ideology of Yugoslav "brotherhood and unity," the concepts of social management and ownership "self-management," foreign politics of "non-alignment," and finally the cultural practice known as "socialist aestheticism."

Simina Bădică focuses on the contemporary exercises of museums in Romania to reframe the objects of the communist era in their exhibitions, in Chapter 9—"Life and Death of the Communist Object in Post-Communist Romanian Museums." She points out that museums employ various strategies to reshape the communist object. Using the examples of the Sighet Memorial Museum, the Romanian Peasant Museum, and the National History Museum of Romania, Bădică argues that museum objects are framed in a way that delivers the exact opposite of the message they were created to deliver. The chapter argues that oftentimes museums deprive historical objects of their power to communicate meaning as they surround them with excessive text and labeling. Although these objects might foster remembering, these exhibitions seem to encourage forgetting rather than remembering. This strategy is linked to an overall anti-communist discourse that museums of communism disseminate.

Eglė Rindzevičiūtė focuses on key museums about the communist past in Lithuania, both newly built and reorganized, in Chapter 10—"Boundary Objects of Communism: Assembling the Soviet Past in Museums and Public Spaces." Drawing on the analysis of exhibitions, interviews with the museum curators and relevant debates in the mass media, Rindzevičiūtė argues that a new methodological approach is needed in order to understand the role that the museums of communism play in the shaping of public understanding of the recent past. The chapter concludes that museum exhibitions should be better studied not as one-way and top-down dissemination of a predetermined ideological narrative but as complex processes of multiple translations of objects and material settings.

In Chapter 11—"Canons of Civilization and Experiments of Spectacle: Exhibiting Contemporary History in Hungary"—Péter Apor argues that the House of Terror is an experimental new media institution that attracts the visitor with a grand-scale audiovisual spectacle. However, its narrative strategy argues for a shift from historical objects and explanations toward the representation of memory and collective experiences. This strategy reduces the common-shared memory of the nation to a limited social experience and detaches the museum display from the established standard of evidence as the basis of historical authenticity.

In Chapter 12—"Museums of Socialism from Below: Local Representations of the Socialist Past in Contemporary Bulgaria"—Rossitza Guentcheva analyzes four instances of remembering and museumizing socialism from below in contemporary Bulgaria—the Museum of Socialism in Garvan village in northeastern Bulgaria, the Red attic of a librarian from the town of Veliko Turnovo, the museum in Skrebatno village in southwest Bulgaria, and the museum in Vrabevo village in central Bulgaria. All four cases represent genuine attempts of local Bulgarian publics to come to terms with the socialist past. They display four different figures of memory, going beyond the classic debate between a totalitarian paradigm and an everyday-objects-centered "normalizing" perspective, namely lived socialism, socialism individually appropriated, a frozen version of socialism, and a *postmortem* reproduction of socialism. The chapter

relies on in-depth interviews with the persons who were the most instrumental in organizing these exhibits as well as with people who contributed to the collection of objects and the elaboration of the expositions' design. Guentcheva concludes that, at a time when the museum as an institution is widely perceived to be in crisis, when the very notion of a museum is attacked from a variety of perspectives and even classical museums strive to go out of officially sanctioned exhibition spaces, focusing on the way distinct publics perform the museum locally could add to the debate on what a museum really is.

On the basis of these case studies, the conclusions reiterate our findings on museums of the recent past in Eastern Europe, against the background of the current European debates on history, memory, and museum practices; provide new comparative insights on the topic; and suggest ways in which the experience of Eastern Europe can be useful for understanding similar developments that take place outside Europe, as well, in East Asia, Latin America, and South Africa.

Notes

1 Daniel J. Sherman, *Worthy Monuments: Art Museums and the Politics of Culture in Nineteenth-Century France* (Cambridge, MA: Harvard University Press, 1989); Dominique Poulot, *Une histoire des musées de France, XVIIIe-XXe siècle* (Paris: Découverte, 2005); Simona Troilo, *La patria e la memoria: tutela e patrimonio culturale nell'Italia unita* (Milan: Electa, 2005); Robin Ostow (ed.), *(Re)visualizing National History: Museums and National Identities in Europe in the New Millennium* (Toronto: University of Toronto Press, 2008).

2 Stephen Bann, *The Clothing of Clio: A Study of the Representation of History in Nineteenth-Century Britain and France* (Cambridge: Cambridge University Press, 1984); Eilean Hooper-Greenhill, *Museums and the Shaping of Knowledge* (London: Routledge, 1992); Susan A. Crane, *Collecting and Historical Consciousness in Early Nineteenth-Century Germany* (Ithaca, NY: Cornell University Press, 2000).

3 Tony Bennett, *The Birth of the Museum: History, Theory, Politics* (London: Routledge, 1995), 39–47.

4 Ivan Karp and Steven D. Lavine (eds.), *Exhibiting Cultures: The Poetics and Politics of Museum Display* (Washington, DC: Smithsonian Institute Press, 1991); Camille Mazé, Frédéric Poulard, and Christelle Ventura (eds.), *Les musées d'ethnologie. Culture, politique et changement institutional* (Charenton-Le-Pont: Laboratoire d'anthropologie et d'histoire de l'institution de la culture, 2013).

5 Pierre Nora, "Between Memory and History: Les Lieux de Mémoire," *Representations* 26 (Winter 1989): 7–25.

6 Jeffrey Olick and Joyce Robbins, "Social Memory Studies: From 'Collective Memory' to the Historical Sociology of Mnemonic Practices," *Annual Review of Sociology* 24 (1998): 105–140.

7 Susan A. Crane, "Memory, Distortion, and History in the Museum," *History and Theory* 36 (December 1997): 44–63.

8 Barbara Kirshenblatt-Gimblett, *Destination Culture: Tourism, Museums, and Heritage* (Berkeley: University of California Press, 1998).

9 David Lowenthal, *The Heritage Crusade and the Spoils of History* (Cambridge: Cambridge University Press, 1998), 110–112.

10 Michael M. Ames, *Cannibal Tours and Glass Boxes: The Anthropology of Museums* (Vancouver: University of British Columbia, 1992); Péter Erdősi, "Kulturális örökség és múzeumi praxis - egy történész szemével" [Cultural Heritage and Museum Practice: A Historian's Perspective], *Tabula* 12, no. 2 (2009): 211–220.

11 James E. Young, *The Texture of Memory* (New Haven, CT: Yale University Press, 1993), 7–8.

12 Michael Fehr, "A Museum and Its Memory: The Art of Recovering History," in Susan A. Crane (ed.), *Museums and Memory* (Stanford, CA: Stanford University Press, 2000), 35–59.

13 Michel Foucault, *Dits et écrits* (Paris: Gallimard, 1994); English edition: "Of Other Spaces, Heterotopias," translated from *Architecture, Mouvement, Continuité*, no. 5 (1984): 46–49, https://foucault.info/documents/heterotopia/foucault.heteroTopia.en/ (accessed May 24, 2019).

14 John Law, *Organising Modernity* (Oxford: Blackwell, 1994); Bruno Latour, *Reassembling the Social: An Introduction to Actor-Network Theory* (Oxford: Oxford University Press, 2005).

15 Patrick Joyce, *The Rule of Freedom: Liberalism and the Modern City* (London: Verso, 2003), 128–137.

16 See, selectively: Volkhard Knigge and Ulrich Mählert (eds.), *Der Kommunismus im Museum. Formen der Auseinandersetzung in Deutschland und Ostmitteleuropa* (Cologne: Böhlau, 2005); Joel Palhegyi, "National Museums, National Myths: Constructing Socialist Yugoslavism for Croatia and Croats," *Nationalities Papers* 45, no. 6 (2017): 1048–1065; Gediminas Lankauskas, "Sensuous (Re)Collections: The Sight and Taste of Socialism at Grūtas Statue Park, Lithuania," *Senses and Society* 1, no. 1 (2006): 27–52; Annette Kaminsky (ed.), *Orte des Erinnerns. Gedenkzeichen, Gedenkstätten und Museen zur Diktatur in SBZ und DDR*, 2nd rev. edn. (Berlin: Ch. Links Verlag, 2016); Juraj Buzalka, "Post-peasant Memories: Populist or Communist Nostalgia," *East European Politics and Societies and Cultures* 20, no. 10 (2017): 988–1006; on China, see Kirk A. Denton, *Exhibiting the Past: Historical Memory and the Politics of Museums in Postsocialist China* (Honolulu: University of Hawaii Press, 2014); and Amy Barnes, *Museum Representations of Maoist China: From Cultural Revolution to Commie Kitsch* (Burlington, VT: Ashgate Publishing Company, 2014). For additional titles, see the Bibliography in this volume.

17 Oksana Sarkisova and Péter Apor (eds.), *Past for the Eyes: East European Representations of Communism in Cinema and Museums after 1989* (Budapest: Central European University Press, 2008), esp. 247–400; Muriel Blaive, Christian Gerbel, and Thomas Lindenberger (eds.), *Clashes in European Memory: The Case of Communist Repression and the Holocaust* (Innsbruck: StudienVerlag, 2011); Georges Mink and Laure Neumayer (eds.), *History, Memory and Politics in Central and Eastern Europe: Memory Games* (New York: Palgrave Macmillan, 2013); Máté Zombory, "The Birth of the Memory of Communism: Memorial Museums in Europe," *Nationalities Papers* 45, no. 6 (2017): 1028–1046.

18 Volkhard Knigge and Ulrich Mählert (eds.), *Der Kommunismus im Museum. Formen der Auseinandersetzung in Deutschland und Ostmitteleuropa* (Cologne: Böhlau, 2005); James Mark, *The Unfinished Revolution: Making Sense of the Communist Past in Central-Eastern Europe* (New Haven, CT: Yale University Press, 2010).

19 Péter Apor, "Eurocommunism: Commemorating Communism in Contemporary Eastern Europe," in Małgorzata Pakier and Bo Stråth (eds.), *A European Memory? Contested Histories and Politics of Remembrance* (Oxford: Berghahn, 2010), 233–246; Ljiljana Radonić, "Slovak and Croatian Invocation of Europe: The Museum of the

Slovak National Uprising and the Jasenovac Memorial Museum," *Nationalities Papers* 42, no. 3 (2014): 489–507.

20 Paul Williams, *Memorial Museums: The Global Rush to Commemorate Atrocities* (Oxford: Berg Publishers, 2007), 3–25.

21 István Rév, *Retroactive Justice: Prehistory of Post-Communism* (Stanford, CA: Stanford University Press, 2005), 292–303.

22 Williams, *Memorial Museums*; Amy Sodaro, *Exhibiting Atrocity: Memorial Museums and the Politics of Past Violence* (New Brunswick, NJ: Rutgers University Press, 2018).

23 Sodaro, *Exhibiting Atrocity*.

24 Knigge and Mählert, *Der Kommunismus im Museum*.

25 Sarkisova and Apor, *Past for the Eyes*.

26 Kirsti Jõesalu, *Dynamics and Tensions of Remembrance in post-Soviet Estonia: Late Socialism in the Making* (Tartu: University of Tartu Press, 2017); Eglė Rindzevičiūtė, "The Overflow of Secrets: The Disclosure of Soviet Repression in Museums as an Excess," *Current Anthropology* 56, no. 12 (2015): 276–285; Sheila Watson, "The Legacy of Communism: Difficult Histories, Emotions and Contested Narratives," *International Journal of Heritage Studies* 24, no. 7 (2018): 781–794.

Part One

History, Memory, and the Politics of History in Eastern European Museums

"Remembering" versus "Condemning" Communism: Politics of History and "Wars on Memory" in East European Museums

Constantin Iordachi

In August 1999, after three unsuccessful attempts, the Bulgarian government led by the Union of Democratic Forces finally managed to blow up the Georgi Dimitrov Mausoleum, a landmark of communism that marked the center of the national capital, Sofia, for five decades (1949–1999). This attempt to eradicate the past "once and for all"—by literarily blowing it up—pointed to Eastern European governments' renewed determination but also repeated failures to fully break up with the communist past in symbolic as well as in material terms.

In Bulgaria, as elsewhere in Eastern Europe, the departure from the communist regime was protracted, arduous, and highly contested: consequently, rather than a complete and sudden rupture with the past, the process of transition resembled a complex tapestry of broken and continuous links. On the one hand, the collapse of the communist system inaugurated an era of tectonic transformations. A well-established sociopolitical system—a peculiar world in itself or, indeed, a *civilization*[1]— that had lasted for over four decades vanished almost overnight, being replaced by new economic, legal, and sociopolitical relations, realities, and expectations. Post-communist states abolished the political monopoly of communist parties and built democratic parliamentary systems, repealed communist legislation, adopted new organic laws, dismantled planned economies, privatized state companies, and integrated their national economies into the global market. An important part of this gigantic transformation was an overall change in cultural policies: following the liberalization of academic life, new educational institutions, research institutes, and museums tackled topics that were previously considered *taboo*. In addition, changes in historical master narratives entailed far-reaching transformations of the officially enforced memory "landscape" of East European societies, marked by the renaming of public spaces, the adoption of new curricula and school textbooks, the commemoration of a new set of historical events, the destruction or removal of old statues, monuments, and mausoleums, and the erection of new ones. In anthropological terms, these massive changes point out to a radical reordering of the universe of social meanings, involving changes in the understanding of key social values such as sacrality, morality,

kinship, suffering, and victimization, affecting concepts of family, the nation, and their place in Europe and the world.[2]

On the other hand, beyond this façade of radical rupture, lie myriad ties with the recent or more distant past. Despite attempts in historiography or the official discourse at writing off the communist experience as a "black hole" or a "parenthesis" in the "normal" development of society, it is amply evident that communist regimes have profoundly shaped East-Central European societies. Although communism seems to be fully compromised as a political project by the failure of the "real existing socialism," its long-term societal impact and its memory in the minds of contemporaries continue to haunt the present in multiple and unexpected ways, at individual and collective levels.

It is not surprising, therefore, that the question of the "legacy" of communist regimes has generated sharp and passionate societal debates among a multitude of actors, whose views are shaped by differing and even contradictory life experiences and links to the past, worldviews, and political attitudes. The legacy of communism is not only a matter of academic history but has entered the realm of what is generally called "public history," which refers to the "uses and abuses" of history outside academia, in the public sphere. Thus, in addition to political discourses on communism, individual or private collective memories have also permeated the public sphere, with various groups asserting their own identity and views of the past. These sharp debates over the memory of communism have led to the emergence of comprehensive campaigns of "historical politics" conducted by governmental or non-governmental organizations or other sociopolitical actors and meant to articulate and disseminate narratives about historical events with the aim of reaching certain (immediate or long-term) political goals. A genuine war on historical memory ensued, involving rival political parties, state institutions, non-governmental organizations, private and public associations as well as various other collective and individual actors.

This chapter explores patterns of representing the past in museums of the Second World War and of communism and their close connection to post-communist transformations. It is argued that the continuous process of creating and recreating the memory of communism in Eastern Europe has been framed by a confrontation, a schism between the understanding of communism as an everyday "lived experience" and communism as a totalitarian, occupational regime, characterized by political repression and criminalized behavior. Within the second approach, I identify a further schism between a civic-liberal condemnation of communism and a conservative-nationalist one. The distinction between the two approaches is, by and large, also chronological: the liberal politics of history dominated the first two post-communist decades (1989–2008/2009) as part and parcel of the process of democratic transformation, whereas the conservative-nationalist approach has become predominant in some countries in close connection to the populist backlash that followed the 2008 Great Recession.

The tension between the two approaches is amply evident in representations of the communist past in museums. After 1989, a plethora of museums and memorials of communism have mushroomed in Eastern Europe. The typology of such museums includes memorials of victims of communism; museums of occupation, terror, and resistance; research and documentation centers; museums of everyday life; entertainment parks and tourist complexes; and statue or memento parks. My research

questions for addressing these representations are: How are these two dominant approaches represented in museums? Are they cohabitating or mutually incompatible? How are they inserted into political master narratives? How are they reconciled at individual and collective level? To answer these questions, the chapter surveys a sum of the most representative museums of the Second World War and of communism in Eastern Europe, by inserting them into a larger comparison with global trends in museum, with a focus on ongoing communist regimes in Cuba, China, and North Korea. Special attention will be given to patterns of historical representation, capitalizing on a set of antithetic emotions, such as universalism vs. parochialism, pro- vs. anti-European feelings, attitudes of collaboration and accommodation vs. heroic resistance, and the pedagogy of "shame" and stigma versus the pedagogy of national pride, charisma, and messianic nationalism. In conclusions, I provide a sum of historiographical suggestions on how to combine insights from the two approaches in order to arrive at a better understanding of the complex and contradictory nature of communist rule.

Communism as totalitarianism vs. communism as a "lived experience"

Communism as a totalitarian regime

To understand the schism in patterns of remembering communism in the region, one needs to explore two dominant interpretative paradigms in approaching the history of former communist regimes: the totalitarian approach vs. the history of everyday life paradigm.[3] The concept of totalitarianism has a long and highly politicized history, its history being closely tied to global geopolitical changes.[4] The "totalitarian thesis" was elaborated in mid-1930s in the United Kingdom and the United States and stressed the similarities between fascist Italy and Nazi Germany as dictatorial regimes and as threats to liberal democracies.[5] In the late 1930s, the concept of totalitarianism was extended to the study of Stalinist Russia, as well, in view of its centralization of power in Stalin's hands and the campaign of repression that culminated in the Great Terror and the Gulag system.[6] This gave birth to the theory of "unitotalitarianism," based on the assertion that—although animated by different ideologies—the fascist, Nazi and Bolshevik regimes shared a common set of characteristics that characterized a new political genus: totalitarianism.

In political propaganda, the evil nature of fascism as a form of totalitarianism was a major mobilizing tool in the Allies' anti-Nazi campaign during the Second World War. Due to the wartime political-military alliance with the Soviet Union, the totalitarian nature of Stalinism was downplayed and the theory of unitotalitarianism tacitly abandoned. After the war, however, the concept of totalitarianism was relaunched with vigor in reference to Stalinism, becoming a central anti-communist slogan during the Cold War. In the 1950s and 1960s, the unitotalitarian thesis was further developed into more elaborated theoretical models and gained a position of hegemony as an explanatory paradigm of fascist and communist regimes. Pioneering books by Hannah Arendt and by Carl J. Friedrich and Zbigniew K. Brzezinski, in particular, emphasized

issues of coercion, repression, and terror in defining the nature of totalitarianism.[7] These works became the standard views on totalitarianism, the "received wisdom" of the Cold War, widely cited in scholarly but also public debates on totalitarian regimes.

The three decades that have passed since the collapse of the communist regimes have witnessed an academic rejuvenation of the public and scholarly interest in the totalitarian paradigm. First, benefiting from the opening of Soviet archives, Sovietologists attempted to revisit the totalitarian approach and to better document the Stalinist terror (mostly by recounting the victims) in the light of novel archival evidence previously inaccessible to researchers.[8] Second, the collapse of communist regimes enabled historians to put forward retrospective overviews of right-wing and left-wing dictatorships during the short twentieth century (1914–1989). This endeavor stimulated historians to relaunch comparative studies of fascism and communism under the conceptual banner of unitotalitarianism, which was characteristic of the interwar period.

Third, and most importantly for our analysis, the concept of totalitarianism permeated scholarship on communism in Eastern Europe as well. After decades of political interdictions, scholars in Eastern Europe and the former Soviet Union have been also actively engaging with the vast literature on totalitarianism produced in the West, trying to adapt the existing theoretical offers to the study of their own societies. While many scholars scrutinized critically the totalitarian model and engaged in innovative comparative and interdisciplinary work leading to alternative concepts meant to capture the complexities and contradictions of communist rule in various countries, others have employed ready-made, classical Cold War models of totalitarianism. As a result, the bulk of the ongoing work on communist regimes in Eastern Europe has been dominated by the totalitarian paradigm and have focused on violent repression and human rights violations and, on this basis, suggested juridical and institutional forms of transnational justice in order to correct these abuses. Dichotomist "black and white" models of totalitarianism have dominated public and political discourse as well, being used as a tool of delegitimizing the past and legitimizing new political elites. In the post-communist political context, the politicized Cold War concept of totalitarianism was thus transformed into a major tool of political propaganda meant to settle scores, to compromise the reformed left—and, by a peculiar extension, also democratic liberalism—and to eliminate rivals from the political scene.

Communism as a "lived experience"

With the death of Stalin in 1953 and the changing nature of real existing socialist regimes in Eastern Europe, the totalitarian model came under concerted attacks in social sciences and the humanities, being challenged by new social, cultural, and anthropological approaches. Faced with the complexities of socialist societies, North American and Western European scholars began to question cliché views on totalitarian regimes characteristic of Cold War discourses. In this context, in the 1960s and 1970s a new generation of social historians rejected simplified accounts of the Soviet society as being made up solely of the ruling communist elite and the working people or, in moral terms, of "victims" and "victimizers," with no intermediary social strata or interest groups in

between. In an attempt to "bring the society back in," the new "revisionist" historians pointed out that the so-called Stalinist "revolution" consisted of multiple forms of social mobility induced "from below" as well as "from above."[9] They also emphasized the complexity of the social structure in socialist societies and the—however narrow—possibility of autonomous action by various social and professional groups.[10]

In the 1980s and 1990s, the totalitarian paradigm was further challenged by a new generation of anthropologists and cultural historians who conducted fieldwork in the Soviet-dominated Eastern Europe.[11] These researchers refuted the idea of a monolithic and almighty totalitarian state, based on the omnipotence of party-state agents and the complete dependence of the local on central agencies. They also criticized "revisionist" historians for their tendency to "normalize" the working of the Soviet system by explaining its longevity and relative stability solely in terms of an implicit social pact between the ruling elite and lower strata of the society interested in opportunities for upward social mobility. Cultural historians and anthropologists attempted instead to "bring the ideology back in," by using new theories and methods—such as oral history—for studying discourses, political languages, and ritual practices. Through a direct access to sources, these scholars were able to uncover multiple forms of legitimization of power in communist societies, relying on harsh repression but also on campaigns of mass mobilization and consensus-building. New studies have underscored, for example, the capacity of the official ideological discourses to instill allegiance to the regime and to mobilize the population in the service of building a utopian future, resulting in novel forms of "participatory totalitarianism," as Stefan Kotkin put it.[12]

These developments were particularly notable in Germany, where the dominant social history paradigm of the Bielefeld School was challenged by a new approach focusing on the history of everyday life, *Alltagsgeschichte*. This peculiar German form of "history from below" was promoted by a new generation of historians, having Alf Lüdtke as a main animator.[13] The new historiographical school departed from the history of "grand social structures without people" promoted by the Bielefeld school, arguing instead that the history of socialism should also be written from the perspective of the ordinary people who remained outside of the party-state structures of power. To this end, historians of everyday life under communism explored a variety of small and apparently insignificant social aspects, related to living conditions and ways of life, sexuality, childhood, consumption, leisure, fashion, tourism, etc.[14] In order to capture the experiences of ordinary people, historians of everyday life took into account novel historical sources, examining memoirs, personal or official letters, petitions and complaints, interviews with workers, peasants or the underclass or the marginals of the socialist order. The key concept of this approach was that of "experience" and not structure; it has been argued that the life experience of ordinary people reveals key aspects in the organization of communist regimes, which cannot be extracted from official documents. By examining patterns of everyday life, scholars argued that it is possible to provide a more authentic or genuine depiction of socialism. This approach led to a debate on the issue of "normality" versus "ideological fiction" under communism, and on the limits of the "everyday life paradigm." The critics of *Alltagsgeschichte* argue that an exclusive focus on the experiences of ordinary people runs the risk of providing

an incomplete and rather naive and sentimental picture of these regimes since it does not take into account their repressive side, which was often hidden from public eyes in late socialism.[15]

The new approach on the history of everyday life under socialism impacted memory studies as well. For example, an international project focusing mostly on Romania and Bulgaria, led by Maria Todorova and Stephan Troebst, focused on communism as a "lived experience," favoring the concept of "remembering" over that of "memory."[16] To illustrate the "complex nature" of the process of remembrance and its multifaceted and relational nature, participants explored multiple factors that shaped patterns of remembrance in post-communist societies, such as generational perspectives, the rural–urban divide, and gender and educational differences. These studies have also addressed the issue of nostalgia for the former socialist rule. As Todorova pointed out, nostalgia is not an attempt to revive the communist past but "should be recognized as part of a more complex healing process and an attempt to come to terms both with the communist era as well as the new inequalities of the post-communist era."[17]

Historiography has not been the only realm of confrontation between these rival approaches to the communist past: the proponents of both interpretations employed a great array of media tools, visual tactics, and commercial strategies in order to substantiate their views and to shape the public opinion. The tension between the two approaches has been amply evident in visual representations of the communist past. In the realm of cinema, for example, compare the 2003 German movie *Good Bye, Lenin!* directed by Wolfgang Becker, with the 2006 film *The Lives of Others* (*Das Leben der Anderen*) by the writer and director Florian Henckel von Donnersmarck.[18] *Good Bye, Lenin!* is representative of the *Ostalgie* movement; it idealizes, personalizes, and sublimates the memory of the GDR. *The Lives of Others*—although apparently downplaying to some extent the oppressiveness of the GDR regime by giving a human face to an officer of the secret police who is monitoring the life of a famous actress—highlights in fact the brutal political and cultural control exercised by the Stasi. The two movies were great box office successes; yet their approaches are not only complementary but also antithetical, *The Lives of Others* being conceived as a direct rebuke of *Good Bye, Lenin!*[19] Equally important, the two approaches shaped public and political discourses on communism and, as it will be shown in the next sections, patterns of representing the past in museums, as well.

From "official memory" to the "politics of history": Memorializing communism

Sacred history, utopian future: Glorifying communism in museums

Museums of communism are not a post-communist invention but are almost as old as the socialist regimes themselves. In their efforts to establish and then consolidate their rule, newly established socialist regimes engaged in campaigns of self-glorification, by way of cinema of propaganda, history museums, the creation of galleries of heroes and martyrs and their celebration in public holidays, and the erection of monuments in new

lieux de memoir to sacralize their history.[20] The establishment of communist parties and then regimes was presented, from a teleological perspective, as the apotheosis of the historical development of the respective people, in line with the scientific laws of historical development professed by the official Marxist-Leninist dogma.

Although sharing common features, the establishment of communist regimes was narrated through a plurality of strategies. In those regimes that came out of a revolutionary war of liberation, the history of the Communist Party was presented as a liberation struggle led by charismatic personalities such as Vladimir Ilich Lenin, Joseph Stalin, and Josip Broz Tito in Eastern Europe, Kim Il-sung and Mao Zedong in East Asia, and Che Guevara and Fidel Castro in Latin America.[21] In countries where such charismatic historical figures were missing, official narratives focused on the story of the party's collective fight in illegality or concentrate on the regime's achievements in building communism.

In Latin American and East Asia, where communist regimes have survived the cataclysm of 1989 to 1991, official museums of communism continue to exist, although in some instances they have been altered to reflect new political circumstances. Examples in this category include the glamorously refurbished Victorious Fatherland Liberation War Museum in Phenian, and the smaller Jonsung Revolutionary Museum at the underground offices of President Kim Il-sung, depicting the history of the Korean War, in North Korea; but also the already shabby Cuban Museum of the Revolution in Havana, which depicts the officially endorsed history of the 1959 revolution, focusing on the roles of Che Guevara and Fidel Castro.

The most impressive museum glorifying the history of a Communist Party is the National Museum of China. The museum was established in 2003 through the fusion of two distinct institutions that existed in the same building for several decades: the Museum of the Chinese Revolution and the National Museum of Chinese History. The renovation of the National Museum of China is an integral part of China's new cultural strategy, "a major cultural landmark symbolizing the increased soft power of Chinese culture."[22] On the one hand, there was a conscious attempt to modernize the museum by employing Western curators and designers to turn it into a paramount representation of the achievements of the Chinese civilization throughout time. On the other hand, the new exhibition redefined the history and mission of the Chinese Communist Party in the new political contexts of openness. The main innovation is the fact that the history of the Communist Party and the history of China are not narrated separately anymore but organically interwoven into a single master narrative on the redemption of the Chinese civilization. The National Museum of China tells a story of rebirth: from China's ancient glory to its feudal decadence at the hand of foreign invaders and its current regeneration under the leadership of the Communist Party. The museum condemns feudal oppression, capitalist exploitation, and the foreign invasion of China; yet it does not symbolically oppose the imperial past to communist China but presents the current republic as a direct continuation of China's imperial glory. From this perspective, communism is depicted as "the inevitable outcome of the course of modern Chinese history."[23] Symbolically, the exhibition ends with a presentation of China's space program, thus projecting the communist futuristic utopia in time and space.

Selling nostalgia: Red tourism, entertainment complexes, and statue parks

Another major form employed to cultivate the image and legacy of communism as a lived experience has been to promote practices of "red tourism" integrating communist museums, memorials, mausoleums, and realms of memory. Such practices developed mostly "from above" in existing communist regimes, such as China or North Korea, as a form of glorifying the history of the communist revolution and of its "founding fathers." Thus, in 2005, in an attempt to boost development in backward regions, the Chinese government initiated a policy of domestic tourism along symbolic itineraries, consisting of emblematic places for the history of the Chinese Communist Party. The route included the Japanese Germ Warfare Experimental Base in Harbin, the Xifeng concentration camp, Mao's hometown of Shǎoshān, and the Forces' Meeting Memorial Hall and the Revolutionary Martyrs' Cemetery in Jinggangshan.[24] Zhang Xiqin, vice-president of the Chinese National Tourism Bureau, pointed out that this initiative "is an economic project, a cultural project and, at the same time, a political project."[25] According to official sources, more than 400 million people had taken red tourism holidays since the policy's inception, generating over $13.5 billion in revenue to local economies on the route. Moreover, almost two million people now owe their jobs to the scheme, either directly or indirectly.[26] Most importantly, the Chinese official emphasized, the project "has significant importance in educating the younger generation about the country's revolutionary past."[27]

Red tourism is not restricting to surviving communist regimes. The idea of making commercial profit from relics of communist history developed as initiatives "from below" in all former socialist states, regardless of their critical or nostalgic association with the past. Naturally, these practices developed mostly in Eastern European cities that benefit from massive tourist inputs, such as Prague and Budapest, but also in other former socialist capitals, such as Warsaw, Bucharest, or Sofia. Most initiatives of this kind are commercial responses to the demand of Western tourists to encounter relics of communism; yet they also respond to feelings of nostalgia for the regime by ordinary people. Red tourism recreates the experience of living under communism by offering comprehensive urban tourist packages that include visits to former monuments and mausoleums and to museums of communism, during which the visitors encounter or even directly experience emblematic products of communist consumption, such as cars, interior design, fashion, TV programs, or publications, among others. One prime motivation is thus economic, as a form of commercialized nostalgia but also as *damnatio memorie*; the project has an educational dimension as well, especially by exposing the young generation to the history of the communist regime via past objects. Other museums cover, in a more anthropological manner, the popular culture of socialism, such as the history of smoking.[28]

Paradoxically, feelings of nostalgia also have been marketed in countries where daily life under a communist regime was particularly harsh, as in Romania. Nostalgia for the old regime and the cult of the dead leader was promoted mainly by former communist apparatchiks or interest groups but also by commercial companies. The most striking attempts to musealize nostalgia in Romania are the Museum of Communism in Scornicești, the birthplace of Nicolae Ceaușescu, and The Museum of the Romanian

Socialist Republic (RSR) in Podari, opened in 2004, in Craiova county. Both initiatives were promoted by Dinel Staicu, a controversial businessman and football club owner, who developed a genuine obsession for the postmortem cult of Nicolae Ceauşescu. Staicu bought the majority of goods that belonged to the Ceauşescu family; he also moved into one of their former residences. Built as an open-air 200-hectare park on the bank of the river Jiu, the Museum of the RSR aimed to recreate the lost social universe of the communist regime, focusing on a mixture of politics, football, and material culture. Upon entry, the visitors were given communist-style identification cards, while a socialist militia team patrolled the compound in an old Dacia 1100 car. A quasi-religious shrine dedicated to Nicolae Ceauşescu was placed at the center of the complex, appealing to Christian redemption for the former communist (and atheist) leaders: "Place of prayer and eternal gratitude to honor the memory of the hero-martyrs of the Romanian nation to whom today we ask forgiveness for the sin of their unjust condemnation."[29] The shrine was adorned with the bust of the former leader, while citations from his works were displayed on huge billboards. In the center of the park there was a hotel furnished in the "retro" socialist style of the 1980s and an open-air swimming pool. The park closed after only one year due to the incarceration of Staicu for bank fraud; later on, it was revitalized by a new owner, Costi Gheorghe, who was convinced that the Museum of the RSR would turn into a lucrative business: "In business there are many opportunities, but you need intuition. I have invested five million USD in this project. The 'Romanian Socialist Republic' is a brand created over a period of fifty years of work, and a business for Romania as a cultic exhibition."[30] Although feelings of nostalgia were increasingly harbored by a part of Romania's population facing the hardship of the transition period, the park failed to attract a large audience, being mostly used as a location for weddings and baptismal ceremonies. The musealization of nostalgia received negative comments in the press, as well, which accused the owner of "trading nightmares."[31] The park was eventually closed down following a devastating flood. If in the case of the Podari Museum the irony is unintended, other—deliberately humorous—museums assembled weird communist artifacts in order to ridicule poor taste, quality, or functionality, such as the Romanian Museum of Kitsch in Bucharest.[32]

While the Podari Museum is representative of the new trend of "commercialized nostalgia" for mercantile purposes, the narrative of Grūtas Park near Vilnius, Lithuania, is more ambivalent: the sculpture garden of around eighty-six Soviet-era statues focuses on themes of victimhood and resistance but does so by inserting it in a large family entertainment complex. The visitors can thus combine their reflections on the "Totalitarian Sphere" and the "Terror Sphere" of Soviet-style communism with visits to a Mini Zoo and a Luna Park. A more neutral example of displaying art artifacts of socialist realism is provided by the "Statue Park" established in the outskirts of Budapest, Hungary, suggestively entitled "The Remains of the Communist Dictatorship." The idea of saving these urban relics of communist official art was salutary, even if they were exiled and quarantined outside the city, in an area difficult to access. The idea was emulated in other capitals: the newly opened Museum of Socialist Art in Sofia includes a "Memento Park" as well, managed by the National Art Gallery.

Museums of everyday life

The approach to representing the history of communism as a "lived experience" was best institutionalized in museums of everyday life. Such museums have been present, by and large, in all former communist countries, but they have predominated mostly in Germany. To be sure, the same tension that has characterized debates over the communist regime in Eastern Europe is evident in Germany as well: condemnation versus normalization. The first direction of study is manifest in new research institutes for studying totalitarianism, in the campaign of lustration of former communist dignitaries, and in the condemnation of the activity of the communist secret police, the Stasi. Yet, normalization and nostalgia after communism, called *Ostalgia*, are also strongly represented in public and historiographic discourses. One major example is the GDR Museum in Berlin; another, less known example, is the Museum of Everyday Life Under Communism in Eisenhüttenstadt, the first museum of this kind in Eastern Europe. The museum is organized in a communist "relic city," a prototype of the Soviet industrialized city at the border with Poland. Built under the name of *Stalinstadt* between 1951 and 1961, the architecture of Eisenhüttenstadt was based on a standard planning arrangement, with residential blocks that included children's day care facilities, schools, and shopping facilities for around 7,000 inhabitants, the majority of whom worked in the newly established Eisenhütten state steel mill. Since 1999, the Documentation Centre on Everyday Life in the GDR (Dokumentationszentrum Alltagskultur der DDR) has staged, in a refurbished nursery, a selection of around 150,000 exhibits relating to everyday life in the GDR. Instead of behaving as a stigmatized and socially deprived relic of socialism, the city decided to build a tourist industry capitalizing on its past.[33] At the moment, the downtown of Eisenhüttenstadt is the largest protected monumental urban area in Germany.[34] Various tourist companies offer guided tours of Eisenhüttenstadt, "in German/English that enable not only historians and architects but also non-specialists to gain enthralling insights into the history of the GDR." These routinely include tours of the town's center, a visit to the Documentation Centre on Everyday Life in the GDR and a visit to the EKO Steelworks (East), and factory installations at Arcelor Eisenhüttenstadt GmbH. The museum and the guided tours do not demonize communist consumption as a surrogate or a substitute for the "real thing," as the Hungarian House of Terror does (see below), but try to reconstruct a world that has suddenly disappeared, with its material culture, symbols, and emblematic consumer goods, in order to bring back the experience of those who lived in those times by means of objects of daily life.

Another, more recent museum of this kind is the Museum of Life Under Communism, Warsaw, alternatively called the Charm of the PRL (People's Republic of Poland), established in 2014 by two private entrepreneurs, Rafał and Marta Patla as part of their Adventure Warsaw touristic company. The owners deplore the fact that the history of communism "does not have its own museum, not to mention a space that could serve as a background to the story of this bygone era."[35] The aim of the museum is to enable "younger generations to get to know the past of their parents, while the older ones will be able to remember the brighter and darker sides of the

People's Republic of Poland (PRL)."[36] To this end, the owners collected items and family memorabilia to recreate a flat interior from the communist times in a garage in Soho Factory. Cramped in a small space, the museum offers a chronological view of the various stages of the communist rule in Poland: propaganda posters and the cabinet of a party dignitary of the 1940s and 1950s; a waiting room to the cabinet in the style of the 1960s and 1970s, adorned with front pages of official newspapers, meat-ration coupons, shop vouchers and books; and the "Solidarity corner" displaying newspapers, leaflets, a stationary soda dispenser, and censored books from the 1980s, including Chris Niedenthal's famous photograph "Apocalypse Now," while on TV one can watch one of General Wojciech Witold Jaruzelski's famous speeches. Empty hooks in the shop point out to economic hardship during communist times. The museum is yet another example of commercialized nostalgia: it organizes tours in historic Nysa 522 vans, and it offers for rent its own space as well as cars, objects, and costumes from the PRL times for photo sessions, film sets, events, etc. The museum is part and parcel of a growing red tourism industry: other local entrepreneurs offer car tours of communist Warsaw in a Fiat 125p, "the iconic automobile of the 70's and 80's" (see Figure 2.1), which include symbols of Polish communism, such as the Palace of Culture and Science, houses for the working class in Constitution Square, and the former House of the Communist Party.

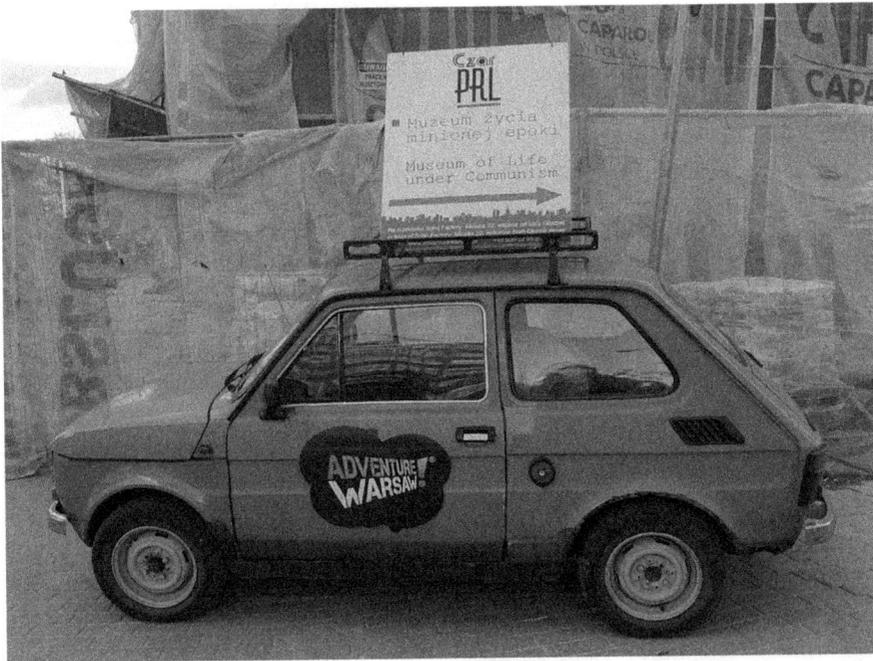

Figure 2.1 Cars as symbols of socialist affluence. A Polish Fiat 126p, a symbol of daily life in socialist Poland, used to advertise the Museum of Life under Communism, Warsaw, Poland. Photograph: Constantin Iordachi.

A similar private museum of everyday life called Ferestroika—The Museum of Family Life during Communism—was recently opened in Bucharest. The museum promises "a one-of-a-kind authentic & interactive experience by visiting the apartment of a real Romanian family from the 1980's."[37] The museum adopts a "Touch–Taste–Learn" approach to the communist past in an attempt to convey the experience of ordinary people living during that era.

Criminalizing the communist past: Retroactive justice and retribution

If nostalgia after communism was present mainly at grassroots level or was promoted by former communist interest groups or commercial entrepreneurs, the political trend of condemning communism resulted in the establishment, all over Eastern Europe, of a plethora of specialized research centers, institututes of national memory, and "truth commissions" for the investigation of the crimes of communism. The legal status of these research units has been very heterogeneous. Some are formally independent public institutions, such as the Institute of National Remembrance—Commission of the Prosecution of Crimes against the Polish Nation (IPN)—established by the Polish Parliament on December 18, 1998, with a special bill and headed by a president elected for a five-year term whose post is independent of the state authorities.[38] Others, such as the Office of the Documentation and the Investigation of the Crimes of Communism in the Czech Republic, which is a police subdivision that investigates the criminal acts from the period 1948 to 1989, functions under the aegis of the Ministry of the Interior.[39]

The mission of condemning communism was subsequently frontally assumed by truth commissions established mostly under the aegis of the presidency in six post-communist countries: Germany (1992),[40] Lithuania (1998),[41] Estonia (1998),[42] Latvia (1998),[43] Romania (2006),[44] and the Republic of Moldova (2010).[45] Their main mandate was to report on the record of human rights violation under communism and to thus contribute to the promotion of justice, reconciliation, and education on democracy in post-communist societies. These reports served as a basis for the official political, moral, and legal condemnation of communism.[46]

The moral and/or legal condemnation of communist regimes by official truth commissions was accompanied by calls for the lustration of former communist dignitaries or collaborators of the secret police, and their exclusion from politics, retribution through legal punishment of abuses against human rights, and the rehabilitation of victims of communism through the restitution of their lost property or status and the awarding of financial compensation for suffering and abuses.[47] These initiatives had a powerful political impact, and shaped the public perception of the history and legacy of communist regimes. Yet, unlike other truth commissions around the world, post-communist truth commissions were less concerned with societal reconciliation and more focused on symbolic forms of *damnatio memoriae*. Moreover, the multiple recommendations of truth commissions concerning transnational justice were rarely implemented in practice; overall, we can speak of a generalized "failure to judicialize" the wide range of human rights violations and crimes perpetrated during state socialism, as Laure Neumayer pointed out.[48]

Damnatio memoriae: Museums of terror and resistance

The musealization of communist regimes was part and parcel of these ongoing campaigns of retroactive justice. In contrast to ongoing glorification in surviving communist regimes, in post-1989 Eastern Europe most official museums of communism have been either disbanded or turned into their opposite, as sites of *damnatio memoriae* rather than glorification. Such a major transformation is exhibited, for example, by the Lenin Museum in Baku: a former branch of the Moscow Lenin Museum, the building now hosts the Independence Museum of Azerbaijan. Similarly, the Bucharest Museum of the History of the Communist Party, of the Revolutionary and Democratic Movement in Romania, was disbanded in 1990, its seat being taken over by the newly established National Museum of the Romanian Peasant. The collection of the old Museum of the Communist Party was relegated to the basement and turned into an ad hoc museum of communism.[49] In the following, I provide an overview of the main types of museums condemning communism in Eastern Europe. Although most of these museums are multifaceted and thus difficult to straitjacket in a single analytical category, I will classify them according to the following typology: memorial museums of terrors, museums of genocide, museums of resistance, and museums of dual occupation.

Most museums of communism have adopted as model *memorial museums* of terror or genocide, thus emulating the memorialization of Holocaust in post-1945 Europe.[50] One of the first and most important museums of communism in the region is the Sighet Memorial Museum in Romania, established in 1994 in the Sighet Prison, as Part of the Memorial of the Victims of Communism (which also include "The International Center for the Study of Communism" led by Romulus Rusan). The Sighet Memorial Museum did not originate as a state-sponsored institution—as the later House of Terror Museum in Budapest (2002, see below)—but as a grassroots initiative of the Civic Academy Foundation (*Fundația Academia Civică*), led by the dissident writer Ana Blandiana. The Sighet Memorial is both a prison museum and a *lieu de memoir*, documenting the extermination of Romania's interwar political elites by the communist authorities. The museum exhibits the prison cells where the high-profile political prisoners were held captive; nearby, the cemetery where the victims were buried in common graves, without crosses or proper religious rites, was discovered and is open for visits. During the time, the prison museum developed into a comprehensive museum of communism: each prison cell displays exhibitions focusing on major themes such as propaganda, religious life, repression, daily life, resistance, etc.

Although the Sighet Museum falls into the category of terror or memorial museums, its message and presentation is animated by civic-liberal values. The museum does not embrace the ideology of victimhood nationalism: it does not aim at blaming the West or external totalitarian regimes for Romania's historical tribulations but presents both Soviet and domestic responsibility for repression. Last but not least, the exhibition does not present the history of communism in Romania in isolation but provides comparative perspectives from other Eastern European countries, with a focus on anti-communist uprisings and dissident movements. Although the Sighet Memorial has imposed itself as the main museum of communism in Romania, and has been very active in organizing education activities, its eccentric location, at the

border with Ukraine, makes it a rather peripheral touristic destination.[51] To alleviate this problem, the museum has recently opened a permanent yet small exhibition in Bucharest.[52]

The Stasi Museum in Berlin offers a comprehensive view of the history of the GDR political police, the Stasi, covering its *modus operandi* and its impact on society in various fields, such as on churches, the workplace, the military, etc. The museum takes an institutional approach to the Stasi, but it also explores its impact on the life of ordinary persons by uncovering individual cases of collaboration, and pointing out the advantages but also the moral compromises involved in making such a pact. The museum is firm in condemning the repressive nature of the communist rule and the nefarious role played by the Stasi, but it does not treat communism as an exclusively occupation regime and does not promote victimhood nationalism.

The Museum of Communism in Prague, the Czech Republic, covers the history of communist rule in Czechoslovakia from the February coup in 1948 to its collapse in November 1989. The exhibition takes a hybrid approach to the history of communism— in between museums of terror and museums of daily life: its exhibition focuses on "the Dream, the Reality, and the Nightmare," thus covering both the utopian core of the communist ideology and its repressive practice.[53] The museum aims to offer "a vivid account of Communism" as a totalitarian regime, focusing on "daily life, politics, history, sports, economics, education, art (specifically Socialist Realism), propaganda in the media, the People's Militias, the army, the police (including the secret police, the StB), censorship, and courts and other institutes of repression, including show trials and political labor camps during the Stalinist era."[54] The exhibition displayed few historical artifacts: instead, it provides a multimedia experience by way of immersive factories, a historical schoolroom, an interrogation room, and newsreels in a "Television Time Machine." Overall, due to its hybrid nature and the reproduction of ideological stereotypes about communism as totalitarianism, the museum seems meant to reinforce in Western tourists their received Cold War wisdom about the nature of communist regimes.

Another major theme, in close relationship to that of repression, was that of anti-communist resistance. Most memorial museums of communism include extensive sections dedicated to heroic resistance. Naturally, this theme was most important in countries that experienced open rebellions against the communist regime and centered around major revolts, such as the 1956 revolution in Hungary, and the 1968 uprising in Prague, or the Solidarity Movement in Poland. Yet, this theme was also amply present in countries where open resistance to the communist regime was less organized, such as Romania. The most paradigmatic museums of resistance revolved around the history of Solidarity, the Polish trade union that grew into the largest civil resistance movement to the communist regime. A first Museum of the Solidarity Movement was organized in an underground gallery in Gdańsk, Poland. The museum provided a vivid reconstruction of Solidarity's fight against the communist regime, by way of posters, archival documents and historical footage. It also portrayed daily life deprivation under communism, reconstructing, for example, a communist food shop with its proverbial empty shelves. The old Museum of Solidarity has been recently replaced by an imposing European Solidarity Center (*Europejskie Centrum Solidarności,*

ESC). The location of the ESC and its design in the form of hulls of ships evokes the origin of the movement at the Gdańsk Shipyard. The opening ceremony, attended by Lech Wałęsa, co-founder of Solidarity and former president of Poland (1990–1995), took place on August 31, 2014, on the anniversary of the 1980 Gdańsk Agreement, which led to the birth of Solidarity. The ESC contains research and academic units and conducts educational activities as well.

Museums of (dual) occupation

The dominant pattern of musealizing communism was that of dual occupation, based on the theory of unitotalitarianism, the idea that fascism and communism belong to a single form of government. In most Eastern European countries, communism was established under a regime of Soviet military occupation and its maintenance depended, throughout its history, on the presence of Soviet troops. From this perspective, national historiographies in these countries have denounced communism as an anti-national regime of occupation. This trend has been dominant in the former Soviet Republics that (re)gained their independence in 1991, such as the Baltic States, in the Caucasus, and more recently also in the Republics of Moldova and Ukraine. But it has been adopted in former satellite countries too, both in those that had a continuous Soviet military presence on their territory, such as GDR and Hungary, and in those where Soviet Union withdrew its troops, such as in Romania (1958), regardless of the fact that in some of these countries communism had domestic roots, as well, and/or was taken over by homegrown leaders.

The first and most emblematic museums of dual occupations are the Ninth Fort Museum in Kaunas, Lithuania, established in 1958 and refurbished after 1991; the Museum of the Occupation of Latvia in Riga, established in 1993; and the Vabamu Museum of Occupations and Freedom in Tallinn, Estonia, opened in 2003. Reflecting the complexities of national history in these countries, all these museums provide overviews of three periods of occupation: the first Soviet occupation (1940–1941), the German occupation (1941–1944), and the second, long-lasting Soviet occupation (1944–1991). All three museums exhibit historical artifacts and archival documents about the Nazi and Soviet terror. They also function as research institutions meant to educate the public about the Soviet regime of occupation.[55]

The Ninth Fort Museum, part of the Kaunas Fortress built in the nineteenth century, illustrates the post-1991 adoption of the paradigm of dual occupation. Under Nazi occupation, the Fort was used as a place for the execution of Jews and other Soviet prisoners, while during the Soviet occupation it served as a prison and transit station for labor camp prisoners. The Fort was established in 1958 as a Museum of Revolution History (in four cells), documenting the Nazi crimes. Following forensic investigations of local mass murder sites, in 1960 the complex was extended to a mass grave and a memorial to the 30,000 Jewish victims executed in the Fort. Currently, the Ninth Fort Museum offers four comprehensive historical exhibitions concerning the *Kaunas Fortress (1882–1915)*, the *Kaunas Hard Labour Prison (1924–1940)*, the period of *Nazi Occupation and Holocaust (1941–1944)*, and the *Soviet Occupation (1940–1941, 1944–1990)*.

The museums of dual occupation in the Baltic States set a trend that has been emulated in other former Soviet Republics as well. However, if in the Baltic States the paradigm of dual occupation had historical grounding, in other borderland republics of the Soviet Union the legacy of communism was either artificially juxtaposed with or contrasted to fascist regimes, leading to narratives of "competing martyrdom" of the nation, revolving around a politicized comparison between the Holocaust and the Gulag. In the Republic of Moldova, for example, political elites and the general public are split between two rival historical narratives: pro-Russian political forces stigmatize the Romanian interwar and wartime legacy as "fascist" while glorifying, at the same time, the Soviet past as a modernizing regime, arguing therefore for the preservation of Soviet symbols, monuments and memorials (see the Trans-Dnister Region, a quasi-Soviet relic); pro-Romanian political forces, in contrast, denounce the Soviet occupation as a departure from the natural course of national history and plead for reunion with Romania. The latter narrative is amply represented in the main exhibition of the National History Museum of Moldova, Chişinău, refurbished in the early 1990s, which presents favorably the interwar history of Moldova within Greater Romania but condemns the Soviet occupation (1940–1941, 1944–1991) as a period of repression and denationalization of Moldova. This narrative was further institutionalized in a distinct Museum of the Soviet Occupation of Moldova, initiated in 2015 and opened in 2016 within the Center of Military History and Culture of the National Army, Chişinău, and dedicated to the victims of those deported or killed by the Soviet authorities.

Another museum of occupation in post-Soviet states directly inspired by exhibitions in Tallinn and Riga, is the Museum of the Soviet Occupation in Tbilisi,[56] documenting the system of organized repression during the Soviet rule in Georgia (1921–1991). Opened on May 26, 2006, as part of the celebrations surrounding Georgia's Independence Day, and formally integrated into the Georgian National Museum, the museum exhibits personal files of the victims of the Soviet repression, artifacts from Soviet-era prison cells, and documents the history of the "anti-occupational, national-liberation movements" in Soviet Georgia. Established at a time of a sharp ideological conflict with Russia, the museum benefited from a special fund granted by President Mikheil Saakashvili and played a central part in his campaign of historical politics focusing on the condemnation of the Soviet occupation of Georgia. The timing of the museum's opening and its symbolism stirred strong reactions of protest from Russia, in the wake of the 2008 South Ossetia War. At the same time—following a visit in March 2007—the president of Ukraine Victor Yuschenko reportedly expressed his willingness to open a similar museum in Ukraine. This plan has not materialized; however, in 2011, the Kiev City Organization of the Memorial Society established a well-documented yet modest Museum of the Soviet Occupation of Ukraine, focusing on the crimes committed by the Soviet occupational regime against the Ukrainian people from 1917 to 1991. Ukrainian authorities have opted, instead, to condemn the Soviet occupation in a museum of genocide; in 2008, the Memorial in Commemoration of Famines' Victims in Ukraine (1932–1933) was opened in Kiev, renamed the National Museum Holodomor Victims Memorial in 2010. The museum consists of a memorial complex and an underground *Hall of Memory* housing a permanent exhibition on the periods of famine.

The concept of "dual occupation" has been promoted as a pattern of remembrance in former satellite countries of the Soviet Union as well, most notably in Hungary and Poland, despite the fact that these countries were not formally incorporated in the Soviet Union. In both countries, the integration of the history of the two totalitarian regimes in an unitary perspective has thus proved more difficult than in the Baltic States, generating arduous debates. Opened in February 2002, the House of Terror Museum in Budapest provides a striking yet highly politicized illustration of the Cold War theory of unitotalitarianism. The museum is also conceived as a *lieu de memoir* "a monument to the memory of those held captive, tortured and killed in this building."[57] The House of Terror Museum is, in essence, a visual representation of the concept of unitotalitarianism: its main aim is to condemn fascism and communism, "the two cruelest systems of the 20th century."[58] This message is coupled with a discourse on the victimization of Hungary by the greatest evils of the twentieth century: Nazi Germany and Soviet Russia.[59] The fascist and communist regimes in Hungary are presented as regimes of foreign occupation: it is telling, in this respect that the museum opens with a room called *Dual Occupation*—presenting the dismemberment of historical Hungary after the First World War, its partially successful revisionist policy during the Second World War and the dual, Nazi and Soviet, occupation of Hungary—and it ends with a room on the withdrawal of Soviet troops in 1991.

In Poland, the impressive Warsaw Rising Museum narrates the tragic history of the 63-day insurrection of August–September 1944 that resulted in over 200,000 dead.[60] The museum opened on July 31, 2004, on the 60th anniversary of the uprising. The declared aim of the museum is to depict "the fighting and everyday life during the Rising, keeping occupation terror in the background."[61] Although it focuses on the Nazi occupation, the Warsaw Rising Museum also includes a section on communism depicting the Soviet takeover and its regime of terror against the Home Army. The section also denounces the "national treason" of the Polish Communist Party in collaborating with the Soviet occupiers.

At first sight, the historical coverage of the two museums is markedly different: the House of Terror focuses on the history of communist Hungary's political police, while the Polish Rising Museum focuses mainly on the failed 1944 Warsaw anti-Nazi uprising. Despite their different chronological focuses, both museums advance a strikingly similar historical master narrative, supported by a common exhibition structure and technical means. Both museums advance impressive multimedia shows, made up of music, sound effects, interviews, cinema rooms, documentaries, posters, and photographs. Both display an imposing central artifact: a Soviet tank in the House of Terror and a Liberator B-24J bomber in the Rising Museum. The Hungarian museum displays mostly posters and text, and as such it can be characterized as an ahistorical representation of the Cold War concept of unitotalitarianism rather than as a history museum. Its exhibition contains few authentic historical objects but instead makes heavy use of photo reproductions, posters, collages, and documentary films. In addition, the exhibition concentrates overwhelmingly on political history, aspects of daily life being only presented toward the end of the exhibition, in a more colorful room about consumerism, reproducing images of Russian *pobeda* (watches), Hungarian Pick salami, interior decoration, fashion, etc. The Rising Museum has been more concerned with gathering and displaying original artifacts, not least through public acquisition campaigns.

Both museums start their narrative with a historical map of Hungary and Poland, respectively, squeezed in between two totalitarian powers, Nazi Germany and Soviet Union. As such, they set the stage for displaying the martyrdom of the two countries during the twentieth century at the hand of foreign powers. The map in the Rising Museum presents the dual occupation of Poland by Nazi Germany and the Soviet Union but makes no reference to the partition of Poland in the eighteenth century. In contrast, the House of Terror starts with the map of Austria-Hungary and the dismemberment of historical Hungary at the end of the Great War; it then presents the partial recreation of Greater Hungary during the Second World War but also its "dual occupation" and dismemberment, once again, at the end of the war. The Trianon Peace Treaty is thus presented as a historical injustice, as part and parcel of an alleged martyrization of Hungary during the twentieth century. This presentation consciously obscures the fact that Hungary was a willing ally of Nazi Germany until March 19, 1944, and that, unlike Poland, Hungary preserved its statehood, government, territorial borders, and embassies abroad even after the Nazi coup d'etat in March 1944.

The exhibitions of both museums are organized around the concept of terror, relating to both the Nazi and Soviet occupational regimes. In Hungary, that word reigns supreme not only in the name of the museum but also on the roof of the building, being projected by sunrays during the day on its walls and the pavement (see Figure 2.2). Both museums highlight the victimization of their country by alien totalitarian powers; both neglect the domestic roots of their own fascist and communist parties, portraying totalitarianism as an exclusively external, occupational regime. This interpretation is particularly

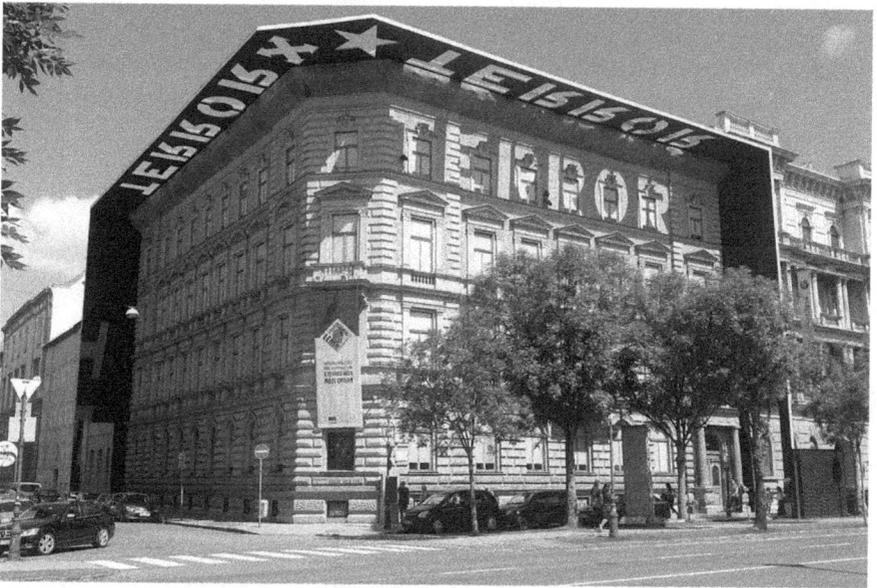

Figure 2.2 The House of Terror Museum, Budapest, Hungary. Note the star and the arrow crosses in the upper corner, flanking the words "Terror," the symbols of the Hungarian Communist Party and of the Hungarian fascist Arrow Cross Party, respectively. Photograph: Constantin Iordachi.

problematic in the case of Hungary: its vigorous, homegrown fascist Arrow Cross is depicted, in a superficial manner, as "Hungarian Nazis," a label which obscures the fact that the Arrow Cross had a huge mass appeal and played an important political role in the last phase of the war as Nazi ally and partner in crimes against the Jewish population. Last but not least, both museums criticize "the West" for its passivity and lack of help. This feature is stronger in the Rising Museum; while less present in the House of Terror Museum, this propaganda trope is, however, increasingly present in the most recent official celebrations of the 1956 Revolution in Hungary, which downplayed the Soviet intervention but blamed the West for its passivity and lack of military support for the revolutionary government. For an uninformed visitor, the image disseminated is that of a homogeneous, monolithic Hungarian society dismembered and martyrized by foreign evil forces. There is also a hint at stigmatizing post-1989 socialist political parties in both countries as continuators of the anti-national policy of the old Communist Party, while the initiators of the two museums (Prime Minister Viktor Orbán in Hungary, and the then-mayor of Warsaw Lech Aleksander Kaczyński, 2002–2005, in Poland, respectively), are hailed as liberators, as ones who worked for restoring true national identity.

Politics and memory war: Museums as political battlegrounds

Due to their paramount importance in articulating political master narratives and in shaping public perceptions, truth commissions, research institutes, and museums of communism have served as battlegrounds for historical politics. First, in many countries, the competition for capturing the symbolic capital associated with condemning communism has led to the establishment of rival truth commissions and research institutions. Thus, in Romania, the political tensions between President Traian Băsescu and the Prime Minister Călin Popescu Tăriceanu, the leader of the National Liberal Party, was also manifest in the field of historical politics, generating a competition for symbolic preeminence between two like-minded institutions, the Institute for the Investigation of the Crimes of Communism and for the Memory of the Romanian Exile, established in 2005 by the government, and the Presidential Commission for the Study of the Communist Dictatorship, set up in April 2006.[62] Second, the research and publication activities of the new institutes for the investigation of crimes of communism has been explicitly directed against feelings of nostalgia for the communist regime harbored by some categories of the population. Marius Oprea, former head of the above-mentioned Institute for the Investigation of the Crimes of Communism, for example, argued that the condemnation of communism cannot coexist with feeling of nostalgia after communism: "The international condemnation of communism obliges us to overcome attitudes of nostalgia toward a regime which lost, a long time ago, any ground for exoneration."[63] A similar goal is assumed by the Estonian Foundation for the Investigation of Communist Crimes; its research results are meant "to dismiss once and for all a shockingly common and ubiquitous illusion that any 'semi-good' violent regimes – yet based on the violation of human rights, torture and constant threat on life – ever existed or could exist."[64]

Since contemporary "narrative museums" are efficient tools in shaping historical remembrance, there has also been an acute political-ideological struggle over

controlling the content of major museums of history. A great number of legal-political battles followed, involving political parties, state institutions, museum professionals, academics, journalists, and the general public. As a result, museum exhibitions have gone through successive revamping, to reflect the political values of new ruling parties. Some of these controversies were stirred by attempts at liberalizing more traditional historical narratives; others were stirred, on the contrary, by attempts at re-nationalizing "universalistic" narratives.

The first trend is exemplified by the debates surrounding the Baltic museums of dual occupation. More recently, there has been attempts to nuance the dual occupation paradigm by enriching it with new themes of social interest. The most comprehensive attempt in this respect was provided by the Museum of Occupations in Tallinn, Estonia. The original exhibition focusing on communism as totalitarianism has been extended to focus on four major teams: "occupations, resistance, restoration, and freedom."[65] The new enlarged focus was meant to educate the public about the Soviet regime of occupation but also about democratic, civic-liberal values: "We educate and involve the people of Estonia and its visitors and encourage everyone to think about the recent past, to sense the fragility of freedom, and to stand for freedom and justice," states the website of the refurbished Vabamu Museum of Occupations and Freedom.[66] These changes stirred a major societal debate. Some critics welcomed this diversification as a confirmation of Estonia overcoming its historical trauma by turning its attention to positive political values, such as freedom and democracy. For others, the new paradigm was an attempt to relativize and thus exculpate the Soviet crimes against the Estonian people. For Marcus Kolga, for example, the attempt "to de-emphasize and sanitize the 'occupations' part of The Museum of Occupation" was "a tragic leap backwards," no more than a campaign for "a new political correctness in Estonia" or "a pseudo-Finlandization"[67] that played into the hands of the Russian propaganda: "Vladimir Putin and his legion of crypto-Soviet propagandists are no doubt licking their lips: the Estonians themselves are completing their work for them."[68]

In the Republic of Moldova, the Museum of Soviet Occupation was openly criticized by the pro-Russian socialist President of Moldova, Igor Dodon, who in November 2019 appointed a new museum director with the task of "making a good, normal, beautiful museum" which to cover the liberation of Moldova by the Red Army, instead of the old one "about I do not know what kind of occupation."[69] The president's initiative was criticized by the initiator of the Museum, former Minister of Defence Anatol Șalaru, as "a new act of aggression against our Romanian identity."[70] Another politician, Anatol Țăranu, argued that Dodon's intervention in museum politics was "a continuation of the offensive meant to prevent the revision of the Soviet part, as part of a conscious campaign to turn public attitudes towards Soviet values, and towards everything that represents the ideology of the Russian world."[71]

In other East European countries, the legacy of communist historical politics, on the one hand, and of successive post-communist campaigns of historical politics, on the other, has led to the uneasy coexistence of rival museums of the recent past. In Georgia, for example, the message of the new Museum of Occupation stands in direct contradiction to the communist-era Joseph Stalin Museum in Gori, Georgia. While the former presents the communist rule as a regime of terror inflicted under Soviet

occupation, the second presents Stalin as a great Georgian historical personality—a brilliant statesman but also a poet—who made an outstanding contribution to the history of the Soviet Union. Opened in 1957, the Joseph Stalin Museum was closed in 1989, but soon reopened. After unsuccessful attempts to close it down, the Georgian government chose to (temporarily) place a banner over its gate, condemning the museum as illegitimate.

In Hungary and Poland, the populist backlash that has followed the 2008 Great Recession has also ushered in concerted campaign of historical politics. In this context, the House of Terror Museum and the Warsaw Rising Museum were designed by the conservative-nationalist ruling forces in both countries as central institutions of a new form of cultural politics meant to shape public opinion. As noted earlier, the aim of the two museums is to offer a grand narrative on national history, characterized by nationalism, historical revanchism, and anti-foreign—mostly anti-Western—feelings. As such, the two museums stand in contradiction to earlier, pro-European, civil-liberal museums of war and of the Holocaust. The competition has been largely uneven, however: the strong state support enjoyed by the House of Terror and the Warsaw Rising Museum, their large budget, impressive multimedia display, and rich educational activities make these museums the most attended and influential exhibitions in their country. No wonder the narratives they promote have managed to marginalize or suppressed alternative lines of interpretation presented in other museums.

The controversies surrounding the House of Terror Museum concerned mostly the uneven comparison between the two forms of totalitarianism, fascism and communism, and the marginalization of the tragedy of the Hungarian Jews during the Second World War. First, the House of Terror Museum focuses overwhelmingly on the history of the communist terror and its secret police. The history of the Arrow Cross's fascist regime is only documented in two rooms; moreover, the treatment of the Arrow Cross is superficial and utterly misleading. The Arrow Cross members are called "Hungarian Nazis" and their uniforms and symbols are intercalated with Nazi ones in order to suggest that Arrow Cross was no more than a fifth column of Nazi Germany, an *instrumentum regni* of a foreign power. This view obscures the Hungarian roots of the Arrow Cross, their original ideology, and the massive popular support they received in Hungary. The overall impression is that the comparison between fascism and communism is meant to further strengthen the anti-communist message rather than being a genuine attempt to document the profile of native fascism in Hungary. Second, and most importantly, the Holocaust of the Hungarian Jews is not covered, except for a few images and sounds of the anti-Jewish pogroms organized in Budapest by the Arrow Cross in the winter of 1944 to 1945. Within this narrative, Hungary is portrayed as a "victim of history"; domestic agency, although not missing from the museum display (see the very last room of the museum, the Hall of Shame, documenting collaboration with totalitarian regimes), is turned in an emotionally driven anti-communist direction, prompting calls for post-communist retribution. The Jewish tragedy and the local responsibility for the Holocaust are marginalized in order to better highlight Hungary's martyrdom.

This revisionist narrative runs contrary to that of the state-sponsored Holocaust Memorial Center in Budapest.[72] Opened in 2004, the Holocaust Memorial Center

documents the existence of rabid anti-Semitism in interwar Hungary, the local roots of fascism, and the Hungarian authorities' collaboration to, and shared responsibility for, the Holocaust of the Hungarian Jews. Embarrassed by this opposing view, the Hungarian government exercised pressure to refurbish the exhibition of the Holocaust Memorial Center. Fearing international reactions, the government abandoned these plans but erected a new $18 million museum of the Holocaust, called the House of Fates – European Education Center at the site of the former Józsefváros Railroad Station, in Budapest's Eight district. In a controversial mode, the museum retells the history of the partnership in crime between Nazi Germany and Hungarian authorities as "*a story of love* between Hungarian Jews and non-Jews," focusing on children's Holocaust stories of deportation and survival.[73] According to the leading Fidesz historian Mária Schmidt, director-general of the 20th Century Institute and of the House of Terror Museum and also the chair of the Scientific Advisory Board of the Public Foundation for the Research of Central and East European History, which oversaw the project, a main aim of the new institution is to refute the "unfounded stigmata" that Hungary was "an anti-Semitic and fascist country," a view that is used "as a political weapon to discredit the Hungarian nation as a whole."[74] Domestic and international voices have expressed the concern that the House of Fates aims to downplay Hungarian responsibility for the destruction of the Hungarian Jews, presenting it as an exclusively German crime, in line with the overarching message of the House of Terror.[75] Following the withdrawal of the Federation of Hungarian Jewish Communities (MAZSIHISZ) and Yad Vashem from the International Advisory Board of the House of Fates, the official opening of the House of Fates has been postponed *sine die* and efforts are under way to cosmeticize the exhibition to render it "acceptable."[76] More recently, in order to "save" this project, the Hungarian government transferred ownership of the House of Fates museum to the Unified Hungarian Jewish Congregation (EMIH); denied that Mária Schmidt was personally involved in shaping the exhibition, authored by EMIH's Rabbi Slomó Köves and his team; and announced a new resolution on the final content of the museum.[77]

Similar tensions occurred in Poland, as well, revolving around the diverging messages of the Warsaw Rising Museum and the Museum of the Second World War in Gdańsk. The museums are emblematic for two rival political projects. While the Rising Museum was supported by the Law and Justice Party (PiS), the Museum of the Second World War was initiated in 2008 by Donald Tusk (born in Gdańsk), former chairman of the "Civic Platform," prime minister of Poland (2007–2014), and president of the European Council (2014–2019). Officially inaugurated in 2017, the Museum of the Second World War provided an equally impressive yet markedly different treatment of the greatest military conflagration—as compared to the Warsaw Rising Museum—mostly "in terms of politics, ideology and civil population." It documented the rise of totalitarian regimes in fascist Italy, Nazi Germany and the Soviet Union and the regimes of terror they instituted in the occupied territories. Yet, the exhibition departs from classical war museums in significant respects: it does not focus on military developments on the Eastern Front and on the situation in Poland but presents the larger context of the world war as a universal experience. To this end,

it explores the lives and fates of civilians and soldiers during the conflagration, with a focus on Central and Eastern Europe. This orientation has influenced the content of the exhibitions: the museum displays mostly everyday objects and personal memorabilia, in addition to military equipment such as American and Soviet tanks. The Gdańsk museum's approach is part of a larger European trend. A similar unconventional treatment of war is provided by the Bundeswehr Military History Museum (*Militärhistorisches Museum der Bundeswehr*) in Dresden. Opened in 2011 in an impressive architectural complex redesigned by the architect Daniel Liebeskind, the museum boasts a rich and multifaceted exhibition, offering eleven themes and thee chronological tours, ranging from 1300 to the present. Instead of glorifying the history of the German Armed Forces, the museum presents a critique of the war as a traumatic societal experience. Just like in the Gdańsk Museum of the Second World War, the emphasis is not on military technology but on the impact of war on society.

Soon after its inauguration, the Museum of the Second World War was attacked by the "Law and Justice" government, who expressed its intention to refurbish the museum to better highlight Poland's heroic fight and martyrdom during the Second World War. Another issue of contention was the treatment of the anti-Jewish Jedwabne massacre, which, as the former director Paweł Machcewicz pointed out, was found provocative in its stress of Polish responsibility.[78] In April 2017, Machcewicz was dismissed on the count that he promoted an universalistic "socialist-pacifist" approach to war focusing on the sufferings of soldiers, civilians, and prisoners of war (POWs),[79] and replaced by the government-appointed Karol Nawrocki, endorsing a conservative-nationalist view of history. The new director implemented strategic changes to the permanent exhibition, concerning, among other issues, the role of Catholic priests during the war, the role of Polish citizens in saving Jews, and statistics about war casualties. For example, a pacifist film illustrating the long-term effects of the war has been replaced by an animated film focusing on the history of Poland in the twentieth century. Resembling addictive computer games for teenagers, the latter film spreads the values of "patriotic militarism." The museum spokesman summarized the reason behind this changes on the count that "it is also a Polish museum financed by Polish taxpayers. Polish people simply want the museum they have financed to tell their story, to refer to the Polish point of view. The museum is located in Poland and must answer to those who financed it."[80] These changes have been openly criticized by numerous domestic and foreign voices, who pointed out that the governmental intervention in the exhibition content placed Poland on the "frontline in the continent's new 'Culture Wars.'"[81]

A similar—yet less acute—tension exists between the Warsaw Rising Museum and the Polin Museum. Although the latter museum offers a rich and balanced view of the Jewish Question in Poland, focusing on societal debates over the status of Jews and taking at times a critical view of Jewish actors themselves and their inadequate reaction to tragic events, its overall approach is seen by many as antithetical in the sense that it focuses on the Jewish tragedy and not on the tragedy of the "titular" nation.[82] Thus, although the establishment of the Polin benefited from broad public support in Poland, the museum has been subject to veiled or overt criticism in nationalist circles for its emphasis on anti-Semitism and Polish participation in anti-Jewish massacres.[83]

Conclusions: Toward a new sociocultural history of communist regimes

This chapter explored patterns of coming to terms with the communist past in Eastern European museums.

It has been argued that, far from being fixed or immutable, the memory of communism in post-communist countries has been continuously shaped and reshaped as part of the political process. The analysis has pointed out that the prevailing patterns of musealizing communism in Eastern European countries have been related to a plethora of structural or contingent factors of differentiation, such as: the pluralistic or more authoritarian nature of interwar political regimes; the existence (or lack of) strong local Marxist traditions; the position of the Communist Party in interwar national politics, and its relationship to Moscow; the nature of the communist takeover, namely self-Sovietization as in Yugoslavia or Soviet military imposition as in the other satellite countries; the nature of de-Stalinization, and the strength of dissent and resistance to communism; the immediate memory of the regime in the 1980s, traumatic, as in the case of Romania, or nostalgic after "gulyas communism," as in the case of Hungary; the nature of the political change in the period 1989–1991, consisting of negotiated reforms in Hungary and Poland, "refolutions" from above in Bulgaria and GDR, a bloody revolt in Romania, etc.,[84] accounting for patterns of continuity, selective or quasi-total political ruptures; the position of former communist parties in the post-communist political system, ranging from dissolution to inner reformation and successful adaptation; and the degree of material hardship and dissatisfaction of the population in the transition period. Other issues that influenced the memory of the former communist rule were the relationship between political transformation and state-building, from the peaceful dissolution of Czechoslovakia and the USSR to the violent break-up in Yugoslavia, and national unification as in the case of the GDR; the reemergence of nationalism and the existence of significant minority issues; and the path taken to democratic consolidation, either through consensus-building or through split, contested memories. Last but not least, the nature of the post-communist political system—be it presidential, semi-presidential, or parliamentary—has influenced power dynamics manifest in the field of historical politics as well.

Due to these numerous factors at work, historical politics concerning the communist past have displayed a great diversity, ranging from official glorification in the Russian Federation, official civic-liberal condemnation in the Baltic States, Romania, and—at least temporarily—the Republic of Moldova, to civic-liberal "governance memory" in Germany, civic-liberal and then conservative-nationalist condemnation in Poland and Hungary, and open yet polarized and rather inconclusive debates in other countries. This chapter has argued that, notwithstanding this variety, the post-communist representations of communist regimes have been shaped—by and large—by an underlying tension between communism as a "lived experience" and communism as a totalitarian, criminal regime. As it becomes apparent from the cases presented here, the two approaches are not seen as complementary but as contradictory: they confront and "denounce" each other as illegitimate. In order to heal this schism and to alleviate sociopolitical cleavages in society, there is an imperious need to rebuild social consensus through democratic, pluralistic, and multigenerational perspectives of the past.

The effort to overcome the dichotomy between the two main rival approaches to the communist past is first and foremost a political issue, since it necessitates the promotion of a civic project of societal reconciliation. To this end, it is imperiously necessary to heal the growing cleavages between the partisan politics of history promoted by political parties, ivory-tower academic discourses, and the lived memory of socialism harbored by "ordinary people." This can be achieved only through an increased dialogue in the sphere of civil society and the promotion of a tolerant and pluralistic political culture that is firmly based on democratic values, while at the same time being open to difference and able to acknowledge nuanced interpretations of the past while unequivocally condemning totalitarian experiments. But the effort also poses a methodological challenge for social scientists, pertinently highlighted by Mary Fulbrook. In *The People's State: East German Society from Hitler to Honecker*, Fulbrook calls on students of communism to go beyond "dualistic models of state versus society, regime versus people" in writing the history of the GDR and to attempt instead to reconcile lived experiences with "underlying structures."[85] How can this dichotomy be overcome? Can one go "beyond totalitarianism" without losing sight of the repressive nature of the communist rule?[86] From a methodological point of view, one strategy to overcome the cleavage between discourses on communism as a totalitarian regime vs. communism as a lived experience is to depart from rigid and static political science approaches to the communist past and to instead promote interdisciplinary approaches that account for and integrate the lives and experiences of ordinary people. To be sure, communist studies have always been interdisciplinary, their subject matter providing an ideal meeting ground for historians, political scientists, and sociologists. More recently, the field has been joined by anthropologists, art historians, gender historians, and students of biomedicine, among others. Interdisciplinarity brings with it both a broadening and a deepening of the research agenda in the field. Nowadays, students of communism explore a richness of new themes, such as the communist ideology and culture, political languages and vocabulary, gender and demographic policies, communist rites and rituals and their connection to religion.

Second, historians of the communist past might benefit from the recent wider international tendency of rejuvenating social research, in close symbiosis with cultural studies. Methodologically, in order to de-essentialize social identities, there is a tendency to consider them in flux and motion, by emphasizing processes of "becoming" and "transformation." There is also a focus on the hybridity and multiplicity of identities rather than on their homogeneity or internal coherence, and on the interplay among various levels of identity, such as legal-political status, age, gender, ethnicity, race, etc. In order to capture the dynamics of these phenomena, and to better explain behavior at an individual level, there is also a tendency to concentrate on small-scale research, using the tools of micro-history and focusing on everyday life, and forms of education and socialization under communist regimes. Yet, for coping with the problems posed by the combination of micro and macro scales of research, there is also a need to bring large structures "back in" in the study of communism and to link them to pre- and post-communist transformations. The combination of these research scales and perspectives would enable historians

to integrate more meaningfully the lived experiences of ordinary people with the scholarly study of the coercive actions and sociopolitical structures of communist regimes and to thus arrive at a more nuanced understanding of the complexities of those regimes, accounting for their violent, repressive nature but also for their contradictory long-term legacies and multifaceted memory.

Notes

1 On this point, see Stephen Kotkin, *Magnetic Mountain. Stalinism as a Civilization* (Berkeley: University of California Press, 1997).

2 Katherine Verdery, *Political Life of Dead Bodies: Reburial and Postsocialist Change* (New York: Columbia University Press, 1999), 26–27.

3 It should be noted from the outset that the two approaches differ in their terminology, as well: totalitarian approaches employ the generic term "communist regimes," while the proponents of "everyday life approaches" use "socialist dictatorships" to refer to the "real existing" socialist regimes. In this essay, I use the terms socialist or communist regimes interchangeably, on the count that, while officially most states were socialist (or people's republics), ruling parties and their official ideology was communist.

4 Domenico Losurdo, "Towards a Critique of the Category of Totalitarianism," *Historical Materialism* 12, no. 2 (2004): 25–55.

5 Michael Halberstam, "Totalitarianism as a Problem for the Modern Conception of Politics," *Political Theory* 26, no. 4 (1998): 459–488.

6 Les K. Adler and Thomas G. Paterson, "Red Fascism: The Merger of Nazi Germany and Soviet Russia in the American Image of Totalitarianism, 1930's–1950s," *American Historical Review* 75 (1970): 1046–1064.

7 Hannah Arendt, *The Origins of Totalitarianism* (New York: Harcourt Brace Jovanovich, 1951); Carl J. Friedrich and Zbigniew K. Brzezinski, *Totalitarian Dictatorship & Autocracy* (Cambridge, MA: Harvard University Press, 1956); 2nd, rev. edn. by Carl J. Friedrich (New York: Praeger, 1965); and Carl J. Friedrich (ed.), *Totalitarianism* (New York: Grosset & Dunlap 1964).

8 For attempts to rejuvenate the totalitarian approach, see Robert Conquest, *The Harvest of Sorrow: Soviet Collectivization and the Terror-Famine* (New York: Arrow Books, 1988); Robert Conquest, *The Great Terror: A Reassessment* (Edmonton: University of Alberta Press, 1990); and Achim Siegel (ed.), *The Totalitarian Paradigm after the End of Communism: Toward a Theoretical Reassessment* (Amsterdam: Atlanta, 1998), among others. A representative book of this trend is Stéphane Courtois (ed.), *Le Livre Noir du Communisme: Crimes, terreur, répression* (Paris: Robert Laffont, 1997); English edition: *The Black Book of Communism* (Cambridge, MA: Harvard University Press, 1999). On neo-totalitarian approaches to the history of the Soviet Union, see Viktor Zaslavsky, "The Post-Soviet Stage in the Study of Totalitarianism: New Trends and Methodological Tendencies," *Russian Social Science Review* 44, no. 5 (2003): 4–31.

9 For the new revisionist trend, see Ronald Grigor Suny, "Revision and Retreat in the Historiography of 1917: Social History and Its Critics," *Russian Review* 53, no. 2 (1994): 165–182; Stephen F. Cohen, "Stalin's Terror as Social History," *Russian*

Review 45, no. 4 (1986): 375–384; William Case, "Social History and the Revisionism of the Stalinist Era," *Russian Review* 46, no. 4 (1987): 382–385. For a critical presentation of these trends, see Sheila Fitzpatrick (ed.), *Stalinism: New Directions* (London: Routledge, 1999).

10 See H. Gordon Skilling, "Interest Groups and Communist Politics," *World Politics* 18 (1966): 435–451; H. Gordon Skilling and Franklyn Griffiths, *Interest Groups in Soviet Politics* (Princeton, NJ: Princeton University Press, 1971); and H. Gordon Skilling, "Interest Groups and Communist Politics Revisited," *World Politics* 36, no. 1 (1983): 1–27.

11 On the political implications of field research in communist societies, see Steven L. Sampson and David A. Kideckel, "Anthropologists Going into the Cold: Research in the Age of Mutually Assured Destruction," in Paul Turner and David Pitt Hadley (eds.), *The Anthropology of War and Peace* (South Hadley, MA: Bergin and Garvery, 1989), 160–173; and Katherine Verdery, "How I Became Nationed," in Ronald Grigor Suny and Michael D. Kennedy (eds.), *Intellectuals and the Articulation of the Nation* (Ann Arbor: University of Michigan Press, 1999), 341–344.

12 See, selectively, Sheila Fitzpatrick (ed.), *The Cultural Front: Power and Culture in Revolutionary Russia* (Ithaca, NY: Cornell University Press, 1992); Sheila Fitzpatrick, Alexander Rabinowitch, and Richard Stites (eds.), *Russia in the Era of NEP: Explorations in Soviet Society and Culture* (Bloomington: Indiana University Press, 1991); Kotkin, *Magnetic Mountain*.

13 Alf Lüdtke, "The Historiography of Everyday Life: The Personal and the Political," in Raphael Samuel and Gareth Stedman Jones (eds.), *Culture, Ideology and Politics: Essays for Eric Hobsbawm* (London: Routledge-Paul, 1982), 38–54; Alf Lüdtke, "Stofflichkeit, Macht- Lust und Reiz der Oberflächen: Zu den Perspektiven von Alltagsgeschichte," in Winfried Schulze (ed.), *Sozialgeschichte, Alltagsgeschichte, Mikro-Historie: Eine Diskussion* (Göttingen: Vandenhoeck und Ruprecht, 1994), 65–80; Alf Lüdtke (ed.), *The History of Everyday Life: Reconstructing Historical Experiences and Ways of Life* (Princeton, NJ: Princeton University Press, 1995). For the history of everyday life and its relation to social history, see Volker Ullrich, "Alltagsgeschichte. Über einen neuen Geschichtstrend in der Bundesrepublik," *Neue Politische Literatur* 29 (1984): 50–71; Roger Fletcher, "History from Below Comes to Germany: The New History Movement in the Federal Republic of Germany," *Journal of Modern History* 60 (1988): 557–568; and David F. Crew, "*Altagsgeschichte*: A New Social History 'From Below?,'" *Central European History* 22 (1989): 394–407.

14 For works that enrich the literature on state socialism by looking at, among other topics, consumption, gender, material culture, and tourism, see Thomas Lindenberger (ed.), *Herrschaft und Eigen-Sinn in der Diktatur: Studien zur Gesellschaftsgeschichte der DDR* (Cologne: Böhlau Verlag, 1999); David Crowley and Susan Reid (eds.), *Style and Socialism: Modernity and Material Culture in Postwar Eastern Europe* (Oxford: Berg, 2000); Kristen Ghodsee, *The Red Riviera: Gender, Tourism and Postsocialism on the Black Sea* (Durham, NC: Duke University Press, 2005); Katherine Pence and Paul Betts (eds.), *Socialist Modern: East German Everyday Culture and Politics* (Ann Arbor: University of Michigan Press 2008); Shana Penn and Jill Massino (eds.), *Gender Politics and Everyday Life in State Socialist Eastern and Central Europe* (Basingstoke: Palgrave Macmillan, 2009); Paulina Bren, *The Greengrocer and His TV: The Culture of Communism after the 1968*

Prague Spring (Ithaca, NY: Cornell University Press, 2010); David Crowley and Susan Reid (eds.), *Pleasures in Socialism: Leisure and Luxury in the Eastern Bloc* (Evanston, IL: Northwestern University Press, 2010); Breda Luthar and Maruša Pušnik (eds.), *Remembering Utopia: The Culture of Everyday Life in Socialist Yugoslavia* (Washington, DC: New Academia Publishing, 2010); Paulina Bren and Mary Neuburger (eds.), *Communism Unwrapped: Consumption in Cold War Eastern Europe* (Oxford: Oxford University Press, 2012).

15 Crew, *"Altagsgeschichte."*

16 Maria Todorova, Augusta Dimou, and Stefan Troebst (eds.), *Remembering Communism: Private and Public Recollections of Lived Experience in Southeast Europe* (Budapest: Central European University Press, 2014); on Bulgaria, see Maria Todorova (ed.), *Remembering Communism: Genres of Representation* (New York: Social Science Research Council, 2010).

17 Maria Todorova and Zsuzsa Gille (eds.), *Post-Communist Nostalgia* (New York: Berghahn Books, 2012).

18 *Good Bye, Lenin!*, directed by Wolfgang Becker (Germany: X-Filme Creative Pool, WDR, and ARTE, 2003); and *The Lives of Others* (*Das Leben der Anderen*), directed by Florian Henckel von Donnersmarck (Germany: Wiedemann & Berg Filmproduktion, BR, Arte France, and Creado Film, 2006).

19 Sometimes, however, directors and scriptwriters alternate the two approaches: Compare Cristian Mungiu's movie *4 months, 3 weeks and 2 days* (*4 luni, 3 săptămâni și 2 zile*; directed by Cristian Mungiu [Romania/Belgium: Mobra Films, CNC, and Saga Film, 2007]), with his newest production, *Tales from the Golden Age* (*Amintiri din Epoca de Aur*; directed by Hanno Höfer, Răzvan Mărculescu, Cristian Mungiu, Constantin Popescu, and Ioana Uricaru [Romania/France: Mobra Films and Why Not Productions, 2009]), a satire based on memoirs of daily life under communism. Note also that *4 months, 3 weeks and 2 days* is a movie about daily life that actually reveals the totalitarian nature of the communist rule.

20 Consider, for example, the dense network of museums of communism in China: the Birthplace of Chinese Communist Party and the Museum of the First National Congress of the Chinese Communist Party in Shanghai; and the Communist Party History Museum of Shandong Province, Jinan, to name but a few.

21 For museums devoted to communist leaders, see the Relic Hall of Mao Zedong in Sháoshān, China, a museum with everyday artifacts used by the Chairman, clothing he wore, and photos from his life, and the Joseph Stalin Museum in Gori, Georgia, opened in 1957. Both museums are popular tourist attractions.

22 Director of the National Museum of China, opening caption in the National Museum of China, Beijing, retrieved by Constantin Iordachi, August 2017.

23 Caption, Section 2, "Setting up the Basic Socialist System," National Museum of China, retrieved by Constantin Iordachi August 2017.

24 Joe Boyle, "China's 'Red Tourism' Stopover," BBC News, May 14, 2008, http://news.bbc.co.uk/2/hi/asia-pacific/7401223.stm (accessed August 27, 2019).

25 Ibid.

26 Ibid.

27 Ibid.

28 See Első Magyar Látványtár Közhasznú Alapítvány, "Kiadványok," 2008–2019, https://latvanytar.com/kiadvanyok (accessed August 27, 2019) [in Hungarian].

29 "Locul de rugă şi veşnică recunoştinţă, ce vine să cinstească memoria eroilor martiri ai neamului românesc cărora noi azi le cerem iertare pentru păcatul de

osândă nedreaptă," see Adevărul, "Hotel de patru stele în muzeul comunismului," Societate, August 7, 2008, https://adevarul.ro/news/societate/hotel-patru-stele-muzeul-comunismului-1_50ad3de27c42d5a663916095/index.html (accessed December 8, 2018) [in Romanian].

30 Mediafax "Comerț cu vise urâte. Fundația PCR înființează muzeul comunismului la Scornicești," *Ziua online*, October 8, 1999, http://www.ziua.ro/display. php?data=1999-10-08&id=32358 (accessed August 27, 2019) [in Romanian].

31 Ibid.

32 See Romanian Kitsch Museum, "Welcome," 2017, https://kitschmuseum.ro/ (accessed August 27, 2019).

33 For the official website of the museum, see Dokumentationszentrum Alltagskultur der DDR, "Home," n.d., https://www.alltagskultur-ddr.de/en/ (accessed August 27, 2019).

34 https://www.alltagskultur-ddr.de/ueber-uns/#flaechendenkmal-eisenhuettenstadt (accessed August 27, 2019).

35 See Muzeum Życia w PRL, "About Museum," n.d., http://czarprl.pl/museum-of-communism/?lang=en (accessed August 27, 2019).

36 Ibid.

37 For the presentation of the museum, see Ferestroika Team, "Ferestroika- The Museum of Family Life during Communism," Eventbrite, 2019, https://www. eventbrite.com/e/ferestroika-the-museum-of-family-life-during-communism-tickets-51884180982 (accessed August 27, 2019).

38 For the official website of the commission, see Institute of National Remembrance, "Home," n.d., http://ipn.gov.pl/en (accessed August 27, 2019).

39 See "The Office for the Documentation and the Investigation of the Crimes of Communism Police of the Czech Republic," Policie ČR, 2019, https://www.policie. cz/clanek/the-office-for-the-documentation-and-the-investigation-of-the-crimes-of-communism-police-of-the-czech-republic.aspx (accessed April 20, 2019), created on January 1, 1995, as a fusion of the Office for the Documentation and the Investigation of the Activity of the State Security (being a part of the Ministry of the Interior) and of the Resource Center of the Unlawful Conduct of the Communist Regime (working at first under the Attorney General and later under the Ministry of Justice). Starting January 1, 2002, according to Act no. 283/1991 Sb., the ÚDV forms a part of the Service of the Criminal Investigation Police.

40 See Enquete-Kommission Aufarbeitung von Geschichte und Folgen der SED Diktatur in Deutschland, set up by the German Parliament in March 1992 to investigate human rights violations under communist rule in East Germany from 1949 to 1989. On the history of the two parliamentary commissions of inquiry created in the 1990s to investigate Germany's post-1945 divided past, see Andrew H. Beattie, *Playing Politics With History: The Bundestag Inquiries Into East Germany* (Oxford: Berghahn Books, 2008).

41 *Tarptautinė komisija nacių ir sovietinio okupacinių režimų nusikaltimams Lietuvoje įvertinti*, established by the President Valdas Adamkus in September 1998. See Komisija, "The Secretariat of the International Commission for the Evaluation of the Nazi and Soviet Occupation Regimes in Lithuania," 2019, https://www.komisija.lt/en/ (accessed August 27, 2019).

42 The Estonian International Commission for the Investigation of Crimes Against Humanity, convened by Lennart Meri, the president of the Republic of Estonia on October 2, 1998. See History Commission, "Estonian International Commission for the Investigation of Crimes Against Humanity," October 1998, http://www.

historycommission.ee/ (accessed August 27, 2019). For a comparative perspective on the Baltic truth commissions, see Onur Bakiner, "Between Politics and History: The Baltic Truth Commissions in Global Perspective," in Cynthia M. Horne and Lavinia Stan (eds.), *Transitional Justice and the Former Soviet Union: Reviewing the Past, Looking Toward the Future* (Cambridge: Cambridge University Press, 2018), 155–176.

43 The Commission of the Historians (Vesturnieku Komisija), convened by the president of Latvia Guntis Ulmanis. See Latvijas Valsts Prezidents, "President of Latvia," 2017, https://www.president.lv/en (accessed August 27, 2019).

44 The Presidential Commission for the Study of the Communist Dictatorship in Romania (Comisia Prezidențială pentru Analiza Dictaturii Comuniste din România) was instituted in April 2006 by President Traian Băsescu. The Final Report of the Commission was presented to Parliament in December 2008, and provided the basis for the condemnation of communism as a criminal regime. See Vladimir Tismăneanu, Dorin Dobrincu, and Cristian Vasile (eds.), *Raport final* (Bucharest: Humanitas, 2007).

45 See the Commission for the Study and Evaluation of the Totalitarian Communist Regime in the Republic of Moldova (Comisia pentru studierea și aprecierea regimului comunist totalitar din Republica Moldova) set up by the interim president Mihai Ghimpu in January 2010 by presidential decree with a mandate to study infringements on human rights under the "Bolshevic totalitarian regime," in the Republic of Moldova between 1917/1924 and 1991. For the official report of the commission, see "Raportul Comisiei pentru studierea și aprecierea regimului comunist totalitar din Republica Moldova," Timpul.md, July 2, 2010, https://www.timpul.md/articol/raportul-comisiei-pentru-studierea-i-aprecierea-regimului-comunist-totalitar-din-republica-moldova-12814.html (accessed August 27, 2019). For a collection of studies that brings together members of the truth commissions in Romania and the Republic of Moldova, and includes research finding of the Moldovian commission, see Sergiu Mustețea and Igor Cașu (eds.), *Fără termen de prescripție. Aspecte ale investigării crimelor comunismului în Europa* (Chișinău: Cartier, 2011).

46 For the first comparative perspective, see Lavinia Stan, "Truth Commissions in Post-Communism: The Overlooked Solution?," *Open Political Science Journal* 2 (2009): 1–13. For a more recent transnational perspective, see Laure Neumayer, *The Criminalisation of Communism in the European Political Space after the Cold War* (London: Routledge, 2019). For truth commissions around the world, see Priscilla B. Hayner, "Fifteen Truth Commissions–1974 to 1994: A Comparative Study," *Human Rights Quarterly* 16, no. 4 (November 1994): 597–655; and Neil J. Kritz (ed.), *Transitional Justice: How Emerging Democracies Reckon with Former Regimes*, 3 vols. (Washington, DC: U.S. Institute of Peace Press, 1995).

47 For overview of transitional justice in former communist countries, see Lavinia Stan, *Transitional Justice in Eastern Europe and the Former Soviet Union* (London: Routledge, 2009); for a more recent survey of judicial and non-judicial transitional justice programs promoted by state and non-state, see Horne and Stan, *Transitional Justice and the Former Soviet Union*. Another example of an official, intergovernmental body on transnational justice is the Regional Commission Tasked with Establishing the Facts about All Victims of War Crimes and Other Serious Human Rights Violations Committed on the Territory of the Former Yugoslavia from 1 January 1991 to 31 December 2001 (RECOM). See Helena Flam and Katarina Ristić, "Truth Commissions and the International Criminal Court,"

in Matthias Middell (ed.), *Routledge Handbook of Transregional Studies* (London: Routledge, 2019), 338–349.

48 Neumayer, *The Criminalisation of Communism*, 174.

49 See Simina Bădică, "Curating Communism: A Comparative History of Museological Practices in Post-War (1946–1958) and Post-Communist Romania" (PhD dissertation, Central European University, Budapest, 2013).

50 On this point, see Paul Williams, *Memorial Museums: The Global Rush to Commemorate Atrocities* (New York: Berg, 2007); and Máté Zombory, "The Birth of the Memory of Communism: Memorial Museums in Europe," *Nationalities Papers* 45, no. 6 (2017): 1028–1046.

51 See the Sighet Summer School, organized annually since 1998, and the journal *Analele Sighet*.

52 Memorialul Victimelor Comunismului şi al Rezistenţei, "Spaţiul Expoziţional Permanent al Memorialului Sighet la Bucureşti," 2019, http://www.memorialsighet.ro/spatiul-expozitional-permanent-al-memorialului-sighet-la-bucuresti/ (accessed August 27, 2019).

53 Museum of Communism, "Homepage," n.d. https://muzeumkomunismu.cz/en/ (accessed August 27, 2019).

54 Museum of Communism, "About," n.d. http://muzeumkomunismu.cz/en/about/ (accessed August 27, 2019).

55 See the Education Department of the Museum of the Occupation of Latvia, Riga, opened in 1996, offering support for Latvian teachers and pupils.

56 See also the *Soviet Occupation Exhibition Hall* in the Simon Janashia Museum of Georgia, see Georgian National Museum, "Soviet Occupation," 2012, http://museum.ge/index.php?lang_id=ENG&sec_id=69&info_id=11868 (accessed August 27, 2019).

57 House of Terror Museum, "The History of the Museum," 2019 http://www.terrorhaza.hu/en/museum (accessed August 27, 2019).

58 House of Terror Museum, "Home."

59 It seems that the museum's intended message does come across, making the expected impact on the visitors, who perceive it as a museum of occupation rather that one on the history of communism. Thus, reviewers on the site of the TripAdvisor characterize the House of Terror as being "more like a [N]azi and [S]oviet occupation history museum," while another one thought it provided "an insight on how the Hungarian people have been oppressed by other Nations over the decades." See TripAdvisor, "House of Terror Museum," 2019, https://www.tripadvisor.com/ShowUserReviews-g274887-d325279-r141513221-House_of_Terror_Museum-Budapest_Central_Hungary.html (accessed December 5, 2019).

60 Muzeum Powstania Warszawskiego, "The Warsaw Rising Museum," 2016, https://www.1944.pl/en (accessed August 27, 2019).

61 Ibid.

62 For the official website of the institute, see the Institute for the Investigation of Communist Crimes and the Memory of the Romanian Exile, "Home," 2015, https://www.iiccr.ro/en/ (accessed August 27, 2019).

63 The Institute for the Investigation of Communist Crimes and the Memory of the Romanian Exile, "About Us," https://www.iiccr.ro/en/about-us/ (accessed August 27, 2019).

64 T. Hiio, M. Maripuu, and I. Paavle, (eds.), *Estonia 1940–1945: Reports of the Estonian International Commission for the Investigation of Crimes Against Humanity* (Tallinn: Estonian Foundation for the Investigation of Crimes Against Humanity, 2006); see

also V. Salo, et al., ed., *The White Book: Losses Inflicted on the Estonian Nation by Occupation Regimes 1940–1991* (Tallinn: Estonian Encyclopedia Publishers, 2005).

65 Visit Estonia, "Vabamu Museum of Occupations and Freedom," n.d., https://www.visitestonia.com/en/vabamu-museum-of-occupations-and-freedom (accessed August 27, 2019).

66 Vabamu, "The Story of Our Freedom," n.d., https://vabamu.ee/en (accessed August 27, 2019).

67 Marcus Kolga, "Marcus Kolga: Welcome to the e-Occupation Museum," ERR.ee, February 22, 2016, https://news.err.ee/117677/marcus-kolga-welcome-to-the-e-occupation-museum (accessed August 27, 2019).

68 Ibid.

69 Alexandra Bacinshi, "Zis și făcut! Dodon l-a demis pe directorul Centrului de Cultură și Istorie Militară în a cărui subordine se află Muzeul Ocupației Sovietice," November 11, 2019, https://h1.md/ro/zis-si-facut-dodon-l-a-demis-pe-directorul-centrului-de-cultura-si-istorie-militara-in-a-carui-subordine-se-afla-muzeul-ocupatiei-sovietice/, accessed November 11, 2019 [in Romanian].

70 Iurii Botnarenco, "Anatol Șalaru, despre inițiativa lui Igor Dodon de a închide Muzeul ocupației sovietice: Este încă un act de agresiune la identitatea noastră românească," October 23, 2019, HYPERLINK "https://m.adevarul.ro/moldova/politica/anatol-Salaru-despre-initiativa-igor-dodon-inchide-muzeul-ocupatiei-sovietice-inca-act-agresiune-identitatea-romaneasca-1_5db0314f892c0bb0c6d70d89/index.htmlnu" https://m.adevarul.ro/moldova/politica/anatol-Salaru-despre-initiativa-igor-dodon-inchide-muzeul-ocupatiei-sovietice-inca-act-agresiune-identitatea-romaneasca-1_5db0314f892c0bb0c6d70d89/index.html, accessed October 24, 2019 [in Romanian].

71 Ibid.

72 "Home," 2011–2019, http://www.hdke.hu/en/ (accessed August 27, 2019).

73 Mária Schmidt, "A Love Story," *Mandiner*, October 2, 2014, http://hungarianglobe.mandiner.hu/cikk/20141003_schmidt_maria_a_love_story (accessed December 18, 2018); my emphasis.

74 Ibid.

75 See Sheena McKenzie, "This Holocaust Museum Cost Millions and Still Hasn't Opened. But That's Not What Worries Historians," CNN International Edition, 2018, https://edition.cnn.com/interactive/2018/11/world/holocaust-museum-hungary-cnnphotos (accessed December 10, 2018); Krisztina Than, "Hungary's New Holocaust Museum Divides Jews, Faces 'Whitewash' Accusations," Reuters, October 19, 2018, https://www.reuters.com/article/us-hungary-holocaust-museum/hungarys-new-holocaust-museum-divides-jews-faces-whitewash-accusations-idUSKCN1MT1QQ (accessed December 16, 2018).

76 For a summary of the domestic and international disagreements surrounding the opening of the House of Fates, see the account of the director's project, exhibition, Schmidt, "A Love Story."

77 Jeremy Sharon, "Hungarian Minister: 'Holocaust Revisionist Historian Not Involved in Museum,'" *Jerusalem Post*, June 19, 2019, https://www.jpost.com/Diaspora/Hungarian-minister-Holocaust-revisionist-historian-not-involved-in-museum-593035 (accessed August 27, 2019).

78 See Paraic O'Brien, "Polish Government Accused of 'Cultural Purge' in World War Museum Row," 4 News, November 22, 2018, https://www.channel4.com/news/

polish-government-accused-of-cultural-purge-in-world-war-museum-row (accessed August 27, 2019).

79 Paweł Machcewicz, "I Wanted to Include the East European Experience into the Western Narrative about WWII [interview]," *TRAFO – Blog for Transregional Research*, August 28, 2018, https://trafo.hypotheses.org/12372 (accessed August 27, 2019).

80 See Julia Michalska, "Outcry over Polish Government's Changes to Second World War Museum" *The Art Newspaper*, no. 296, December 21, 2017, https://www.theartnewspaper.com/news/outcry-over-polish-government-s-changes-to-second-world-war-museum (accessed August 27, 2019).

81 O'Brien, "Polish Government." See also Timothy Snyder, "Poland vs. History," *New York Review of Books*, May 3, 2016, https://www.nybooks.com/daily/2016/05/03/poland-vs-history-museum-gdansk/ (accessed August 27, 2019); and David Clarke and Paweł Duber, "Polish Cultural Diplomacy and Historical Memory. The Case of the Museum of the Second World War in Gdańsk," *International Journal of Politics, Culture, and Society* (2018): 1–18.

82 It is telling in this respect that many of my Polish contacts lamented, in private conversations, the fact that many foreign tourists to Poland only visit sites of Jewish tragedy during the Second World War but do not visit representative sites of Polish history and culture, such as the National Museum or the Rising Museum. This perception reveals the existence of a public tension between the messages of the two museums.

83 Piotr Osęka, "The Polish Debate on the Core Exhibition of the POLIN Museum of the History of Polish Jews," *Cultures of History Forum*, November 9, 2015, doi:10.25626/0045.

84 The term refolution was coined by Timothy Garton Ash in "Refolution: The Springtime of Two Nations," *New York Review of Books*, June 15, 1989, https://www.nybooks.com/articles/1989/06/15/revolution-the-springtime-of-two-nations/ (accessed August 27, 2019).

85 Mary Fulbrook, *The People's State: East German Society from Hitler to Honecker* (New Haven, CT: Yale University Press, 2005), xi.

86 Michael Geyer and Sheila Fitzpatrick (eds.), *Beyond Totalitarianism: Stalinism and Nazism Compared* (Chicago: University of Chicago Press, 2009). The volume aims at rethinking, from a comparative perspective, the nature of Stalinism and Nazism, by means of a new methodology that overcomes the twentieth-century models centered on concepts of totalitarianism, ideology, and personality.

Part Two

Museums of Occupation

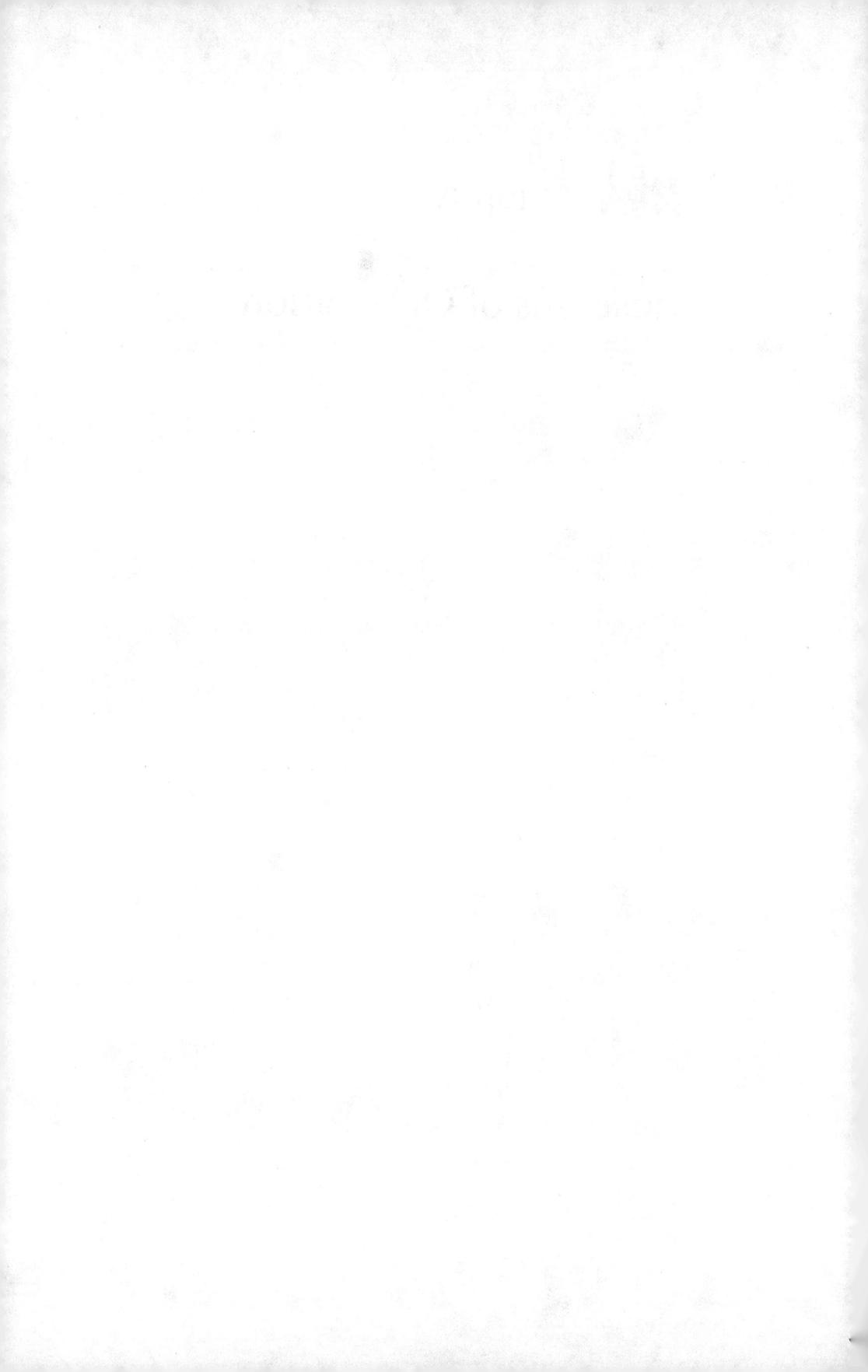

From Museum as Memorial to Memory Museum: On the Transformation of the Estonian Museum of Occupations

Ene Kõresaar and Kirsti Jõesalu

Hello. I'm your guide and I'm going to talk to you in this museum about freedom [...] Just one more moment before we set out. Here I'm going to tell you about that part of Estonian history that was filled with terror, murders, and deportations, but this building is not about hatred, fear, or revenge. At the opening of this museum, Estonia's former President Lennart Meri said: "This building is not a building of hate, but rather a building of our victory, a house of our freedom. Turn your backs on hatred and remembering the bad. This is a building of our freedom and it should remind us of only one thing – how weak and fragile the boundary is between freedom and the opponents of freedom."

With these words, the suggestive voice of a well-known Estonian actor in the audio guide invites visitors to explore the new core museum exhibition of the Vabamu Museum of Occupations and Freedom, in Tallinn, Estonia. Previously named the Estonian Museum of Occupations, the museum changed its name in 2017 to mark its conceptual transformation. The name change was simultaneously directed toward expanding the borders of Estonian post-communist discourse beyond suffering and survival, which the museum perceived as limiting and hegemonic, and to open up to more diverse social groups.[1] On July 14, 2018, Vabamu opened its new core exhibition to complete this transformation. Already during the name change campaign Vabamu excited a debate about what creates Estonian memory and what should be its content, thereby opening up a potential to positively re-politicize historical memory and increase society's self-reflexivity.[2] This chapter offers an insight into the new exhibition with regard to what has been the core of the museum from its very foundation—the representation of the Second World War and the communist past. What are the most

This research was funded by the institutional research grant IUT34-32 from the Estonian Ministry of Research and Education. We are grateful to all interviewees; our special thanks goes to Merilin Piipuu and Sander Jürisson for kindly sharing the materials and responding to our follow-up emails with patience and openness.

significant changes as compared to the previous exhibition? How do the display of war and communism reflect the attempted conceptual transformation of the museum? Which memory practices are reflected in the new exhibit? How would the conceptual and representational transformation of the museum be situated in the contemporary Estonian mnemonic landscape?

From Museum of Occupations to Museum of Freedom

On the occasion of the centennial of the Republic of Estonia (1918) quite a few groundbreaking exhibitions on the recent past were opened, most notably in the Estonian National Museum, Estonian History Museum, and Vabamu. The latter deserves a closer analysis due to its assumed central role in forming and transforming Estonian post-communist memory culture.

The predecessor of Vabamu, the Estonian Museum of Occupations (EMO) was initiated by the Kistler-Ritso Estonian Foundation, founded by the Estonian émigré Olga Kistler-Ritso in 1998. The museum was opened as the Museum of Occupations of the Recent Past in 2003. Symbolically, the first director of the museum was a former Soviet-era dissident and prisoner of conscience, Heiki Ahonen. The main curator of the exhibition was historian Endel Tarvel. The exhibition remained open until January 2018, without any major changes.

EMO belonged to a wave of cultural institutions dedicated to the experience of communism in Eastern Europe since the beginning of the 1990s.[3] According to its founder Olga Kistler-Ritso, the main aim of the museum was "to research recent years of German and Russian occupations. How those influenced the fate of Estonian nation, culture, way of life, population, economy, education and so on."[4] To this end, an exhibit on the chronology of the occupations of Estonia between 1940 and 1991, the national resistance movement, and the return of independent statehood were displayed. The past was presented in the permanent exhibition predominantly as a trauma narrative focusing on the atrocities committed by the Soviet regime, which also served as a framework for looking at the Nazi occupation.[5] In its limited space, items representing Soviet everyday life were also exhibited. Since its opening the exhibition received contradictory responses: while critics agreed that by focusing on the political history of the occupation the museum was implicitly excluding those who were not directly victims of Soviet repression,[6] others have pointed out that the objects in the exhibition were selected and displayed in a way that allowed for an individualized and emotional interaction with the Soviet past, including nostalgia.[7]

During the 2000s EMO gained a symbolic status as a commemorative place of and for those who suffered under the communist regime. Its meaning for the victim organizations was further intensified by the absence of a central memorial for the victims of communism until August 2018. Despite its symbolic role the museum was losing visitors, especially among the locals. By 2015, only 10 percent of visitors (approximately 2,000 people per annum) were local.[8] The museum needed to find its audience again.

The planning of the long-awaited update of the exhibition started with the election of the new managing director in spring 2015. The new leaders of the museum, all born in the late 1980s, have expertise in social, political, and historical sciences as well as transnational experiences of studying and practicing abroad. As museum professionals they are deeply embedded in cosmopolitan discourses of memory and history. As young individuals who were brought up by the nationalist history narrative during the 1990s they have increasingly become aware of the restrictive and manipulative influence of this narrative on their later lives and actions[9] as well as on Estonian society as a whole. The new management was supported by the new international board connected to the global start-up world and which promoted the idea of Estonia as a successful e-government.

By the year 2015 when the owner of the museum appointed the new management to improve the museum's position in an inter/national cultural market and to compete more effectively for local and international visitors, several transformations had already taken place in the Estonian mnemonic landscape toward a more democratic and multifaceted direction as compared to the end of the 1990s when the preparation of the EOM started. Estonian remembrance culture of the 1990s focused on processing the Soviet annexation and the following Stalinist mass repressions in the light of which the whole Soviet past was understood as a negative rupture. Also, the general commemorative landscape of the Second World War was developed, and the foundation laid for the national narrative of war remembrance that was strongly filtered by the experience of the Soviet occupation and annexation. The new anti-communist mnemonic template that was created and fixed by the end of the 1990s formed the axis for the first permanent exhibit of the EOM. However, since the turn of the millennium, the usefulness of this mnemonic process for society's identity-building purposes has been exhausted. Around the turn of the century, the first Soviet-born generation (born in the 1940s) increasingly started to voice their experiences of Soviet socialism and to question the established anti-communist mnemonic template by emphasizing (nostalgic) experiences of continuity and normality in late socialism. At about the same time an even younger generation, the people born in the 1970s, have made their own contribution to interpreting late socialism by expressing their distinct identity through the image of an exotic and innocent Soviet childhood.[10] While the entering of different generational memories have significantly diversified memories of the late Soviet period since the 2000s, the negative discourse of rupture—also called the "occupation paradigm[11]"—remained to be used solely in reference to the Second World War and Stalinism. In addition to this a more ambivalent approach to the Second World War developed with regard to the role of Estonian men in the Nazi armed forces from the end of the 1990s, first due to Estonia's applying for EU membership and second due to the "memory wars" of the 2000s. Since then the topic of "freedom-fighting" in the Second World War has exhausted itself in institutional and monumental commemorations, and the controversiality of the topic has become widely recognized.[12] Also recently the Estonian military has included the Bronze Soldier monument dedicated to fallen Red Army soldiers, which was relocated into Estonian military cemetery, in its

annual V-Day commemoration ritual. Last but not least, the issue of the mutual convergence of Estonian and Russian communities in Estonia has arisen, especially after the Bronze Soldier crisis in 2007[13] and the war in Crimea since 2014. Against this changed mnemonic background, the new management felt that the message of the EMO was outdated and had to be revised.

In accordance with the long-time expectations of the Kistler-Ritso Foundation, the major funding body of the museum, the new management started to modernize the museum in educational, museological, and organizational ways. It was the museum's stated aim to change from "a repository of traces of the past" to a participatory museum that is active in civil society, and to take a more active stance toward the challenges that Estonian society is facing, in particular dwelling more on the integration of Estonian- and Russian-speaking communities.

The museum targeted its conceptual change at younger generations whose experiential horizon was not only radically different from the generation(s) of the repressed but also from subsequent Soviet generations. Representing the past through the prism of "freedom" meant drawing more on the present-day experiences and future of young people as well as on their more individualized perception of freedom. Managing Director Merilin Piipuu argued for a reorientation from the past to the future: "the narrative of suffering cannot lay a foundation to sustainability and future of the peoples of Estonia [eestimaalased]. [...] The future needs active citizens taking actions, not sufferers – passive victims."[14]

Thus, the museum undertook a paradigm innovation to attract a younger audience and enlarge its target demographic. The transformation was manifested in a new name—the Museum of Freedom (Vabamu for short)—which was publicly announced in early 2016. After a heated debate among the Estonian speaking population that revived old issues around the "occupation paradigm" such as the unstable state of Estonian–Russian relations, the Holocaust memory culture, and the politics of recognition of the victims of the Stalinist repressions, the museum maintained the word "occupations" in its name for the sake of a compromise.[15] The name debate showed that omitting the term "occupation" from the name of the museum was unacceptable for the larger part of Estonian society. Several already existing tensions were activated in society by the name change initiative that the EOM did not foresee. First of all the securitization of "occupation memory" discourse[16] has become topical again after the Russian invasion of Ukraine in 2014 thus reproducing a sense of insecurity vis-à-vis the Russian neighbor. Also, the announcement of the name change in early 2016 coincided with the rise of conservatism in society, most notably reflected in heated discussions of the cohabitation law since spring 2014 and on the wave of migration since summer 2015.[17] Against the background of the polarization of society reflected in these debates, the EOM's leaders were perceived as an "e-generation with weakened ties to Estonia" that cannot be trusted with safeguarding memory.[18] Thus, during the debate over the name of Vabamu national and cosmopolitan perspectives collided, similarly to many other controversies in Eastern and Central Europe over dealing with the violent past of the twentieth century.[19]

The debate over Vabamu was, first and foremost, about the name and what it signified. No further debate followed when the museum started to use the short form

Vabamu in daily communications since opening the new exposition in 2018. Despite the initially turbulent criticism the museum encountered when introducing its paradigm change, a new core exhibition was built within a half a year (with a significant financial contribution from the Ministry of Culture among others). According to the speech of Managing Director Piipuu on the opening of the core exhibition the museum stood firm to its concept as a civil societal agent aimed at changing society by decisively departing from an "occupation paradigm":

> This exhibit will not judge, this is not an exhibit about who is innocent, who is guilty or even more guilty in our past sufferings. [...] Our museum doesn't carry hatred and fear in our hearts. [...] Our museum speaks [...] of our experience that freedom cannot be limited [...] People's aspiration for freedom is always stronger than whatever fetters.[20]

Freedom without Borders: An overview

The new exhibit of Vabamu, guided by the concept of freedom reflected in the title *Freedom without Borders*, is divided into five topics: "Inhumanity" (the Second World War and its aftermath), "Exile" (the story of Estonian diaspora), "Soviet Estonia" (from the 1940s to late 1980), "Recovery" (1987 to the twenty-first century), and "Freedom" (its meaning to present-day Estonian inhabitants). The topics cover a time period from the Second World War to the present. The curators have backgrounds in social and cultural history; they worked closely together with interior architects, exhibition designers, and the production firm Motor.[21] Additional competence was brought in by political scientists and a visual artist.

Museologically, the new exhibit stands in strong contrast with the previous one. In terms of Barbara Kirshenblatt-Gimblett, the old exhibit was a classic in-context display:[22] material objects, photos, and historical documents were displayed in classical showcases chronologically, with very few textual components. It was a nation-centered historiographical narrative of the twentieth century (1939–1991), mediated via documentaries and an audio guide that brought them to life. However, there still was a mixture of pragmatic frameworks that were integrated simultaneously into this classical representation: the one of professional historians and the other of the community of survivors of Soviet repressions, donating their belongings and mementos.[23] These objects were presented as testimonies—material facts that could speak for themselves.

The new exhibit of Vabamu, in turn, is organized thematically and tends more to privilege "experience."[24] Although every display has an element of theatricality, the new exhibit, especially in rooms where the Second World War and communism are displayed, employs a vast range of performative elements from visual to tactile. Many innovative practices and mediums from in-built interiors, interactive screens, and games to vast variables of personal experience stories, visuals, and sounds are used in the display. Although using mostly objects from the first exhibit, Vabamu's relationship to these objects differs from it radically: in the new exhibit the story of the object and its owner dominates and is an important part of the exhibit's emotional

strategies. The major means of implementing emotional strategies is the museum's multimedia guide (MMG) that frames the visitor experience. It contains both an audio performance and a reading device to get acquainted with the objects' stories.[25]

Another major conceptual change of the new exhibit is related to prioritizing memories over historiography. Vabamu sees historiography merely as one way to present the past. Moreover, in many instances the museum expresses doubt that the truth about the past can be achieved at all. Instead, the exhibit relies on individual memories that complement and sometimes contradict each other, thus forming a web of interpretations of the past for the visitor to navigate. The twentieth century past particularly is guided by four symbolic life trajectories of a survivor of the Stalinist repressions, a Holocaust survivor, a Second World War refugee, and an ordinary "soviet" life. As the life stories are meant to serve as symbolic guidelines for the visitors, they are mediated exclusively by a professional actor. Therefore, albeit present with their (first) names and faces, the four persons themselves are denied agency for the sake of generalization. As we will see below similar strategies of presentation are prevalent throughout the exhibit in different ways.

Additionally, the new exhibit seeks more embeddedness in the global memory culture of the twentieth century. In the introductory frame of the display not only are major turning points of Estonian history linked to global events but also famous quotes (of Elie Wiesel and Lech Wałęsa, among others) on the meaning of remembering and freedom positions the exhibit into the web of memory regimes on the Holocaust and communism.

In what follows, the thematic displays "Inhumanity," "Soviet Estonia," and "Recovery" will be analyzed from the perspectives of museology and memory studies.[26] While implementing the principle of methodological pluralism that brings together research conducted within different disciplinary approaches,[27] the focus is laid on methods of museum anthropology: participatory observation of the visitor experience, visual and textual documentation of the display, narrative and discourse analyses, and interviews with curators, the copywriter, and museum architects. From the museological point of view this analysis takes into account that despite their declared aims, museum discourses are rarely coherent. Rather, the messages displayed are hybrid, inconsistent, and even contradictory on different levels, i.e., on the object level and the narrative level.[28] The relationships displayed can be fragmentary and the display itself is highly dynamic, particularly so soon after opening when there are still elements to be added to the display. In addition to that, agents (museum curators, guest curators, the production firm) involved in preparing the exhibit may have different aims and views of fulfilling them as well as different degrees of power in different cases.

From the perspective of memory studies, the hybridity of exhibition practices corresponds to the museum's changing role in the landscape of memory, politics of identity, and cultural policy. As a result of new museology debates and the recent memory boom, museums are expected to take a stance on social issues and facilitate public debate, to "open up spaces for contestation in which controversial viewpoints can be voiced."[29] Yet as a memory agent the museum is embedded in the field of (trans/national) politics of memory and heritage, the interests of diverse stakeholders and memory communities (while curators as individuals also being part of one or

another memory community), and power relations. By building up an exhibition that simultaneously seeks to empower visitors and entertain them, the museum negotiates between emotional, ideological, political, and commercial interests.[30]

Inhumanity: Multidirectionality, universalization, and memory politics

The topic of crimes against humanity during and after the Second World War— the Stalinist repressions and the Holocaust—is the core theme that links the new exhibition of Vabamu to the first exhibit of the EMO. Unlike the earlier approach that followed the chronological order of events, the new exhibit focuses on the experience of mass violence under inhuman conditions—the loss of freedom and lives. The crimes of the Nazi and Soviet regimes are brought under a common metaphor of "unfathomable evil" (curator text, CT) that serves as a ground for both comparison and universalization. The comparative approach to the mass violence committed by the two regimes is displayed on multimedia touchscreen *Geography of Evil* showing the Soviet administrative districts and prison camps where Estonians were confined, and the Nazi concentration camps in Estonia related to the Jewish and the Roma Holocaust. On this multilayered touchscreen additional information is provided about the groups and number of victims, about the major events as well as about the groups and institutions responsible for the crimes along with personal testimonies about the camps. Despite its metaphorical title the screen is the only example in the display of *Inhumanity* that represents historiographical discourse. The universalizing approach to the two totalitarian regimes is provided narratively by the audio guide, which refers to "power" that "always" aims at "taking away people their names, subjectivities, humanity, and turning them into a part of a plan."

Symbolically, the experiences of inhumanity under the Soviet and Nazi regimes are represented by a freight/cattle wagon interior built as a passage in the museum. According to head curator, the wagon "is a symbol of [...] the both dictators of World War II in whose hands the freight wagon was an effective tool in getting rid of people."[31] The motif of a cattle wagon is deeply rooted in Baltic post-communist memory culture of Stalinist repressions and is much exploited in the public sphere. Therefore, it was not the first choice for the curator.[32] The wagon was insisted on by exhibition architects who were inspired by a Holocaust display in Berlin. In order to enter the exhibition room, the visitor has to step into the wagon that moves and produces sounds of movement. The sensory experience is further facilitated by a multimedia game *A Minute for Leaving* at the exhibition gate as well as by the audio guide, which encourages the visitor to touch the wagon walls and listen to a folk song of deportees.

Just like the design of a freight wagon and the use of the metaphor of evil were inspired by Holocaust exhibits worldwide,[33] so were the dark aesthetics of the exhibit space. During the preparation of the EMO's first exhibition this kind of aesthetic was rejected as oppressive and not supportive to learning.[34] In the new exhibit, however, it is applied in a complex manner, combining sensory and visual elements with belongings and mementos of witnesses and survivors of Stalinist mass repressions. The dominant

representational strategy is universalization through individualization, which is also widely but not exclusively used in Holocaust museums.[35] Objects, documents, and photos, even wagon planks, are linked to concrete individuals and equipped with stories mediated by an e-guide. The availability of emotional stories has obviously been a primary criterion for the selection of objects, many of which were displayed in the first exhibition.[36] The stories, told in third-person mode by the museum, touch upon the context of the repressions and the fate of the owner who is represented solely by his or her first name. Persons reminiscing in the audio guide have no names at all. Individuals represented under the topic of Stalinist mass repressions do not represent themselves but are, according to the curator, "examples of how things could turn out."[37] At the end, the individualized stories, either told in first- or third-person mode, convey an idea of the universal story of suffering, death, survival, and hope rather than a personal history and experience of the Stalinist mass repressions.

On the other hand, the display of the Stalinist repressions negotiates the post-communist discourse of victimization and thematizes the possibility of subjectivity under the circumstance of severe trauma.[38] Right in the beginning of the display the visitor encounters the question of shared responsibility: "Why were these people taken? Who selected them? It was us, ordinary people [...] like you and me" (MMG). Further on, memories of hunger, terror, death, and hard work are compared with memories of maintaining normality and encountering kindness. The representation of objects as "maintainers of the will to live" and "weapons against the hunger" refers to the agency of victims, while in the first exhibit the very same objects were represented through "the smell of blood and sweat" (audio guide, January 3, 2018). The image of Siberia as a prolonged imprisonment in the old exhibit (audio guide, January 3, 2018) is now scattered by a remembrance of a deportee about Siberia as a home (MMG).

Compared to the first exhibit, which had a competitive relation to the issues of the Soviet and the Nazi crimes,[39] the Holocaust and Stalinist mass violence are brought together in a shared space in the new exhibit. The Holocaust, in turn, is displayed in a very different modus than in the earlier exhibition. The EMO first exhibit focused on everyday life under the Nazi occupation (with Estonian nationalists and Jews mentioned as main targets) and on the choices of Estonian men during the Second World War. The murdering of Jews was represented in the documentary *The War and the German Years*, which used the Red Army's documentary cadres about Klooga mass murder from 1944, yet the camp was presented as a part of the everyday of the war (documentary sequence 24:38–25:02), the responsibility for the murders was attributed solely to the Nazi occupiers (25:07–25:31), and the scale of the Holocaust in Estonia was not mentioned.

The Holocaust display in Vabamu is detached from a reserved deindividualized mode of representation characteristic to post-communist memorial museums.[40] It is also more personalized than the representation of the Stalinist repressions. The Holocaust in Estonia is represented with the life story of Daisy Levin (1933–1941), who was murdered in Pärnu synagogue. Daisy's story is displayed through photographs and her nanny's letters to her family. In the media, the museum has related Daisy's story to the story of Anne Frank.[41] Daisy's parents' fate is also told on the e-guide from a perpetrator's perspective. The presence of a perpetrator is another aspect that

differentiates the Holocaust display from the representation of the Stalinist repressions: the touchscreen that gives an overview of the Holocaust in Estonia explicitly names Nazi authorities and Estonian military units as responsible. With regard to the Stalinist repressions the Soviet authorities are referred to and related to "people like us" by the audio guide. Hence, the issue of responsibility remains rhetorical in the case of the Stalinist repressions, whereas in case of the Holocaust it is more concrete. Lastly, differently from the case of the Stalinist repressions, the audio narrative is told from a more authoritative position without reflexivity, assuring that the Holocaust in Estonia was a reality and Estonians had a role in it as bystanders, perpetrators, and saviors.

In sum, Vabamu displays the issues of Soviet and Nazi mass violence complementarily as inhumanity faced by various groups rather than being experienced specifically by an individual group. This pluralistic perspective comes close to what is called multidirectional memory.[42] Still, facing the Estonian mnemonic landscape, both representations have different aims. The representation of the Stalinist repressions aims at the dissolution of the post-communist discourse of collective ethnic victimization. The aim of the representation of the Holocaust is to ensure it gets its rightful, multifaceted place in Estonian historical memory.

Soviet Estonia: Individual choices, absence of freedom, and collective responsibility under Stalinism

The section on "Soviet Estonia" is divided between two rooms and periods. The first room deals with the era of Stalinism and with the question of power, absent freedoms, dissent, and collaborationism; the second one with the late Soviet everyday life. This division reflects post-socialist studies, where two periods also are quite clearly distinguished.[43] The distinction is not as common, however, in this kind of exhibition, yet.[44]

The section of "Soviet Estonia" is connected to the section "Exile through an iron curtain" made of books. The entrance to the Soviet period is dominated by murals of gigantic Soviet ideological symbols. The "Stalinist" room is in red-blue-gold colors, symbolizing the flag of the ESSR. Its walls are painted in blue; heavy, red velvet curtains with golden cords cover its four showcases. The dominant element in this room is a showcase in the shape of the iconic Soviet red star (itself actually a golden star), where three touchscreens are installed. Over the red star a large picture of Stalin "gazes across the first room watchfully" (CT). According to the audio guide, exhibiting the red star as a key element is symbolizing freedom: "because in a free society symbols are not forbidden" (MMG),[45] admitting though that it is "a symbol of terror" (MMG).

The lack of freedom of expression and the censorship as part of the Soviet system is a topic depicted in this part both in general and particular ways. This censorship and the destruction of old national symbols are exemplified in a destroyed book and in an album where Estonian symbols are cut out. The question of censorship is combined with examples of state violence against individuals. Here we see elements of traditional post-communist museums, which are dealing with the question of repression and violence.

As an introduction to the Stalinist or "red star" room, the audio guide asks several thought-provoking questions: "What does it mean to have a successful career or to make everyday decisions under authoritarian rule? Where is the line between adaption and collaboration? What choices would you have made?" (CT). A similar question about adaptation and collaboration is raised in the multimedia guide. The main idea is to encourage people to reflect about the different choices available during the Soviet era, at the same time the museum does not want to give any "right" answers.

The question of collaborationism and complicity during the Nazi and Soviet occupations has not been clearly voiced in earlier exhibitions dealing with the recent past in Estonia, so this is quite a new topic here.[46] The old exhibition of the museum was among other things criticized for this,[47] and as a response collaborationism during the Soviet period is now emphasized.

The audio guide points to the complicity of fellow countrymen, like the narrator and visitor: "Stalin gave the order, the NKVD [the People's Commissariat for Internal Affairs] and the army carried it out but somewhere there were ordinary people, like you and me, who collaborated too. They denounced their colleagues, co-students, childhood friends [...] Often to save themselves because if they hold a gun at your forehead [...] whose life would you choose?" (MMG). Here the hegemonic discourse of victimhood is challenged by a discourse of collective responsibility.

The question of collaborationism is connected with everyday choices people made, by asking visitors to think about it on a personal level: "But if in this case the collaborator was also your grandma who worked as a teacher during the Soviet era?" (MMG). Here, the museum relates to the post-communist image of history that understood the entire Soviet period as a disruption in national history.[48] Within this discourse of rupture, indeed, the competence of Soviet-era teachers was discredited[49] and the chairmen of the kolkhoz were marginalized.[50] Even if the recent studies have shown that since the end of 1990s, but especially since the 2000s, the remembering of the Soviet era has become more diverse, and the discourse of rupture has lost its hegemonic status in interpreting the Soviet experience,[51] it has remained an important point of reference for Vabamu probably because the EMO was formerly associated with this discourse.[52]

The main emphasis of the display of "Soviet Estonia" is thus on individual choices under communism, which is an addition to earlier studies and exhibitions dealing with communism as a regime of occupation imposed from "above" and by force of the Soviet Army.[53] The old exhibition was a part of this framework, which focused on the relationship with state authorities, restructuring industry and agriculture, closed borders, and cultural resistance. Briefly, the question of power and regime is represented also at the current exhibition; it is handled on a touchscreen placed into a "red star," where the regimes of two totalitarianisms are comparatively displayed under the title "Anatomy of totalitarianism."[54] Out of the ten topics, five deal with general aspects of a totalitarian state based on a comparative view of the Soviet and the Nazi totalitarian regimes. This method supports the universalizing approach of the exhibit treating the violent regimes in Estonia as exemplary to totalitarianism. The other five topics represent a narrower historiographical approach of the case of Estonia in particular in its dealing with Second World War governance, casualties, and military

mobilizations under the Soviets and the Nazis. With "Anatomy of totalitarianism" the Estonian-centered horizon is widened to a European level and eventually to a global scale also by means of historiographical discourse.

In addition to the touchscreen the items in one showcase could be associated with the question of power.[55] Here among others are displayed objects such as a badge of Komsomol, the black coat of a village commissioner, and a work permit of the Institute of Party History of the Central Committee of the Communist Party. The objects are mediated through contemporary language, adding a touch of irony at some points. For example, a badge of Komsomol is labeled as "career ladder," explaining that membership in Komsomol was the first rung of beginning a career in Soviet society, being a member offered a possibility to do something "cool" together with other young folks; joining the Little Octobrists or Pioneers is comparable with undertakings of guides and scouts.

The Stalinist room is developed more or less traditionally with accents of a new design—the visitor can look at items and read longer texts on the e-guide. However, before entering the everyday part of the late Soviet period, the visitor is also invited to interact. On the interactive screen (s)he is asked to play a game called *Difficult Choices*, based on life stories from the Estonian Cultural Historical Archive. With the help of that game the visitor has the possibility to walk in the shoes of people who lived during Soviet era, to relive "a past they have not experienced first-hand."[56] In general the depicted stories enable life during the Soviet era to be interpreted in the discourse of trauma and suffering (from which the museum aimed to depart from); just one of the stories speaks more on everyday choices where the personal, social, and public are entangled.

Resistance: Beyond the narrative of freedom-fighting

Resistance was one of the central themes for the Vabamu exhibition team[57] as well as in the first exhibit. The two central topics of resistance, displayed in the room on Stalinism and as a transition to Soviet everyday life, which to some extent mark the continuity with the first exhibit, are dissidence and "forest brothers" (anti-communist partisans).

Dissidence was attributed a significant role in the narrative of the exhibit in the first exhibition both by way of variety and the number of displayed objects and the place it was given in the documentary *Stagnation 1968–1987*, for which prominent dissidents such as Enn Tarto and Heiki Ahonen were interviewed. Objects are more or less the same in both displays, used to tell stories of youth resistance, underground organizations, samizdat, informing the West, conspiracy, persecution, imprisonment, and public protests—a selection based on the museum's collecting work and research since its opening. A significant change in the representation of dissidents in the new exhibit is depersonalization: central persons in the history of Estonian dissidence, former political prisoners, and the intelligentsia are presented only by their first names, thus matching the general strategy of universalization. By means of emotional and generalizing stories, related to objects, an insight is given into the dissidents' life

world. As a result, an image is formed about anti-Soviet dissidence as a "universe of its own" (MMG with reference to samizdat), the political significance of which is either downplayed or presented rather differently from the first exhibit. For example, the prominent "Letter of a Forty" from 1980 was displayed previously as a political act against Russification that paved the way to the later pro-independence movement. In Vabamu this document is exhibited as a unique act of civic protest, the first of its kind in Soviet Estonia. The way this showpiece has been reinterpreted, refers to the deconceptualization of the role of Vabamu from a classical political history museum to a civic societal agent.

The display of anti-communist partisans embodies an even greater conceptual change. In the old exhibit, the narrative of "an active resistance to the red terror" was told via audio guide and a documentary on Stalinism, which included the voices of the partisans themselves. In the new exhibit, the stories related to the objects are woven into an emotional story of partisan life (not only of their fight): failed hopes, the will to fight, bunker boredom, and yearning for intimacy, betrayal, NKVD surveillance, torture of close ones, death, and imprisonment. The human perspective of living in a forest is even more intensified by the audio guide and the visitor's empathy is put to the test:

> Imagine, for a minute, that it's winter with -25 degrees outside, and you are in the woods [...] your hands are squeezing the gun, and you are staring into the darkness. Any minute somebody may come from the darkness, even a classmate or a cousin, wanting to shoot you. And you are alone, deprived from everything and nowhere else to go. [...] What are your choices? (MMG)

Another moment of choice occurs for the visitor when (s)he is directed to a dark and uncanny "forest" display, built in a corridor, with walls full of mirrors to increase reflexivity: would one skip this "forest" to enter conformist Soviet everyday life right away or would one still choose the life of resistance?

The museum insists on reflecting on (available) choices in almost every part of the exhibition, but this is particularly vivid with the topic of partisans. Oppositional historical roles from partisans and their supporters are juxtaposed with Estonian soldiers in Red Army units and fellow people becoming traitors, ending with a remembrance by a local about violence committed by the partisans themselves. Thus the strategy of juxtaposition also introduces a publicly hidden knowledge that counters the heroic narrative of resistance.[58] In this way the new exhibit differs from the old one: "Partisan warfare [...] is not a story of mere resistance and heroes" (MMG). As a culmination, the topic of partisans is left open ended, which literally undermines the previous core message of anti-Soviet armed resistance as a fight with major moral significance even when militarily unsuccessful (documentary *Stalinism 1944–50*, 8:20). In the new exhibit the visitor is left with doubt in the traditional image of partisans: were they resistance fighters or just desperate people? Did they have a purpose or were they just killing, tired from hiding in the woods? Did their fight change something, did it give hope for others or was it all in vain?

The representation of resistance, in sum, embodies the very transformation of Vabamu. The change is not even in all levels of representation, i.e., the choice and narrativization of objects is still linked to peculiarities of the museum's collections molded by dissidents and former partisans themselves. The narrative, however, is dominated by the audio guide, which by means of psychological and reflective strategies questions and scatters the old narrative of freedom-fighting.

Late Soviet period: Everyday environments and debating the image of history

Moving forward, leaving behind the years of Stalinism, resistance, and collaboration, we approach the environment of the everyday of late Soviet Estonia. If there were many objects in the room of the "red star" then here the dominance is on built-in environments, and there are no museum objects proper on display. As guidance the curator explains that "as things became easier in the late Soviet period: mass consumer goods were produced and living conditions improved" (CT). Mostly we will learn about the improvement of everyday life during late socialism and will hear debates over the historical image of that period.

At the old exhibition the period of the late Soviet era was treated in two documentaries (*Sixties 1956–1968; Stagnation 1968–1987*) and some everyday objects were displayed, which also allowed nostalgic interaction with the exhibition.[59] In the documentaries the central topics are changes in agriculture and in economics generally but also cultural resistance. The word is given to dissidents as well as members of the nomenclature (ministers Albert Norak and Elsa Gretškina), ordinary workers, agriculture specialists, and the cultural elite.

In the current display the focus is mainly on city life and everyday experiences there, with the common topic in both displays being the topic of economy of shortage. On the one wall we see pictures of blockhouses of the district Õismäe in Tallinn. In the old exposition the new blockhouse districts symbolized the ethnic Other, Russification, and poor building quality (*Stagnation 1968–1987*), whereas here the blockhouse stands for Soviet modernity. To live in this kind of district, to inhabit apartments with warm water and central heating was a dream for many people during the Soviet period, as also the audio extract from the archive tells.[60] In the small corner a color TV set with two armchairs are placed, and a Soviet style kitchen—mixing different styles and periods—is rebuilt. In this kitchen "alternative communities" (audio guide) that enabled trust in the "middle of the desert of censorship" were coming together. For stressing the private nature of the "Soviet" kitchen in the otherwise controlled society on the table one can watch Soviet-era "home videos."

In a virtual reality game the visitor is offered the possibility of furnishing a typical Soviet time apartment in the blockhouse district; for every item (such as tapestry, couch) one has only three choices (or something could be also out of stock). The game refers to the Soviet time economy of shortage and to the limited choices one had.

Interestingly, on the old and new display children are used to represent propaganda. In the old documentary (*Stagnation 1968–1987*, 1:38) children sing a hymn to Lenin, the author's voice, historian Enn Tarvel, continues after that with critiques of the creation of Soviet men. In the current display we hear an extract from the archive, where schoolchildren become little Octobrists, the audio guide brings up the issue of empathy and engages with the (hegemonic) picture of the Soviet period, where everything connected to the Soviet power structure, even little Pioneers were categorized as morally bad.

> I guess you are feeling disgust – little brainwashed children singing praise to the dictator. The power does not want to be learned – it wants to be grown into. So what choices did these kids have? Or their parents? Yes, of course you could refuse to become a Young Pioneer, no one imprisoned you for that, the times were already different by then, but was it really so easy to say no? If you think it was easy to refuse, why did not everyone just do that? Who are you judging when you are judging a Little Octobrist?

The absurdity of the Soviet everyday is reflected on a wall covered by anecdotes. Before leaving this part of the exhibition the visitor could enjoy a glass of sparkling water from a Soviet-era soda-vending machine and look at the photographs from 1978, taken by an exile Estonian photographer for *National Geographic* that depicts the worn out faces of the Soviet people.

The curator underlined that his idea was to offer insight into the many layers of the everyday, to show what life choices were available as well as the ambivalence of the Soviet period. Throughout this part the audio guide is reflecting on choices people had available during the Soviet period, thereby comparing Soviet society with contemporary society, thus contesting a one-sided picture about the Soviet era. Even more, while referring to contemporary social pain points such as costs of education and medical care, unemployment, accessibility of kindergartens throughout the display of "Soviet Estonia" (including Stalinism), the audio narrative seems to follow up a critical discourse from the end of 1990s and 2000s, which was once labeled as Soviet nostalgia.[61] The audio guide encourages visitors to think of contemporary problems in comparison with the freedoms, limitations, and resources of the Soviet era. Thereby the museum not only offers the possibility to reflect on democratic freedoms but to revise the existing image of history.

Recovery: Many paths to the future

The last part under study is titled "Recovery," which depicts the period of regaining independence and "leaving communism behind." The visitor is moved up by an elevator to the second floor. Symbolically one is moving from the dark underground into bright and light rooms upstairs (from the era of darkness toward the bright and light future). "Recovery" handles the period from 1987 until the twenty-first century with the main focus on the end of 1980s and the beginning of the 1990s, which coincides with the focus of the old exhibit. The turbulent years of 1987 to 1991 were depicted in the old

exposition mainly through the documentary *Liberation*, concentrating on political events and political movements. The endpoint of the old display was the Declaration of Re-Independence on August 20, 1991, and the departure of the Soviet Army in 1994. Also some items connected with political struggle were on display. At the current exposition, the longer period of transition is displayed including the social and economic reforms of the 1990s. As a novelty, political science discourse is added to the display by two interactive screens: *Which form of government do you prefer?* (or *Choose your own basic law*) and *Make your own independent Estonia!*[62] The latter one depicts the standpoints of different mass movements of the 1980s in Estonia. An extra screen is dedicated solely to the events of August 20. The events in Estonia are explored in a broader Eastern European context without an attempt to universalize as in previous parts of the exhibit.

Instead, "Recovery" puts an emphasis on personal stories and individual experience. The room is dominated by a figural depiction of the Baltic Way (1989, a peaceful demonstration for Baltic independence) and by eight portrait screens. The Baltic Way was a marker of the 50th anniversary of the Molotov–Ribbentrop Pact (1939) and a symbol of peaceful revolution as a cornerstone of Baltic national narratives of re-independence and joining the European Community. The role of the political and cultural elite of the 1980s is omitted in the display and the Baltic Way is presented solely as a people's endeavor.[63] Also the curator emphasizes processes and the role of everyman in political changes: "men and women, Estonians and Russians, city people and countrymen gathered together and discussed, how to achieve freedom" (CT).

The eight short video portraits, co-authored by artist Tanja Muravskaja,[64] are part of this strategy. People from different backgrounds voice their experience from the 1980s and 1990s. From eight persons three are women and five men; two of the men are Russian speakers.[65] Differently from before, these individuals speak for themselves, except the two Russian men who speak through the actor's voice in Estonian. The storytellers also donated an item connected to their experience to the museum.

Every personal story is connected to broader social processes on the screen in *The years when Estonia changed*. As an example, the Estonian actor Merca's reminiscence about her little protests as a punk in the 1980s is linked to the topic of "Revolutionary time" focusing on the freedom of expression, freedom of gatherings, and civic protest. Another story of a Russian speaker, Vladimir, the organizer of a referendum for Narva's autonomy (1993), is connected with the topic "New dissidents,"[66] which emphasizes that not everybody was enthusiastic about the revolution. The role of Intermovement (the International Movement of Soviet Estonian Workers) is underlined with a message that there was a part of the population who defended the united and inseparable Soviet Union. In contrast to the old display, the curator is broadening the experience of transition beyond the perspective of the titular nation. The juxtaposition of contradicting viewpoints is a way for the curator to remind the visitor that "A single, right path to freedom is yet to be found" (CT).

Last but not least, the discrepancy between different museological discourses that is evident in previous parts of the exhibition, i.e., object presentation and the audio narrative, is even stronger in "Recovery." The audio guide does not speak so much, explaining that "free people should speak for themselves." Yet it underlines the sudden and abrupt change of the society when the curator carefully draws on diverse processes of the post-communist transition.

Conclusion

When adopting the name of the Estonian Museum of Occupations and Freedom Vabamu, the museum aimed at a profound change of its image, message, and its relation to society and to the past. Today, Vabamu understands itself as a participatory and education-oriented museum that aims at enhancing civic courage by dealing with the recent past and its troubled relationship with freedom.[67] The new core exhibition *Freedom without Borders* embodies this change from several aspects.

On the one hand, the exhibition is strongly influenced by cosmopolitan thinking: "Cosmopolitan thinking means to be able to shift focus from one's own ethnic or national community and instead consider primarily the need to show respect for all human lives and possibly feel compassion to all human suffering."[68] Cosmopolitan thinking has an important general impact on museology through evoking critical questions about heritage and identity in a globalized world, recognition of the Other as well as otherness in a self-enhancing dialogue and participation, and mediating between differences.[69] With respect to representations of the Second World War and communism, the Holocaust memory, and human rights criticism of former abuses has given rise to a cosmopolitan "memory imperative" as a universal code for the handling of past experiences.[70] The Vabamu exhibit, in the sections "Inhumanity" and "Soviet Estonia," shares some of the cosmopolitan repertoire of remembering: the multidirectional representation of victimhood as a way to imagine different sites of violence together,[71] a reflective narrative attempting to reflect empathy and responsibility for other human beings,[72] and an abstract representation of "evil."[73] At the same time, in certain respects, the exhibitions tend to integrate individual experiences and the historical context of twentieth-century Estonia into a larger European context. In terms of display tactics and forms of representation, Vabamu comes close to "memory museums" where, according to Silke Arnold-de Simine, "visitors are supposed to gain access to the past through the eyes of individuals and their personal memories, by 'stepping into their shoes', empathising and emotionally investing in their experiences, (re)-living a past they have not experienced firsthand and thereby acquiring 'vicarious memories.'"[74] In museological terms the change from "a repository of traces of the past" to contemporary museum mediating narratives has been implemented in Vabamu in an emotional and engaging manner.

On the other hand, although Vabamu has presented itself as focusing on human experience rather than politics[75] and not taking part in "a contest of (historical) narratives,"[76] this seems exactly what the museum is doing. In order to replace the existing "occupation paradigm" dominant in the first exhibition with the narrative of freedom, the museum has undertaken a series of changes that read as an extensive commentary to the narratives of suffering, survival, and resistance connected with this paradigm. Moreover, as was demonstrated in the overview analysis of the new exhibit, the museum's audio narrative frequently refers to the old paradigm of suffering and resistance it opposes to and makes use of alternative social memory discourses emerging since the millennium.

A major change in the Vabamu exhibit was moving away from a classical historiographical approach that aimed at a consensual understanding of the past

(first exhibit audio guide, January 3, 2018) and replacing it with a memory-centered pluralistic approach. The museum focuses on showing multiple truths (MMG) and stresses the importance of individual memories in both museological storytelling and societal memory work.[77] This step is also pivotal in negotiating the "occupation paradigm." More concretely, the view on communism as a regime of occupation imposed from "above" and by force of the Soviet Army is challenged in the exhibition by presenting individual choices in Soviet Estonia. Also, the heroic narrative of postwar partisan freedom-fighting as a discourse resulting from the "occupation paradigm" is opposed by juxtaposing contradicting individual memories, thus enhancing the pluralist approach.

The victimization discourse is negotiated in Vabamu, first, by means of universalization of experience. This is most evident in representing the Holocaust and the experiences of the Stalinist mass repressions as experiences of inhumanity and using common symbols and emotional strategies. Secondly, the victimization discourse was challenged by reflexive strategies represented predominantly by the museum's multimedia guide. In the displays of Soviet Estonia, Stalinist repressions, and the Holocaust, the issues of collective responsibility, collaboration, and conformism were introduced, albeit with different accentuations. On a personal level, as well, the visitor encountered a question of choice resulting in both empathy and a testing of one's own prejudices and the dominant historical narratives.

It must be pointed out as well that the representational strategies used in the exhibition do not necessarily form a coherent whole. On the object level, a "survivor memory" enters the exhibit due to the previous orientation of the museum's collecting work and the contribution of survivors of mass violence, ex-partisans, and dissidents to the collections. Visitors not using the audio guide and only focusing on the visual and the textual, will not encounter the negotiations of the discourses of victimhood and heroism as explicitly as via the audio narrative. The display of everyday life in Soviet Estonia allows nostalgic feelings attached to the material display and nostalgic criticism toward contemporary society mediated by the audio guide, which relies on a particular social memory discourse arising since the millennium. The display of the post-communist turn and the transition period represents a perspective of civic nationalism with an attempt to critically deal with the issues of citizenship and political, social, and economic equality, which in turn is a different approach than in other parts of the exhibit.

There are thus many different, sometimes even contradictory museological discourses and mnemonic dispositions in the museum narrative that intermingle in the new exhibit of Vabamu. The exhibition, however, has received very little feedback— only two thorough reviews have been published in Estonian media during the first four months—and the responses have been contradictory as well. Though, they may be telling in terms of how Vabamu managed to address different generational memories. Shortly after the opening of the exhibition an art curator, Rebeka Põldsam (b.1989), prized the empathy and emotionality of the new display and interpreted it through the keyword diversity, which offers a place in society for everybody.[78] A couple of weeks later, an intellectual and a publicist, Kaarel Tarand (b.1966), objected to the assumption of total collaboration presented in the section of late Soviet everyday life.

He remembered dignified non-collaborationists among his circle and criticized the undifferentiated and simplified treatment of freedom in Vabamu.[79]

The profound transformation of the Estonian Museum of Occupations, now Vabamu, has not evoked as much response in Estonia as could be expected based on the lively debate that followed its name change in 2016. There may be several reasons for this lack of debate. First of all, even if the "occupation paradigm" remains a cornerstone of contemporary Estonian nationhood, in social and cultural memory work multiple and even contradictory interpretations of the Soviet past and the experience of the Second World War have come to coexist. Vabamu's new exhibit is another step in this dynamics of remembering. Secondly, two other major museum exhibits that apply pluralist methods in displaying the multiplicity of Soviet and war experiences and memories have opened recently in the Estonian National Museum (2016) and the Estonian History Museum (2018). This means that there has been a general shift from "historiographical consensus" mediating national narrative toward a more pluralist and inclusive approach to the past in the Estonian museum landscape and Vabamu's exhibit does not distinguish in this respect.[80] Last but not least, much of the symbolic burden Vabamu was dealing with when starting its paradigm change was removed by the opening of the memorial to Estonia's victims of communism in Tallinn on August 23, 2018,[81] and announcing plans for establishing an International Museum for the Victims of Communism under the auspices of Estonian Institute of Historical Memory.[82]

The transformation of the Estonian Museum of Occupations to Vabamu as reflected in the representation of the Second World War and the communist past in the museum's new core exhibition, is a result (and a part) of the dynamics of social and cultural memory processes since the millennium in terms of challenging the suffering and resistance narrative from a self-reflective point of view, adding pluralist and dialogical perspectives, recognizing historical experiences other than ethnic Estonians. Ambivalent and dissonant mnemonic discourses occasionally revealed in the exhibitions point not only to a hybrid nature of museum discourse but also to the changing of Estonian memory culture in process. Vabamu's profound turn from a memorial museum mediating the national narrative of the communist past to a pluralist memory museum coincided with the opening of a major commemoration site dedicated to victims of communism that at the time took away much of the public attention. It remains to be seen if the memorial as well as the new planned museum of communism would, in the future, deprive Vabamu of being the central museum of communism in Estonia.

Notes

1 Ene Kõresaar and Kirsti Jõesalu, "Okupatsioonide muuseumist Vabamuks: nimetamispoliitika analüüs," in Pille Runnel, Anu Kannike, and Agnes Aljas (eds.), *Eesti Rahva Muuseumi aastaraamat* (Tartu: Eesti Rahva Muuseum, 2017), 136–161, 160.

2 Maria Mälksoo, "Mäluseadused ja julgeolek," *Vikerkaar*, nos. 10–11 (2015): 120–128.

3 Volkhard Knigge and Ulrich Mählert (eds.), *Der Kommunismus im Museum: Formen der Auseinandersetzung in Deutschland und Ostmitteleuropa* (Cologne: Böhlau, 2005); Péter Apor "Eurocommunism: Commemorating Communism in Contemporary Eastern Europe," in Bo Stråth and Gosia Pakier (eds.), *A European Memory? Contested Histories and Politics of Remembrance* (Oxford: Berghahn Books, 2008), 233–246.

4 Ede Schank Tamkivi, *Ühe muuseumi lugu. Okupatsioonide ja vabaduse muuseum* (Tallinn: Kistler-Ritso Eesti Sihtasutus, 2018), 32.

5 James Mark, "Containing Fascism: History in Post-Communist Baltic Occupation and Genocide Museums," in Oksana Sarkisova and Péter Apor (eds.), *Past for the Eyes: East European Representations of Communism in Cinema and Museums after 1989* (Budapest: Central European University Press, 2008), 335–369; Ljiljana Radonić, "Post-Communist Invocation of Europe: Memorial Museums' Narratives and the Europeanization of Memory," *National Identities* 19, no. 2 (2017): 269–288, 280.

6 Aro Velmet, "Occupied Identities: National Narratives in Baltic Museums of Occupations," *Journal of Baltic Studies* 42, no. 2 (2011): 189–211; Hanna Kuusi, "Prison Experiences and Socialist Sculptures – Tourism and the Soviet Past in the Baltic States," in Auvo Kostiainen and Taina Syrjämaa (eds.), *Touring the Past: Uses of History in Tourism* (Savonlinna: MAVY, 2008), 105–122; Ein studentischer Erfahrungsbericht, "Kommunismus zum Anfassen? Museen zur Geschichte der kommunistischen Diktaturen in Ostmitteleuropa," in Volkhard Knigge and Ulrich Mählert (eds.), *Kommunismus im Museum: Formen der Auseinandersetzung in Deutschland und Ostmitteleuropa* (Vienna: Böhlau, 2005), 193–223, 198.

7 Kuusi, "Prison Experiences"; Ein studentischer Erfahrungsbericht, "Kommunismus zum Anfassen?," 205.

8 Kõresaar and Jõesalu, "Okupatsioonide muuseumist," 141.

9 Biographical interview with Managing Director Merilin Piipuu, October 13, 2016.

10 On the respective dynamics of remembering the Soviet past in Estonia, see Kirsti Jõesalu and Ene Kõresaar, "Continuity or Discontinuity: On the Dynamics of Remembering 'Mature Socialism' in Estonian Post-Soviet Remembrance Culture," *Journal of Baltic Studies* 44, no. 2 (2013): 177–203.

11 Tatiana Zhurzhenko, "The Geopolitics of Memory," *Eurozine,* May 10, 2007, www.eurozine.com (accessed October 10, 2018).

12 For a more thorough analysis of Second World War remembrance, see Ene Kõresaar, "World War II Remembrance and the Politics of Recognition: An Outline of the Post-1989 Mnemohistory of Estonian 'Freedom-Fighters,'" in Laxar Fleischman and Amir Weiner (ed.), *War, Revolution, and Governance: the Baltic Countries in the Twentieth Century* (Boston, MA: Academic Studies Press, 2018), 165–193.

13 Külliki Korts and Triin Vihalemm, "Rahvustevahelised suhted, kontaktid ja meie-tunne," in *Integratsiooni monitooring 2008* [Integration Monitoring 2008], https://www.kul.ee/sites/kulminn/files/rahvustevahelised_suhted_kontaktid_ja_meie_tunne.pdf (accessed November 22, 2016), 111.

14 Merilin Piipuu, "Mis mahub kannatuste vahele? Marginaalia Eesti lähiajaloos," *Vikerkaar,* nos. 7–8 (2016): 96–101.

15 For a further analysis of the debate see Kõresaar and Jõesalu, "Okupatsioonide muuseumist." Lorraine Weekes, "Debating Vabamu: Changing Names and Narratives at Estonia's Museum of Occupations," *Cultures of History Forum,* April 25, 2017, http://www.cultures-of-history.uni-jena.de/debates/estonia/debating-vabamu-

changing-names-and-narratives-at-estonias-museum-of-occupations/ (accessed October 10, 2018).

16 Maria Mälksoo, "'Memory Must Be Defended': Beyond the Politics of Mnemonical Security," *Security Dialogue* 46, no. 3 (2015): 221–237. doi:10.1177/0967010614552549.

17 Human Rights Centre, "The Situation of LGBT Persons," in *Human Rights in Estonia 2016–2017* (Tallinn: Human Rights Centre, 2017), https://humanrights. ee/en/materials/inimoigused-eestis-2016–2017/lgbt-inimeste-olukord/ (accessed November 22, 2018); Peeter Vihalemm, "Estonian Society Divided between Drivers and Inhibitors of Change," ERR, April 18, 2017, https://news.err.ee/590540/essay-estonian-society-divided-between-drivers-and-inhibitors-of-change (accessed November 22, 2018).

18 Kõresaar and Jõesalu, "Okupatsioonide muuseumist," 151.

19 Barbara Törnquist-Plewa, "Local Memories under the Influence of Europeanization and Globalization: Comparative Remarks and Conclusions," in Barbara Törnquist-Plewa (ed.), *Whose Memory? Which Future? Remembering Ethnic Cleansing and Lost Cultural Diversity in Eastern, Central, and Southeastern Europe* (New York: Berghahn Books, 2016), 208–226.

20 Opening speech, August 14, 2018, courtesy Merilin Piipuu.

21 The curators of the displays are: *Inhumanity*—Sander Jürisson, historian, Museum of Occupations and Freedom; *Exile*—Maarja Merivoo-Parro, historian, Tallinn University; *Soviet Estonia*—Uku Lember, historian, Tallinn University; *Recovery*—Aro Velmet, historian, University of Oxford, University of Southern Carolina; *Freedom*— Kaido Ole, artist, and Daniel Vaarik, communication expert. The exhibition partners were architecture and design company Koko (see Koko, "Homepage," n.d., http://www.koko.ee/en/ [accessed August 2, 2019]) and production firm Motor (Motor, "Permanent Expositions," n.d., http://motoragency. eu/en/permanent-expositions [accessed August 2, 2019]). Most of the curators were born in the 1980s.

22 Barbara Kirshenblatt-Gimblett, *Destination Culture: Tourism, Museums and Heritage* (Berkeley: University of California Press, 1998), 3.

23 Regarding the mixture of pragmatic frameworks in Lithuanian museums of communism, see Eglė Rindzevičiūtė, "Boundary Objects of Communism: Assembling the Soviet Past in Lithuanian Museums," *Etnologie française* 2, no. 170 (2018): 275–286.

24 Kirshenblatt-Gimblett, *Destination Culture*, 3.

25 In this chapter we refer to the Estonian language guide. The multimedia guide is available in English, Russian, Finnish, Spanish, French, and German. The author of the audio performance is Estonian dramatist and art historian Eero Epner, who has been working mostly for postdramatic theater NO99. The Estonian version is presented by well-known actor Sergo Vares. The foreign language guides slightly differ from the Estonian one.

26 The thematical rooms *Exile* and *Freedom* were not analyzed for this article as they provide very few points of comparison with the first exhibit.

27 Sharon Macdonald, *Memorylands: Heritage and Identity in Europe Today* (London: Routledge, 2013), 7.

28 Kirshenblatt-Gimblett, *Destination Culture*; Rindzevičiūtė, "Boundary Objects."

29 Silke Arnold-de Simine, *Mediating Memory in Museum* (Basingstoke: Palgrave Macmillan, 2016), 2.

30 Ibid., 2–8.

31 Sander Jürisson in the radio broadcast Muuseumiminutid, May 30, 2018. Radio Kuku, "Muuseumiminutid 2018-05-30," May 30, 2018, http://podcast.kuku. postimees.ee/podcast/muuseumiminutid-2018-05-30/ (accessed August 27, 2019).

32 The in-built wagon is integrated into Estonian memory of mass deportation using its central motif of the lost home. Wood from a deserted farm that belonged to a repressed family was used to build the wagon and the story is narrated via audio guide.

33 The exhibition team has a broad experience of museums across Europe and the United States. During the preparation period they named the Museum of Tolerance, the Simon Wiesenthal Centre Museum in Los Angeles, the Anne Frank Museum in Amsterdam, and the Jewish Museum in Berlin as their inspiration but the list is definitely longer.

34 Heiki Ahonen, "Wie gründet man ein Museum? Zur Entstehungsgeschichte des Museums der Okkupationen in Tallinn," in Knigge and Mählert, *Der Kommunismus im Museum*, 107–116, 108; Mark, "Containing Fascism," 351. Critics of the EMO's first exhibit have interpreted this as a rejection of integrating the Holocaust memory culture in EMO.

35 Ljiljana Radonić takes the use of universalization through the individualization strategy in Central and East European memorial museums as a direct internalization of the Holocaust representation. However, within the framework of the new museology paradigm that has become influential in Baltic museums since the 2000s, trends such as telling stories with objects, displaying individualized viewpoints to avoid homogeneous perspectives, showing social processes through its impact on an individual, etc, have been widely accepted and applied. Museological trends and mnemonic processes reflected in museums are tightly intertwined and complex and not always reduced to one-way processes. Cf. Radonić, "PostCommunist Invocation."

36 Interview with employees of production firm Motor, August 27, 2018.

37 Interview, August 16, 2018.

38 Leena Kurvet-Käosaar, "Voicing Trauma in the Deportation Narratives of Baltic Women," in Gabriele Rippl, Philipp Schweighauser, Tiina Kirss, Margit Sutrop, and Therese Steffen (eds.), *Haunted Narratives: Life Writing in an Age of Trauma* (Toronto: Toronto University Press, 2013), 129–151.

39 Mark, "Containing Fascism."

40 Radonić, "PostCommunist Invocation," 270.

41 Merilin Piipuu interview by Arp Müller, see Vikerraadio, "Uudis+2. tund," ERR, July 13, 2018, https://vikerraadio.err.ee/843197/uudis-arp-muller/867453 (accessed August 27, 2019).

42 Michael Rothberg, *Multidirectional Memory: Remembering the Holocaust in the Age of Decolonization* (Stanford, CA: Stanford University Press, 2009).

43 Alexei Yurchak, *Everything Was Forever, Until It Was No More. The Last Soviet Generation* (Princeton, NJ: Princeton University Press, 2006). The curator of that period had researched the late Soviet era from an oral history and interethnic perspective. Uku Lember, "Temporal Horizons in Two Generations of Russian–Estonian Families during Late Socialism," in Raili Nugin, Anu Kannike, and Maaris Raudsepp (eds.), *Generations in Estonia: Contemporary Perspectives on Turbulent Times* (Tartu: University of Tartu Press, 2016), 159–187.

44 At the two other main new exhibitions dealing with the Soviet period—at the Estonian National Museum and at the Estonian History Museum—this clear distinction is not made.

45 The use of Soviet symbols as a mark of a free society was stressed also by the head curator in the interview, bringing out that it is also a sign of a free liberal society. In contrast to two other Baltic states, the public use of communist and Nazi symbols is not forbidden in Estonia. There have been several debates over banning, but the Parliament ruled in favor of a freedom of speech ideal.

46 The "whipped cream collaborationism" of late socialism was acknowledged by the first director of the EMO, but this approach was not explicitly adopted in the first exhibition. Schank Tamkivi, *Ühe muuseumi lugu*, 33.

47 Velmet, "Occupied Identities," 196, 201.

48 Ene Kõresaar, "The Notion of Rupture in Estonian Narrative Memory: On the Construction of Meaning in Autobiographical Texts on the Stalinist Experience," *Ab Imperio*, no. 4 (2004): 313–339.

49 Ene Kõresaar, "Towards a Social Memory of Work: Politics and Being a Good Teacher in Soviet Teachers' Biographies," in Klaus Roth (ed.), *Arbeit im Sozialismus - Arbeit im Postsozialismus. Erkundungen der Arbeitswelt im östlichen Europa* (Münster: Lit-Verlag, 2004), 291–310.

50 Kristi Grünberg, "'Nagu me ei olekski tööd teinud.' Katkestused ja järjepidevused endiste põllumajandusjuhtide omaeluloolistes jutustustes," in Vilja Kohler (ed.), *Maaelu ja elu maal muutuste tuultes. Põllumajandusreform 20* (Ülenurme: Eesti Põllumajandusmuuseum, 2014), 169–194.

51 Kirsti Jõesalu, *Dynamics and Tensions of Remembrance in post-Soviet Estonia: Late Socialism in the Making* (Tartu: University of Tartu Press, 2017).

52 Even if the exhibition spatially and textually differentiates between two periods of the Soviet era, the audio guide tends to mix between the periods especially when engaging in the discourse of rupture.

53 Maria Mateoniu and Mihai Gheorghiu, "Theories and Methods of Studying Everyday Life: Everyday Life during Communism," *Martor*, no. 17 (2012): 7–18.

54 The two other screens display Soviet-era propaganda posters, thereby touching on the question of propaganda and art.

55 As there are no titles for the showcases, the interpretations are made by authors.

56 Arnold-de Simine, *Mediating Memory*, 11.

57 Kõresaar and Jõesalu, "Okupatsioonide muuseumist," 142.

58 Kirsti Jõesalu, "'We Were Children of Romantic Era': Nostalgia and the Non-ideological Everyday through a Perspective of 'Silent Generation,'" *Journal of Baltic Studies* 47, no. 4 (2016): 557–577. doi:10.1080/01629778.2016.1248685.

59 Ein studentischer Erfahrungsbericht, "Kommunismus zum Anfassen?," 205.

60 About Õismäe and its significant place in the memories of younger Soviet generations, see Kirsti Jõesalu and Raili Nugin, "Reproducing Identity through Remembering: Cultural Texts on the Late Soviet Period," *Folklore. Electronic Journal of Folklore* 51 (2012): 15–48. doi:10.7592/FEJF2012.51.joesalu-nugin. In Tallinn there are three bigger districts of blockhouses: Mustamäe, Õismäe, and Lasnamäe, in the exhibition the focus is on two of them, Õismäe and Mustamäe.

61 Jõesalu, *Dynamics and Tensions*.

62 The content is provided by political scientists from the University of Tallinn.

63 Accentuating the collective role in the Singing Revolution and downplaying the role of the elite seems to be a common trend in major (cultural) history exhibitions in contemporary Estonia.

64 Tanja Muravskaja was selected as an artist dealing critically with issues of nationalism in Estonia.

65 There are over 365,000 Russians and Russian speakers living in Estonia, over a quarter of the population. The experiences of Russian speakers are represented through two older men from the border city Narva; both of those experiences are connected to the protest against Estonian citizenship and the language law. On a critical note—the Russian speakers are represented still in a unifying way.

66 The other topics on the screen included perestroika, environmental issues at the end of the 1980s, student protests, free market reforms, privatization, social security, success of young people, emerging political organizations, restructuring the agricultural sector, peripheralization, unemployment, work migration, issues of citizenship and language, different understandings of history, stigmatizing Russian speakers, the Bronze Soldier riot, the development of cultural life and media, the role of the Open Society Foundation, and music festivals.

67 Vabamu, "The Story of Our Freedom," https://www.vabamu.ee/en (accessed November 22, 2018).

68 Barbara Törnquist-Plewa, "Cosmopolitan Memory, European Memory and Local Memories in East Central Europe," *Australian Humanities Review* 59, (2016): 136–154, 144.

69 Mason Rhiannon, "National Museums, Globalization, and Postnationalism: Imagining a Cosmopolitan Museology," *Museum Worlds: Advances in Research* 1, no. 1 (2013): 40–64.

70 Daniel Levy, Michael Heinlein, and Lars Breuer, "Reflexive Particularism and Cosmopolitization: The Reconfiguration of the National," *Global Networks* 11, no. 2 (2011): 139–159, 141.

71 Rothberg, *Multidirectional*, 1–11.

72 Katrine Tinning, "To Survive Ravensbrück: Considerations on Museum Pedagogy and the Passing on of Holocaust Remembrance," *Museum and Society* 14, no. 2 (2016): 338–353, 345. The main curator maintained in the interview (August 16, 2018) that the ethical imperative of "never again" had an influence in preparing the display. The manager director, in turn, referred to the need to educate citizens (with the help of the museum's reflexive audio guide) who think, doubt, and ask critical questions (presentation in an annual conference of the Estonian Museum Society, September 24, 2018).

73 Anna Cento Bull and Hans Lauge Hansen, "On Agonistic Memory," *Memory Studies* 9, no. 4 (2016): 390–404, 390.

74 Arnold-de Simine, *Mediating Memory*, 10–11.

75 Merilin Piipuu's opening speech, August 14, 2018.

76 Interview with a main curator Sander Jürisson, August 16, 2018.

77 The historiographical discourse is marginal at the exhibit and partly in great discrepancy with the audio narrative, the exhibit's audio narrative even goes as far as to deny the possibility of historical truth about the past and instead makes appeals to emotions and personal beliefs of the visitor.

78 Rebeka Põldsam, "Roosa müts- Milline on Sinu vabadusvõitlus?," *Sirp*, August 3, 2018, http://www.sirp.ee/arvamus/roosa-muts-milline-on-sinu-vabadusvoitlus/ (accessed November 22, 2018).

79 Kaarel Tarand, "Habras asi valel põhiteesil?," *Sirp*, August 17, 2018, https://sirp.ee/s1-artiklid/c9-sotsiaalia/habras-asi-valel-pohiteesil (accessed November 22, 2018). For the more recent analytical reviews of Vabamu from a museological and mnemopolitical perspectives respectively, see Anu Kannike and Jana Reidla, "Vabadusel ei ole piire? Museoloogiline pilk Vabamu uuele püsinäitusele," *Tuna. Ajalookultuuri Ajakiri*

no. 1 (2019): 139–146; and Heiko Pääbo and Eva-Clarita Pettai, "A Museum of Memories: The New 'Vabamu' in Tallinn," *Cultures of History Forum*, March 27, 2019. doi:10.25626/0096.

80 Indeed, Tarand is his review even poses the question of whether the Estonian museum landscape needs one more museum dealing with the recent past, as the topic is covered by other museums already (Tarand, *Habras*).

81 "Estonia's victims of communism 1940–1991: The Memorial," https://www. memoriaal.ee/en/ (accessed August 27, 2019).

82 International Museum for the Victims of Communism, https://patareiprison.org/ en/visit/ (accessed September 9, 2019). The International Museum for the Victims of Communism and Research Centre of Communist Crimes is to be established in Tallinn, the capital of Estonia, led by the Estonian Institute of Historical Memory with the support of the Government of Estonia and leading remembrance institutions in Europe and beyond. The first part of the museum opened in May 2019.

Institutionalized Narratives of Communism in Slovakia: Substituting the Nonexistence of the Official Museum of Communism

Martin Kovanič

Modes of remembering the communist era and the institutionalization of its memory are shaped largely by various museums of communism. The establishment of an official narrative on the communist period as a past criminal regime is one of the aims of transitional justice.[1] Many state-sponsored museums, such as the Terror House in Budapest or the Stasi Museum in Berlin, serve the role of canonizing this narrative and present visitors with a more direct experience of it. This means that museums of communism serve a purpose; they present a politicized memory, which is anti-communist and often also anti-authoritarian.[2] Moreover, they aim at creating a "prosthetic memory," a deeply felt personal experience with the exhibition that aims at shaping individual subjectivity and political attitude.[3]

The establishment of memorial museums concerning communist regimes can therefore be considered one of the indicators of how post-communist societies deal with their non-democratic past and how they try to construct their post-authoritarian identity. In the post-communist area, several governments established or supported museums of communism or similar memorial museums that focus on this problematic past.

The Slovak Republic is one of the exceptions in this regard. In this country to this day there is no state-sponsored museum that focuses on the historical experiences of the communist regime.[4] This is relatively surprising considering the existence of two post-communist governments, both of which consisted of a majority of anti-communist political parties. The first one, during the period of 1998–2006 established the Slovak Nation's Memory Institute (NMI) and granted a relatively inclusive access to the former secret security files.[5] In the second period of 2010–2012, there were attempts to establish an official memorial museum of communism, but it was unsuccessful due to the early fall of this government.

This work was supported by the Slovak Research and Development Agency under the contract No. APVV-16-0389.

Similar to the trajectory of transitional justice measures in Slovakia,[6] the status of a state-sponsored museum of communism is dependent on the configuration of the political elite and their attitudes toward the communist past. Besides civil society representatives, artists, and private individuals who are active in memory politics, there are also important actors who affect the chances of creating such a museum.[7] Developments in the institutional representations of the memory of communism can therefore be understood as a confrontation of multiple mnemonic actors within a broader context of struggles over memory in Slovakia.

The purpose of this chapter is to provide an analysis of the discussions on the establishment of the official state-sponsored museum of communism in Slovakia in the context of memory politics as well as explanations for the lack of success in this field. Additionally, it will explore initiatives of other actors in this regard and provide an overview of the existing museums operated by private entrepreneurs/politicians and civil society, and how they portray the narrative of the communist regime. Eventually, it will present an overview of exhibitions organized by the Nation's Memory Institute, which are a substitute for the nonexistence of an official permanent museum and have comparatively larger access to the public sphere.

Narratives in museums of communism

To gain a better understanding of the willingness of official elites to establish a museum of communism, I will first present the discussions on memorial museums and their representations of historical facts. Memorial museums often present a politicized memory, which is dependent on whose memory is included and whose is excluded. In this sense, they function as "public, national institutions of memory" even if their political objectives are obscured.[8] The establishment of such institutions is therefore always a result of conflicting interests between various groups of official and unofficial actors, including politicians and historians as well as victims.[9] These mnemonic actors often treat history instrumentally, attempting to construct a representation of history that is effective for the purposes of legitimation of their political ambitions.[10] Attempts of legitimizing contemporary power claims through uses of memory and creation of official historical narratives are a historicization strategy, a form of symbolic politics dependent on a conviction that uses certain representations of memory in the public sphere that have mobilizing political potential for specific groups.[11]

In the post-communist context, memorial museums produce conflict similar to other official memory institutions, which are subject to political negotiations[12] and susceptible to changing political alignments.[13] Official historical narratives of the communist regime are instrumental to legitimize the developments after the fall of communism after 1989 through rejection of the communist regime.[14] For this reason, official historical narratives of communism focus on traditional political history under a totalitarian paradigm, which juxtaposes the "evil regime" and "innocent repressed society."[15]

Contemporary museums of communism, such as the Terror House in Budapest or the Stasi Museum in Berlin, function within a broader European context. They

"Europeanize" the memory of communism, which is constructed within the frameworks of a trans-European discourse, with the aim of producing a popular anti-communist historical narrative. Through these channels, they "enabled the successful transmission of the vocabulary and argumentative repertoire of European anti-Communist historical revisionism into the national contexts."[16] Along with the memory of the Holocaust, the experience of communism is presented as the constitutive European experience. Apor argues that the exclusive image of communism in the form of a completely decontextualized terror is largely based on comparative evocations of fascism.[17] The narrative presented in these museums falls within the totalitarian paradigm, which is generally in conflict with the narrative of reconciliation and forgiveness,[18] a frequent aspiration of transitional justice.

However, museums of communism are not always state-sponsored. The best example in the region is the Museum of Communism in Prague (*Muzeum komunismu*), which is a private enterprise, built by an American entrepreneur. The museum is focused on the display of artifacts, which are designed to play a primary role in the construction of the experience. The exhibition is complemented with the presentation of opposition movements as well as repressive and destructive aspects of the regime.[19] Therefore even a privately owned institution, which focuses more on the entertainment aspects, provides an anti-communist narrative.

It can be concluded that memorial museums dedicated to the era of communism present a politicized memory with a focus on political developments, repression, and victims. Besides transitional justice goals, such as symbolic denunciation of the perpetrators and representation of the victims, they also serve contemporary political aims. Presentation of this type of historical narrative is supported by specific groups of mnemonic actors, who are present in the political arena in the given countries.

Struggles over the official memory of communism until the establishment of the Nation's Memory Institute

Attitudes toward the communist regime have been a source of contention in Slovak politics since its breakdown in 1989. This is a result of the overall attitudes toward the regime in the population as well as the old elite relegitimizing the new political order. Attitudes toward the regime are dependent on the distinct Slovak experience with communism. Although not enjoying high levels of legitimacy, the communist regime was more popular in Slovakia during the normalization period due to the lower level of political repression and realization of Slovak national sovereignty with the formal federalization of the state.[20] Additionally, the majority of the post-communist Slovak political elites had ties with the former one, since no alternative elites were available. The Slovak umbrella-party Public against Violence (Verejnosť proti násiliu, VPN), established during November 1989, consisted of only a minority of dissidents, and included reform communists, former managers, and nationalist intellectuals.[21] Despite of that, a number of transitional justice measures were applied in Czechoslovakia following the breakdown of the communist regime—retributive as well as reparatory,[22] including a comparatively strict lustration mechanism.[23]

The splits within VPN and the establishment of the nationalist populist Movement for Democratic Slovakia (Hnutie za demokratické Slovensko, HZDS) in 1991 by Vladimír Mečiar led to the prevalence of former communists and nationalists in the Slovak political arena. After the establishment of independent Slovakia in January 1993, the ruling elite decided not to implement any harsh transitional justice measures and the implementation of the lustration law was prevented by Mečiar.[24] This era, in which no major measures regarding the communist past were passed in Parliament, even though some new reparatory measures were implemented, can be labeled a decade of silence in terms of transitional justice.[25] In terms of memory politics, HZDS and other Slovak nationalists viewed November 89 as the precondition to the independent nationhood, and for them its significance is primary in terms of the national question.[26]

Proponents of transitional justice, and to some extent "mnemonic warriors" who appropriated the positive memory of November 89 and the criticism of the communist regime, have been the parties of the political right, which had direct personal or partisan ties to leaders of the Velvet Revolution or Slovak dissidents,[27] which advocated an anti-communist narrative of history. The victory of center-right parties in the 1998 elections brought back the debate about communism and the need to address it on the societal level. This culminated in the establishment of the Nation's Memory Institute and the security agencies' archives being opened up in 2002.[28] The main responsibility of the institute became the administration of the communist security files, historical research, and public propagation of the official narrative of communism. Similarly, memory politics have remained relevant for the decisions on the institutional representations of the communist past, which I will discuss further in this chapter.

The unfinished saga of the official museum of communism

In August 2007, the Slovak conservative weekly magazine *Týždeň* (Week) posed the question of whether Slovak society was mature enough to open a museum of totalitarianism,[29] for the first time after 1989. In the article, some of the most important mnemonic institutions gave their answers. The then-director of the Slovak National Museum (SNM) Peter Maráky claimed that the question was incorrect and that Slovaks should instead ask themselves why there was no museum of modern history in Slovakia. According to Maráky, the Slovak non-democratic regimes could be presented in a wider historical context. A similar idea was echoed by Stanislav Mičev, the director of the Memorial Museum of the Slovak National Uprising, which is dedicated to the anti-fascist uprising of 1944.

The president of the Nation's Memory Institute at that time, Ivan Petranský, claimed that he had been pondering the idea for a long time. However, he believed that the initiative could not come from the institute, since it had only a very limited budget and its main activities concerned archival work. Petranský himself added that there was no consensus over the period of communism (nor the interwar Slovak state)[30] among the political elite, and such a project would require political backing.

At the time, political backing was unattainable. The governing coalition at the time consisted of the left-wing Nationalist SMER-SD party (Direction-Social Democracy), the far-right Slovak National Party (Slovenská národná strana, SNS), and HZDS. The strongest position in the government was held by SMER-SD, a communist successor party,[31] without any strong commitment to transitional justice processes.[32] The continuity with the Communist Party of Slovakia, however, does not mean there was support for and dismissal of the crimes of the previous regime. On the contrary, as argued by Juraj Buzalka, they have been successful in manipulating economic nostalgia and "mobilizing nostalgia related to socialism but not nostalgia for socialism itself."[33] Still, the manifest support for anti-communist initiatives is not a viable strategy for the SMER-SD and its voters. The Ministry of Culture of the Slovak Republic at the time managed by Minister Marek Maďarič considered the creation of neither a museum of communism, nor a museum of modern history as a priority at that time. The official "Strategy of the Development of Museums and Galleries in the Slovak Republic until the year 2011," which was accepted by the government in 2006, did not mention the establishment of such a museum at all.[34]

The establishment of the official museum of communism was not on the political agenda until 2010, when the Radičová government of center-right parties, which praised itself as the first government in which no minister had a communist past, was established. Even though it was ideologically heterogeneous, consisting of the center-right Slovak Democratic and Christian Union – Democratic Party (Slovenská demokratická a kresťanská únia – Demokratická strana, SDKU), the liberal party Freedom and Solidarity (Sloboda a Solidarita, SAS), the conservative Christian Democratic Movement (Kresťanskodemokratické hnutie, KDH), and the party of the Hungarian-Slovak cooperation MOST-HÍD (Bridge), the parties shared a strong anti-communist ethos. The KDH was traditionally a party that initiated various transitional justice mechanisms and adopted a strict anti-communist stance.[35] The political configuration therefore became favorable to various policies for dealing with the communist past. Even though, the establishment of the museum was not formulated directly in the government manifesto, it acknowledged the "bitter experience with the totalitarian past" and claimed that the government "supports just dealing with this past."[36] This was a considerable change in rhetoric after the previous SMER-SD dominated government.

Nevertheless, the first stimulus came from the side of civil society and conservative Christian circles. On November 25, 2010, the day commemorating the release of the last political prisoners in former Czechoslovakia, the Forum of Christian Institutions (Fórum kresťanských inštitúcií, FKI) submitted a petition that supported the idea of the establishment of the museum of the crimes of communism.[37] The petition was also supported by the Nation's Memory Institute, the Confederation of Political Prisoners in Slovakia, and the Konrad Adenauer Stiftung, and signed by more than 3,000 individuals. The initiative was able to secure institutional support from a similar German museum as well, when Hubertus Knabe, then director of Gedenkstätte Berlin-Hohenschönhausen (Museum of Stasi) was present at the press conference and articulated support for its establishment. Ján Čarnogurský, a former political prisoner,

former Slovak prime minister, and former minister of justice as well as one of the founding members of KDH, also participated at this conference.[38]

In early 2011, the idea of establishing a museum of communism was also formulated by Prime Minister Iveta Radičová.[39] After considering several possibilities, the space for the museum was found in one of the buildings at the Government Office of the Slovak Republic. It was to be shared with the offices of the Nation's Memory Institute, which had its seat in a rented building of the Ministry of Transport at that time. In June 2011, the government officially approved the document, "Intention to Establish a Museum of Communism and Totalitarian Regimes in Bratislava." The document of intent provided that the museum would focus on the non-democratic regimes of the twentieth century in Slovakia, which included both the communist regime and the Second World War Slovak state. The proposal specified the focus of the museum, which was to be on "the development of the communist totalitarian regime in Slovakia (in Czechoslovakia) and its specifics in the context of the development of the Soviet bloc after the Second World War" as well as focus on the repressive apparatus, violations of human rights, and the opposition to the regime. It also added the theme of everyday life in Slovakia.[40]

The conception of the museum was prepared by a wide coalition of mnemonic actors. It was cooperated by the Ministry of Culture, in coordination with the Nation's Memory Institute, the Government Office of the Slovak Republic, the Slovak National Museum as well as the Forum of Christian Institutions, the organization who had originally proposed the idea. Institutionally, it was to be administered by the NMI and, until the new legal status of the NMI was resolved, provisionally operated in the premises of the Historical Museum in Bratislava.[41]

However, the initiative came to a halt in the very same month. The Radičová government was given a vote of no confidence in Parliament on October 11, 2011, due to the conflicting views of coalition parties toward the ratification of the European Financial Stability Facility, which was opposed by the Freedom and Solidarity's economic liberals.[42] This development also meant a standstill in the efforts to establish the museum. The early 2012 elections brought a decisive victory of the SMER-SD party.[43] The plan to set up a museum of communism was dismissed by the restored minister of culture Marek Maďarič on the grounds that funds for museums were limited and these were needed for the proper functioning and development of the existing museums throughout Slovakia.[44] In 2013, the Ministry of Culture prepared a new "Strategy of the Development of Museums and Galleries in the Slovak Republic until the year 2018." This strategy document yet again contained no mention of any memorial museum.[45] In 2016, the elections were won again by the SMER-SD party and a coalition government with the Slovak National Party and MOST-HÍD was established,[46] showing no preference for furthering any transitional justice agenda.

Despite of the reluctance of this political elite to support anti-communist programs, another initiative came in the second half of 2016 from the Nation's Memory Institute. Its then-director, Ondrej Krajňák, allocated the task to prepare a draft for the museum of communism to the Section of Oral History of the NMI. After its preparation, Krajňák conducted a few meetings with the representatives of the Bratislava Self-Governing Region about the intention to establish the museum in one of their buildings. The

development of the idea, which intended to connect more stakeholders—such as the Slovak National Museum, historians, civil society representatives, and others—in the near future, was halted in the autumn of 2017.[47]

The reason for this was a proposal of the amendment to the law on memory of the nation that was presented in Parliament,[48] which also initiated a broader discussion about the role of the Institute and its public activities. The primary aim of the amendment was the implementation of a new mechanism of electing the leadership of the Institute, which was to be performed by the collective Board of Directors and not the Parliament anymore. This proposal, prepared and vehemently promoted by the SNS, was explained by the ongoing conflicts between Ondrej Krajňák and the Board of Directors.[49] The new proposal also included a minor change in the paragraph, which outlined the functions and responsibilities of the institute. The old legislation contained the word "mainly" in front of the list of responsibilities, and therefore created room for the institute to organize additional activities—especially educational activities for the wider public, such as organization of festivals, exhibitions, preparation of documentary films, etc.—which were not explicitly specified by the law. The word "mainly" was to be removed, which meant that the passage of the new legislation in this form would likely prevent NMI from carrying out these activities, including the possible administration of a museum of communism.

The efforts of the director and the institute as a whole therefore shifted to the struggle against the new legislative proposal and the negotiations for the museum came to a halt.[50] The proposal also inspired a relatively strong criticism from both opposition parties and civil society.[51] Criticism materialized in the civic initiative Pamätaj (Remember), which became visible in the public sphere, receiving attention in the media as well as spreading throughout social media. The initiative was created by students and young people, mainly from the conservative Christian sphere, who considered remembering the past non-democratic regimes important for society and opposed the changes to the institute, since in their view these would lead to the crippling of its functions and operation.[52] Pamätaj embraced the totalitarian historical narrative of communism presented by the NMI. It was then supported by several civil society organizations, including the Open Society Foundation and the Euro-Atlantic Centre as well as the educational institution Kolégium Antona Neuwirtha (Anton Neuwirth College) and several prominent public persons. The petition to withdraw the amendment from the legislative process was signed by more than 7,500 individuals.[53]

Other activists included a representative of the Forum of Christian Institutions making a public comment on the proposed novelization, which criticized the suggested changes and explicitly mentioned that "it would mean a stop for the museum of the crimes of communism."[54] This criticism did not manage to stop the novelization; however, it succeeded in shaping its final form. The final version brought changes in the constitution of the leadership of the institute, but it did not affect its functions and responsibilities.[55] As a result of this process Krajňák resigned from the position of director in November 2017, and the new leadership of the NMI does not consider the establishment of the museum a priority and currently is not taking any action in this regard.[56] Nevertheless, the possibility to establish a museum of communism under the authority of the NMI in the future remains open.

Jiří Přibáň argues that due to the early implementation of the instrumental administrative transitional justice legislation, such as the lustration law in 1991, Czechoslovakia, and conversely also its successor states, witnessed a "growing public indifference and marginalization of moral issues of the political past."[57] This explains the relative public indifference toward implementation of additional transitional justice mechanisms, including a possible museum of communism. In the case of Slovakia, it was strengthened by the compositions of the ruling coalitions, which preferred the preservation of the status quo in the field of memory politics. On the other hand, societal pressure organized by a coalition of mnemonic actors surrounding the new legislation aimed at curbing the activities of the Nation's Memory Institute was able to find wider appeal, spread into the public discourse, and affect the final amendment of the law. However, afterwards the coalition disintegrated, and it was not able to push forward any other agenda.

Private initiatives: The Museum of 17 November in Bratislava

In the case of Slovakia, institutionalized narratives of communism were left to unofficial—meaning non-state-sponsored—mnemonic actors. Some of the institutions, which exhibit communism to the wider public, are private enterprises established with the idea of being economically viable and generating profit. A regional example is the Museum of Communism in Prague, which was established by American and Canadian entrepreneurs in 2001, and driven by the idea that there was "a hole in the market," and tourists could not get any complex information about the communist times in a museal form while visiting Prague.[58]

Slovak entrepreneur and at that time political activist Alojz Hlina[59] presented an idea to establish a memorial museum of November 17 (Múzeum 17. Novembra) (the day of the start of the Velvet Revolution, the end of the communist rule in Czechoslovakia) in Bratislava in November 2011.[60] The decision was presented together with political actors, such as former Public against Violence politician Peter Zajac, former dissident and later KDH politician František Mikloško and anti-corruption politician and the president of the newly established Ordinary People and Independent Personalities (Obyčajní ľudia a nezávislé osobnosti, OĽaNO) party Igor Matovič. In the 2012 election, Alojz Hlina[61] was elected to Parliament as a candidate of the OĽaNO party. In this context, the establishment of the museum could be considered as part of political marketing, even though this idea was rejected by Hlina himself.

It was decided that the focus of the museum would be the 1989 revolution. This decision can be understood in the context of the appropriation of November 17 by right-wing politicians, both liberal and conservative, in the course of the political struggles against Vladimír Mečiar and afterwards Róbert Fico in Slovakia.[62] The museum was prepared in cooperation with the Nation's Memory Institute, which was asked to prepare the presentation panels for the exhibition. These panels were prepared by the NMI historians Peter Jašek and Ondrej Podolec in cooperation with Ján Pálffy, who was responsible for the design. According to Peter Jašek, who was in charge of its preparation, they were requested to prepare a narrative that would focus on the events

of November 17 and the historical developments that had led to this day and also what followed afterwards. Otherwise, they were given complete freedom.[63]

The museum itself is situated in the back of the coffee house owned by Alojz Hlina. It is located at the square of the Slovak National Uprising, which was the place of the largest Slovak protests in 1989. As illustrated in Figure 4.1, the signboard of the museum is located next to several other ones, and it is hard to spot it from the street. If one notices the sign, (s)he has to walk in the coffee house and ask about its location, since it is displayed in a small room at the back of the coffee house with an entrance next to the toilets. The museum is accessible free of charge during the opening hours of the coffee house.

The museum itself is very small, consisting of only nine exhibition panels located in one room. There are neither interactive exhibits nor any original historical artifacts. There is only one television screen, which is supposed to be showing the film *November +20*, from the production of the Nation's Memory Institute. However, the TV is turned off most of the time. The exhibition panels were designed to tell a story of "the genesis, course of and consequences of the fall of the communist regime in Slovakia."[64] All the panels are divided into three parts, the upper half contains period photographs, the majority of which were taken by photographer Ján Lörincz and the bottom half consists of explanatory texts, both in Slovak and English.

The narrative starts with the Sovietization of Czechoslovakia after the Second World War and a description of the nature of the communist political regime in three subsequent periods. According to the exhibition, the first period is characterized by "brutal repression against the general population," including forced collectivization,

Figure 4.1 The entrance to the Museum of 17. November, Bratislava. Photograph: Martin Kovanič.

political trials, and the destruction of the Church.[65] Next, the panel briefly describes the liberalization process of the Prague Spring, its suppression, the following "normalization period" and the eventual decline of the regime in the 1980s. The next panel focuses on dissent movements and individual dissidents in Slovakia. Then the narrative moves its focus toward students, who played an important role in the fall of the regime. In the Slovak case, the first demonstration was organized by the student movement on November 16, 1989, and the demonstration in Prague followed the next day on the occasion of International Student Day.

Subsequent panels display the emergence of opposition movements and the following mass demonstrations of November 1989 and the general strike of November 27, as well as the forthcoming collapse of the communist regime and the retreat of communists from power. Afterwards, visitors can learn about political negotiations, the construction of the new government, the presidential election of Václav Havel, and finally the first free election of June 1990.

The last panel stands out from the presented narrative. It focuses on the role of the State Security (*Štátna bezpečnosť*, ŠtB) in the process of the fall of the regime. This panel explains several operations that were put into practice during the November events, the closing down of the activities of the State Security after the general strike and the destruction of evidence and its files after December 1989. Jašek claims that this panel can be considered a sort of contribution of the Nation's Memory Institute to the story, since it administers and researches the archive of the State Security.[66] In this way, the panel brings the narrative back to the repressive nature of the regime, which was started in the first panel.

The Museum of 17. November is located in a space that is not suitable for housing a more complex exhibition about the communist regime, the events of November 1989 and their aftermath. All in all, it is just one room with nine exhibition panels, housed at the back of a coffee house with a TV that is turned off. The narrative that the exhibition tells is in line with the understanding of the communist past as expressed by right-wing political parties, with a focus on its repressive nature. November 1989 is presented as the defining point in the road to freedom, an important milestone, which "paved the way for the transformation of totalitarian Czechoslovakia to a democratic state. One of its main contributions is the practical exercise of fundamental human rights and freedoms, as well as the removal of a dysfunctional centralized economic system."[67] It is therefore understood as an event that meant Slovakia's return to the Western political and economic system.

Even though the Museum of 17. November is privately owned, it does not fall into the category of commercial museums. It is better characterized as a space for the permanent presentation of one of the NMI's exhibitions. The only commercial initiative that was publicized was an attempt to establish a museum of communism by a private company owning a restaurant in an observation deck above one of the bridges in Bratislava. The idea was to prepare an exhibition of how society lived under the communist regime, with the focus on both everyday lives but also its darker sides, such as communist surveillance and social control. The museum was supposed to be opened on the 25th anniversary of the fall of the regime in November 2014.[68] However, the museum has never materialized.

Civil society initiatives: The Museum of the Crimes and Victims of Communism in Bratislava

Another attempt, which was to some extent successful, came from civil society, from the civic association Inconspicuous Heroes (Nenápadní hrdinovia). Inconspicuous Heroes, created in November 2011 and administered by František Neupauer, a historian then working in the Nation's Memory Institute, was originally created as an educational project, which encouraged students to look for "inconspicuous heroes" in the fight against communism in their families and communities, and to record their stories. In November 2010, it was established as a civic association and functioned in partnership with the NMI until January 2012, when several employees of the institute, including Neupauer, were dismissed. Afterwards, Inconspicuous Heroes continued their activities on their own.[69]

František Neupauer is an important mnemonic actor, who had been moving between the official state-sponsored NMI and various civil society organizations. In the past, he was also responsible for the petition on the establishment of the museum of communism in November 2010, when he held the position of president of the Forum of Christian Institutions and worked as a historian in the NMI as well. In 2012, his main organization was Inconspicuous Heroes. Neupauer claims that the idea of the establishment of the museum of communism stayed with him all this time, and some steps were being taken even during the period, when the official museum was planned under the Radičová government. After being laid off by the NMI, he got a position at the St. Elizabeth University of Health and Social Work located in Bratislava. The university endorsed his idea of the establishment of the museum on its grounds and offered spaces and some minor financial help. After struggles with preparations of a suitable place, the Museum of the Crimes and Victims of Communism (Múzeum zločinov a obetí komunizmu) was presented to the public on November 16, 2012.[70] It officially opened its doors to the public on March 25, 2013, the 25th anniversary of the Candle demonstration[71] in Bratislava. According to Neupauer, the choice of the name is significant for two reasons. First, it highlights the fact that the communist regime was criminal and, second, it shows that the focus is on the victims of the regime and their stories,[72] emphasizing moral responsibility toward the victims of communism.

The museum itself cannot be labeled as a museum in the traditional understanding of the word, since it does not have any permanent exhibition. It is located in a university building in the wider center of Bratislava and consists of the Library of Inconspicuous Heroes, the administrative office of the association, and the Wall of Inconspicuous Heroes, which is located next to the building, but it is behind a closed gateway. The wall is incidentally located between the university building and the spaces of the Government Office of the Slovak Republic, which was supposed to house the museum of communism planned in 2011. On the wall there are portraits of two Christian dissidents, Vladimír Jukl and Silvester Krčméry, as well as political prisoner Zdenka Scheligová, who was arrested and tortured for her faith and as a result died in a hospital after her release from prison. The location of the museum and the wall can be seen in Figures 4.2 and 4.3:

Figures 4.2 The Museum of the Crimes and Victims of Communism, Bratislava. Photograph: Martin Kovanič.

Figures 4.3 The Wall of Inconspicuous Heroes, Bratislava. Photograph: Martin Kovanič.

The activities of the museum focus more on outdoor walking tours, which take the visitors to the places and memorials connected to the communist regime, its victims and perpetrators—focusing on the political history of the regime. The indoor space of the library is used in case of unfavorable weather conditions. Despite the fact that there is no permanent exhibition, the museum is in possession of several original artifacts, such as a printing machine used to print samizdat literature and a few items produced by political prisoners held in Jáchimov. Currently, the museum has no fixed opening hours and it receives visitors only by appointment. Taking into account all of the other activities of Inconspicuous Heroes, the museum is not a priority. Nevertheless, they are open to future cooperation in the establishment of an official museum with other actors.[73]

Temporary exhibitions: The Nation's Memory Institute in cooperation with other institutions

The key player in constructing a memory of communism, what Přibáň labels a "construction of a morally normative collective memory of the nation"[74] is the NMI. Incidentally, it played a major role in all of the discussions about the establishment of an official museum of communism, as well as a decisive hand in the exhibition of the Museum of 17. November. One of their activities has always been the preparation of exhibitions that focus on the communist regime and its repressive apparatus, often in cooperation with other institutions.

Peter Jašek, a long-time NMI historian and current head of the Section of Historical Research, which is responsible for the preparation of exhibitions, considers them to be an important activity in educational programs of the institute and the propagation of its ideas to the wider public, especially to young people.[75] The first exhibition was *February 1948* on the communist takeover in Czechoslovakia organized in 2008, which was accompanied by a conference on the events of February 1948 and Slovakia. Jašek claims that the first few exhibitions were relatively simple and straightforward. A more sophisticated model for the display of the narratives was developed around 2010/2011. Since then, the panels have consisted of both Slovak and English texts, photographs, documentary movies or clips, and additional original artifacts.

The first one of these exhibitions was *Top Secret* (Prísne tajné), which was organized in Bratislava in 2011 in collaboration with the Slovak National Museum and housed in one of its buildings. It focused on the development and the role of the State Security (StB) in communist Czechoslovakia.[76] The second one was *Anti-Communist Resistance* (Protikomunistický odboj) prepared in cooperation with the private Pan-European University. This exhibition focused on the resistance to the communist regime in its various forms.[77] In 2013, another exhibition relating to the 25th anniversary of the Candle demonstration was arranged in cooperation with the SNM in Bratislava Castle.[78] The most recent major exhibition was *August 1968: Hopes and Disillusionments* (August 1968: Nádeje a vytriezvenia) organized this year in partnership with public Radio and Television Slovakia and was displayed in the Radio building.[79] All of these

exhibitions then traveled to other regions of Slovakia in some form, usually after being requested by institutions, such as universities, or as a part of events organized by the NMI. These exhibitions represent the view of the NMI and therefore focus on the political history and repressive apparatus of the communist regimes. Their content is drawn heavily from the State Security files stored in the Archive of the NMI. Consequently, they construct a politicized, anti-communist narrative of the communist era.

Conclusion

Transitional justice in independent Slovakia, which took a trajectory from "silence to Nation's Memory Institute,"[80] created only a small window of opportunity for the possibility of the establishment of a memorial museum of communism that would present an official anti-communist narrative of the past regime. In a way, the establishment of the NMI was seen as the ultimate success in dealing with the non-democratic past. All the official attempts, which only seriously started in 2011, failed due to the unfavorable political elite configuration and their preference of maintenance of the status quo in the field of memory politics. The establishment of the official museum, which is still supported by several mnemonic actors, therefore remains delayed indefinitely.

Its nonexistence, however, does not mean that there are no institutionalized narratives about the communist past presented in the form of various exhibitions. The privately owned Museum of 17. November, founded by the current president of the Christian Democratic Party, is an attempt that best fits the criteria of the museum. On the other hand, it is presented in an unsuitable space and the exhibition is very basic and non-interactive. The second initiative, the Museum of the Crimes and Victims of Communism, established by a civic organization, is an institution, which has no permanent exhibition and no fixed opening hours. They focus on educational activities that take place outside of the museum's premises. What they both have in common is the lack of funding and the consequent lack of promotion and development.

Additionally, narratives presented in these museums lead back to the NMI: the exhibition of the former was prepared by NMI historians and the president of the latter is a current NMI employee. The institute itself carries out educational activities, which include the organization of exhibitions. In this sense, these can be considered as a substitute for the nonexistence of the museum, which was one of the institute's long-term initiatives. Major exhibitions are often organized in cooperation with other public institutions, such as a national museum or universities, and therefore have relatively widespread publicity and a higher visitor rate.

All the activities relating to the establishment of a museum of communism in Slovakia, as well as its substitutes, are associated with the work of the Nation's Memory Institute, its mnemonic activities and their attempts at construction of the hegemonic anti-communist narrative for the whole society. The institute and its current and former employees played a crucial role in the activities that aimed to establish the

official museum by the official political actors around 2011. Despite the failure of these efforts, NMI was able to shape the narratives presented by the existing museums as well as a majority of the exhibitions relating to the communist regime taking place at other national or local museums.

The struggles for the establishment of the official museum can be understood as a continuation of the struggles over memory politics. There is no consensus on the interpretation of the past among the major political actors from the different sides of the political spectrum, and in the past fifteen years, Slovak politics have been dominated by parties that are able to mobilize socialism-related nostalgia and do not have political incentives to further institutionalize anti-communist narratives of the past.[81] Nevertheless, the establishment of the official museum of communism remains a future goal for some of the mnemonic actors, centered around the NMI and conservative political circles.

Notes

1 Ruti G. Teitel, *Transitional Justice* (Oxford: Oxford University Press, 2000), 69–118.
2 Sara Jones, "Staging Battlefields: Media, Authenticity and Politics in the Museum of Communism (Prague), The House of Terror (Budapest) and Gedenkstätte Hohenschönhausen (Berlin)," *Journal of War & Culture Studies* 4, no. 1 (2011): 97–111.
3 Alison Landsberg, *Prosthetic Memory: The Transformation of American Remembrance in the Age of Mass Culture* (New York: Columbia University Press, 2004), 2–3.
4 The only memorial museum in Slovakia is the Museum of the Slovak National Uprising which, however, ends its focus in 1948. See more in Barbara Lášticová and Andrej Findor, "From Regime Legitimation to Plurality of History?: Europeanization in a Slovak Museum," in Barbara Törnquist-Plewa and Krzysztof Stala (eds.), *Cultural Transformations after Communism: Central and Eastern Europe in Focus* (Falun: Nordic Academic Press, 2011), 163–179; Ljiljana Radonić, "Slovak and Croatian Invocation of Europe: the Museum of the Slovak National Uprising and the Jasenovac Memorial Museum," *Nationalities Papers* 42, no. 3 (2014): 489–507; and Ljiljana Radonić, "Post-communist Invocation of Europe: Memorial Museums' Narratives and the Europeanization of Memory," *National Identities* 19, no. 2 (2017): 1–20.
5 Reiner Schiller-Dickhut and Bert Rosenthal, *The "European Network of Official Authorities in Charge of the Secret Police Files": A Reader on the Legal Foundations, Structures and Activities*, 2nd rev. edn. (Berlin: Federal Commissioner for the Records of the former German Democratic Republic, 2014), 68–77.
6 For the overview and wider context, see, for example, Martin Kovanič, "Transitional Justice Dynamics in Slovakia, From Silence to the Nation's Memory Institute," *CEU Political Science Journal* 7, no. 4 (2012): 385–410; Nadya Nedelsky, "Divergent Responses to a Common Past: Transitional Justice in the Czech Republic and Slovakia," *Theory and Society* 33, no. 1 (2004): 65–115; and Nadya Nedelsky, "Czechoslovakia and the Czech and Slovak Republics," in Lavinia Stan (ed.), *Transitional Justice in Eastern Europe and the Former Soviet Union: Reckoning with the Communist Past* (New York: Routledge, 2009), 37–75.

7 Sara Jean Tomczuk, "Contention, Consensus, and Memories of Communism: Comparing Czech and Slovak Memory Politics in Public Spaces, 1993–2012," *International Journal of Comparative Sociology* 57, no. 3 (2016): 108.

8 Amy Sodaro, *Exhibiting Atrocity: Memorial Museums and the Politics of Past Violence* (New Brunswick, NJ: Rutgers University Press, 2018), 83.

9 David Clarke, "Understanding Controversies over Memorial Museums: The Case of the Leistikowstraße Memorial Museum, Potsdam," *History and Memory* 29, no. 1 (2017): 41–71.

10 Jan Kubík and Michael Bernhard, "A Theory of the Politics of Memory," in Michael Bernhard and Jan Kubík (eds.), *Twenty Years after Communism: The Politics of Memory and Commemoration* (Oxford: Oxford University Press, 2014), 9.

11 Georges Mink, "Between Reconciliation and the Reactivation of Past Conflicts in Europe: Rethinking Social Memory Paradigms," *Czech Sociological Review* 44, no. 3 (2008): 473.

12 Jiří Přibáň, "Politics of Public Knowledge in Dealing with the Past: Post-communist Experiences and Some Lessons from the Czech Republic," in Uladzislau Belavusau and Aleksandra Gliszczynska-Grabias (eds.), *Law and Memory: Towards Legal Governance of History* (Cambridge: Cambridge University Press, 2017), 212.

13 Georges Mink, "Institutions of National Memory in Post-Communist Europe: From Transitional Justice to Political Uses of Biographies (1989–2010)," in Georges Mink and Laure Neumayer (eds.), *History, Memory and Politics in Central and Eastern Europe: Memory Games* (New York: Palgrave Macmillan, 2013), 166–168.

14 Francoise Mayer, *Češi a jejich Komunismus* (Prague: Argo, 2009), 19.

15 Adam Hudek, "Totalitno-historické rozprávanie ako dedičstvo normalizačnej historiografie," *Forum Historiae* 7, no. 1 (2013): 92.

16 Máté Zombory, "The Birth of the Memory of Communism: Memorial Museums in Europe," *Nationalities Papers* 45, no. 6 (2017): 1032.

17 Péter Apor, "Master Narratives of Contemporary History in Eastern European National Museums," in Dominique Poulot, Felicity Bodenstein, and José María Guiral (eds.), *Great Narratives of the Past: Traditions and Revisions in National Museums* (Linköping: Linköping University Electronic Press, 2012), 582.

18 Sheila Watson, "The Legacy of Communism: Difficult Histories, Emotions and Contested Narratives," *International Journal of Heritage Studies* 24, no. 7 (2018): 789.

19 Jones, "Staging Battlefields."

20 The reasons for higher legitimacy of communist regime in post-Prague spring Czechoslovakia are discussed in detail in Nedelsky, "Divergent Responses to a Common Past," 82–88.

21 Ibid., 89.

22 An overview of the measures can be found in Nadya Nedelsky, "From Velvet Revolution to Velvet Justice: The Case of Slovakia," in Vesselin Popovski and Mónica Serrano (eds.), *After Oppression: Transitional Justice in Latin America and Eastern Europe* (Tokyo: United Nations University Press, 2012), 390–417.

23 For the discussions of lustration, see, for example, Roman David, "Lustration Laws in Action: The Motives and Evaluation of Lustration Policy in the Czech Republic and Poland (1989–2001)," *Law & Social Inquiry* 28, no. 2 (2003): 387–439; or Kieran Williams, "Lustration as the securitization of democracy in Czechoslovakia and the Czech Republic," *Journal of Communist Studies and Transition Politics* 19, no. 4 (2003): 1–24.

24 Jana Kunicová and Monika Nalepa, "Coming to Terms with the Past: Strategic Institutional Choice in Post-Communist Europe," Working Paper, December 2006, http://www.sscnet.ucla.edu/polisci/cpworkshop/papers/Kunicova.pdf (accessed November 23, 2018).

25 See, for example, Kovanič, "Transitional Justice Dynamics in Slovakia."

26 Carol Skalnik Leff, Kevin Deegan-Krause, and Sharon Wolchik, "I Ignored Your Revolution, But You Forgot My Anniversary: Party Competition in Slovakia and the Construction of Recollection," in Michael Bernhard and Jan Kubík (eds.), *Twenty Years after Communism: The Politics of Memory and Commemoration* (New York: Oxford University Press, 2014), 114–115.

27 Ibid., 106.

28 The overview of the debates leading to the establishment of the institute can be found in Martin Kovanič, "Institutes of Memory in Slovakia and the Czech Republic: What Kind of Memory?," in Péter Apor, Sándor Horváth, and James Mark (eds.), *Secret Agents and the Memory of Everyday Collaboration in Communist Eastern Europe* (London: Anthem Press, 2017), 81–104.

29 Jozef Majchrák, "Zrelí na múzeum totality?," *Týždeň* 35, August 2007, https://www.tyzden.sk/casopis/764/zreli-na-muzeum-totality/ (accessed October 8, 2018).

30 The period of the Petranský management of the NMI is controversial in itself, since he was a candidate of the Slovak National Party and several members of the institute's leadership were wartime Slovak state sympathizers and the production of the institute shifted to this period. See Nadya Nedelsky, "'The Struggle for the Memory of the Nation': Post-Communist Slovakia and its World War II Past," *Human Rights Quarterly* 38, no. 4 (2016): 969–992.

31 Marek Rybář and Kevin Deegan-Krause, "Slovakia's Communist Successor Parties in Comparative Perspective," *Communist and Post-Communist Studies* 41, no. 4 (2008): 497–519.

32 SMER was established in 1999 by Róbert Fico, after he had left the Party of the Democratic Left (Strana demokratickej ľavice, SDL). SDL was a transformed Slovak Communist Party, renamed after the fall of communism. During the period 1998–2002, Fico was the only SMER member of Parliament. In 2002, during the vote on the act on national memory (nb. 553/2002 Coll.), Fico abstained. This law established the Nation's Memory Institute. Here it is interesting to note that all of the remaining SDL MPs were not present, abstained, or voted against the legislation. The full vote can be found online, see https://www.nrsr.sk/web/Default.aspx?sid=schodze/hlasovanie/hlasklub&ID=10907 (accessed October 5, 2018).

33 Juraj Buzalka, "Post-peasant Memories: Populist or Communist Nostalgia," *East European Politics and Societies and Cultures* 20, no. 10 (2017): 3.

34 "Návrh Stratégie rozvoja múzeí a galérií v Slovenskej republike do roku 2011," Rokovanie Vlády Slovenskej Republiky, December 20, 2006, http://www.rokovania.sk/Rokovanie.aspx?BodRokovaniaDetail?idMaterial=6114 (accessed October 5, 2018).

35 KDH was established in February 1990, only a few months after the fall of the communist regime and included several prominent Catholic dissidents. At the time, the party could be positioned within the conflict over the character of the regime cleavage and later on within the residual communist vs. anti-communist cleavage when it comes to party politics in Slovakia. This included issues such as attitudes toward the communist past and de-communization policies. See Vít Hloušek and

segmentype

Lubomír Kopeček, "Cleavages in the Contemporary Czech and Slovak Politics: Between Persistence and Change," *East European Politics and Societies* 22, no. 3 (2008): 524–525.

36 *Občianska zodpovednosť a spolupráca. Programové vyhlásenie vlády Slovenskej republiky na roky 2010–2014* [Civic responsibility and cooperation. Programme Manifesto of the Government of SR for the years 2010–2014], August 2010. http://www.vlada.gov.sk/data/files/18_programove-vyhlasenie-2010.pdf (accessed October 9, 2018), 4.

37 For the petition, see http://www.peticia.sk/muzeumzlocinovkomunizmu/ (accessed October 9, 2018).

38 Ján Fabičovic, "Výzva za vznik Múzea zločinov komunizmu po roku," Fórum kresťanských inštitúcií, November 28, 2011, http://fki.sk/vyzva-za-vznik-muzea-zlocinov-komunizmu-po-roku/ (accessed October 9, 2018).

39 Miroslav Kern, "Na Úrade vlády bude múzeum komunizmu," SME, March 2, 2018. https://domov.sme.sk/c/5789618/na-urade-vlady-bude-muzeum-komunizmu.html (accessed October 9, 2018).

40 "Návrh zámeru zriadenia Múzea komunizmu a totalitných režimov," Rokovanie Vlády Slovenskej Republiky, October 5, 2011. http://www.rokovania.sk/Rokovanie.aspx/BodRokovaniaDetail?idMaterial=20288 (accessed October 5, 2018).

41 "Ministri vzali na vedomie zámer založiť Múzeum komunizmu," Aktuality, October 5, 2011, https://www.aktuality.sk/clanok/194710/ministri-vzali-na-vedomie-zamer-zalozit-muzeum-komunizmu/ (accessed October 12, 2018).

42 Sharon L. Wolchik, "Iveta Radičová: The First Female Prime Minister in Slovakia," in Verónica Montecinos (ed.), *Women Presidents and Prime Ministers in Post-Transition Democracies* (London: Palgrave Macmillan, 2017), 245–246.

43 The ideological profile of SMER-SD has been developing but at the beginning of the 2010s the party focused on issues of wealth redistribution as well as protection of national interests. A more detailed description can be found in Darina Malová, "Slovakia," in Jean-Michel De Waele, Fabien Escalona, and Mathieu Vieira (eds.), *The Palgrave Handbook of Social Democracy in the European Union* (New York: Palgrave Macmillan), 550–574.

44 "Maďarič: Rezort kultúry nemá peniaze na múzeum komunizmu," SME, April 4, 2012. https://domov.sme.sk/c/6327462/madaric-rezort-kultury-nema-peniaze-na-muzeum-komunizmu.html (accessed October 10, 2018).

45 "Návrh Stratégie rozvoja múzeí a galérií v Slovenskej republike do roku 192018," Rokovanie Vlády Slovenskej Republiky, April 3, 2013. http://www.rokovania.sk/Rokovanie.aspx/BodRokovaniaDetail?idMaterial=22230 (accessed October 10, 2018).

46 The original member of the ruling coalition was also a center-right party Sieť (Web). However, the party imploded straight after the March 2016 elections and it lost almost all of its MPs by August, when a new coalition government treaty was signed by SMER-SD, SNS, and Most-Híd. The parliamentary club of Most-Híd was able to attract five of the former Sieť MPs.

47 Author's interview with Slavomír Zrebný, Bratislava, October 17, 2018. Zrebný was a director of the Section of Oral History at the NMI at the time of the development and negotiations of the museum of communism at that time.

48 For the original proposal of the amendment, see https://www.slov-lex.sk/legislativne-procesy/-/SK/dokumenty/LP-2017-537 (accessed October 10, 2018).

49 See, for example, Martin Hanus, "Prečo treba ÚPN založiť znova," Postoj, September 11, 2017, Available online: https://www.postoj.sk/26760/preco-treba-upn-zalozit-znova (accessed October 10, 2018).

50 Interview with Slavomír Zrebný.

51 See, for example, "OĽaNO vyzýva koalíciu na stiahnutie novely zákona o ÚPN," SME, May 30, 2017. https://domov.sme.sk/c/20546213/olano-vyzyva-koaliciu-na-stiahnutie-novely-zakona-o-upn.html (accessed October 10, 2018).

52 "Pamätaj sú mladí ľudia, ktorým na histórii záleží," SME, November 10, 2017, https://domov.sme.sk/c/20693335/pamataj-su-mladi-ludia-ktorym-na-historii-zalezi.html (accessed October 10, 2018).

53 "Iniciatíva Pamätaj odovzdala 7 500 podpisov za stiahnutie novely zákona o ÚPN," Pravda, September 13, 2017. https://spravy.pravda.sk/domace/clanok/441568-iniciativa-pamataj-odovzdala-7-500-podpisov-za-stiahnutie-novely-zakona-o-upn/ (accessed October 10, 2018).

54 For the full text, see https://www.slov-lex.sk/legislativne-procesy/SK/LP/2017/537/hromadne-pripomienky/COO-2145–1000-3–2067770 (accessed October 11, 2018).

55 "Poslanci schválili novelu o ÚPN. Krajňák príde o časť kompetencií," SME, September 14, 2017. https://domov.sme.sk/c/20649210/parlament-schvalil-novelu-zakona-o-upn-krajnak-pride-o-cast-kompetencii.html (accessed October 11, 2018).

56 Author's email communication with Ján Mitáč, director of the Section of Oral History of NMI, September 3, 2018.

57 Přibáň, "Politics of Public Knowledge in Dealing with the Past," 205.

58 Iva-Hedvika Zýková, *Doba temna? neb o tom, co dnes v Praze zahraničním turistům z komunismu ukazujeme, o čem jim vyprávíme a co si necháváme pro sebe.* Diplomová práce (Prague: Univerzita Karlova v Praze, 2012), 34–39.

59 Apart from anti-corruption activities, Hlina presented a hard anti-communist stance. For example, in August 2012, on the anniversary of the 1968 Warsaw troops occupation of Czechoslovakia, Hlina brought a tank and pointed it to the windows of the residence of Vasiľ Bilak, a former Communist Party high functionary responsible for the signature of the invitation letter, which was the basis for the entrance of the Warsaw troops to Czechoslovakia. Read more at "Pred Biľakovu vilu pristavil Hlina sovietsky tank," SME, August 31, 2012. https://domov.sme.sk/c/6516654/pred-bilakovu-vilu-pristavil-hlina-sovietsky-tank.html (accessed October 16, 2018).

60 "Aktivista Hlina otvorí v Bratislave Múzeum 17. novembra," SME, November 16, 2011. https://bratislava.sme.sk/c/6142566/aktivista-hlina-otvori-v-bratislave-muzeum-17-novembra.html (accessed October 16, 2018).

61 Since then, Alojz Hlina left the OĽaNO party after conflicts with its president, established his own party Citizens of Slovakia (Občania Slovenska) in 2014, and then entered KDH in 2015. In June 2016, he became the president of KDH and upheld the position in March 2018.

62 James Mark, Muriel Blaive, Adam Hudek, Anna Saunders, and Stanisław Tyszka, "1989 After 1989: Remembering the End of State Socialism in East-Central Europe," in Michal Kopeček and Piotr Wciślik (eds.), *Thinking through Transition, Liberal Democracy, Authoritarian Past, and Intellectual History in East Central Europe After 1989* (Budapest: Central European University Press, 2015), 482.

63 Author's interview with Peter Jašek, Bratislava, October 4, 2018.

64 Ibid.

65 Panel "Czechoslovakia as Part of the Soviet Bloc," Museum of 17. November, Námestie SNP 8, Bratislava, September 27, 2018.

66 Author's interview with Peter Jašek.

67 Panel "First Free Elections," Museum of 17. November, Námestie SNP 8, Bratislava, September 27, 2018.

68 Barbora Kalinová, "V Bratislave spravia Berlínsky múr a múzeum v Moste SNP," SME, August 6, 2014. https://bratislava.sme.sk/c/7320780/v-bratislave-spravia-berlinsky-mur-a-muzeum-v-moste-snp.html (accessed October 16, 2018).

69 Author's interview with František Neupauer, Bratislava, October 5, 2018.

70 "V Bratislave je už Múzeum zločinov a obetí komunizmu," Bratislavské Noviny, November 18, 2012. https://www.bratislavskenoviny.sk/kultura/33179-v-bratislave-je-uz-muzeum-zlocinov-a-obeti-komunizmu (accessed October 18, 2018).

71 The Candle demonstration (Sviečková manifestácia) was a peaceful manifestation for religious and civil rights, which took place in Bratislava on March 25, 1988, and which was violently suppressed by the communist regime. For more information, see, for example, Peter Jašek, František Neupauer, Ondrej Podolec, and Pavol Jakubčin, *Sviečková manifestácia I: Štúdie, spomienky a svedectvá* (Bratislava: Ústav pamäti národa, 2015).

72 Interview with František Neupauer.

73 Ibid.

74 Přibáň, "Politics of Public Knowledge in Dealing with the Past," 210.

75 Interview with Peter Jašek.

76 More information can be found at "Slovenské národné múzeum prináša reálny pohľad na ŠtB," Webnoviny, May 12, 2011. https://www.webnoviny.sk/slovenske-narodne-muzeum-prinasa-realny-pohlad-na-stb/ (accessed October 20, 2018).

77 See "Protikomunistický odboj na Slovensku," Webnoviny, November 15, 2012. https://www.webnoviny.sk/protikomunisticky-odboj-na-slovensku/ (accessed October 20, 2018).

78 See "Výročie sviečkovej manifestácie," SME, March 25, 2013. https://bratislava.sme.sk/c/6746161/vyrocie-sviesckovej-manifestacie-otvorili-vystavu-a-odhalili-mur-nenapadnych-hrdinov.html (accessed October 20, 2018).

79 See "ÚPN a Rozhlas a televízia Slovenska spoločne pripravujú výstavu August 1968: Nádeje a vytriezvenia," Teraz.sk, August 18, 2018. https://www.teraz.sk/slovensko/ustav-pamate-naroda-si-pripomenie-inv/343514-clanok.html (accessed October 20, 2018).

80 Kovanič, "Transitional Justice Dynamics in Slovakia."

81 Leff, Deegan-Krause, and Wolchik argue that memory politics in Slovakia depend predominantly on political advantage that certain history-related activity might bring for the party, rather than interpretation of the history itself. See Leff, Deegan-Krause, and Wolchik, "I Ignored Your Revolution."

(Re)constructing the Past: Museums in Post-Communist Croatia

Vjeran Pavlaković

The wars that accompanied the disintegration of the Socialist Federated Republic of Yugoslavia (SFRY) in the 1990s not only resulted in far-reaching political and economic transformation, they prompted new processes of nation-building, identity formation, and cultural memory construction.[1] In Croatia, the post-communist transition was thus intimately linked with the Croatian War of Independence (known as the Homeland War, or *Domovinski rat*, 1991–1995, a war between Serbia and Croatia following the dissolution of Yugoslavia), profoundly affecting memory politics in the last two decades. In fact, the Constitution and the parliamentary Declaration on the Homeland War (2000) reinforce the position that the modern Croatian state is founded precisely on the events of the independence struggle. Franjo Tuđman, elected president after free democratic elections in 1990, was a pivotal figure in reasserting Croatian identity by restoring historic symbols, traditions, holidays, and suppressing collective memories in order to sever the connection with the shared Yugoslav historical and cultural narrative. Similar transformations took place in other European countries that had once been under Soviet influence. However, in Croatia, the new forms of cultural memory did not merely challenge the ideology of the former communist regime but emphasized the Croatian ethno-national identity of the newly independent country. In addition to revising textbooks, constructing a new commemorative calendar, changing street names, and erecting new national monuments, the Croatian authorities sought to enforce the official narratives through the country's history museums and memorial parks. While other countries in the region have established national museums and private institutions that address the communist period (for example, the House of Terror in Budapest, the Museum of Genocide Victims in Vilnius, and the GDR Museum in Berlin), Croatia still lacks a museum or permanent exhibition that addresses the communist past. Moreover, any discussion of the communist legacy in Croatia and the former Yugoslavia inevitably requires an analysis of the Second World War. Yet this period of Croatian history is also effectively missing from the museological landscape.

This chapter examines why the memorialization of the communist era and the Second World War in Croatia has not resulted in a permanent exhibition. A few sites of memory (*lieux de mémoire*), described in more detail below, touch upon the

communist-led Partisan struggle, the Holocaust, and the communist legacy, but these are limited in scope and fall short of any kind of national memory politics. Instead, ideological debates about twentieth-century history generally take place during commemorative events held at emotionally powerful memory sites and in sensationalist media coverage accompanying those political rituals.[2] Symbolic politics and debates over contested histories take center stage at commemorations that pay respect to the anti-fascist struggle as well as those that exclusively remember the communist terror that followed the defeat of the Ustaše, Croatia's pro-Axis regime during the Second World War.[3] Increasingly revisionist trends in the years since Croatia became a member state of the European Union in 2013 have resulted in the Partisans being depicted exclusively as perpetrators of crimes and not liberators, while the Ustaše in the wartime Independent State of Croatia (Nezavisna Država Hrvatska, NDH, 1941–1945) were simply anti-communists and patriots rather than Holocaust collaborators.[4] Even though remembrance politics are focused on the more recent Homeland War, memories of the Second World War and the communist regime are often blurred into debates about the conflict of the 1990s and vice versa. Moreover, the cultural memory of the Second World War and communism in Croatia is not divided only along ideological lines. The traumas of the twentieth century have exerted enormous influence on the construction of collective memories and the ethno-national identity of both Croats and Serbs (as well as other ethnic groups) living in Croatia, further complicating the process of reaching even a minimal consensus on key moments in the past that would be enshrined in a national history museum, resistance museum, or museum of communism.

Cultural memory and museums

The work of scholars in recent decades has clearly shown the relationship between memory and identity, both of which are constructed and reconstructed. According to John Gillis, "just as memory and identity support one another, they also sustain certain subjective positions, serial boundaries, and of course, power."[5] The collective remembrance of certain events or eras in a society changes over time and is influenced by different actors or groups that can be top-down and institutionalized, bottom-up and challenging the dominant narrative, or a combination of multiple mnemonic groups seeking to strengthen their version of the past. Scholars such as Aleida Assmann,[6] Brian Conway,[7] and Michael Bernhard and Jan Kubík[8] offer useful frameworks for analyzing the multiple levels at which mnemonic actors function and the various typologies of those actors. According to Assmann, social memory results from the interaction of individual recollections, yet is often limited within a generation due to the shared experiences. However, once memories are unified and institutionalized they become part of transgenerational political memory, functioning as a society's dominant historical narrative. Cultural memory is the ultimate memory and can stretch far back into the past that draws upon myths as much as historical facts.[9] Conway suggests a similar structure of memory, beginning with individual and going up to small-group,

then social, and finally institutional memory.[10] Both authors show the process over time of how certain narratives become institutionalized and marginalize the memories of groups with weaker political or social capital.

Bernhard and Kubík's examination of the 20th anniversary of the fall of communism provides insights into the kind of groups that can convert small-group memories into institutionalized narratives. They identified four categories of mnemonic actors: mnemonic warriors, mnemonic pluralists, mnemonic abnegators, and mnemonic prospectives.[11] Mnemonic actors in many post-communist countries were determined enough to establish museums of communism, create institutes investigating communist crimes, and push through resolutions condemning all totalitarianisms in the European Parliament. In Croatia, however, the focus of the leading political mnemonic actors has been on memorializing the Homeland War, whereas the narratives of the Second World War and the communist regime are far more contested and divided, and subsequently not institutionalized.

Collective memory, especially in relation to museums, can be defined as "a representation of the past, both that shared by a group and that which is collectively commemorated, that enacts and gives substance to the group's identity, its present conditions, and its vision of the future."[12] Furthermore, "cultural institutions such as museums have played a central role in the construction of a coherent national discourse that reinforce a sense of collective identity and social cohesion through common understandings of order, aesthetic, and symbols."[13] While many post-communist countries have struggled with creating a coherent national narrative after emerging from behind the Iron Curtain, Croatia's experience with the fall of the communist regime was a bloody war against rebel Croatian Serbs and aggression by the Yugoslav People's Army, contributing to the difficulty in creating a consensus over the past. Research into symbolic nation-building strategies in the Yugoslav successor states reveals that while a majority of Croats and mainstream political parties supported the official narrative of the Homeland War, there were deep divisions in society over the Second World War.[14]

National history museums enshrine the objects, images, and narratives that transmit the values and instill loyalty to the state or even specific regimes. According to Carol Duncan, "museums can be powerful identity-defining machines. To control a museum means precisely to control the representations of a community and some of its highest, most authoritative truths."[15] It is not surprising, therefore, that a museum such as the Museum of the History of Catalonia—whose motto is "the memory of a country"—immediately replaced all of its Spanish-language captions with Catalan texts after the death of General Francisco Franco, who had banned the public use of Catalan during his dictatorship. This history museum in Barcelona was thus part of the process of reasserting Catalan identity in the mid-1970s. Museologist Peter Davis argues that "museums have assumed cultural significance because they have formed collections of objects in which history and attitudes are reflected," even though many traditional museums focused more on form than content and subsequently did not always influence cultural identity.[16] Museums in Croatia seem to be struggling between the traditional approach of displaying as many objects as possible, a characteristic of

the communist-era museums dedicated to memorializing the Second World War, and implementing new, postmodernist theories that threaten to distance the audience too much from the reality of the past.

Moreover, the issue of how to incorporate Croatia's Serbs into the idealized representations of the nation state is relevant not only for Croatian museologists but for Croatian society at large. According to a September 2011 opinion poll, only 43.4 percent of respondents believed that the institutions of Croatia's Serbs should be involved in the development of history museums dealing with the twentieth century (39.3 percent believed they should not be involved, while 17.3 percent answered that they did not know).[17] As scholars of nationalism have concluded, "cultural institutions such as museums have played a central role in the construction of a coherent historical national discourse that reinforce a sense of collective identity and social cohesion through common understandings of order, aesthetics, and symbols."[18] The disintegration of the Yugoslav state and communism in the 1990s resulted in a comprehensive rewriting of historical narratives of the twentieth century. Both the Second World War and the Homeland War resulted in traumatic episodes of interethnic violence that overshadow the centuries of cooperation between Croat and Serb communities.

Many memorial museums seek to create empathy and affect through the exhibitions, ideally contributing to creating a more tolerant and pluralistic society. Memorial sites associated with mass crimes and the Holocaust in Western Europe, such as Camp des Mille[19] in France and Bergen-Belsen[20] in Germany to name two examples, provide extensive programs and additional exhibition space to address contemporary issues of racism, intolerance, anti-Semitism, and hate crimes. In her volume on museums dealing with trauma and nostalgia, Silke Arnold-de Simine notes that "empathy, in the form in which it is propagated in museums and heritage sites, appears to transcend time and space: its redemptive power lies in the hope that it will enable visitors not only to go beyond the boundaries of traditional forms of kinship and community but to experience and feel with 'the other.'"[21] This is relevant not only in addressing the crimes of both fascist and communist regimes, but the war crimes committed in the wars of the 1990s. Incorporating Serb narratives and cultural contributions into the dominant national narratives of Croatian state-building and victories over Greater Serbian ideology (according to Serbian nationalists Greater Serbia should have included territories of present-day Croatia, too) complicate the task of curators and museum officials, in particular, in addressing civilian victims of crimes committed by Croatian forces. Since the Serb nationalist project was defeated during the Homeland War, Croatia's Serbs look to their role in the anti-fascist, and multiethnic, Partisan movement for historical continuity. However, this is in itself problematic, because the Partisan victory resulted in the restoration of a Yugoslav state (and not Croatian independence) under a communist dictatorship as well as in a massive postwar repression that claimed tens of thousands of lives. Reflecting on the debates surrounding controversial exhibitions in the United States, Steven Dubin argues:

> Museums have become places where conflicts over some of the most vital issues regarding national character and group identity—the struggle between universalism and particularism—regularly break out. These conflicts are displays

of power, the result of groups flexing their muscles to express who they are or to beat back the claims of others.[22]

Although in Croatia the arena for these kinds of contests over the past tends to be commemorative events rather than museum exhibits, the lack of history museums dealing with the twentieth century can be attributed to the sensitivity of displaying representations of interethnic bloodletting in a manner that will not perpetuate new conflicts. This lack of dealing with the recent past was addressed in the widely read weekly *Globus* titled "Croatian Museums of Historical Forgetting." The curators and museologists interviewed in the article admit that the political atmosphere in Croatia, and more broadly the region, make it nearly impossible to deal with such difficult issues as the Second World War and communism without it becoming politicized.

While art and ethnographic museums assist in the construction of national identity by displaying a nation's cultural heritage, history museums are considerably more politicized and explicitly present historical narratives. This raises the question: who determines the narrative, and who is the intended audience? The original history museums in Europe were established to celebrate military victories and were maintained by the state.[23] Yet new trends in international museography have expanded the range of subjects covered by national history museums. As noted by Stephen Weil, the history museum "has shown that beyond being celebratory, it can also … be compensatory, and that beyond praising history's winners, be they military, political, professional, or economic, it can also seek to soothe the pain—or at least recognize, memorialize, and try to understand the losses—of history's victims."[24]

In fact, the proliferation of truth commissions and other forms of transitional justice in the last few decades has impacted the role of history museums, which increasingly serve as memorial sites in addition to places of community education and repositories of historical objects. This new role of history museums presumes that they can contribute to reconciliation in post-conflict states such as Croatia. A study of the impact of museums on reconciliation states that if,

> One analyzes the reports of a range of truth commissions, memorializations and conflict-oriented museums are clearly advocated, but exactly what contribution they can make is seldom expressed. Equally, memorial museums are spoken about by those who run them as having profound educational benefits and as being instrumental in preventing human rights violations, but exactly how they do this is generally not articulated.[25]

The authors of the article concede that there are differing views on whether memorial museums should offer a single metanarrative or present multiple narratives. However, they do agree that these kinds of museums should be accompanied by long-term investment and accompanying educational programs as well as other transitional justice mechanisms. Although the prospect of a truth commission in Croatia in the immediate future is unlikely—the political difficulties of the RECOM (Regional Commission for Establishing the Facts about the Victims of War Crimes and Other Serious Human Rights Violations)[26] initiative is indicative of the challenges facing the

implementation of transitional justice mechanisms in the region—any kind of history museum dealing with the twentieth century will have to include some references to victims and perpetrators of war crimes on all sides of the conflict.

Along with the challenges facing Croatian museologists in defining the goals of museums dealing with the twentieth century (for instance, whether to present only the nation-building narratives that buttress the legitimacy of the political elites or to develop exhibitions that acknowledge the complexities of the past and contribute to building an atmosphere of interethnic tolerance), the intended audience of the history museums should be taken into account. Croatia relies heavily on the tourism industry for revenue, and international visitors' attendance at national history museums must be taken into account when deciding how to represent the past. For example, the House of Terror Museum in Budapest appeals to foreign visitors with its slick and innovative displays, although it has been widely criticized for manipulating the past in order to discredit left-wing political parties in Hungary.[27] In Prague, the Museum of Communism seems to be pitched exclusively at tourists, who are invited to purchase a variety of satirical communism-inspired shirts, mugs, posters, and other objects in the large gift shop.[28] Similar objects are available at Memento Park on the outskirts of Budapest, although in recent years the curators have considerably improved the historical information available to explain their collection of old communist-era monuments.[29] Marita Sturken tackles the phenomenon of memorial site souvenirs and their (in)ability to connect the visitor to the trauma exhibited in the museum, claiming that it is "when kitsch, consumerism, and reenactment aim to smooth over the moment in which grief and loss are powerfully present that opportunities for broader cultural empathy and new ways of response are lost."[30] Although the Museum of Yugoslavia (Belgrade) and the History Museum of Bosnia-Herzegovina (Sarajevo) offer a much wider selection of communist-era souvenirs than similar sites in Croatia (see below), even the most traumatic memorials now feature some kind of gift shop or souvenir stands, such as the Ovčara mass grave memorial site where locals sell magnets and decorated bottles for *rakija* (brandy).

Although the Adriatic coast remains the primary draw for tourists visiting Croatia, cities such as Zagreb have seen an increase in visitors and have thus made efforts to offer more museums. According to research on war, tourism, and memory by Lauren Rivera, "in its post-war tourism promotion campaign, the Croatian government omitted a crucial part of Croatian history—the war that initiated its independence."[31] However, a decade after Rivera's article, there have been new efforts to offer war experiences to visiting tourists, including an outdoor collection of war equipment in Turanj (near Karlovac), a tank camp near Benkovac, and an entire memoryscape of memorials and museums in Vukovar.[32] This chapter touches upon how the Croatian state represents the recent past to an international audience, in contrast to the discourse geared toward domestic consumption. On the one hand, Croatia is marketed to potential foreign tourists as a peaceful Mediterranean country that is far removed from the instability plaguing its Balkan neighbors. On the other hand, the memory of the Homeland War is constantly evoked through commemorations and monuments, while the legacy of the conflict is omnipresent in the media, culture, interethnic relations, and regional as well as domestic politics. Any future museum dealing with the twentieth century will thus not

only have to negotiate between the contested ideological and ethno-national narratives but will also need to find a balance between serving as an institution of cultural memory involved in nation-building and presenting Croatian history to a foreign audience, a balance that is in line with the current paradigm of European remembrance.

Communist legacies, contemporary narratives

During the communist era, the regime strictly controlled the representations of the past, especially those housed in history museums across Yugoslavia. Renata Jambrešić-Kirin, writing on the politics of memory related to the Second World War, concludes that "the Yugoslav animators of cultural memory" were important in "affirming the political order, the ideology of brotherhood and unity, and the legitimacy of the ruling party, while repressing the problem of interethnic conflicts."[33] Not only did each Yugoslav republic have its own museum dedicated to the People's Liberation Struggle (*Narodnooslobodilačka borba*, as the Second World War was known in Tito's Yugoslavia), museums were located at important sites related to the Partisan struggle, such as the battlefields of Sutjeska and Neretva, the cave in Drvar where Tito was nearly captured by German paratroopers, and the concentration camp in Jasenovac. Following the political crisis during the Croatian Spring (1971), the Yugoslav veteran association (SUBNOR) organized a two-day meeting in Belgrade to discuss the role museums in nurturing the revolutionary tradition. Concluding that many museums did not have competent curators, dynamic exhibitions, or enough funding, SUBNOR issued recommendations to improve their revolutionary educational work since they were crucial in transmitting the values of the Partisan struggle.[34]

The Second World War museum in Zagreb, housed in the pavilion designed by noted sculptor Ivan Meštrović on Victims of Fascism Square (and which briefly served as a mosque during the war), is illustrative of communist-era cultural memory policies. The Peoples' Revolution Museum (after 1960 called the Revolution of the Peoples of Croatia Museum, or Muzej Revolucije naroda Hrvatske) held its first exhibition in 1955. In addition to the permanent collection on the history of the Yugoslav Communist Party and Partisans, there were thematic exhibitions and an archive of materials related to the Second World War. In this sense the museum functioned as an archetypal *lieux de mémoire* (site of memory), since it was "concerned less with establishing the veracity of historical facts than with the ways in which the past is understood and appropriated within contemporary consciousness."[35] An institution such as a museum was an ideal vessel by which to construct the communist narrative of the past, along with public rituals, holidays, school curriculum, monuments, and all of the other components of the culture of memory mentioned earlier. The brochure from the 1961 exhibition *Croatia in 1941* states that:

> This exhibition—lively, picturesque, and easily accessible—will enable our youth to become familiar with the most important events from the beginning of the People's Liberation Struggle. By bringing these events to life, it will also be considerably easier for our educators in interpreting our revolution.[36]

Children, and the public at large, were indoctrinated about the communist version of the past through the museum exhibitions, as ultimately the regime's culture of memory about the Second World War served to legitimate and perpetuate its monopoly on political power. Examples of other exhibitions include *Forty Years of the Communist Party of Yugoslavia* (April–July 1959), *Testimonies about the Uprising in Croatia in 1941* (July 1981), and *Fortieth Anniversary of the People's Front* (July–August 1984), which filled Meštrović's gallery spaces with materials and images buttressing the one-sided view of the past.

But by the mid-1980s, growing criticism of the ruling communist ideology extended to its production of cultural memory. In 1986, on the 50th anniversary of the beginning of the Spanish Civil War, the museum on Victims of Fascism Square organized an exhibition honoring the nearly 1,700 Yugoslavs who joined the International Brigades to defend the Popular Front government in Spain. The official brochure for the exhibition referred to the members of the International Brigades as a "symbol" and "legends," stating that their decision to volunteer was a "heroic deed par excellence."[37] Lucija Benyovsky, a museologist initially involved with the exhibition, issued a scathing critique of it in the journal *Informatica museologija*. She pointed out a number of factual errors (for example, the exhibition featured a large model of a Luftwaffe "Stuka," an airplane that played a very limited role in the Spanish Civil War), the lack of informative captions on pictures and displays, and the haphazard method for organizing the material on the Yugoslav volunteers.[38] More important, in Benyovsky's opinion, was the misguided decision by the exhibition's creators, Đurđa Knezević and Snježana Pavičić, to base it upon a "symbolic-thematic overview of history" due to a dearth of physical objects that could be displayed.[39] The reliance on symbols and images without the accompanying systematic historical explanations resulted in an exhibit that merely perpetuated the mythologization of the war in Spain and by extension the construction of the Yugoslav communist past. She concludes that without the necessary background information, visitors of the exhibit "could not get the full picture of who fought against whom, what each side's goals were, what the situation on the battlefield was like, what the source and nature of aid to the warring sides consisted of, and what kind of role in all of this the [Yugoslav] volunteers played in Spain and later in our People's Liberation War."[40] Although some of Benyovsky's criticism can be attributed to private disputes among the curators, its appearance in a journal indicated that there was a basis for the criticism of the exhibition.

The broader public were not reading these specialized journals and were unaware of disputes over the content. The state-controlled press rated the exhibition a "must see." Revolutionary museums in communist Yugoslavia, which served to visually inform children and the public at large about the accomplishments of the Partisan struggle, had sought to present a black-and-white version of twentieth-century history: fascism, capitalism, and nationalism were evil, while anti-fascism, communism, and internationalism were good. Within this paradigm, an exhibition depicting General Franco standing next to Hitler and Mussolini, or several photographs of Yugoslav communists who fought in the ranks of the International Brigades, would convey the basic idea that the nationalists were villainous fascists and that the Yugoslav

volunteers were on the side of the good, anti-fascist Republicans. Yet these simplistic binary depictions were having less of an impact on the citizens of Yugoslavia, faced with an economic crisis, a communist party with flagging legitimacy after Tito's death, and increasing challenges to the Partisan narrative. During this period there were attempts to revitalize some museums, such as the Memorial Museum in Glina (which had been turned into a movie theater by locals),[41] and plans to build a memorial center and museum to fallen Partisans and civilian victims in Dotršćina Park in Zagreb that were never realized.[42]

The victory of Tuđman's nationalists in multiparty elections permitted by the regime in the spring of 1990 meant that revolutionary museums across Croatia, including Meštrović's pavilion, lost their ideological purpose. The new administration in Zagreb quickly shut down the museum and its communist version of the past, and the pavilion was renamed the Pantheon of Croatian Great Men (Panteon hrvatskih velikana). There were rumors that the building would be used to house a Croatian history museum or even that Tuđman had considered making it his mausoleum, but the war conditions and lack of funding meant that those plans were shelved. Other local museums similar to the one housed in the Meštrović pavilion dedicated to the National Liberation War were closed throughout Croatia, even in regions such as Istria and cities such as Rijeka that had leftist local governments after 1990 and continued to venerate anti-fascist traditions. The purging of communist institutions included shutting down those museums that had perpetuated the regime's monopoly over historical narratives. About seventy museums were damaged or destroyed during the war, including many history museums and memorial sites dedicated to the Second World War, while others were stripped of their collections during the rebel Serb occupation.[43]

The Croatian National History Museum and Zagreb City Museum

The devastating consequences of the Homeland War and the emergence of an independent Croatian state resulted in a sweeping revision of the former regime's historical narratives and institutionalized memory. Instead of historical interpretations that depicted as inevitable the formation of a joint Yugoslav state under the leadership of the revolutionary Communist Party, textbooks,[44] monuments,[45] public spaces,[46] and museum exhibitions had to be transformed to reflect the Croatian nation-building project. Since most of the history museums had been dedicated to the People's Liberation War, one of the pillars of the regime's legitimacy during the Tito era, the exhibitions were outdated ideologically as well as methodologically. Some museums handled the transition by cutting out the exhibitions related to the Second World War and relying on less controversial earlier historical periods (such as the History Museum of Istria in Pula), while others ceased to display a permanent exhibition (such as the Croatian History Museum). The result is that in the two decades since independence, there has been a conspicuous vacuum in professional history museum exhibitions dealing with the Second World War and the rest of the twentieth century.[47] While the memorialization of the Homeland War is a priority for the Croatian state,

since the political establishment draws on its legacy for electoral support, Croatian participation in the Partisan anti-fascist resistance movement (one of the largest in Europe) and the Croatian experience of communist rule are given scant attention in official museums.

The Croatian History Museum (founded in 1846) is the obvious choice for housing and displaying the narrative of Croatian history, from the seventh century (when Croats allegedly arrived on the Balkan Peninsula) to the formation of the modern independent state. However, at this writing, the museum is still in the process of preparing a permanent exhibition that would be housed in a former tobacco factory in Zagreb. For the last two decades, the vast majority of the museum's artifacts, including those related to the Second World War, have been in storage. While there have been many temporary exhibitions, only two have explicitly dealt with the Second World War or the communist period. The highly acclaimed exhibition *El Shatt* (December 2007–January 2009) explored the everyday life of Dalmatian refugees in Egyptian camps from 1944 to 1946, but only briefly touched upon the complexities of the war in Croatia and the rest of Yugoslavia. The more controversial exhibition *45.* (March 10–October 30, 2016) tackled the divided legacy of the year 1945. Half of the exhibition examined the political, cultural, and social transformations undertaken by the Partisans and subsequently communist regime as they came to power. The second half, which some observers believed was overly influenced by the new, right-wing minister of culture (and historian) Zlatko Hasanbegović, explored communist crimes and repression.[48] While the exhibition displayed an impressive amount of material, objects, and documents, its overwhelming emphasis on communist crimes without adequately addressing Ustaša and other collaborationist terror left critics feeling this was part of the anti-communist agenda of the recently elected government that had been formed by a coalition of parties openly trying to undermine the anti-fascist foundations of the Croatian state. Other exhibitions delved further into the past, so did not require tackling potentially controversial political subjects.[49]

The Zagreb City Museum (established in 1907) partially fills the gap created by the lack of a permanent national history museum with its overview of Zagreb's history, redesigned in 1997. Many of the key events in Croatian history impacted the growth of Zagreb over the centuries, and the museum portrays the main sociocultural developments effectively in a relatively up-to-date display. Yet the incredibly complex period from the start of the Second World War to the end of the twentieth century is exhibited in a single room. The exhibition, consisting of a few photographs and objects, barely scratches the surface of Croatian history since 1941, although the emphasis is on daily life rather than political events. Moreover, the transition from communism to democracy and the war for independence is explained via a collection of election posters, several photographs and a short video of Yugoslav Air Force attacks on Zagreb in 1991, and a picture of Pope John Paul II during his 1994 visit to Croatia.

Thus, unlike the capitals of many other post-communist countries, Zagreb is a city full of sites of memory and embroiled in the politics of the past but without an appropriate museum to explain the complexities of recent history, either for the city's residents or waves of tourists who often stop by after a visit to the coast. The

need to revise the communist narratives of the Second World War made the People's Liberation War museums obsolete, but little has been done to replace them with new exhibitions stripped of totalitarian ideologies. The communist era has also been torn out of the city's exhibition spaces. On the one hand, Croatia never undertook any lustration of former communist apparatchiks, primarily because of the need for unity in a time of war, allowing many individuals to easily switch over into the new political system that wanted to forget the ties with the communist past. On the other hand, the cultural memory of the communist era is constructed primarily through commemorative practices that, by their nature, only present the repressive side of the communist regime through the memorialization (and manipulation) of victims.[50] While Croatia lacks museums of the Second World War or communism on the national level, several smaller museums at the local level have tried to fill the gap.

The Memorial Center Lipa Remembers (Lipa pamti) near Rijeka has been praised by practitioners as one of the best museums dealing with the Second World War.[51] Nazi German forces supported by Italian fascists burned the village of Lipa in April 1944, killing almost three hundred villagers in retaliation for Partisan attacks. The museum was renovated in 2015 (winning architectural awards for its innovative design) and is proactive by using the tragedy of the village to educate visitors about tolerance and learning from the past.[52] The memorial museum engages in international cooperation with other destroyed villages, such as Oradour-sur-Glane (France) and Lidice (Czechia), to transmit the universal lessons of such traumatic sites of memory.

The same year that the Lipa Memorial was renovated, the Maritime and History Museum in Pula opened a large exhibition titled *Freedom to the People: Antifascism in Istria* (*Sloboda narodu: antifašizam u Istri*). Although seemingly a temporary exhibit, in 2018 it was still open to visitors. Pula, located at the tip of the Istrian Peninsula, generally preserved the anti-fascist and Partisan heritage in public space unlike many other regions in Croatia. Although its revolutionary museum was dismantled in the 1990s, much of the collection was reintroduced through this exhibition, which presented a regional perspective on the Second World War and didn't engage with issues such as the Holocaust or Serb–Croat violence, due to the fact that the Partisans in Istria were fighting against Italian fascism and later direct Nazi German occupation. The catalog accompanying the exhibition was published in September 2018, and as of this writing it is not clear if the materials will be taken down and replaced with another temporary exhibit or if it will continue to be on display.

In 2016, local anti-fascists and activists opened the Museum of Victory and the Liberation of Dalmatia in the Second World War (Muzej pobjede i oslobođenja Dalmacije u Drugom svjetskom ratu) in Šibenik.[53] While this is more of a memorial room than a true museum, it displays numerous objects from the Second World War and several panels of historical texts that focus on Dalmatia during 1944 and 1945. It lacks a more in-depth analysis of the factors leading up to the war, a broader discussion of the war in regions beyond Dalmatia, or information on the aftermath of the communist victory. Nevertheless, the organizers seek to use the space as a place to exchange ideas and host historical debates in a city that had a strong anti-fascist movement yet has sought to deny it in public space for the past two decades.

The Jasenovac Memorial Site—Between Holocaust museum and postmodern trash?[54]

Although not exactly a resistance or Second World War museum, the Jasenovac Memorial Site is the only significant museum in Croatia dealing with any aspect of the Second World War, specifically the system of concentration camps built in the area by the Ustaša regime.[55] Shortly after the Independent State of Croatia was proclaimed in April 1941, a number of racial laws against Serbs, Jews, and Roma were enacted, followed by both systematic arrests of non-Croats and mass killings of Serbs by so-called "wild" Ustaše.[56] In contrast to the gas chambers of the Nazi death camps, victims in Jasenovac, nearby Stara Gradiška, and other Ustaša camps were often murdered by less systematic but more brutal methods. The estimated number of victims at Jasenovac has fluctuated wildly over the years and was subject to considerable political manipulation almost immediately after the end of the war. The statistic of 700,000 victims was considered sacrosanct in communist-era Yugoslavia, and by the 1980s some scholars inflated that figure to allege that over one million individuals, predominantly Serbs, were killed in the camps alone.[57] The reaction of Croatian nationalists, such as Franjo Tuđman, was to minimize the numbers. Even before he became president, Tuđman argued that the total death toll for camps in Croatia was not more than 40,000, a figure he continued to cite in the 1990s.[58] The museum's website currently lists just over 80,000 Serbs, Jews, Roma, Croats, and individuals of other nationalities as victims,[59] although scholars estimate that the final tally of victims is probably as high as 100,000.[60]

Unlike other Second World War camps in Europe that have been preserved and transformed into memorials, at the Jasenovac site no original structures remain. The Ustaše destroyed the camp and nearly all administrative records in 1945 when it became clear the war was lost, and in subsequent years the inhabitants of the town of Jasenovac scoured the ruins for building material to repair their devastated homes. The Croatian People's Liberation war veterans' organization chose Belgrade architect Bogdan Bogdanović's *Stone Flower* (*Kameni cvijet*) design, symbolizing "indestructible life," as the central monument.[61] Work on the monument lasted from 1964 until the opening ceremony on July 4, 1966.[62] Construction on a museum was begun in September 1967 and completed in July 1968, the same year the Jasenovac Memorial Site Institution was established to administer the museum. In 1983 the Jasenovac Memorial Site was expanded to include all of the outlying camps that constituted the Jasenovac system, such as Krapje, Uštice, Stara Gradiška (the location of a women's camp), and Donja Gradina. The latter location is a massive killing field across the Sava river and is currently located in Bosnia-Herzegovina (in the Republika Srpska entity), which has physically divided the once-united memorial site between two countries. The fragmentation of the memorial site has resulted in two radically different constructions of the past: the Croatian one, which offers a contemporary museum space and commemorative site, and a Bosnian Serb one that perpetuates the Jasenovac myths from the communist period.

The memorial museum's exhibition was originally established in 1968 and was updated in 1988. Both permanent exhibitions featured horrific photographs of corpses and murders being committed by Ustaše and other pro-Axis forces, along

with a large collection of objects (including many weapons allegedly used to kill the victims) that traumatized generations of students who visited Jasenovac. In her book on images and the construction of narratives, Nataša Mataušić reveals that about half of the photographs exhibited in the museum were in fact taken in German concentration camps or locations that had nothing to do with Jasenovac or even the Ustaša perpetrators.[63] In 1991 the memorial site was occupied by rebel Serb forces who devastated the museum and looted its collection. The objects ended up in a storage facility in Banja Luka (Bosnia-Herzegovina), were transferred to Washington, DC, with the help of the United States Holocaust Memorial Museum in 2000, and were finally returned to Croatia in 2001.[64] Several thematic exhibitions[65] were organized at the memorial site, and the Stone Flower monument was restored in 2003–2004, but the most important development was the preparation and implementation of the permanent exhibition at the memorial museum.

On March 8, 2001, the Croatian Parliament passed a new law on the administration of the Jasenovac Memorial Site, which included the appointment of a nine-member advisory board, a five-member governing board, and a new director, who was tasked with developing the concept for the permanent exhibition. As Ljiljana Radonić notes in her sharp critique of the Jasenovac museum, the authors of the new permanent exhibition had to negotiate between European standards of (Holocaust) memorialization and the specificities of the Jasenovac camp and its victims.[66] In early 2006, months before the new exhibition was opened, an intense public debate erupted over the museum's conceptual design. Since 2002, the staff at the Jasenovac Memorial Site worked closely with the United States Holocaust Memorial Museum, and in 2005 Croatia became a regular member of the Task Force for International Co-operation on Holocaust Education, Remembrance, and Research. The debate centered on fears that Jasenovac would become exclusively a Holocaust memorial, which would obfuscate the genocidal policies of the Ustaše against Serbs (who were the most numerous victims at the camp), Roma, and other targets of the regime. Zorica Stipetić, a historian and the head of the advisory board, stated in an interview before the exhibition opened that:

> The symbol of the Holocaust is a gas chamber, while the symbols of Jasenovac are a dagger and the letter "U" [for Ustaše]. If those are removed or marginalized, then we will hide the true character of that camp; in other words, we will not present the full truth and educational potential of what really happened there.[67]

Moreover, the decision to focus on individual victims rather than the collective victims who were killed only because they were the "wrong" religion or nationality, raised the issue that the magnitude of the murders would be minimized. The decision to list the names of all the victims on glass plates that hang in the museum was considered controversial, since their nationality was not included, so two plasma screens with all the names and nationalities were subsequently added.

The controversy over the museum did not subside after the official opening of the new exhibition on November 27, 2006. Croatia's political leaders—the president, prime minister, and speaker of the Parliament—gathered at the memorial site and gave

speeches about the meaning of Jasenovac. Stjepan Mesić, the president at the time, emphasized the importance of the camp as a Second World War site of memory:

> If there is a place in Croatia where there can be absolutely no doubt about how this country views what happened in World War II, then it is here—Jasenovac […] If there exists a place where it is possible to be informed of the crimes of the Ustaša so-called state, then that place is here—Jasenovac. To be absolutely clear: this museum can not only illustrate the crimes that were committed, but it must provide information about them, completely and decently.[68]

Croatia's prime minister at the time, Ivo Sanader, went a step further and drew parallels with the war for independence and placed the museum exhibition within the context of Croatia's road toward European Union membership.[69] After the speeches the politicians toured the new exhibition along with the museum staff and several hundred visitors, but their statements afterwards were noticeably more critical than earlier.

Mesić criticized the minimalist and rather avant-garde design because "it did not adequately present the brutality of the killings, even though it was good that the victims were individualized. Perhaps I am subjective, but this was a concentration camp of horror and the most terrible kinds of death."[70] Milorad Pupovac, a parliamentary deputy and the president of the Serbian National Council (Srpsko narodno vijće, or SNV), stated that:

> This is only the first step, which needs to be built upon in collaboration with the representatives of the victims. This is more of an informational-documentary center than a museum, more of an installation that can be anywhere rather than a place that is connected to what Jasenovac really was.[71]

Zorica Stipetić, the above-mentioned head of the advisory board, agreed that the museum was not ideal and that efforts would be made to add to the permanent exhibition. She concluded that the problem was not the material that was displayed but the items that were missing: "I believe that there should be one more exhibition space that could display more authentic artifacts and objects which were in the original exhibition, so as to get a feel for the truth of what happened here."[72]

Other critics were even harsher in their opinions. Efraim Zuroff, the director of Jerusalem's Simon Wiesenthal Center, called the exhibition "postmodern trash" after visiting the museum when it opened. He added that:

> In the new exhibition there is nothing about the ideology of Ustaša massacres. Based on the exhibition, no one can understand anything about the ideology of the Ustaše, who tried to turn Croatia into a purely Catholic country, without Serbs, Jews, and Roma. There is no context, nothing about World War II, and hardly any historical evidence of genocide and the Holocaust.[73]

Despite many of the negative comments, two staff members from the US Holocaust Memorial Museum in Washington, DC, Diane Saltzman and Arthur Berger, blamed the

museum's flaws on the small exhibition space and emphasized that it had nevertheless succeeded in "returning individual victims their identity, because that was taken away in the concentration camp."[74]

Twelve years after its reopening, the Jasenovac museum de facto has the only significant permanent exhibition in Croatia dealing with the Second World War. But is it effective in fulfilling its role as a history museum? While the phrase "postmodern trash" is perhaps a bit too harsh, the exhibition has opted for an artistic design over the kind of content one would expect in a traditional history museum. Unlike similar museums dealing with the Holocaust (such as the Oskar Schindler Factory Museum in Kraków or the Holocaust Memorial Center in Budapest), there is no historical narrative to guide visitors through the events that led up to the construction of the camp and the political context from which the Ustaša movement emerged. Some captions are placed low, near the ground, so it is a challenge to read them, while all of the captions in English are printed in white on a gray background, rendering them practically illegible. The interior of the museum is black, dark, and oppressive, but it does not convey what the victims experienced (unlike the barracks and gas chambers visitors can walk around in Auschwitz). Moreover, there are no models or maps of what the camp looked like, so one is expected to reconstruct the past through oral histories presented on video screens and a few grainy photographs. A timeline and chronology has subsequently been added to the education center located next to the main exhibition space (as well as an outdoor exhibition showing the construction of Bogdanović's monument), but this has not fully addressed the inadequacies of the main museum.

Although the decision to focus almost exclusively on the victims is a legitimate approach, the exclusion of the perpetrators gives only a partial picture of what happened during the Second World War. All the other museums mentioned above that served as a model for Jasenovac extensively analyze the ideology and movements that perpetuated the Holocaust and other crimes against humanity in the various countries, so it is surprising that the Jasenovac museum only acknowledgment of this topic is a single photograph of the Ustaša leader Ante Pavelić meeting with Adolf Hitler. The curator speaking to the visiting Italian students explained that not showing the perpetrators honors the victims, but the result is that visitors who have not extensively studied the subject leave more confused than enlightened.

Memories of communism, memories of Tito: Kumrovec, Brijuni Islands, and Goli otok

Whereas memories of communism in other Eastern European countries included Soviet occupation, economic deprivation, and generally gray and forgettable apparatchiks, communist Yugoslavia was defined by one man: Josip Broz Tito. Born in Croatia, Tito served in the Austro-Hungarian Army during the First World War and subsequently became the Comintern's leading operative in Yugoslavia. In the midst of Stalin's great purges in the 1930s and the Spanish Civil War, Tito became general secretary of the Communist Party of Yugoslavia and organized the Partisan resistance that would

emerge victorious in 1945. Although the Red Army helped liberate Belgrade in 1944, the Yugoslav communists, under the umbrella of the National Liberation Movement, effectively defeated the Axis forces and their domestic collaborators alone and without the Soviet occupation that the rest of Eastern Europe experienced. Tito's split with Stalin and the Cominform in 1948 allowed Yugoslavia to forge a separate path from the rest of the Soviet bloc, yet still remain outside the sphere of capitalist Western Europe. The Yugoslav socialist experiment (self-management, or Titoism) ultimately led to the economic implosion of the 1980s and the disastrous ethnic wars of the 1990s, although for several decades it appeared that Yugoslavia had found a successful formula for modernization and social harmony.

A key factor holding the system together, along with the mythical narratives of the Partisan struggle ("Brotherhood and Unity") and the Yugoslav People's Army, was the figure of Tito. After he died in 1980, Yugoslavia plunged toward uncertainty and eventual fragmentation.[75] The cult of personality and his charismatic leadership inevitably fused memories of the past system with the personality of Tito. Sociologist Todor Kuljić examines how Tito's position as benign dictator was not only a product of the Balkan phenomenon of a strong leader but the communist system's need for a leader who symbolized the party organization's ideological and institutional unity.[76] Yugoslavia was an actor in international politics because Tito was active on the world stage through initiatives such as the Non-Aligned Movement. Domestically, he ruled with an iron fist—though not as brutally repressive as Stalin—along with a policy of commemorative spectacles celebrating the Partisans and Tito as the supreme commander.

As with any powerful political figure, under Tito there were those who benefited and those who suffered. Many people associate the positive aspects of socialist Yugoslavia (such as low unemployment, the seeming absence of nationalist tension, the ability to travel freely throughout the world, and free health care and education) with Tito's rule. Nostalgia for the Tito era continues to flourish in the Yugoslav successor states, a phenomenon Mitja Velikonja has called "Titostalgia." According to Velikonja, nostalgia:

> Is not just a desire for something that no longer exists, nor the realization that it can never truly return to that moment. The past that nostalgics yearn for never even existed in the form they imagine: the nostalgia in question is a yearning for something that never existed, a sentimental return to the nonexistent, dreams about former dreams and not about a former reality. Nostalgia, therefore, is not (only) a story about what we once *were*, but rather what *we never were*.[77]

These individuals continue to venerate Tito and celebrate the holidays and rituals that served to reinforce his cult of personality, such as his birthday (May 25, the Day of Youth) and the associated baton (*štafeta*) relay throughout all of Yugoslavia, or the Day of the Republic (*Dan republike*, November 29). Velikonja also discusses "neostalgia," which he attributes to the new generations who venerate Tito even though they were born after his death and therefore cannot remember life in the former system.[78] There are many parallels with Yugonostalgia, which carries a particularly negative

connotation in Croatia since independence, although the sense of loss of the common country is less articulated in public than that of active collective memories of Tito.

Many individuals, especially in Croatia, emphasize only the negative aspects of Tito's rule and the communist system. Yugoslav communism was especially brutal in the first years after the end of the Second World War, and tens of thousands of collaborators (both real and alleged) and class enemies were liquidated by the communist regime. In Croatia, the repression, collectively known as Bleiburg and the Way of the Cross, symbolizes the summary executions and death marches that took place in the final weeks of the war and immediately afterwards.[79] Many of the victims, who were mostly Ustaše and other fascist collaborators (Serb and Montenegrin Četniks, Slovenian White Guards, Germans, and other groups unable to escape the Partisan forces) but also included innocent civilians, ended up in unmarked mass graves, hundreds of which are still scattered throughout Slovenia and Croatia. These victims, whose numbers were exaggerated and inflated in a similar fashion as those in the Jasenovac concentration camp, served to discredit both Yugoslav and communist ideology as well as all Serbs, who were said to have initiated those anti-Croat ideas. The Catholic Church, heavily repressed during communism and one of the few institutions that consistently resisted the regime, was a key social actor in the Croatian nation-building project and war for independence. It is one of the main promoters of the cult of martyrs, particularly those whose death is attributed to the communist regime, and since 1990 numerous monuments and commemorative events have constructed a narrative of the communist era focused exclusively on repression and murder. The demonization of the anti-fascist forces that fought on the Allied side in the Second World War and a focus on only Croat victims significantly contributed to the rehabilitation of the Ustaše in the last two decades. Right-wing and conservative political parties hold Tito, as the supreme commander, directly responsible for all the crimes committed by the Partisans and continue to demand the removal of all symbols and place names associated with him. In 2017, after several years of protests and political bargaining, the Zagreb city council voted to change Marshal Tito Square into the Republic of Croatia Square, erasing this toponym from the capital of Croatia's landscape.

Even though Croatia lacks a true museum of communism, Tito as a representation of Yugoslav communism is displayed in two existing museums (Kumrovec and the Brijuni Islands) and one planned memorial center (Goli otok). Kumrovec, in the Croatian Zagorje region near the Slovenian border, is Tito's birthplace. When he was still alive, the village was transformed into an ethnographic museum that replicated nineteenth-century traditions and craftsmanship. A large political school to train Communist Party cadres was built near the ethnographic part of the village, and while it was closed during the democratic transition, the Kumrovec School still symbolizes the generations of Croatian politicians who emerged from the communist system. After Tito's death, the village became a commemorative site where thousands of supporters gather every year on May 25.[80] Although in the 1990s the commemorations were poorly attended, in the last few years several thousand visitors from all over the former Yugoslavia have been drawn to Kumrovec to celebrate Tito's legacy.[81] Numerous stands sell all kinds of Tito memorabilia in the festive atmosphere, from dusty tomes of Tito's most famous political tracts to T-shirts and wine carrying images of the Marshal.

Even though the vast majority of visitors go to see the house where Tito was born and the small museum inside (next to the famous statue of the wartime Tito by sculptor Antun Augustinčić), the official website of the Kumrovec ethno-village (Staro Selo) makes no mention of Tito.[82] The exhibition in Tito's birthplace has no pretensions of being an official museum of Yugoslavia's former strongman (although there were plans to transform the political school into a true history museum dedicated to Tito), but the complete absence of Tito in the village's tourist information illustrates the complexities of the communist past. The locals clearly live off the Tito-related tourism and its functionality as a site of memory, yet they are reluctant to advertise their village as a museum of the communist past.

The largest of the Brijuni Islands, just off the coast of the Istrian peninsula, is another site of memory associated with Tito. He spent summers at a villa there and kept animals, many of them gifts from world leaders, in a zoo built nearby. After his death, a museum was established that highlights Tito's travels around the world and the various international dignitaries who came to the Brijuni Islands as well as a collection of taxidermically mounted animals who either did not survive the trip to Croatia or died of old age. Tito's convertible Cadillac sits in front of the museum, available for a drive around the island. Visitors to the museum are first given a tour through the zoo in a small train before seeing the exhibition, which adds to the surrealism of the entire experience. There is little effort to explain the communist era in this museum; rather, it is a strange view into Tito's private life, which had little to do with everyday life in communist Croatia or Yugoslavia, but a lot to do with the image of Tito as an important actor on the world stage. As with Kumrovec, the official tourist web page is notable for the absence of Tito; only in the section on exhibitions does a visitor learn that a Tito museum can be found on the large island.[83] The souvenir shop, however, is full of official Tito memorabilia, similar to the kind of items that can be found in Prague's Museum of Communism or Berlin's GDR Museum that caters to those suffering from *Ostalgie*. In 2006, Tito's granddaughter copyrighted Tito's image and signature, transforming the leader who dared to stand up to Stalin into a brand name like that of Che Guevara.[84]

In contrast to the two aforementioned sites of memory associated with Tito, which present a rosy picture of a benign ruler, a third location has long been associated with the darkest aspects of the regime. Goli otok ("Barren Island") is located near some of Croatia's most popular tourist destinations, but this barren island never housed an elite resort. Instead, it was the location of a notorious prison complex where thousands of disowned party members were sent to be physically and psychologically tortured, especially after the 1948 Tito-Stalin split. Although conditions on the island were not as brutal as in the Soviet Gulag, nor was there systematic killing of prisoners, the inmates who emerged from the island were psychologically broken and permanently scarred. Goli otok (and nearby Sveti Grgur, which held a women's prison camp) represents the most repressive side of the communist regime. An estimated 40,000 to 60,000 prisoners were held there between 1949 and 1989.[85] After the prison was shut down, many of the buildings were torn down, so today visitors who reach the island by private boat can see relatively few artifacts at the site. The establishment of a memorial museum on the island has been discussed for years, but with few results. Members of the Croatian

Association of Political Prisoners told reporters that the state has shown no interest in funding such a museum:

> As early as 1995, we proposed that Goli otok should be turned into a memorial center for the victims of crimes from all over Croatia and a place for a spiritual catharsis for future generations from the entire world. Funds for the realization of this idea were even secured in Germany, but it was impossible to pass the government filter, even though the president at the time, Franjo Tuđman, supported the idea [...] Already by 1990 the former secret police destroyed most of Goli otok and hid the evidence of their crimes, so the devastated site today is impossible to connect with the place we were forcibly brought to long ago.[86]

Despite the lack of progress so far, a number of non-governmental organizations (NGOs) from various political backgrounds support the establishment of a real memorial center on the island. While the commemorations associated with Bleiburg and the massacres immediately after the war are easily manipulated and subject to constant exaggerations of numbers of victims, Goli otok could serve as a concrete space to examine the repressive mechanisms of the communist regime. The emphasis is still heavily weighted on the victimization of Croatian society under communism (even though prisoners on Goli otok came from all parts of Yugoslavia and had a high proportion of Serbs and Montenegrins), so a proper museum would still require a more balanced representation housed in the National Museum in Zagreb. But a memorial museum and center on Goli otok would contribute to a better understanding of how the undemocratic regime punished those who were critical of the system.

Conclusion

While the Croatian state embarked on a broad revision of institutionalized cultural memory since independence in 1991, history museums have been sidelined during this process and can be considered part of the country's "culture of forgetting" rather than its culture of memory. As discussed above, any representation of the communist past invariably has to include an analysis of the Second World War, and the ongoing ideological and ethno-national divisions in everyday politics means that reaching an even minimal consensus about the recent past is nearly impossible. Croatia, which had one of the largest resistance movements in occupied Europe, is thus left with hardly any exhibition space dedicated to this period. Jasenovac, which partially plays the role of a resistance museum, remains too controversial to be an effective educational tool for displaying the complete history of the Second World War. There are initiatives to return exhibitions to some other memorial sites (Glina, Petrova Gora) and vague plans for a future museum of victims of all wars (an initiative by the NGO Documenta), but at the moment this period remains in a museological void, except for the few regional museums mentioned earlier.

The creation of a permanent exhibition in the National History Museum is going to be challenging and will test Croatia's ability to come to terms with the past. While

for years there have been plans to move the museum to a new space and develop the permanent exhibition, no public debate about the content has taken place; all discussion has been at internal meetings in the Ministry of Culture. The committee in charge of designing the new exhibition has included representatives of broad segments of Croatian society (including the Serb minority), presumably so it does not become exclusively a state-building historical narrative of ethnic Croats. The United States faced numerous challenges in developing a National Museum of African American History and Culture, with debates about whether the narrative should focus on the victimization of blacks in American history or portray a rosy picture of overcoming the legacy of slavery and racism?[87] How will Serbs in Croatia be portrayed in the National History Museum? Will the narrative treat them as equal partners in forming the political and cultural heritage of the country, or as a negative factor that obstructed the Croatian state-building project? Will the exhibition move beyond the Yugocommunist and Serbo-Četnik discourses of the 1990s, which associated all Serbs with communism, a Yugoslav state, and murderous extremism? In an opinion poll conducted as part of the Strategies of Symbolic Nation-Building in South Eastern Europe project in 2011, respondents were asked if they thought Croatian Serb institutions should be involved in the development of history museums dealing with the twentieth century. Out of 1,500 Croatian citizens who responded, 43.4 percent answered yes, 39.3 percent said no, while 17.3 percent did not know or refused to answer.[88] Those respondents who were more educated or in a higher age bracket as well as those from regions not affected by fighting, were more likely to support Croatian Serb participation in conceptualizing museum narratives. In the Rijeka region, for example, nearly 60 percent supported including Croatian Serb organizations, while in Dalmatia only around 30 percent thought they should be involved.

Since the initial version of this text in the scope of the project, several private initiatives and exhibitions have appeared throughout Croatia. Modeled on the GDR Museum in Germany and focusing on everyday life, the MEMO Museum of Good Memories[89] in Pula and the 80s Museum[90] in Zagreb opened in 2018 and present a Yugonostalgic vision of the past. The Red History Museum,[91] scheduled to open in Dubrovnik in 2019, likewise emphasizes the positive aspects of communism and Yugoslavia's unique version of socialism, situated between the East and the West during the Cold War. A number of art museums and galleries in Zagreb hosted exhibitions dealing mainly with cultural issues during socialism, such as *The Nineteen-eighties: The Sweet Decadence of Postmodernism* (*Osamdesete: slatka dekadencija postmoderne*) in the Croatian Association of Artists Pavilion (Dom HDLU), *The 1960s in Croatia* (*Šezdesete u Hrvatskoj*) in the Museum of Arts and Crafts, *Reflection of the Times* (*Refleksija vremena*) in Klovićevi dvori, and *Unfinished Modernization* (*Nedovršene modernizacije*) in the Gliptoteka. The subject of the last of the exhibitions, the architectural achievements of socialist Yugoslavia, received an incredible amount of attention at the *Toward a Concrete Utopia* exhibition at the Museum of Modern Art in New York City in the second half of 2018. While all of these exhibitions dealt with some aspects of communism in Croatia and the other Yugoslav republics, they nevertheless revealed only select glimpses at the system and do not fulfill the role of a serious history museum.

While the complexities of the Second World War and the communist period contribute to the continued lack of history museums covering the post-1945 period, another factor is the active memorialization of the Homeland War, from monument-building to commemorative events and the establishment of museum exhibitions dedicated to Croatia's struggle for independence. The town of Vukovar, whose capture by Serbian troops and paramilitaries after a three-month siege in 1991 became a symbol of Croatian victimization, also functions as an outdoor museum full of sites of memory (such as the heavily damaged water tower and the street known as the "Graveyard of Tanks"). There are official museum sites in and around Vukovar, such as the Memorial Center of the Homeland War in Vukovar, the city hospital (Vukovar Hospital—Site of Memory Museum), the Ovčara Memorial Site (the site of a massacre of over two hundred Croatian soldiers and civilians), and the Memorial Cemetery. The experiences of the Homeland War undoubtedly influence how the Second World War and the communist era are interpreted both at the official level as well as in Croatian society at large. In a country full of memory politics, it will be important for Croatia's political elites and museologists to coordinate the creation of permanent exhibitions dealing with the twentieth century that convey a pluralistic narrative of the past in line with European Union paradigms of remembrance.

Notes

1 Vjeran Pavlaković. "Fulfilling the Thousand-Year-Old Dream: Strategies of Symbolic Nation-building in Croatia," in Pål Kolstø (ed.), *Strategies of Symbolic Nation-building in Southeastern Europe* (Farnham: Ashgate, 2014), 19–50.

2 The project "Framing the Nation and Collective Identity in Croatia: Political Rituals and Cultural Memory of Twentieth Century Traumas" (FRAMNAT) analyzed commemorative practices in Croatia for four years (2014–2018) and showed how sites of memory were used by various political and social actors to frame the past to fit their ideological frames. A complete database of commemorative speeches, video clips, photographs from fieldwork, and media coverage is available at FRAMNAT, www.framnat.eu (accessed August 28, 2019).

3 The Ustaša (plural: Ustaše) movement, after the Croatian word for "insurgent," was formed in the early 1930s by Ante Pavelić, a member of the Croatian Party of Rights who had fled into exile after the assassination of several Croatian deputies in the Yugoslav Assembly in 1928. This radical Croatian separatist movement was dedicated to the violent destruction of the Yugoslav state, was alternatively supported and suppressed by Mussolini's Italy, and eventually came to power in April 1941 on the heels of the Axis destruction of the Kingdom of Yugoslavia. See Rory Yeomans, *Visions of Annihilation: The Ustasha Regime and the Cultural Politics of Fascism, 1941–1945* (Pittsburgh, PA: University of Pittsburgh Press, 2013); and Sabrina P. Ramet (ed.), *Nezavisna Država Hrvatska* (Zagreb: Alinea, 2016).

4 The U.S. State Department's annual International Religious Freedom Report for Croatia in 2016 reported on trends that can be considered historical revisionism, including the boycott of the official 2015 Jasenovac commemoration by the Jewish and Serb communities and anti-fascist organizations due to revisionist positions of the Croatian government. U.S. Department of State, *2016 Report on International*

Religious Freedom, August 15, 2017, https://www.state.gov/reports/2016-report-on-international-religious-freedom/(accessed August 28, 2019). See also *SNV Bulletin #10: Historijski revizionizam, govor mržnje i nasilje prema Srbima u 2016* (Zagreb: SNV, 2017).

5 John R. Gillis, "Introduction," in John R. Gillis (ed.), *Commemorations: The Politics of National Identity* (Princeton, NJ: Princeton University Press, 1994), 4.

6 Aleida Assmann, "Four Formats of Memory: From Individual to Collective Constructions of the Past," in Christian Emden and David Midgley (eds.), *Cultural Memory and Historical Consciousness in the German-Speaking World since 1500* (Bern: Peter Lang, 2004).

7 Brian Conway, *Commemoration and Bloody Sunday: Pathways of Memory* (Basingstoke: Palgrave Macmillan, 2010).

8 Michael Bernhard and Jan Kubík, *Twenty Years after Communism: The Politics of Memory and Commemoration* (Oxford: Oxford University Press, 2014).

9 Assmann, "Four Formats of Memory," 22–37.

10 Conway, *Commemoration and Bloody Sunday*, 5.

11 Bernhard and Kubík, *Twenty Years after Communism*, 11.

12 Barbara Misztal, quoted in Sheila Watson (ed.), *Museums and Their Communities* (London: Routledge, 2007), 375.

13 Lorena Rivera-Orraca, "Are Museums Sites of Memory?," in *The New School Psychology Bulletin* 6, no. 2 (2009): 32.

14 Pavlaković, "Fulfilling the Thousand-Year-Old Dream," 36–41.

15 Carol Duncan, quoted in James Cuno, "Money, Power, and the History of Art," in Watson, *Museums and Their Communities*, 514.

16 Peter Davis, "Place Exploration: Museums, Identity, Community," in Watson, *Museums and Their Communities*, 56–57.

17 The survey was conducted among 1,500 respondents throughout Croatia by IPSOS Strategic Marketing as part of the Symbolic Strategies of Nation Building in the West Balkan States project. The complete results of the survey are available at UiO, "Strategies of Symbolic Nation-Building in West Balkan States: Intents and Results (Completed)," January 7, 2011, www.hf.uio.no/ilos/english/research/projects/nation-w-balkan/index.html (accessed August 28, 2019).

18 Rivera-Orraca, "Are Museums Sites of Memory?," 32.

19 See Memorial site of Camp des Mille Camp, http://www.campdesmilles.org/home2.html (accessed August 28, 2019).

20 See Gedenkstätte Bergen-Belsen, https://bergen-belsen.stiftung-ng.de/en/ (accessed August 28, 2019).

21 Silke Arnold-de Simine, *Mediating Memory in the Museum: Trauma, Empathy, Nostalgia* (Basingstoke: Palgrave Macmillan, 2013), 201.

22 Steven C. Dubin, "The Postmodern Exhibition: Cut on the Bias, or is *Enola Gay* a Verb?," in Watson, *Museums and Their Communities*, 225.

23 Stephen Weil, "The Museum and the Public," in Watson, *Museums and Their Communities*, 35.

24 Ibid., 36.

25 Brandon Hamber, Liz Ševčenko, and Ereshnee Naidu, "Utopian Dreams or Practical Possibilities? The Challenges of Evaluating the Impact of Memorialization in Societies in Transition," *International Journal of Transitional Justice* 4 (2010): 399.

26 Information about the Coalition for RECOM, which includes hundreds of NGOs and other organizations throughout the former Yugoslavia, can be found at https://www.recom.link/ (accessed September 9, 2019).

27 The museum was supported by Viktor Orbán's right-wing party when it opened in February 2002 and overtly demonizes the socialists while minimizing Jewish victims and the crimes of Hungarian fascists. *Jewish News*, July 26, 2002, http://www. jewishaz.com/jewishnews/020726/budapest.shtml (accessed August 25, 2011) (web page now blocked). See also Mária Schmidt, *House of Terror Museum* (Budapest: Public Endowment for Research in Central and East-European History and Society, 2008).

28 See Museum of Communism, https://muzeumkomunismu.cz/en/(accessed August 25, 2011).

29 See Memento Park, http://www.mementopark.hu/(accessed October 20, 2018).

30 Marita Sturken, *Tourists of History: Memory, Kitsch, and Consumerism from Oklahoma City to Ground Zero* (Durham, NC: Duke University Press, 2007), 31.

31 Lauren A. Rivera, "Managing 'Spoiled' National Identity: War, Tourism, and Memory in Croatia," *American Sociological Review* 73, no. 4 (August 2008): 620.

32 See Metod Šuligoj, "Warfare Tourism: An Opportunity for Croatia?," *Economic Research-Ekonomska Istraživanja* 30, no. 1 (2017): 439–452.

33 Renata Jambrešić-Kirin, "Politička sjećanja na Drugi svjetski rat u doba medijske reprodukcije socijalističke kulture," in Lada Čale Feldman and Ines Prica (eds.), *Devijacije i promašaji: Etnografija domaćeg socijalizma* (Zagreb: Institut za etnologiju i folkloristiku, 2006), 166.

34 Archive of Bosnia-Herzegovina, Čedo Kapor collection, SUBNOR, box 2, "Međurepubličko savjetovanje o ulozi muzeja revolucije u njegovanju revolucionarne tradicija," April 25–26, 1972.

35 Peter Carrier, "Places, Politics and Archiving of Contemporary Memory in Pierre Nora's *Les Lieux de mémoire*," in Susannah Radstone (ed.), *Memory and Methodology* (Oxford: Berg, 2000), 43.

36 *Hrvatska 1941. godine* (Zagreb: Muzej Revolucije naroda Hrvatske, 1961), inside front cover.

37 *Rat u Španjolskoj* (Zagreb: Muzej Revolucije naroda Hrvatske, 1986), 1.

38 Lucija Benyovsky, "Španjolski građanski rat i naši interbrigadisti," *Informatica museologija* 17, nos. 1–4 (1986): 46.

39 Ibid. Benyovsky quotes Knezević and Pavičić from an interview in *Vjesnik* (December 19, 1986), where they explain how the conditions facing volunteers fighting in Spain (evading police, living in internment camps, illegal border crossings back into Yugoslavia) meant that few artifacts from that period survived into the present.

40 Ibid., 47–48.

41 Arhiv Sisak (AS), Spomen-muzej Glina, no. 2194–01-89-1, "Odluka o učešću u financiranju izgradnje spomen-obilježja u Glini," June 1, 1989.

42 Out of about 18,000 victims from Zagreb in the Second World War, some 7,000 were estimated to have been killed by the Ustaše in Dotrščina, a forested area on the edge of the city. While the park is filled with dozens of monuments dedicated to fallen civilians and Partisans, the memorial center was never built. *Večernji list* (March 14, 1981), 6–7. See also Saša Šimpraga, *Zagreb, javni prostor* (Zagreb: Porfirogenet, 2011), 243.

43 For details about the damage to individual museums, see the website of the Museum Documentation Center at www.mdc.hr/RatneStete/eng/fs-glavni.html (accessed August 25, 2011).

44 Stefano Petrungaro, *Pisati povijest iznova: Hrvatski udžbenici povijesti 1918–2004* (Zagreb: Srednja Europa, 2009).

45 Juraj Hrženjak (ed.), *Rušenje antifašističkih spomenika u Hrvatskoj, 1990–2000* (Zagreb: Savez antifašističkih boraca Hrvatske, 2002).

46 Dunja Rihtman-Auguštin, *Ulice moga grada* (Belgrade: XX vek, 2000).

47 For a comparative analysis of former Yugoslav history museums, see Alina Zubkovych, *Dealing with the Yugoslav Past: Exhibition Reflections in the Successor States* (Stuttgart: Ibidem, 2017).

48 tportal.hr/Hina, "Otvorena izložba '45.' u Hrvatskom povijesnom muzeju," *Tportal*, March 11, 2016, https://www.tportal.hr/kultura/clanak/otvorena-izlozba-45-u-hrvatskom-povijesnom-muzeju-20160310 (accessed November 1, 2018).

49 Exhibitions in the past several years included *Portraits in the Print Collection of the Croatian History Museum*, *Pistols and Revolvers from the Arms Collection of the History Museum*, *I Gave Gold for Iron: Croatia in World War I*, and *Memories of a Ban: The Jelačić Legacy*, the latter dealing with mid-nineteenth-century national hero Ban Josip Jelačić. For details of the exhibitions, see Croatian History Museum, "Exhibitions," http://www.hismus.hr/en/exhibitions/ (accessed August 28, 2019).

50 For example, on August 24, 2011, the Croatian minister of the interior, Tomislav Karamarko, attended a commemoration for fifty individuals killed by Partisans on the island of Daksa after the liberation of Dubrovnik in October 1944. In a campaign speech that many observers said was intended to mobilize right-wing constituents, Karamarko called for the removal of all communist-era iconography from public spaces, including all streets and squares named after Tito: Branimir Pofuk, "Antifašizam u Ustavu treba zamijeniti antitotalitarizmom," *Jutarnji list* (August 25, 2011): 14–15. The Second World War veterans' organizations quickly condemned Karamarko's comments, which they characterized as "hate speech" that demonized the anti-fascist resistance movement and represented an "open call to lynch and persecute officials from the former system, Partisan veterans, and their children": Damir Kundić, "Boljkovac prijeti Karamarku: Sve znam, a imam i svjedoke," *Novi list* (September 1, 2011): 11.

51 Memorial Center Lipa Remembers, http://lipapamti.ppmhp.hr/en/ (accessed August 28, 2019).

52 Andrej Petrak, "Putovanje kroz povijest zločina za bolju budućnost," *Novi list* (April 12, 2015): 6–7.

53 Igor Lasić, "Naprijed uz druga je drug," *Novosti* (November 11, 2016): 24–25.

54 Parts of this section were previously published in Croatian as "Sukobljena jasenovačka kultura sjećanja: postkomunistički memorijalni muzej u Jasenovcu u doba povijesnog revizionizma," in Andriana Benčić, Stipe Odak, and Danijela Lucić (eds.), *Jasenovac: manipulacije, kontroverze i povijesni revizionizam* (Jasenovac: Spomen područje Jasenovac, 2018), 111–142.

55 Several recent books on the history of Jasenovac include Nataša Mataušić, *Jasenovac 1941–1945* (Zagreb: Kameni cvijet, 2003); Tea Benčić Rimay (ed.), *Jasenovac Memorial Site* (Jasenovac: Spomen-područje Jasenovac, 2006); and Mišo Deverić and Ivan Fumić, *Hrvatska u logorima, 1941–1945* (Zagreb: Savez antifašističkih boraca i antifašista Republike Hrvatske, 2008).

56 For example, the "Decree regarding Racial Affiliation and the Decree regarding the Protection of Aryan Blood and the Honor of the Croatian People" was passed on April 30, 1941, less than three weeks after the NDH was established. *Hrvatski narod* (Zagreb, May 1, 1941): 1. For more details on the NDH, see Jozo Tomasevich, *War and Revolution in Yugoslavia, 1941–1945: Occupation and Collaboration* (Stanford, CA: Stanford University Press, 2001); Fikreta Jelić-Butić, *Ustaše i Nezavisna Država*

Hrvatska (Zagreb: SN Liber, 1978); Tvrtko Jakovina, "The Independent State of Croatia in Hitler's Axis System," in Rimay, *Jasenovac Memorial Site*, 16–43; and Ramet, *Nezavisna Država Hrvatska, 1941–1945*.

57 Vladimir Žerjavić, *Opsesije i megalomanije oko Jasenovca i Bleiburga* (Zagreb: Globus, 1992), 11–12, 44; and Nataša Mataušić, "The Jasenovac Concentration Camp," in Rimay, *Jasenovac Memorial Site*, 47–48.

58 Ivo Goldstein, *Jasenovac* (Zagreb: Fraktura, 2018), 772–797. See the discussion of manipulating the number of Jasenovac victims in Franjo Tuđman, *Bespuća povijesne zbiljnosti: Rasprava o povijesti i filozofiji zlosilja* (Zagreb: Nakladni zavod Matice Hrvatske, 1990), 56–58. The notion of collective guilt was one of the central tenets of Tuđman's challenging the number of Serbian victims in the Second World War. According to him, the number of victims was exaggerated to justify a unified Yugoslavia and Serb dominance in key party, police, and military positions in Croatia. Franjo Tuđman, "The Sources, Changes, and Essence of the National Question in the Socialist Federal Republic of Yugoslavia," reprinted in Peter Sugar (ed.), *Eastern European Nationalism in the Twentieth Century* (Washington, DC: American University Press, 1995), 330–331.

59 For tables identifying the victims at the Jasenovac camp by nationality, see Jasenovac Memorial Site, "List of Individual Victims of Jasenovac Concentration Camp," www.jusp-jasenovac.hr/Default.aspx?sid=6711 (accessed August 1, 2011).

60 Archive of Javna ustanova Spomen područje (JUSP) Jasenovac, Fond SPJ-Komemoracije, A-745, Slakvo Goldstein, "Procjene o priližnom broju žrtava ustaškog logorskog sustava Jasenovac 1941–1945," April 21, 2005.

61 Bogdanović stated in an interview that "in the Jasenovac Flower I denoted life—the crimes which took place in Jasenovac were terrible, but it is important to show what comes afterwards." Quoted in Nataša Jovičić, "The Alchemy of the Flower," in Rimay, *Jasenovac Memorial Site*, 229. See also Nataša Jovičić and Tea Benčić Rimay, *Geneza cvijeta Bogdana Bogdanovića* (Jasenovac: Spomen-područje Jasenovac, 2009).

62 Lončar, *Deset godina spomen-područja Jasenovac*, 13–14.

63 Nataša Mataušić, *Jasenovac fotomonografija* (Zagreb: Spomen-područje Jasenovac, 2008). Mataušić reveals how many photographs were used in different publications and exhibits with various captions to manipulate the victims for political purposes.

64 Nataša Mataušić, "The Jasenovac Concentration Camp," in Rimay, *Jasenovac Memorial Site*, 54. Croatian authorities estimate that about 30 percent of the collection, which in 1991 consisted of some 14,000 objects and 2,500 publications, is still missing. It is believed to be in Bosnia-Herzegovina or Serbia.

65 From April 2002 to April 2003, the memorial site hosted the exhibition *The Jasenovac Concentration Camp: An Exhibition about the Beginning of the Camp System, August 1941–February 1942*, which featured numerous original artifacts, models, and photographs of the camp, and a life-sized reconstruction of the main gate. Compared to today's relatively abstract permanent exhibition, this exhibition was far more effective at conveying the look and feel of the Jasenovac camp.

66 Ljiljana Radonić, "Univerzalizacija holokausta na primjeru hrvatske politike prošlosti i spomen-područja Jasenovac," *Suvremene teme* 3, no. 1 (2010); 55–58.

67 *Identitet*, no. 94 (January 2006): 10.

68 Speech of former president Stjepan Mesić at Jasenovac, November 27, 2006, for the transcript, see Jasenovac, http://www.stjepanmesic.hr/hr/arhiva-govori/27112006-jasenovac (accessed September 9, 2019).

69　Speech of former prime minister Ivo Sanader at Jasenovac, November 27, 2006, transcript in the possession of the author.

70　Boris Pavelić, "Mesić: Nedovoljno je prikazana patnja," *Novi list* (November 28, 2006): 3.

71　Ibid.

72　Tanja Šikanjić, "Prikrivanje istine o Jasenovcu," *Nezavisne novine* (December 2, 2006). This daily newspaper, published in Banja Luka (Republika Srpska), also emphasized how the museum had "minimized" the victims by claiming there were "only" about 70,000 and not 700,000, the official statistic that continues to be used by the Bosnian Serb authorities.

73　Boris Pavelić, "Zuroff: Postav je postmodernističko smeće," *Novi list* (November 29, 2006): 5.

74　Boris Pavelić, "Jasenovac učilište osobne odgovornosti," *Novi list* (December 2, 2006): 6.

75　Some authors, such as Dejan Jović, have argued that the seeds of Yugoslavia's demise were already planted in the 1974 Constitution and the political framework conceptualized by one of Tito's closest collaborators, Edvard Kardelj. Dejan Jović, *Yugoslavia: A State that Withered Away* (West Lafayette, IN: Purdue University Press, 2008).

76　Todor Kuljić, *Tito: sociološkoistorijska studija* (Zrenjanin: Gradska naroda biblioteka Žarko Zrenjanin, 2004), 156.

77　Mitja Velikonja, *Titostalgija* (Belgrade: XX vek, 2010), 36.

78　Ibid., 39.

79　See Martina Grahek Ravančić, *Bleiburg i križni put 1945* (Zagreb: Hrvatski institut za povijest, 2009). Bleiburg is the small Austrian town near the Slovenian border where the NDH forces capitulated on May 15, 1945, but symbolizes the entire postwar repression against real or alleged fascist collaborators.

80　A collected volume of ethnographic, anthropological, and historical texts analyzing the Kumrovec phenomenon was published in Croatia in 2006. See Nevena Škrbić Alempijević (ed.), *O Titu kao mitu: Proslava dana mladosti u Kumrovcu* (Zagreb: Srednja europa, 2006).

81　In 2010, an estimated 11,000 people attended the commemoration, which was also significant because for the first time a right-wing political party organized a counter-commemoration of 150 protesters at the site. The protesters carried signs such as "For Croatia and Christ against the communists and Yugoslav bandits who gathered here today." Dražen Ciglenečki, "Što je više keveta i laži, Tito postaje miliji i draži," *Novi list* (May 23, 2010): 3. The following year, only about 5,000 people attended the commemoration due to the cold and rain. Boris Pavelić, "Oživjeli protjerane partizanske pjesme," *Novi list* (May 29, 2011): 2.

82　See Kumrovec museum, www.mdc.hr/kumrovec/eng/index.html (accessed August 30, 2011).

83　See Brijuni National Park, https://www.np-brijuni.hr/en(accessed August 28, 2019).

84　Tanja Simić, "'Spriječila sam prodaju Titova imena," *Nacional* (November 21, 2006), http://arhiva.nacional.hr/clanak/29235/sprijecila-sam-prodaju-titova-imena (accessed September 9, 2019). For the commercialization of Ernesto "Che" Guevara, see Michael Casey, *Che's Afterlife: The Legacy of an Image* (New York: Vintage, 2009).

85　"Spomen žrtvama Golog otoka na Adi," *Glas javnosti* (December 3, 2007), http://www.glas-javnosti.rs/clanak/glas-javnosti-03-12-2007/spomen-zrtvama-golog-

otoka-na-adi (accessed September 9, 2019). Historians estimate that between 4,000 to 15,000 prisoners died on the island, but no official tally has yet been published.

86 Siniša Pucić, "Robijali, ali odbačeni," *Novi list* (May 24, 2011): 27.
87 "The Thorny Path to a National Black Museum," *The New York Times*, January 22, 2011, www.nytimes.com/2011/01/23/us/23smithsonian. html?_r=1&scp=1&sq=thorny%20path%20to%20a%20national%20black%20 museum&st=cse (accessed January 24, 2011). The museum opened in September 2016 in Washington, DC, and continues to sell out reserved passes months in advance.
88 See UiO, "Strategies of Symbolic Nation-Building in West Balkan States," 72–74.
89 See MEMO Museum, http://www.memo-museum.com/(accessed August 29, 2019).
90 See Zagreb 80s Museum, https://www.zagreb80.com/pocetna/ (accessed August 29, 2019).
91 See Red History Museum, https://www.redhistorymuseum.com/home (accessed August 29, 2019).

Part Three

Museums of Communism

6

The "Display" of Communism in Germany

Irmgard Zündorf

In Germany there is no "museum of communism," but there are more than 618 memorials and museums, as well as smaller plaques or stones, that commemorate the Soviet Occupation Zone (SBZ) (the official name of Eastern Germany occupied by the Red Army, 1944–1949) and the German Democratic Republic (GDR, officially established in 1949 as a sovereign socialist state in the eastern German territories).[1] In addition, there is a governmental concept for the commemoration of contemporary German history. This concept has significantly shaped the commemoration culture regarding the Nazi past, as well as the communist past, in Germany since its publication.

To analyze the presentation of communism in German museums, this text begins by taking a closer look at the national commemoration concept, its development, and its main topics, because this concept provides a framework for the display of communism in German museums. Afterwards this text focuses on the presentation of communism in different kinds of museums and memorials: the museums, financed by the federal government; the memorials, based in former Soviet special camps, in former prisons of the GDR state security (Stasi), or at the former German–German border, financed half by the federal government and half by the state government; and in contrast to these institutions, the private GDR museums, which operate independently of the national concept. The commemoration culture of communism in Germany is formed by all these institutions.

Today there are more than fifteen museums and memorials permanently supported by the government and more than twenty privately financed museums of GDR history.[2] To cover all these museums and memorials would exceed the scope of this contribution. Therefore, I would first like to give a short overview and then focus on some selected official museums and memorials as well as on some private museums. The government-funded museums and memorials mirror the official German view of history, which focuses on the GDR as the SED[3] dictatorship.

Although it would be more correct to speak about "(real) socialism" with regard to the GDR, because "communism" demands a much broader time framework and does not properly reflect the GDR's political system, the chapter uses the term in line with the title and general topic of the anthology, fully aware of the oversimplification connected to it.

Against this background I will take a short look at the smaller private museums that mostly try to show the "good" side of the GDR.

This article seeks to answer the question of how and why the German government intervenes in this commemoration culture and what the German memorials and museums, both official and private, display. Even thirty years after the end of the SED regime, the German variant of communism has obviously not found a clear position in German cultural memory.[4] This part of German history seems to be a "battlefield of memory."[5] Today we can distinguish at least three different categories of memories that arose after 1990 and draw our picture of the GDR: the most visible memory in our public commemoration culture is the "memory of dictatorship," which emphasizes the repression of the SED system. It focuses on the differences between victims and perpetrators and considers its most important task to be remembering the history of suffering and opposition. Accordingly, its structure is normative and teleological. The second one is the "memory of arrangement," which refers to the connection between political developments and everyday life. It is not as prominent as the memory of dictatorship, but many former East German citizens remember their lives in the GDR as a good life within a wrong system (*Das richtige Leben im Falschen*). They think of their "normal" lives, which were not dominated by daily suffering but by arrangements[6] and self-assertion. Third, there is the "memory of progress," which still believes that the GDR was a legitimate alternative to the capitalist social order. This memory is not very popular, but it exists, even if there are few if any memorials for it.[7] Of course, in reality these memories are not closed entities; they are rather intertwined and in many cases overlapping processes. In terms of the museums and memorials presented here, the question arises: which of these memories dominate, and what narratives are told in the exhibitions? What topics are displayed, and which period is focused on? Is there a sort of "division of labor" between the museums and memorials regarding the different memories?

German government intervention into the commemoration culture

Cultural affairs in Germany are normally the duty of the *Länder* (federal states), and not of the federal government. However, after negative experiences with the efforts to come to terms with the National Socialist legacy, for example, starting too late with official support for memorials, working with the communist legacy was seen as the responsibility of the whole nation and not just of the so-called "new" states. Therefore, the federal government has founded several commissions since 1990 to consider a concept for this commemoration culture. In March 1992 a public inquiry was set up with the task of "Working through the History and Consequences of the SED Dictatorship in Germany."[8] One legislative period later, in 1995, came the commission of inquiry for "Overcoming the Consequences of the SED Dictatorship in the Process of Germany Unity."[9] In its 1998 closing report, the second commission declared that the federal government was responsible for preserving the memory of both German dictatorships and their victims.[10] Both commissions led to the establishment of the Federal Foundation for the Reappraisal of the SED Dictatorship[11] by Germany's

Federal Parliament in 1998. The Parliament assigned to the commission the task of "coming to terms"[12] with the communist dictatorship in East Germany. Its mandate covers the support of exhibitions, publications, conferences, and awarding doctoral grants for displaying or exploring the communist past.

In 1998 the federal government also created the post of Federal Government Commissioner for Culture and the Media[13] (BKM), which has its own bureaucratic apparatus and funds the memorials of national relevance. Since 2005 it has also been responsible for the Federal Foundation for the Reappraisal of the SED Dictatorship and for the Federal Commissioner for the Stasi Files. The BKM is accountable to the permanent Committee of the Federal Parliament for Culture and Media. The resulting concentration of cultural power in the federal government has its critics, who observe that "memory has become an object of coherent policy-making."[14]

As an answer to the commissions of inquiry, the BKM announced its first commemoration concept in 1999. The paper presented by the BKM gave the broader frame for the whole commemoration culture for contemporary history in Germany. It declared that the government would support memorials and projects if, first, they were of national and international importance and, second, the sites were relevant to one or more forms of repression. The second point in particular, with its emphasis on repressions, was one of the most important reasons why the early commemoration politics concerning the GDR focused on the memory of repression and its victims. Thus preference was given to the building of memorials instead of museums.

The commissions published two reports that characterized the GDR as a dictatorship of one party, the SED, and a system of suppression, indoctrination, and control. Even if this view of the GDR was useful to describe the state power mechanisms, it was "less suitable for gaining insight into the various productive and creative ways people dealt with the realities of life," as Joes Segal and Uta Balbier correctly stated.[15] This is one reason why in the late 1990s a "counter-narrative"[16] appeared. The phenomenon, which highlighted the more positive sides of East German culture and society, was called *Ostalgie*, an abbreviation of *Ost* (East) and "nostalgia." It describes a particular view of the GDR that both approves of the GDR state and implies an apolitical position.[17] *Ostalgie* does not really help society to understand how the GDR functioned, but it shows a desire to understand the whole system and not just the political one. Parallel with this phenomenon, some social and cultural historians such as Jürgen Kocka, Thomas Lindenberger, and Martin Sabrow started to focus their research on the everyday life of East German citizens.[18] Their approaches laid the foundation for the subsequent displays on everyday life in the official museums.

In 2005 the BKM appointed a new expert commission to draw up guidelines specifically for the commemoration culture of the SED dictatorship.[19] The commission concluded that in the commemoration culture of GDR history, the history of repression and official power was very well represented, but the Berlin Wall and the history of everyday life barely seemed present. The members of the commission claimed that all four topics—repression; the border and the Wall; the history of governance; and the history of everyday life—should be part of the commemoration culture and therefore supported by the government.

The recommendation of the expert commission to bring everyday life into the museums led to a widely publicized discussion.[20] Opponents argued that the display of everyday life would push the repression into the background, painting a harmless picture of the GDR. However, twenty years after the peaceful revolution and reunification, there is a generation of young adults who have no personal recollection of the GDR. The memory of the GDR is transforming from experience into history. In short, the transition from collective memory to cultural memory has started. The new generation forms its picture of the GDR from different sources: family, school, literature, film, and TV as well as museums. These young people's interests are focused on how people actually lived in the GDR. The approaches to answering this question demonstrate the need to explain how ordinary people lived within the political and economic system. In addition, the debate revealed that it was precisely everyday life—the lives of the majority of the people—that could shed light on the functioning of the SED regime. Despite this recognition, it was decided that in the commemoration culture, the core topics "repression" and "border" should not be marginalized but enriched by the new field of everyday life.

According to these considerations, the 2008 commemoration concept of the Federal Republic specified that, besides repression and the history of political power, the expositions of state-supported museums also had to show everyday life.[21] The concept declared that the whole system of the GDR could only be made understandable by displaying both the repression in the former Stasi prisons and the mundaneness of everyday life. However, to avoid nostalgia, everyday life always had to be displayed in the context of the dictatorship. The following topics were to be elucidated: the "comprehensive state control" of all people in the GDR, the "pressure to adapt," the "willingness to participate," and the instruments the SED used to penetrate the society ideologically.

The concept specified that the political structure and everyday life of the GDR should be on display in the following national museums: the German Historical Museum in Berlin (*Deutsches Historisches Museum*, DHM); the House of the History of the Federal Republic of Germany in Bonn (*Stiftung Haus der Geschichte der Bundesrepublik Deutschland*, HdG) and its branches, the Forum of Contemporary History Leipzig (*Zeitgeschichtliches Forum Leipzig*, ZFL), the Palace of Tears Berlin (*Tränenpalast Berlin*), and the *Kulturbrauerei Berlin*. Furthermore, it also mentioned the Documentary Center for the Everyday Culture of the GDR (Dokumentationszentrum Alltagskultur der DDR, DOK) in Eisenhüttenstadt as an important place to display East German history. Even though this declaration did not make a commitment to permanent financial support for the Documentary Center, it will be described here together with the national museums, because it is the only institution whose main focus is on everyday life in the GDR.

The musealization of the GDR

In West Germany before 1990, the history of the GDR and communism was of interest primarily to experts. It was neither a focus of the universities nor of the memorials or the museums.[22] Of course, in the GDR this history, as it was seen by

the SED, was displayed in the Museum of German History in Berlin and in local museums.[23] Most of the local museums closed their GDR exhibitions in 1990. Afterwards they only displayed local history until 1933 and avoided contemporary history. This development has led the Federal Foundation for the Reappraisal of the SED Dictatorship to announce a program to support local museums in their efforts to display GDR history every year since 2009.[24]

However, going back to the 1990s, we see the start of the memorialization of the GDR in the early years of the united Germany. First the former Stasi prisons were transformed into memorials, the former Stasi central offices were converted into museums, and the everyday items typical of the GDR were collected by museums and some individuals. It was only the 1,400 kilometers of German–German border installations that vanished almost completely.[25] However, today the border and GDR repression, as well as the history of governance and everyday life, are covered in several museums and memorials.

The museums financed by the government

Although cultural policy has in principle been the concern of the German federal states, a number of museums were already government-funded in the 1980s, including the German Historical Museum in Berlin and the House of History in Bonn. After 1990 the Leipzig Forum of Contemporary History, the Military History Museum (MHM) in Dresden, and the Jewish Museum in Berlin (JMB) were added to the list of government funding. All these museums display German history from their own perspectives. The museums cover the GDR's history to varying degrees. For example, the MHM seeks to display the cultural history of violence in Germany over the last eight hundred years. Therefore the history of the Kasernierte Volkspolizei (the first army in the Soviet Occupation Zone and later in the GDR) and the National People's Army (NVA), as well as the border guard, is part of the chronological exhibition. Although the building housed the Military Museum of the GDR until 1990, the GDR is no longer the museum's main focus. The socialist army is just another part of German history. This is, however, far more than the visitor could find in the JMB, which in its first permanent exhibition (opened from 2001 to 2017) tried to display "Germany of the past and present through the eyes of the Jewish minority."[26] Here the GDR was not even mentioned—other than in the DHM and in the HdG, where it is, of course, part of the general exhibition but to varying degrees.

The German Historical Museum in Berlin

The German Historical Museum in Berlin is housed in a building from the early eighteenth century, which was first used as an arsenal by the Prussian military. In 1891 it became a museum of Prussian history with a notable collection of militaria. From 1952 to 1990, now on the territory of East Berlin, it was called the Museum for German History (*Museum für Deutsche Geschichte*), revamped under the direction of the Central Committee of the SED. In September 1990, the last government of the GDR dissolved the museum. Its collections and properties were transferred into the hands of the German Historical Museum, which had been founded three years earlier

by the Federal Republic of Germany and the Land Berlin.[27] This transfer explains why there are many official objects from the SED and the GDR government in the collection. However, there are also some everyday objects that the Museum of German History collected in 1990. With the slogan "history into the museum," they sought to encourage the public to bring their objects to the museum and not just throw

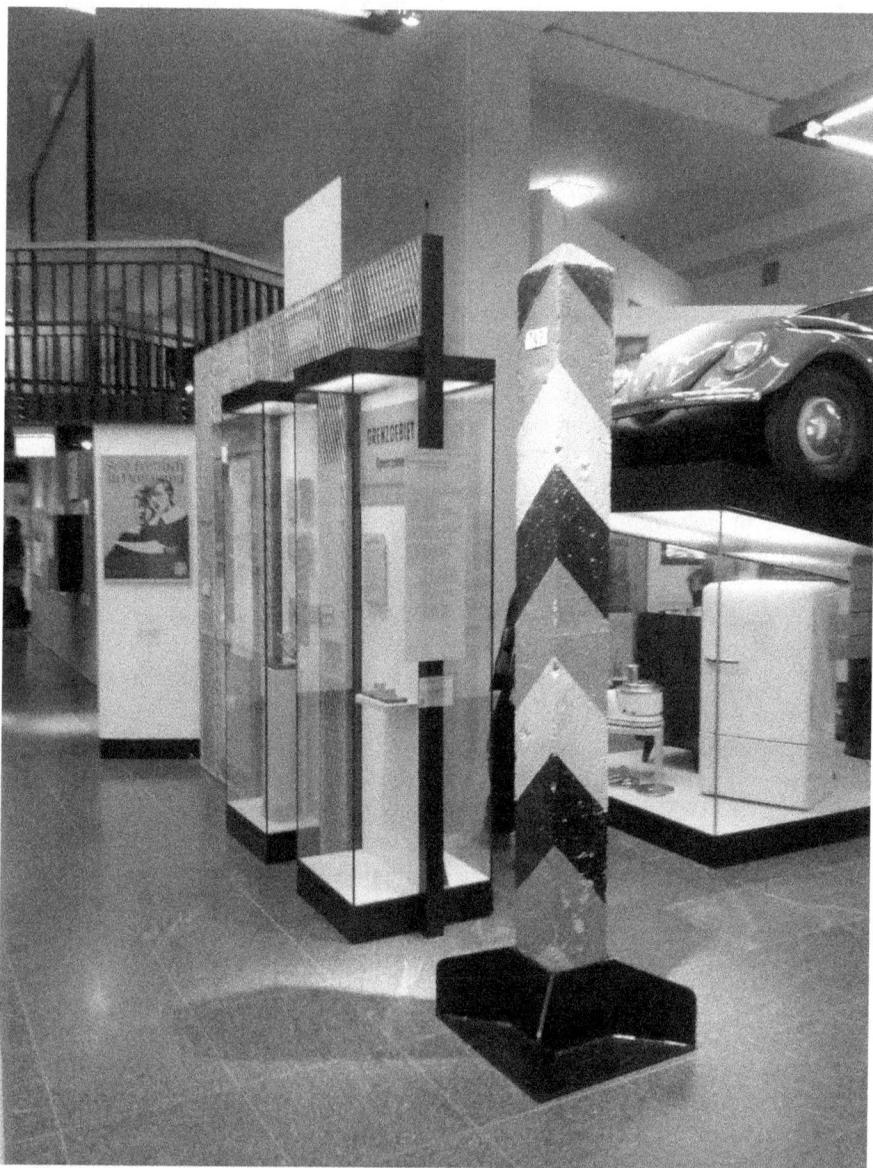

Figure 6.1 Room featuring the post-1949 history of GDR and the Federal Republic of Germany, German Historical Museum, Berlin.

them away.[28] To date the museum has dedicated three large temporary exhibitions to GDR history: 1995's *GDR-Art*, 1996/1997's *Party Order: A New Germany; Towards an Iconography of the GDR*, and, one year after the expert commission's recommendation in 2007, an exhibition about everyday life in the GDR.

In its permanent exhibition, which opened in 2006, the museum seeks to show more than two thousand years of German history chronologically. In this timescale, only limited space can be given to post-Second World War history. The period following 1949, when the GDR and the Federal Republic were founded, is displayed in one room: (Figure 6.1) the GDR on the left and the Federal Republic on the right. Both parts are given nearly the same amount of floor space. The display of the two countries is divided at a boundary post that is followed by physical barriers. These barriers become more and more opaque as you move forward in time. In this structure the visitor is invited to walk through the history of either West or East Germany. One has to choose a path. However, here and there, the visitor may glance over the (symbolic) border dividing the room.

The exhibition focuses on political history. The first station of GDR history is the founding of the new state in 1949, described as a copy of the Soviet prototype, with nationalization of property, a planned economy, the leadership of the Communist Party, and the militarization of the whole society. The main problem for the curators was that the collection mainly consists of official objects such as propaganda posters, busts of Marx and Lenin, flags from the Communist Party, or uniforms of the national army. With these objects the development of the GDR, as the political leaders saw it, can be shown but not the dictatorship behind the propaganda. Besides the official history, the history of the opposition is presented in the form of the desk of a famous dissident, the writer Wolfgang Harich, and photos of the uprising on June 17, 1953. There is also a model of a Soviet tank that was used to defeat the uprising. A real tank could not have been placed in the building, but the model looks like a toy and does not clarify the danger posed to the people in the GDR by the crackdown.

The next important station in the exhibition belongs to the construction of the Berlin Wall on August 13, 1961. The objects displayed show the GDR myth, calling the Wall the "anti-fascist Wall of defense against the imperialist West." The text in the exhibition explains that the Wall stabilized the GDR because it stopped the flight to the West. (From 1949 on, more than 2.7 million people escaped from the GDR into the Federal Republic.) After the closing of the still-permeable border between East and West Berlin, there was a small economic miracle in the GDR, represented in the museum's exhibition by some typical East German consumer goods. A period of tolerance, called the "political thaw," ended in 1965, when authors critical of the state were publicly censured and films were banned. As with the parts mentioned above, the discrepancy between propaganda and reality is not made clear in the exhibition. It tries to explain why the GDR government built the Wall and what positive effects it had. Thereby it neglects to reveal the cruelty of the Wall.

The next station shows the transition from Ulbricht to Honecker. In 1971 Erich Honecker became the head of the party as well as of the government. His leadership is portrayed as a failed effort to improve the economy, a successful foreign policy, and a domestic policy increasingly influenced by the Ministry of State Security. The

repression is shown by a cell from Bautzen II, a jail where prominent victims of the regime were imprisoned. Soon thereafter the visitor comes to the end of the Cold War, with the unification of East and West Germany. The exhibition then ends with the withdrawal of Allied forces in 1994.[29]

The chronological structure shows the developments in the East and the West separated by the Wall. Each is presented in contrast to corresponding developments on the other side. For example, the founding of the governments is shown to be influenced by the Americans in the West and by the Soviets in the East. Even the cultural spheres and the economic systems of East and West Germany are shown in opposition to each other. The British historian Bill Niven has reviewed the exhibition, and his main criticism concerns this division—here the GDR, there the Federal Republic—because it obstructs a truly integrated understanding of postwar German history. The presentation neither shows nor explains the interconnections between the two states. What is demonstrated is the parallel development of two different states.[30] Visitors might get the idea that the GDR was just another German state with more economic and political problems. One of the curators explained that the dictatorship could not be properly displayed because they did not possess the right objects. There are only a few objects relating to the "bad side" of the system: most GDR objects were made by the system and for the system. However, this answer seems a bit too easy, but it shows the problems faced by a curator who has a lot of interesting propaganda objects to show and only documents or texts to explain the other side of the system. And there is another problem, because some objects have more presence and a more lasting impact than others. For instance, a toy often evokes positive memories; by contrast, a bust of a politician or document leaves a rather weak impression. Thus the historian Stefan Wolle came to the conclusion that "the teddy bear will always remain the victor."[31] The teddy bear has a high recognition value, both in the East and in the West, for the young as well as for the old, and it awakens positive memories. The concern is that everyday objects could dominate a whole exhibition and distract from the main issue. There is no simple solution, but some museums—presented below—have found a way to show everyday life within the dictatorship.

To sum up, the exhibition in the DHM gives a sober overview of the main political developments in East and West Germany after 1945, with a short excursion into cultural history. What is missing are questions and interpretations, and for this reason it cannot be easily attributed to one of the memories mentioned above.[32]

This corresponds to the whole permanent exhibition in the DHM, which was widely discussed long before its opening. The idea of a German National Museum, which presents more than two thousand years of history, must culminate in a truncated presentation of the twelve years of National Socialism and thus in a trivialization of the Holocaust. However, the exhibition covering the twentieth century takes up almost half of the DHM's space, and the period between 1933 and 1945 is represented in a differentiated way. By contrast, the portrayal of the GDR seeks to present just the main political events but does not reflect on the meaning behind them. What is evident is that the period after 1945 is not understandable without taking the period before it into account. This is even clearer in the House of History in Bonn, whose official task is to display the history of the Federal Republic of Germany and which opens its presentation with the war and the Holocaust.

The House of History in Bonn

In the House of History of the Federal Republic of Germany in Bonn, an altogether more critical view of the GDR is displayed. As the name indicates, the museum displays the history of Germany after 1945. The permanent exhibition is chronologically structured from the end of the Second World War to the present. Thus the decades of German division and the reunified Germany are the main focus. There was no collection before the museum was founded. Thus the concept for the collection follows the concept of the exhibition.

Opened in 1994, the exhibition was partly reworked over the years, but the modes of display of the GDR remained the same until 2011. The main focus of the permanent exhibition was firmly on political history. Sections of the 1994 exhibition dealing with the SED state were designated by placing a screen of wire fencing in front of them, dividing them from the exhibition of the history of West Germany displayed in the same rooms (Figure 6.2). The visitor was confronted with this screen throughout the exhibition. It started with the founding of the GDR in 1949; the next section showed the uprising on June 17, 1953, followed by rearmament in the West and East in 1956. In the next part, cultural life in both German states was displayed, divided into films, books, and magazines. In this cultural section, there was, as in the rest of the exhibition, more space dedicated to the West than the East, but here the objects were shown together and not divided by a fence. As the exhibition then moved on to the

Figure 6.2 Room featuring the post-1949 history of GDR and the Federal Republic of Germany, House of History, Bonn.

states' economic systems, the fence returned for the East German part. The visitor saw products of the West German "economic miracle" and examples of the attempts at a miracle in the East. Even in the planned economy, the exhibition explained, there was economic growth, though it was not as rapid and far-reaching as in the West. Moving on, the visitor came to the period from 1956 to 1963. The East was again behind the fence, and the tour ended in anti-tank barriers, symbolizing the building of the Berlin Wall. At this point, it became impossible for the visitor to cross from the East section to the West any more, and one had to go back (to 1956) to exit this part of the exhibition. Behind the fence, the political development in the GDR was the focus, but there were also some vitrines with, for example, the children's cartoon character "the Sandman," invented in 1959. As for the Western side, after the economic miracle was depicted, the living conditions and social changes in the West came into focus. In the section covering 1963 to 1989, the visitor again had to decide whether he or she wanted to walk through the East or the West. One could go through a border checkpoint and enter the part called "From Ulbricht to Honecker," which concentrated on the political changes of the 1970s, but there were also some objects showing the economic problems in the East. For example, the sign "No goods today" (*Heute keine Ware*) exemplified the shortages of basic foodstuffs in East Germany. The display of shortages was juxtaposed with official propaganda to show the contrast between political promises and everyday realities. In the East German section of the exhibition, the visitor could also find a homemade antenna symbolizing Western radio and television—which was seen and heard in the East and the most important cultural connection between East and West.

This short overview clarifies the view of German–German history in the museum until 2011: the GDR was shown in its political and economic development as an appendix to West Germany and always behind a fence.[33] Successful Western development was foregrounded, and behind the fence the visitor saw (on a much smaller scale) its negative mirror image. However, in addition to the dictatorship, the GDR system's economic and political problems were given more space. As in the DHM, the opposition was displayed first in connection with the uprising on June 17, 1953, and secondly in the form of some dissidents. Repression was shown in the form of a prison cell and closed-circuit television monitors from the Stasi. Although this exhibition was more differentiated than the one in the DHM, it still did not explain how the system worked. The repressive side of the system was only shown through the Wall or the Stasi, and everyday life was barely mentioned.

In 2011 the display of the GDR in the Bonn museum was thoroughly revised. Now there is far more space for the history of East Germany, and more attention is given to explaining how the GDR functioned. The structure is still chronological, and the main turning points remain the same. But both states, the Federal Republic and the GDR, are no longer simply presented in opposition to each other. In the new exhibition, the GDR is given its own space. Another crucial difference can be seen in the focus on communist propaganda, which is set against the pictures of repression: for example, in the section dedicated to the period of the Soviet Occupation Zone, an "altar" to Stalin (Figure 6.3) is juxtaposed with a huge photo of a Soviet special camp. Furthermore, the GDR is always displayed with a red background. Moreover, the fence, which already signified the GDR in the old exhibition, is still there.

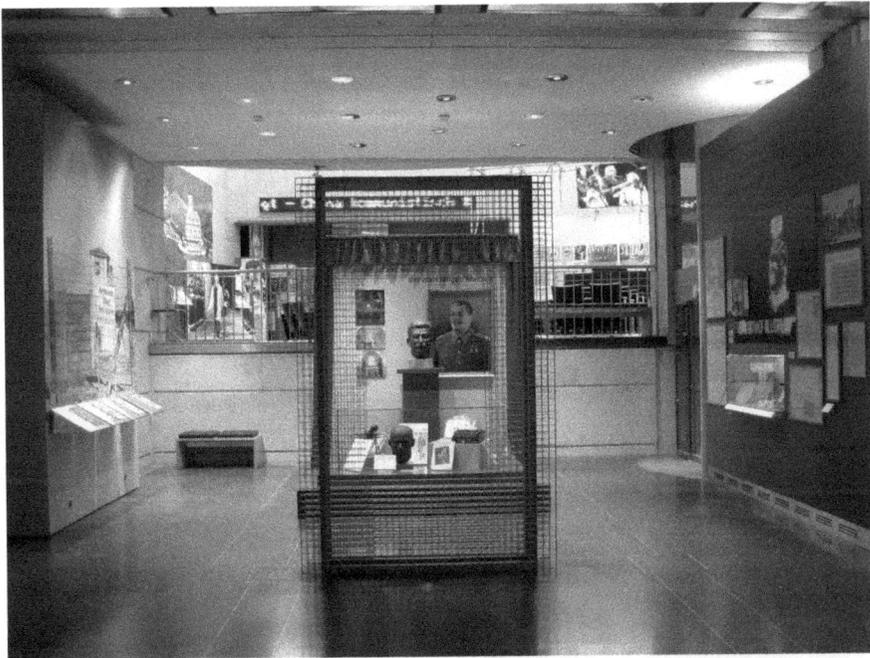

Figure 6.3 "Altar" to Stalin, House of History, Bonn.

After the section on the Soviet Occupation Zone, the exhibition continues with the founding of the Federal Republic of Germany and its democratic structures. Moving on, the visitor sees a red wall, a huge photo of Stalin, and a statue of a Soviet soldier. This part again emphasizes communist propaganda, in contrast to the repression, which is represented by a Soviet tank and photographs of the uprising of June 17, 1953. The rest of the exhibition is built in the same way: the GDR is no longer juxtaposed with the Federal Republic, and the official propaganda is shown as well as everyday life and repression. Central are the objectives of the GDR government, and these are set against, for example, a view into a GDR prison or pictures of the Berlin Wall. Statements from contemporary witnesses can be viewed in multimedia installations.

This new exhibition clearly tries to explain the GDR in more depth than its forerunner. It attempts to show how the people lived behind the fence and why, ultimately, the failure of the system was inevitable. What is still missing is the European and international context. The GDR seems to be on an island, surrounded by the Federal Republic. In summary, we can see that the display in the HdG shifted from the "memory of dictatorship" to the "memory of arrangement."

There are two associated institutions to the House of History: the Forum of Contemporary History (ZFL) in Leipzig and the Palace of Tears in Berlin. The exhibitions all share a common style, but the ZFL takes an important step forward by addressing the GDR system as well as everyday life. It was founded after reunification and opened its first permanent exhibition in 1999, which sought to present East

German history from the perspective of repression and resistance.[34] In 2007, one year after the public discussion on representing everyday life in the museums cited above, the display was reworked to include "everyday life in the communist dictatorship."[35] Now the exhibition presents the official narrative of repression and opposition in the GDR. As in Bonn, political developments are the main focus of the exhibition.[36] It covers the well-known events in chronological order the founding of the two German states, the consolidation of the SED, the land reform, the uprising on June 17, 1953, rearmament, the building of the Berlin Wall, the transition from Ulbricht to Honecker, and lastly, reunification. However, it also gives us an insight into everyday life in the GDR. For example, there is a diorama of a "typical" living room, accompanied by some twenty pictures of living-room scenes from the GDR (Figure 6.4). The traditional

Figure 6.4 Photos of "typical" living rooms from the GDR, Forum of Contemporary History, Leipzig.

Christian confirmation and the *Jugendweihe* (a socialist ceremony for the young person's entrance into society) are also compared. The East German kindergartens, which aimed at political education from the very first day, are depicted as well as some vitrines with typical GDR consumer goods. The exhibition shows the official ideology of the communist state but also what the people living there chose to do with the possibilities they had. Still, the exhibition is largely concerned with repression and resistance. Although the resistance was not part of the everyday life of most people in the GDR, the exhibition shows that the resistance was—especially in the 1980s—known to everyone through the music and the books that were only available under the counter (known as *Bückware*) or from watching Western television. By and large this exhibition tries to give a view of GDR society from the inside. It is a balanced blend of the memory of dictatorship and the memory of arrangement.

In contrast to the ZFL, the exhibition *Border Experiences*, which opened in 2011 in Berlin's Palace of Tears, seems to be a step backward. The building was constructed in 1962 in the GDR. Until 1990 it was the departure hall for the people who left East Berlin for the West. The new exhibition tells the history of Germany's division and the Berlin Wall as well as the stories of some people who wanted to leave the GDR and the function of the Palace of Tears at the German–German border in the middle of Berlin. As at the HdG and the ZFL, the exhibition shows the chronological history of divided Germany. However, the Palace of Tears, for its part, focuses on the Wall. It starts with a picture of the "Big Three" from the Potsdam Conference, continues with the well-known images from the erection of the Berlin Wall and ends with the iconic scenes of people sitting on the Wall, celebrating its fall. At the back of the exhibition, there is an original checkpoint booth that reminds the visitor of the strict border controls. This object is the main focus besides the building itself, because it shows the humiliating clearance process that everybody from East or West had to go through to leave the East. In the center of the exhibition are media installations playing firsthand testimonials from those who speak about their reasons for leaving the GDR and their attempts to do so—legally or illegally.

Even though the building is mentioned in the 2008 commemoration concept as part of the Berlin Wall memorial,[37] and is charged with displaying everyday life at the German–German border, it exhibits more of the history of the Cold War than "normal" life at the border. Therefore it is reasonable to argue that it is dedicated to the memory of dictatorship.[38]

The Documentary Center for the Everyday Culture of the GDR"

The last example of a publicly financed museum is the Documentary Center for the Everyday Culture of the GDR in Eisenhüttenstadt, a small town about 100 kilometers away from Berlin that was named Stalinstadt in the early years of the GDR. Basic funding for the Documentary Center comes from local supporters such as the city and the state, but it is mentioned in the commemoration concept as an important museum for the everyday life of the GDR. This mention was the reason the museum received a grant from the Federal Government Commissioner for Culture and the Media in 2011 to redesign the permanent exhibition. There was only one condition: everyday life had

to be shown in the context of the dictatorship. The museum opened its new exhibition in 2012, but I mention the collection here because of its outstanding quality and range. The Documentary Center was founded in 1993. It collected everyday objects and their "biographies" through appeals to the public. The museum asked people to bring their GDR objects into the museum and explain their history: "When did they obtain it? Who used it? What special memories do they connect with the object and the like?" The purpose of the collection is to bring experiential history into the museum, as has been done with oral history projects since the 1980s.[39] The collection today contains more than 150,000 objects from all areas of everyday culture, but most are consumer goods. Thus there are all types of kitchen utensils, furniture, clothing, and even foodstuffs. Some of the objects look new, but others have obviously been used and then restored for display, such as a GDR radio with a Western music sticker on it and a homemade lawnmower.

These objects, together with the stories told by the people who used them, offer an exciting opportunity for the curator trying to show everyday life within a dictatorship. Even though the collection has no objects of repression, such as something from a GDR prison or from the Stasi, these objects of arrangement may provide another perspective on repression in the dictatorship.

Private GDR museums

Besides these publicly financed museums, there are more than fifteen private GDR museums, which operate independently of the national commemoration concept.[40] They have been appearing throughout the former GDR and in Berlin since the mid-1990s. While some of these museums are amusing chambers of horrors or shrines to nostalgia, some deserve recognition as serious museums. However, all of them respond to a public demand.

In terms of exhibition structure, there are three types of museums. These types could be classified, to quote Jana Scholz, as "classification, chronology and diorama."[41] Even though in practice these approaches are combined, we can use them to describe the exhibitions. As seen above, the official museums are mostly structured chronologically, following political and economic events that framed German social development. By contrast, the private museums mostly take the approaches of classification or diorama and do not display any political context. They are characterized by their comprehensive collection of consumer goods and government insignia. Interestingly, what is missing are personal objects such as photographs, diaries, or letters—but also items that have been personalized, such as a record player covered with stickers of the owner's favorite pop group. In fact there seems to be a desire to display "new" objects that have not been used. This is why in these types of exhibitions the visitor will find a colorful and bountiful consumer world that never existed in the GDR. In addition, there are few if any objects that display the history of repression and opposition. The Stasi, the border, and the resentment against the government are almost not part of these exhibitions.

Museums employing classification follow the early methods of presenting collections, developed in the nineteenth century. The exhibitions appear to provide a glimpse at a larger collection, organized according to categories (for example: textiles,

machines, vehicles). They do not seem to follow any external organizing principle but instead attempt to show the collection as a whole. The only selection criterion is that the objects were produced in the GDR. In this context, the objects appear in the first place as "typical" of the GDR. Most private museums belong to this first group; the classification and the exhibitions appear as though the owners just want to show all the things they have collected.[42]

The second-largest group belongs to the third type, the diorama. Such museums focus on giving spontaneous insights into life in the GDR.[43] Dioramas of flats, kindergartens, or cooperative stores predominate. Sometimes mannequins are dressed in original East German clothing. In addition, some "museums" offer "typical food in original surroundings," which suggests event gastronomy more than serious museum curation.[44]

In the more personal of these museums, this reenactment belies an unscientific but very human desire to reconnect with the past. In others the motivation is more commercial. However, the crucial problem is that all these exhibits lack context: objects are seldom labeled and introductory texts are scarce. There is no political, economic, or cultural context. Both approaches, classification and diorama, put all the original objects together in the hope of recreating something of the GDR, but the objects alone do not explain anything. From the moment they were pulled out of their normal surroundings and brought to the museum, they ceased to be objects of utility and became objects of culture. To see this change, it is necessary to explain the former function of the objects and their history. Without this background knowledge the visitor can rarely understand the GDR, and the only possible aim of the exhibition is that the audience will recognize its own history. In this way these exhibitions seem to be made for people with "GDR experience" who would like to maintain a relatively one-sided and uncritical view of the past.

All these museums have a touch of *Ostalgie*, but there are four private museums that claim to display everyday life inside the totalitarian system: the *DDR-Geschichtsmuseum im Dokumentationszentrum Perleberg*, the *Sammlung Gegen das Vergessen* in Pforzheim, the *Mauermuseum – Museum Haus am Checkpoint Charlie*, and the GDR Museum (DDR Museum) in Berlin.[45]

The most professional one is the GDR Museum, which has been open since 2006 and has already had more than 5.5 million visitors.[46] It started its exhibition with a focus on everyday life. In 2010 the museum doubled its space. In the new rooms the history of the political system, the SED, the Stasi, and the NVA has been added. The visitor has to go through the section on everyday life first; then, behind a wall of artificial fog, the political system is displayed. Even though this design may have a practical justification, because the museum did not change the old exhibition and just added a new one, it looks like there was visible normal life on the one hand and hidden political life on the other.[47] Aside from this criticism, the exhibition has a clear thematic outline, the objects are labeled, and the various topics have an introductory text. So far, the museum looks more like the official museums. But it has one feature not found in state-funded museums: the opportunity to experience the original objects "hands-on." The visitor is allowed to sit in a "Trabi" (the Trabant, a typical GDR car) and to touch the clothes or the books or anything else in the museum. Touching

and smelling the objects engages other senses and allows visitors to build up a more intensive relationship with the exhibit. However, there are also some disadvantages to touchable objects. They soon become worn and may not be restorable. In addition, this method of display can only work if there is a reserve of objects available. In this way the unique object is devalued: it becomes ordinary and exchangeable. This also explains why the focus of the exhibition is on the 1980s: they simply do not have that many older objects.

Besides the exhibition, until 2015 there was also a restaurant in the GDR Museum serving typical GDR food, and it was possible to rent the whole location for events. Here the museum shows its private character. Even if this museum tries to display both sides of the GDR, the private life and the official system, it seeks less to explain the GDR in a reflective way than to entertain. It shows the clichés of the GDR, the Spreewald gherkins as well as the nudist beaches, but also a Stasi interrogation room and the portraits of the SED leaders. This approach fails to explain the development of the system. For visitors who do not have enough background knowledge, the exhibition may at times be disturbing but always remains a kind of entertainment.

To sum up, a standard modern exhibition with vitrines, audio and video installations, introductions, and object labels cannot be found among the GDR museums. Due to the lack of money or a desire to entertain its visitors, the exhibitions are a mixture of dioramas and collections without any explanations. In addition, hardly any of the private exhibitions display any regional connections or any correlation to the political, cultural, or economic history of the GDR. Accordingly, there is no chronological structure of GDR history or any attempt to embed the GDR in the history of the twentieth century. The "insights" are therefore mostly only snapshots of a selected consumer world of the 1980s. However, the sheer number of private GDR museums indicates that there is a desire and demand for this kind of museum of everyday life, dedicated to the "memory of progress." It is interesting to note that all these museums are within the borders of the former GDR or Berlin. There is only one private museum in the West (in Pforzheim), and it deals critically with GDR history. Therefore it belongs to the memory of dictatorship and not to the memory of progress, as most of the other private museums do.

The GDR Museum in Berlin says that the largest proportion of its visitors come from western Germany, but many also come from eastern Germany and from all over Europe. Information about the composition of visitors of the other museums is not available, but as most of them are located in smaller cities and are little-known, one might guess that their visitors come from nearer by. What we still lack is research soliciting the reactions of visitors. Only large museums such as the HdG conduct extensive visitor surveys.

Memorials

Besides museums, there are also memorials dedicated to displaying GDR history. All the memorials mentioned here are parts of the commemoration concept and financed by the federal government and the state governments. They all commemorate the repression in the SED dictatorship but focus on different parts

of it. They do this within their exhibitions, which is why they are also called "contemporary museums."[48] In English-language literature, they are also referred to as "memorial museums."[49] These terms emphasize that these memorials have the same function as museums. Like museums, they are devoted to the acquisition, conservation, and exhibition of historical artifacts. In addition, the memorials are mostly based on historical sites, and they commemorate the suffering that took place there. In the following the term "memorial" is used for institutions that could also be called memorial museums.

The biggest memorials in Germany, such as Sachsenhausen, Ravensbrück, and Buchenwald, have a double past: they were National Socialist concentration camps and after 1945 Soviet special camps (*Speziallager*). In these camps "minor" Nazis and German non-Nazis considered anti-Soviet were imprisoned. During the GDR the sites were National Sites of Commemoration and Remembrance (Nationale Mahn- und Gedenkstätten der DDR), which commemorated only National Socialist crimes and focused on the "antifascist resistance fighter." They were redesigned into memorials for the dual past after 1990. There was an emotionally heated discussion about the transformation, because of the difficulty of commemorating the victims of National Socialism and communism at one site.[50] To find a way to present the dual past, the German historian Bernd Faulenbach created a formula, which defined a dual limitation: "Neither must the Nazi crimes be relativized by the crimes of Stalinism nor the crimes of Stalinism be trivialized by hinting at the Nazi crimes."[51] This sentence became a "golden rule for further decision-making" in this extremely sensitive field.[52] Today the three memorials display repression during the Soviet occupation in several exhibitions. They concentrate on the structure and the victims. But as a new development in German memorial exhibitions, the perpetrators are also kept in the frame.

Similar to the camp memorials are the memorials in the former prisons of the Ministry of State Security (*Ministerium für Staatssicherheit*). The biggest ones were the ones in Bautzen and in Berlin-Hohenschönhausen. Bautzen II prison was closed in 1992, and the Bautzen Memorial was opened in 1993.[53] The exhibition is located in the former prison building. Information panels with texts and photos explain the most important locations and their function within the prison, the daily life of the prisoners, and the biographies of some of the victims of the Ministry of State Security. Besides these main topics, the visitor also finds information about the prison personnel.[54]

The memorial in Hohenschönhausen was opened in 1994.[55] Since 2013 the memorial has also had a permanent exhibition.[56] It is one of the most visited GDR memorials. The website of the memorial describes it as "the key site in Germany for victims of communist tyranny."[57] When visitors enter the memorial today, their visit usually starts with a film about the Stasi system. Afterwards they can walk through the memorial (not individually, but only on a guided tour) and see the former prison as it was left in 1989. They can see both the cells in the cellar from the Soviet time and the cells above that belonged to the SED regime, the interrogation rooms, the entrance with security gate, the yard with the watchtowers, and the Wall topped with barbed wire. Most of the guides are former prisoners. They explain the SED dictatorship, the Stasi system, and the functioning of the Hohenschönhausen prison. But they also

speak about their own experiences as prisoners. Thus far they have functioned as both historians and witnesses—a distinction that is usually difficult for visitors to recognize. This is one of the reasons why other memorials decided to have professional guides and moderated discussions with witnesses.

Both memorials display (in different ways) the Stasi prison system, on the one hand, and the biographies of some prisoners, on the other. The biographical perspective is often used in German museums and memorials. With the biographies the curators want to connect the history with the lives of the visitors. They try to give the victims a life and a face. These biographies explain that most prisoners were normal people. They were not famous dissidents but, for example, people who just wanted to leave their country.

Besides these memorials at former sites of repression, there are also exhibitions at the former sites of the perpetrators. The history and the activities of the state security service are displayed in an exhibition in House 1 in Normannenstraße in Berlin, the former headquarters of the Ministry of State Security. The exhibition is designed by the Antistalinistische Aktion Berlin Normannenstraße (ASTAK), a private foundation of former GDR civil rights activists. The exhibition opened in 2012 in House 1.[58] However, there was another Stasi exhibition in the center of Berlin that opened in January 2011 near Checkpoint Charlie, a popular place for tourists. The exhibition's structure was not chronological but thematic. It showed the development of the Ministry of State Security as well as the impact of its work on its victims and on everyday life in the GDR.[59] The main focus was on the lives of the victims. However, everyday life was also shown, and this should be seen as a tribute to the discussion in Germany about everyday life and repression. The Stasi exhibition, as well as part of the museum in the renovated House 1, are planned by the employees of the Federal Commissioner for the Records of the State Security Service of the Former German Democratic Republic (BStU).

There are also special memorials for the former German–German border. It was the "physical embodiment of communist repression and the most visible sign of the moral failure of the idea of communism"; it symbolized the Cold War period. That is why today, along the former borderline, there are more than thirty-five small "border museums" outside of Berlin that commemorate the country's division. Most of them are run by private organizations, partly in cooperation with local and regional authorities.[60] However, the main institution to commemorate the German–German border is the Berlin Wall Foundation with the memorial at Bernauer Straße and the Marienfelde Refugee Center Museum in Berlin. The memorial is placed on the former border in the middle of Berlin.[61] It tries to explain the function of the entire Wall system as well as commemorating the victims of the Wall as victims of the communist regime. The Marienfelde Museum documents the flight and emigration from the GDR into West Germany between 1949 and 1990. It addresses the reasons for leaving the GDR, the escape routes, and the surveillance by the Stasi as well as the problems associated with a new start in West Germany. There are only a few authentic parts left of the Wall system. This makes it difficult for visitors to understand how dangerous and all-encompassing the border was. The memorial decided not to reconstruct any parts of the Wall, which is typical of German

commemoration culture. Reconstruction is seen as creating a "Disney World," which is not desirable for memorials. This is why the remains of the Wall were shown and put into a contextual relationship by adding information boards. In addition, a film in the documentary center shows the whole border system. Plans call for an exhibition explaining the history of the Wall.

Outside of Berlin there are two more memorials for the border financed by the government as part of the 2008 commemoration concept: the memorial to German partition on the former border in Helmstedt/Marienborn and the German–German museum in Mödlareuth. The memorial is based on a former border checkpoint and documents the border system outside of Berlin as well as the history of the German–German border. Mödlareuth was called "Little Berlin" because the small village was divided by the German–German border during the Cold War.

It is the aim of all these institutions to display the cruelty of the communist system and to explain the effects on everyday life. Therefore they all belong to the memory of dictatorship. Only the perspective differs: from the camps, to the prisons and the Stasi, to the border.

Conclusion

This short overview of the memory landscape of the German communist past, including the government commemoration concept as well as official and private museums and memorials, gives an idea of how the communist period is displayed in reunified Germany today, when the younger generation have no memories of their own of the GDR.

In the years immediately after 1990, there was a public desire to come to terms with the history of the GDR more professionally than had been done with the Nazi legacy in the 1950s. The commissions of inquiry decided that it was important to explain the SED system and to inform people about communist repression. This is why preference was given to the building of memorials instead of museums. Fifteen years later many East Germans decided that their past was not part of the history displayed in the memorials. Most former GDR citizens were not dissidents; they described themselves as apolitical. Their memories consist largely of their private lives, how they grew up, went to school, met their partners, studied or worked, got their first flat, and the like. These memories were not found in any memorial or museum that only presented the memory of dictatorship, and consequently the question of the everyday gained importance. In addition, the young generation, who could not remember the GDR, wanted to know how their parents lived in that state.

First, private museums opened that tried to show everyday life in the GDR, most of them ignoring the repressive system. After a public discussion in 2006 about presenting everyday life in the GDR in museums, the official museums also started to display everyday life. This was, however, in connection with the dictatorship as required by the governmental concept of 2008. The current exhibitions try to show the GDR as a whole: the political system, the repression, and everyday life. The best example of a successful attempt at this is the ZFL.

There are still publications that see a clear division between the museums. They argue that the HdG presents political history; the ZFL resistance and dictatorship; and the private GDR Museum in Berlin, as well as the partly government supported DOK, everyday life.[62] However, the HdG and the ZFL, as well as the GDR Museum, have reworked their exhibitions. Even though in the official museums the chronological organization of the exhibitions still follows political developments, these museums give insights into cultural life as well as everyday life, and the private museum in Berlin gives insights into the political system. There is no longer a clear division of labor. Of course, the memorials still focus on repression.

This first conclusion highlights the most important distinction of GDR museums: there are still several generations living who have their own memories of this state. As Hans Rothfels famously put it, contemporary history is "the epoch of those who are living through it." Contemporary history exhibitions face the challenge of explaining history to the people who are living through it. These people will not find their whole past experience in any exhibition, and they have special demands on the exhibitions. Furthermore, the generation after the witnesses also have their own interest in the past. In addition, a major proportion of the German population has had only an indirect relationship with the GDR. This has led to conflicting ideas about the GDR, which are the result of its long existence and also of the Eastern inside perspective and the Western outside perspective.[63] Thus besides the interested and well-informed visitor, there are two extremely different audiences: visitors with personal and sometimes strongly emotional memories, and visitors who see themselves without any relationship to this part of German history. While the individuals with firsthand knowledge of the GDR may not need any explanations, these are very important for the others. Together with the different memories of "dictatorship, arrangement, or progress," the expectations of visitors regarding communism in German museums range from the widely discussed and very eloquently composed exhibitions about repression in the memorials of the dual past to the presentation of many items of "GDR stuff" without any explanations in the private museums.

Another problem in displaying the communist past concerns the objects. First, most of the remaining consumer goods showing everyday life are from the 1980s. This is why most of the everyday-life exhibitions look like snapshots from this time. There seems to be neither the possibility of providing a chronological overview of the GDR nor putting the GDR into the context of twentieth-century German history. Second, the objects used to display the political system in East Germany were mostly made by the system itself: they are objects of propaganda. The museums have the challenge of explaining the complex reality of the dictatorship through these objects. Therefore, the repression is displayed on original sites—the former prisons themselves seem to be the best objects to explain the cruelty of the system. Whenever this part of the communist period is displayed in a museum, there is a copy of a prison cell (like in the DHM, the HdG, or the ZFL), some listening devices and closed-circuit television monitors, or some uniforms and weapons from GDR soldiers. Because these objects in the museum cannot explain the repression, an audio or video installation is usually added in which former victims tell their story

of oppression and persecution. This biographical access to history is a common tool in German exhibitions. It is seen as a bridge between the objects, which present the past, and the visitor's life.

None of the exhibitions mentioned above display the regional connections or international relationships of the communist system, and the connection between political, cultural, economic, and social life is often missing. They all focus on the German, and some on the German–German, history. This cannot be explained by the objects but perhaps by the special view of the twentieth century in Europe as the "century of extremes" (Eric Hobsbawm) and the German role in it. In this perspective the GDR was the second dictatorship in Germany and one consequence of the National Socialist regime. Thus communism in Germany seems to be special and the focus of the exhibitions on the German–German relationship. Therefore the official exhibitions try to follow the concept of an "asymmetrically integrated parallel history" ("asymmetrisch verflochtene Parallelgeschichte," Christoph Kleßmann), which emphasizes the complex relationship between the two German states. This means avoiding the simple division between the histories of success and failure and not simply explaining the GDR from its end. Instead, the exhibitions should try to display a multi-perspective view on the political system connected with the experiential history.[64] However, this seems to be a major challenge for books, and it is even more difficult to display in an exhibition, as we have seen above. None of the exhibitions are really successful in showing the special relationship or a multi-perspective view. They display a "master narrative" rather than giving some possibilities for interpretations[65] and clarify that the exhibition is just a reconstruction of history.[66] All we have for the exhibitions are objects from the dictatorship, which do not speak for themselves. The interpretation comes from the curators. In official museums and memorials these interpretations are determined by the commemoration concept, which belongs to the memory of dictatorship and, since 2008, also to the memory of arrangement. Some of the private museums are directed by commercial interests; they belong to no special memory but look like a mixture of all approaches and seek to entertain rather than to explain. By contrast, most of the private museums belong to the memory of progress and try to provide insights for all the people who have a positive personal memory of the GDR.

At the very least, the number of small private museums in the German provinces, as well as the growing number of visitors to the central museums and memorials, provides proof of an increasing public interest in the communist past in Germany. In 2008 the most frequently visited of all the GDR museums was the HdG in Bonn, with more than 900,000 visitors. However, it is free of charge. It is followed by the most expensive private museum, House am Checkpoint Charlie, with more than 850,000 visitors. Regular admission is 12.50 euros. The national museum in Berlin, the DHM, was next with 766,000 visitors. Even the smaller private GDR Museum had 308,000 visitors, the memorial for the Berlin Wall had 304,000 visitors, and Hohenschönhausen had 248,000 visitors.[67] The memory of progress, as is shown in most of the private museums, still exists but can be seen more as a marginal phenomenon. The dominant memory of the GDR seems to be one of dictatorship, followed by the memory of arrangement.

Notes

1 Annette Kaminsky (ed.), *Orte des Erinnerns. Gedenkzeichen, Gedenkstätten und Museen zur Diktatur in SBZ und DDR* (Berlin: Ch. Links Verlag, 2016; 2nd rev. and enlarged edn.).

2 For an overview of the names and founding dates of the various exhibitions on GDR everyday history, see Kerstin Langwagen, *Die DDR in der Vitrine* (Berlin: Metropol Verlag, 2016), 122–125.

3 The Communist Party in the GDR was the Sozialistische Einheitspartei Deutschlands (Socialist Unity Party of Germany), the SED.

4 Martin Sabrow, "Die DDR erinnern," in *Erinnerungsorte der DDR* (Munich: C. H. Beck, 2009), 11–27, here 15.

5 Ibid., 16.

6 Arrangement in this case is understood as adapting one's life to make the best of a difficult situation.

7 Ibid., 18–19.

8 In German called the Enquete-Kommission zur Aufarbeitung von Geschichte und Folgen der SED-Diktatur in Deutschland.

9 In German called the Enquete-Kommission zur Überwindung der Folgen der SED-Diktatur im Prozess der deutschen Einheit.

10 The work of these two commissions is analyzed in Andrew H. Beattie, *Playing Politics with History: The Bundestag Inquiries into East Germany* (New York: Berghahn Books, 2008).

11 The Bundesstiftung zur Aufarbeitung der SED-Diktatur (Bundesstiftung Aufarbeitung).

12 For the difference between the discourse of "coming to terms," in contrast to "coping with the past," see Martin Sabrow, "The Post-Heroic Memory Society: Models of Historical Narration in the Present," in Muriel Blaive, Christian Gerbel, and Thomas Lindenberger (eds.), *Clashes in European Memory: The Case of Communist Repression and the Holocaust* (Innsbruck: StudienVerlag, 2011), 88–98, here 93ff.

13 The Bundesbeauftragter für Kultur und Medien, BKM.

14 Thomas Lindenberger, "Governing Conflicted Memories: Some Remarks about the Regulation of History Politics in Unified Germany," in Blaive, Gerbel, and Lindenberger, *Clashes in European Memory*, 73–87, here 73.

15 Joes Segal and Uta A. Balbier, "Introduction," in Uta A. Balbier, Cristina Cuevas-Wolf, and Joes Segal (eds.), *East German Material Culture and the Power of Memory*, Supplement 7, (Washington, DC: German Historical Institute, 2011), 5–12, here 7–8.

16 Ibid., 8.

17 Thomas Ahbe, "'Ostalgie' als eine Laien-Praxis in Ostdeutschland: Ursachen, psychische und politische Dimensionen," in Heiner Timmermann (ed.), *Die DDR in Deutschland: Ein Rückblick auf 50 Jahre* (Berlin: Duncker und Humblot Verlag, 2001), 781–802.

18 For example, Thomas Lindenberger (ed.), *Herrschaft und Eigen-Sinn in der Diktatur. Studien zur Gesellschaftsgeschichte der DDR* (Cologne: Böhlau Verlag, 1999).

19 In German called Expertenkommission zur Schaffung eines Geschichtsverbundes zur Aufarbeitung der SED-Diktatur.

20 Martin Sabrow, Rainer Eckert, and Monika Flacke (eds.), *Wohin treibt die DDR-Erinnerung? Dokumentation einer Debatte* (Göttingen: Vandenhoeck und Ruprecht, 2007).

21 The Bundestag on the Internet, *Drucksache 16/9875: Fortschreibung der Gedenkstättenkonzeption des Bundes "Verantwortung wahrnehmen, Aufarbeitung verstärken, Gedenken vertiefen,"* June 19, 2008, http://dipbt.bundestag.de/dip21/btd/16/098/1609875.pdf (accessed October 19, 2018).

22 Bernd Faulenbach, "Die neue geschichtspolitische Konstellation der neunziger Jahre und ihr Auswirkungen auf Museen und Gedenkstätten," in Volkhard Knigge and Ulrich Mählert (eds.), *Der Kommunismus im Museum: Formen der Auseinandersetzung in Deutschland und Ostmitteleuropa* (Cologne: Böhlau Verlag, 2005), 55–69, here 58.

23 Jan Scheunemann, *Gegenwartsbezogenheit und Parteinahme für den Sozialismus: Geschichtspolitik und regionale Museumsarbeit in der SBZ/ DDR 1945–1971* (Berlin: Metropol Verlag, 2009).

24 The funding guidelines are available on the internet, see Bundesstiftung zur Aufarbeitung der SED-Diktatur, "Förderung," https://www.bundesstiftung-aufarbeitung.de/foerderung-1075.html (accessed October 19, 2018).

25 Gerd Knischewski and Ulla Spittler, "Memorialization of the German-German Border in the Context of Construction of Heimat," in Bill Niven and Chloe Paver (eds.), *Memorialization in Germany since 1945* (Basingstoke: Palgrave Macmillan, 2010), 318–328, here 319.

26 See Jüdisches Museum Berlin, "Exhibitions," http://www.jmberlin.de/main/EN/01-Exhibitions/00-exhibitions.php (accessed May 15, 2013). A new permanent exhibition will open in 2020.

27 See Deutsches Historisches Museum (DHM), "Foundation and History," https://www.dhm.de/en/about-us/foundation-history.html (accessed October 19, 2018).

28 Monika Flacke, "Alltagsobjekte der ehemaligen DDR. Zur Sammlungstätigkeit des Deutschen Historischen Museums," in Bernd Faulenbach and Franz-Josef Jelich (eds.), *Probleme der Musealisierung der doppelten deutschen Nachkriegsgeschichte* (Essen: Klartext Verlag, 1993), 57–61, here 61.

29 Glenn Penny mentioned in his review the brief coverage of the Cold War but explained that the exhibition's focus was on a *longue durée*: H. Glenn Penny III, "Productive Wonder in Berlin's German Historical Museum," H-Net, 2006, https://networks.h-net.org/node/35008/discussions/112826/exhibit-review-deutsche-geschichte-bildern-und-zeugnissen-die (accessed October 19, 2018).

30 Bill Niven, "Colourful but Confusing: The Permanent Exhibition in the German Historical Museum," in Jan-Holger Kirsch and Irmgard Zündorf (eds.), *Thema: Geschichtsbilder des Deutschen Historischen Museums: Die Dauerausstellung in der Diskussion* (Zeitgeschichte-online, July 2007), http://www.zeitgeschichte-online.de/sites/default/files/documents/dhm_niven.pdf (accessed October 19, 2018).

31 Stefan Wolle, *Der Beitrag der Brandenburger Heimatmuseen zur Aufarbeitung der DDR-Geschichte* [The Contribution of the Brandenburg "Heimat" Museums to Coming to Terms with GDR History], 2012, https://www.parlamentsdokumentation.brandenburg.de/parladoku/w5/drs/ab_8500/8500_21.pdf (accessed October 19, 2019), 83.

32 For the diverse reviews on the internet, see Jan-Holger Kirsch und Irmgard Zündorf (eds.), *Geschichtsbilder des Deutschen Historischen Museums: Die Dauerausstellung in der Diskussion* (Zeitgeschichte-online, July 2007), http://www.zeitgeschichte-online.de/md=DHM-Geschichtsbilder (accessed October 19, 2018).

33 Andreas Ludwig, "Discursive Logics in the Material Presentation of East German History: Exhibition and History 'Ten Years After,'" paper given to the conference

Ten Year After – German Unification, December 2, 1999, University of Michigan, Ann Arbor.

34 Stiftung Haus der Geschichte der Bundesrepublik Deutschland, Zeitgeschichtliches Forum Leipzig (ed.), *Einsichten: Diktatur und Widerstand in der DDR* (Leipzig: Reclam Verlag, 2001), 16.

35 See Zeitgeschichtliches Forum Leipzig (ZLF), "Permanent Exhibition: Our History. Dictatorship and Democracy after 1945," https://www.hdg.de/en/zeitgeschichtliches-forum/exhibitions/our-history-dictatorship-and-democracy-after-1945/ (accessed August 28, 2019).

36 A new exhibition opened 2018. This presentation cannot be discussed here, as the opening took place after this text had been completed.

37 For the concept from 2006, see Thomas Flierl, "Gesamtkonzept zur Erinnerung an die Berliner Mauer: Dokumentation, Information und Gedenken," Gesamtkonzept Berliner Mauer, June 12, 2006, https://www.berliner-mauer-gedenkstaette.de/de/uploads/allgemeine_dokumente/gesamtkonzept_berliner_mauer.pdf (accessed October 19, 2018).

38 In 2013 the permanent exhibition *Everyday Life in the GDR* (*Alltag in der DDR*) was opened in the Kulturbrauerei in Berlin. Since the opening took place after this text had been completed, it is not possible to go into more detail about this exhibition here.

39 Andreas Ludwig, "Musealisierung der Zeitgeschichte: Die DDR im Kontext," Bundeszentrale für politische Bildung, October 5, 2011, http://www.bpb.de/themen/89NA65,0,Musealisierung_der_Zeitgeschichte.html (accessed October 19, 2018).

40 For an overview, see Jan Scheunemann, "Gehört die DDR ins Museum? Beobachtungen zur Musealisierung der sozialistischen Vergangenheit," *Gerbergasse 18* (2009): 34–37. Irmgard Zündorf, "DDR-Museen als Teil der Gedenkkultur in der Bundesrepublik Deutschland," in Bernd Wagner (ed.), *Jahrbuch für Kulturpolitik vol. 9: Erinnerungskulturen und Geschichtspolitik* (Essen: Klartext Verlag, 2009), 139–145.

41 See Jana Scholz, *Medium Ausstellung: Lektüren musealer Gestaltung in Oxford, Leipzig, Amsterdam und Berlin* (Bielefeld: Transcript Verlag, 2004), 27–28.

42 See the nostalgie-Museum auf dem Domstiftsgut Mötzow near Brandenburg/Havel; the DDR-Museum Malchow; the Museum für DDR-Produkte in Erfurt, http://www.ddr-museum-erfurt.de (accessed October 19, 2018); the Ostalgie-Kabinett in Langenweddingen, http://www.ostalgie-kabinett.de/ (accessed October 19, 2018); the Museumsbaracke Olle DDR in Apolda, www.olle-ddr.de (accessed October 19, 2018) (the last one also displayed scenes and therefore the museum is a mixture of both types).

43 Like the DDR Museum in Pirna, www.ddr-museum-pirna.de (accessed October 19, 2018); the DDR-Museum Zeitreise in Dresden; and the Haus der Geschichte in Wittenberg, http://www.pflug-ev.de (accessed October 19, 2018).

44 Like the DDR-Museum Tutow, www.ddr-museum-tutow-mv.de/index.htm (accessed October 19, 2018).

45 DDR-Geschichtsmuseum im Dokumentationszentrum in Perleberg, www.ddr-museum-perleberg.de (accessed October 19, 2018); the collection Gegen das Vergessen, zur Geschichte der DDR, http://www.pforzheim-ddr-museum.de (accessed October 19, 2018); Mauermuseum. Museum Haus am Checkpoint Charlie, http://www.mauermuseum.de/ (accessed October 19, 2018).

46 DDR Museum in Berlin, http://www.ddr-museum.de (accessed October 19, 2018).

47 The exhibition was extended again in 2016. However, the new presentation cannot be discussed here, as the extension took place after this text had been completed.

48 See, International Holocaust Remembrance Alliance (IHRA), "International Memorial Museums Charter," 2018, https://www.holocaustremembrance.com/index. php/international-memorial-museums-charter (accessed October 19, 2018).

49 A short definition can be found in Paul Williams, *Memorial Museums: The Global Rush to Commemorate Atrocities* (Oxford: Berg, 2007), 8.

50 A good overview of the discussion in Sachsenhausen is given in Petra Haustein, *Geschichte im Dissens: Die Auseinandersetzungen um die Gedenkstätte Sachsenhausen nach dem Ende der DDR* (Leipzig: Leipziger Universitätsverlag, 2006).

51 Bernd Faulenbach, "Probleme des Umgangs mit der Vergangenheit im vereinten Deutschland: Zur Gegenwartsbedeutung der jüngsten Geschichte," in Werner Weidenfeld (ed.), *Deutschland. Eine Nation – doppelte Geschichte: Materialien zum deutschen Selbstverständnis* (Cologne: Verlag Wissenschaft und Politik, 1993), 175–190.

52 Lindenberger, "Governing Conflicted Memories," 77–79.

53 For the development of the memorial, see Carola Rudnick, *Die andere Hälfte der Erinnerung. Die DDR in der deutschen Geschichtspolitik nach 1989* (Bielefeld: Transcript, 2011), 131–226.

54 Susanne Hattig, Silke Klewin, Cornelia Liebold, and Jörg Morré, *Stasi-Gefängnis Bautzen II 1956–1989: Katalog zur Ausstellung der Gedenkstätte Bautzen* (Dresden: Schriftenreihe der Stiftung Sächsische Gedenkstätten, 2008); the Bautzen II Memorial, "Stasi Prison 1956–1989," http://en.stsg.de/cms/node/995 (accessed October 19, 2018).

55 For the development of the memorial, see Rudnick, *Die andere Hälfte der Erinnerung*, 227–331.

56 Since the opening took place after this text had been completed, it is not possible to go into more detail about this exhibition here.

57 The Berlin-Hohenschönhausen Memorial, https://www.stiftung-hsh.de/about-us/ (accessed October 19, 2018).

58 Since the opening took place after this text had been completed, it is not possible to go into more detail about this exhibition here. For the development of the memorial, see Rudnick, *Die andere Hälfte der Erinnerung*, 433–530.

59 See the exhibition catalog Bundesbeauftragte für die Unterlagen des Staatssicherheitsdienstes der ehemaligen Deutschen Demokratischen Republik, ed., *Stasi: Die Ausstellung zur DDR-Staatssicherheit* (Berlin, 2011).

60 Knischewski and Spittler, "Memorialization," 319.

61 For the development of the memorial, see Rudnick, *Die andere Hälfte der Erinnerung*, 547–654.

62 Segal and Balbier, "Introduction," 8.

63 Sabrow, *Erinnerungsorte*, 16.

64 Christoph Kleßmann, "Die Geschichte der Bundesrepublik und der DDR: Erfolgs- contra Misserfolgsgeschichte?," in Bernd Faulenbach and Franz-Josef Jelich (eds.), *Asymmetrisch verflochtene Parallelgeschichte? Die Geschichte der Bundesrepublik Deutschland und der DDR in Ausstellungen, Museen und Gedenkstätten* (Essen: Klartext Verlag, 2005), 15–31, here 31.

65 Andreas Ludwig, "Zunehmende Distanz: Perspektiven auf ein künftiges Bild von der DDR," *Horch und Guck* 50 (2005): 1–5, here 4.

66 Andreas Ludwig, "Alltagskultur als Zugang zur DDR-Geschichte?," in Faulenbach
 and Jelich, *Asymmetrisch verflochtene Parallelgeschichte?*, 175.
67 City of Berlin, "2009 weiter steigende Besucherzahlen in zeitgeschichtlichen Museen
 und Gedenkstätten," [Press release] December 9, 2010, http://www.berlin.de/sen/
 kultur/presse/archiv/20101209.1200.322353.html (accessed October 19, 2018).

Remembering the GDR

Martin Sabrow

The German Democratic Republic is history, yet in some ways it is more present than ever. The second German state lasted forty years and has had a lasting impact on the thinking and mentality not only of East Germans, who had to live *in* the GDR, but also of West Germans, who had to live *with* the GDR. The four decades of its existence have also influenced the generation born after its demise, affecting family, school, and the media.

Of no less importance today is the material legacy of the GDR. True, the Berlin Wall was ground into aggregate and used as foundation material for the newly rebuilt autobahns of eastern Germany, thus connecting rather than dividing the country. And the Palace of the Republic in Berlin has likewise disappeared, passing straight from the Volkskammer, the East German Parliament, to the automobile manufacturer Volkswagen, which recycled the building's steel girders to make engine blocks for the Golf Mk6. But the wounds remain visible nonetheless; the wrecking ball and the deliberate or careless neglect of historical places and neighborhoods in the name of socialism flattened the urban landscape even more than what was done in the name of reconstruction in West Germany. The prefab apartment blocks of socialist housing are unmistakably present. Irreparable damage was caused by the transformational fury in urban planning that the Socialist Unity Party (SED) regime pursued over the course of forty years in the attempt to implement its concept of a modern city.

Yet other relics of the second German state turn the bygone past into the political present—for example, when revelations from the Stasi files or the statements of contemporary witnesses suddenly and unexpectedly cast doubt on the integrity of certain politicians or luminaries, unmasking supposedly upright and honest individuals as one-time regime supporters and turncoats of the revolution. Sometimes new revelations from the files, the archived memory of the GDR, can force some astonishing historical rewrites, not only of the GDR but of the old Federal Republic, too. This was the case with the realization, supported by the files, that bribes from the Ministry for State Security played a role in the failed vote of no confidence against the social-liberal government of Willy Brandt in 1972. This was also the case with the exposure as a Stasi spy of West Berlin policeman Karl-Heinz Kurras, who fired the shots that killed Berlin student Benno Ohnesorg in 1967, turning the student protests against the bourgeois establishment into a nationwide movement. The German press's

effort in the early summer of 2009 to link Kurras's firmly established historical role as the "muzzle flash" of an anti-communist and intolerant West Germany with his secret activities for the SED power apparatus goes to show once again that even after its dissolution, the GDR's Ministry for State Security has remained what it was before 1989: an all-German institution of considerable influence.

Of course, it is not only the material remnants that shape the present-day image of a defunct GDR. Far more influential are the ideas it conjures up in retrospect. Even decades after its downfall, the second German state presents itself in a flood of images and concepts, data and symbols, which serve as a guide to historical memory. Still inscribed in the German vocabulary are the names of party leaders such as Walter Ulbricht and Erich Honecker, of athletes such as racing cyclist Täve Schur and ice princess Katarina Witt, of rock bands such as the Puhdys and Karat, the names of things such as *dacha* (summer cottage) and "Trabi," the quintessential East German car. Day-to-day expressions such as *Spitzbart* (goatee) or *Wahnsinn* (madness) and technical jargon such as "zone" or "security partnership" have all outlived the GDR as well as historical—and unhistorical—sentences such as "No one intends to build a wall" (Ulbricht) and "I love you all" (Mielke), but also the battle cry of street protesters in the fall of 1989: "We are the people." Memories of the GDR are no less stirred by certain iconic images: the handshake of Wilhelm Pieck and Otto Grotewohl sealing the founding of the SED in 1946; the East German soldier leaping to his freedom over barbed wire in 1961; the refugee Peter Fechter bleeding to death at the Berlin Wall; the fraternal kiss of Honecker and Brezhnev; the pennants referred to as "waving elements" (*Winkelemente*); banners held up by marching masses "demonstrating" for socialism; the long lines outside food stores; sunbathing at the FKK nudist beach; and dilapidated historical city centers.

The GDR is present today in the form of various signs and institutions of cultural memory. This includes monuments erected both before and after 1989, as well as state or civic memorial sites and learning centers for political persecution such as former camps, prisons, and border fortifications. Historical-memory functions are adopted by regional art depositories, museums of everyday life, and urban ensembles such as Eisenhüttenstadt or Jena-Lobeda, as well as by cultural establishments that survived the collapse of the GDR, such as the *Volkssolidarität* social-welfare agency for the elderly or the state-sponsored alternative to confirmation, the dialectical-materialist *Jugendweihe* ceremony.

Much of what made the GDR and life in it has been omitted from this public memory, either because of indifference or simply because it seems unspeakable due to a lack of symbols or concepts. "Fear," "powerlessness," and "hopelessness" are vestiges of memory of the GDR that scarcely lend themselves to being communicated and that perhaps can only really be grasped in the prison cells of Bautzen and Hohenschönhausen. The same goes, conversely, for the feelings of hope and confidence that inspired many "activists of the first hour" who took part in the political experiment known as the GDR, as well as the enthusiasm and creative energy of the *Aufbaujahre*, the "years of construction," linked as they were with a "determined No" to fascism and a "determined Yes"[1] to a new and better Germany. It is the primordial mobilizing power of a confidence in the future drunk with its own sense of strength which, from the

teleological perspective of hindsight, can scarcely hold its own in the culture of social memory and is all too easily suffocated by the overpowering memory of the collapse of communism in 1989. The same goes for the pre-political, day-to-day identification with the project of socialism among large segments of the population that SED rulers drew on as late as the 1980s, and which apparently lost its right to remembrance along with its right to political existence in the context of a reunified Germany.

Confidence and powerlessness, despair and belief were passed down through other channels of remembrance and were particularly well anchored in autobiographical writings. Already during its lifetime, and especially in the 1970s, the GDR became the vanishing point of polyphonic and parallel ego-narratives. Pro-communist "biographies of arrival" (*Ankunftsbiographien*) invert the traditional bourgeois "novel of education" (*Bildungs- und Erziehungsroman*) and portray the various individual paths to becoming a partisan of communism and its German state. Ex-communist "biographies of losing the faith" (*Abkehrbiographien*) attest to the allure of totalitarian thinking and the difficulty of breaking with the "God that failed" evoked by Arthur Koestler. Particularly influential in our day is the stream of post-communist "biographies of coping" (*Bewältigungsbiographien*), whose retrospective coming to terms with the age of communism is so glaringly different from the deafening silence of ego-narratives after the end of Nazism. All of them deal with the experience of autobiographical ruptures, which led these individuals to turn to the communist idea and its state after 1945 and to break with it decades later—and which ultimately resulted, after 1989, in the sudden disappearance of the communist system in Europe.

Apart from the written word, it is the memories preserved in everyday speech that transmit the bygone GDR into the present—in the family, in social clubs, and at the workplace, passing it on to the next generation in the form of communicative memory. Often in competition with this, especially in the former East Germany, is the conception of history conveyed in schools, where the memory of the GDR prescribed in syllabuses and textbooks frequently runs counter to the social experiences of pupils and teachers. The official memory of the GDR sometimes tries to reshape the relativizing perspective of family narratives but not infrequently yields to them, producing parallel memories mentally divorced from each other. Schools are generally successful in conveying historical knowledge and interpretations only when they confirm and develop the ideas handed down to pupils outside of this learning environment, and not when they try to blot them out. To make matters worse, usually only a few lessons are set aside for dealing with the GDR. Like scholarly literature on the subject, history lessons in school are often fighting a losing battle against depictions of the GDR in the media of film and television, having infinitely less appeal and effectiveness than the latter. Feature films such as *Sonnenallee, Good Bye, Lenin!* or *The Lives of Others*, together with TV movies such as *The Woman of Checkpoint Charlie* or *Wir sind das Volk* (The Final Days)—despite or because of their historical stereotyping and narrative simplification—have contributed more, and in a more lasting way, to placing the GDR in the collective memory than any other form of visualizing the past, even though the long-term discursive influence of historiographical knowledge via the channels of opinion-forming media and political education should not be underestimated.

The image of the GDR that emerges from this flood of accumulated remnants and experiences is not a cohesive one; indeed, it is rather fragmented. Not unlike a kaleidoscope, it presents the East German state and its society in ever new variations. The "traffic-light man" icon, or *Ampelmännchen*, at East German pedestrian crossings or Spreewald pickles evoke different memories of life under the hammer and sickle than the remaining fragments of East German border fortifications or Soviet special camps. Likewise, the category "GDR nostalgia" (*DDR-Ostalgie*) at various internet trading sites for historical memorabilia does not bear witness to the same GDR presented in the extremely condensed overviews of school history textbooks. The picture of the GDR conveyed by the testimonies of those who were desperate to escape is certainly different from the impression offered by the notion of the GDR as a "land of readers" (*Leseland DDR*) and the carefully prepared editions of literature put out by state-run East German publishers such as Aufbau-Verlag.

Unlike the other major dictatorships of the twentieth century in the guise of fascism and Nazism, the German variant of communism has yet to find a clearly marked position in German cultural memory. This is due in part to the fact that, despite many similarities in the way the GDR and the Third Reich staged and exercised power, the GDR, unlike the Third Reich, did not result in a "rupture of civilization" (*Zivilisationsbruch*). The fundamental difference in our cultural memory of the two major dictatorial systems in Germany is that, for all the murderous parallels in political practice, the respective promises of salvation underlying them are not the same when measured against the now universally recognized norms of human coexistence. Inherent to National Socialism is the belief that human beings are unequal and that only the fittest survive, whereas the project of communism, despite its structural tendencies to violence, was linked to aims such as equality, justice, and solidarity, none of which have lost their value since communism's demise. The socialist dream allows more room for interpretation than the Nazi breach of civilization. Even those who view the GDR as a total *Unrechtsstaat*,[2] an "unjust state," and who have no qualms about measuring the *Aufarbeitung*, or historical reappraisal, of communism after 1945 against the process of coming to terms with Nazism after 1945 can hardly deny that the ideology of the communist movement, however perverted it may have been, aspired to more humane goals than that of National Socialism. To put it differently: it goes without saying that Bertolt Brecht and Anna Seghers are part of a modern literary canon, whereas Artur Dinter and Erich Edwin Dwinger are certainly not. The various perceptions of the GDR and its character are more easily and freely negotiable than those of Nazi Germany. In their diversity and ambiguity, they run up against much less marked limits of the articulable than the memory of life in the grip of the Nazi "national community" (*Volksgemeinschaft*) and its power of exclusion. The image of the GDR and of the inter-German history of demarcation and integration also acquires its complexity from the fact that the SED state existed for well over a generation and that even today it is contextualized from the various angles of an internal Eastern and an external Western perspective.

Thus while a basic public consensus was finally achieved, after decades of silence and reproach, about the character of the Nazi state, in the case of the GDR, public debate continues, fueled by the asymmetry between "actual" history and the history

of reception. The specific history of East Germany is effectively dealt with in an all-German public sphere, the majority of whose participants were never subject to the constraints East Germans had to face. There is no single answer to the question of whether the GDR was a failed experiment, a "comfy" dictatorship (*kommode Diktatur*) with many niches, or a totalitarian despotism. The efforts of contemporary historians in the years after the GDR's demise and the large-scale opening of archival sources without a moratorium have not resulted in an established historical narrative about the GDR supported by any kind of social consensus. Instead, the GDR has become a battleground of memories, where various views compete for a coherent image of the now-historical GDR much more loudly than they did in the case of Nazi Germany in the first two decades after its downfall.

In doing so they continue a debate that began well before 1989 and that goes back to the immediate postwar period. The experience of suffering during the occupation and the readmission of political parties in the Soviet Occupation Zone, agrarian reform and forced collectivization, SED campaigns and reconstruction, the June Uprising of 1953 and the erection of the Berlin Wall in 1961 were just a few of the key dates and events around which East and West constructed historical narratives, often initially in agreement but diverging more and more over time. The only form of remembrance officially sanctioned in the GDR was a regime-legitimizing "memory of tradition" (*Traditionsgedächtnis*). It sought to reshape or wholly suppress politically undesirable memories through censorship, indoctrination, and outright repression, elevating in an idealized, hagiographic manner the evolution of the GDR into a continual process of maturing, manifest in the annual celebrations on the "birthday of the Republic."

In contrast to the dictatorially established memory of tradition in the East, the West had a regionally varied but generally widespread and virulent "memory of indignation" (*Empörungsgedächtnis*) that was manifest in the commemorative ceremonies for "June 17th" or the documentation of cases of political violence with the aid of a "Central Registry of State Judicial Administrations" in Salzgitter and that attempted to promote an awareness of the SED dictatorship as being fundamentally "unjust" and "lawless." The memory of indignation began to lose its force in the 1960s and hardened in the ensuing years and decades into a political routine of memorial rituals, briefly revived on occasion by the stories of ransomed East German prisoners or the news of a failed attempt to flee. In its place emerged a narrative pattern beholden to progressive normalization that pushed the image of an inhuman dictatorship into the background, treating it as a relic from the height of the Cold War. The ever more distant and vague knowledge of an East German developmental history, which increasingly lost its biographical references, was reorganized over the years in the West into a new memorial narrative with strains of parallel and convergence history. Based on a comparative system analysis rather than being normative, it now emphasized the difficult starting conditions in the East, calling to mind the various advances and setbacks on the path to a more or less accommodated existence in divided Germany.

None of these three patterns of remembrance survived the sea change of 1989 to 1990 unscathed. They were all subject to an abrupt or subtle, but at any rate ineluctable, reorientation: the unexpected downfall of the second German state, whose permanence no one had seriously questioned before. And yet the GDR, having

vanished from the stage, seemed to have lost its history as well. In the months of hope accompanying the *Wende* and the fall of the Wall, amidst the experience of revolution and the joy of reunification, there were few voices willing to name anything worth preserving from a social order abandoned by its own citizens. In the period of transition, the physical and mental legacy of the GDR was perceived as a hindrance to German unification, as an irksome memory of the long-despised and recently disparaged SED state. Nothing illustrates this desire to free oneself from the past more than the phenomenon of the "wall-pecker" (*Mauerspecht*), a new species that emerged after the fall of the Wall: the souvenir-seekers chipping away with their hammers, breaking off bits of a wall that once divided, for the sake of a shared future—and to general public applause.

Only during the crisis of unification in the early 1990s, which sharpened the awareness of an East German identity against the backdrop of disappointed hopes for the future, did three distinct versions of remembering the past take shape that, in their conflicting approaches and competition for authority, determine our image of the GDR nowadays. The focus of public commemoration is the "memory of dictatorship" (*Diktaturgedächtnis*), which emphasizes the repressive character of the SED regime and the courageous victory over it in the peaceful revolution of 1989 to 1990. Dictatorship-centered remembrance primarily focuses its attention on the communist regime's apparatus of power and repression, insisting that the Stasi is more important for understanding the GDR than state-funded day care is. In this memorial mode, the fundamental difference between political freedom and political subjugation with respect to the dignity of human life is accorded a much higher value than social and economic benefits, which in hindsight made the GDR seem more like a "welfare dictatorship" (*Fürsorgediktatur*) in view of the faltering economy and high unemployment in West Germany. Instead, this version of remembrance, centered on the unjust and lawless quality of SED rule, endeavors first and foremost to keep the places of terror of communist rule—from Soviet internment camps and KGB prisons to the Stasi's system of surveillance and spying—alive in the consciousness of future generations. The memory of dictatorship revolves around the perpetrator-victim dichotomy. It attaches prime importance to the misdeeds, betrayal, and failure of SED rulers and sees the commemoration of suffering, sacrifice, and resistance as the most important task in nurturing an awareness of the past that will enable us to learn the lessons of history and avoid repeating them in the future. The memory of dictatorship is correspondingly structured in a normative and teleological way. It portrays the GDR as a negative contrast to the rule of law and the tradition of freedom, which the communists, once in power, flouted literally from day one to the very end.

While this state-sanctioned image of the GDR dominates the space of public memory, a second model of GDR remembrance has a deeper social impact and demands its own right to existence—sometimes in silent defiance, sometimes with noisy vehemence. This is the "memory of accommodation" (*Arrangementgedächtnis*), the often prevailing form of remembrance in eastern Germany to the present day, which talks of "living the right life in the wrong place" and preserves the memory of "getting by" under party rule, a circumstance unwanted by the majority but accepted as unalterable or simply taken for granted. The memory of accommodation links the sphere of power to day-to-day living environments. It tells of self-assertion in daily life

under adverse conditions, but also of the collaboration that was demanded or offered voluntarily, and of the pride of achievement in the GDR. In short, it refuses to neatly differentiate between biography and the system of rule, as the memory of dictatorship does. Instead, it cultivates a certain memory-assisted skepticism toward the new values propagated in the reunified Germany, oscillating between ironic invocations and a nostalgic veneration of the lives lived in East Germany. The memory of accommodation overlaps at many points with the memory of dictatorship, albeit with different associations. Thus the blue shirts of the Free German Youth are reminiscent not only of the regulatory power of party rule but also of the carefree days of youth. Likewise, the string shopping bag denotes not only the depressing shortage of goods but also the value things had in those days.

Overshadowed even more by the official public memory is a third pattern of remembrance that clings to the notion that the GDR was a legitimate alternative to the capitalist social order. This "memory of progress" (*Fortschrittsgedächtnis*) sees the GDR primarily from the perspective of its origins. It constructs its memories based on the supposed moral and political equality of the two German states, which led to peaceful coexistence and mutual recognition, its adherents claim, until the mistakes of East German leaders, unfavorable historical circumstances, or the machinations of the West brought this socialist vision of the future to its final—or perhaps only temporary—fall. The material sites of authentication of this form of remembrance have largely lost their communicative presence, as many of the hallowed sites of the anti-fascist struggle have disappeared from the landscape of the former GDR. They repeatedly reappear from the shadows of public awareness when another piece of socialist built heritage is about to be demolished or when "inherited" social benefits are cut. Things are different with the immaterial places of memory. The image of the East German head of state Erich Honecker being welcomed by West German chancellor Helmut Kohl in Bonn, the revaluation of the supposedly unappreciated advantages of the East German educational system, the ugly face of a world financial system spun out of control, the retrospective notion of the GDR as a well-ordered world where human beings were not commodities and women were treated as equals—such are the links that bolster the memory of progress.

In this triangle of forces, the GDR past is renegotiated daily. Anniversaries of the fall of the Wall and disclosures about the former Stasi collaboration of politicians and other prominent figures offer an opportunity to play up and reinforce the memory of dictatorship. The memory of accommodation predominates in the arena of literary narratives and daily communication, whereas the memory of progress is mainly cultivated in the networks of old GDR elites and in the circle of the former Party of Democratic Socialism, today's Left Party (Linkspartei). For years these three forms of GDR remembrance largely ran parallel to each other, with the initially predominant memory of dictatorship only gradually making way for the memory of accommodation, which began to find a voice of its own in the mid-1990s with the incipient crisis of unification.

Since the beginning of the twenty-first century, however, these two cultural-interpretive camps have increasingly come into fierce conflict. The growing friction between all three parallel historical worlds might be explained in large part by the fact

that, twenty years after the fall of the Wall, the transition from a communicative to a cultural memory has begun, and that hitherto self-evident knowledge of daily life in the GDR is slowly losing its presence in schools as well as in public discourse, acting less and less as a corrective to the opinion-forming power of the media. No less important is the fact that, unlike in the early 1990s, the debate about the role of the GDR in contemporary memory is no longer being conducted in the academic discipline of history as such, as the question of how to research the GDR has yielded to the question of how we should remember it. The growing need to reaffirm the fading feelings of living in the GDR by purchasing specifically East German brands, as well as the sharp rise in demand for exhibitions about daily life in the GDR and the satisfaction of this need through a rapidly growing number of corresponding—and usually less than professional—museums, clearly shows that the GDR as a self-evident part of our world of experience is increasingly disappearing. Having turned into a kind of projection screen, it has thus literally become more questionable and contentious than ever.

The controversies arising from this have revolved around the question of what space daily life in the GDR should and is entitled to take in the public memory of the GDR. A broad debate was unleashed in 2006 when an expert commission on the future of GDR *Aufarbeitung* recommended giving more space in the public memory to East German society and life. Critics staunchly protested that "daily life and the cohesive forces of communist dictatorship are being given greater attention by state-funded institutions" and concluded that the "insistent homeopathization of the East German history of dictatorship" was downplaying the political realities of an unfree society.[3] Much-discussed two years later was the publication of an empirical study on schoolchildren's poor level of knowledge about the GDR, which attributed this deficiency to the fact that the memory of dictatorship did not have sole explanatory authority. "In their retrospective view of the GDR [...], quite a few East Germans relativize and make light of substantial elements of this dictatorship. They enjoy the support of scholars who reduce the dictatorship of real socialism to a 'democratic deficit' or claim that the GDR was more than just a dictatorship."[4] In this regard, the parallel memory of accommodation is tantamount to a social menace that needs to be countered: "A nearly insurmountable barrier in many eastern German schools is the parents and grandparents of students, who reject the picture of the GDR conveyed by critical teachers and essentially impose their own nostalgic view on their children."[5]

Such battle cries, on the other hand, make it easy for the adherents of opposing positions in memory politics to dodge any serious discussion of the dictatorial character of communist rule. One example, in the spring of 2009, was the unwavering public demands to counteract any attempt to downplay the SED dictatorship in election campaigns and to condemn the GDR as an "unjust state" without reservation. Many former GDR citizens, who perceived this as an expropriation of their own personal biographies, immunized themselves against the memory of dictatorship's claim to validity by interpreting it as an expression of a historical victor's mentality and as the urge of an official state culture of remembrance to condemn the GDR in a wholesale manner. The former party newspaper *Neues Deutschland* remarked with satisfaction that a generation-spanning majority of the population in eastern Germany would "not

be intimidated by the slogans of an unjust state" and that it would continue "to consider social institutions and the egalitarian morals of the GDR useful for today's society."[6] Valued by the one camp as a litmus test of successful dissociation from dictatorship, eschewed by the other as the "Gessler hat" of a decreed official memory, the delimiting term *Unrechtsstaat*—as indispensable for political self-understanding as it is useless for historical analysis—has become the object of a historico-political conflict about the "right" form of remembrance.

The various memories of the GDR would be fleeting and unstable if they were only based on individual recollections. Their stability and binding social character are drawn from cultural signifiers that lend common expression to prevailing ideas of the past in society and thus function as the mental and material framework of collective memory. Following the theory of collective memory developed by French sociologist Maurice Halbwachs in the early twentieth century, the term *lieu de mémoire* or *Erinnerungsort* (place/site/realm of memory) has been adopted to designate these anchor points of collective memory. The term was coined by cultural historian Pierre Nora, who conceived it as a response to the progressive dissolution of social narrative communities in the present day. In order for the nation not to lose its historical identity, traditional *milieux de mémoire* (environments of memory) have been replaced by *lieux de mémoire* (places of memory), whose task is to preserve the *patrimoine national* for posterity.

Lieux des mémoire, according to Nora, designate the accepted forms of expression in the communal household of memories that a society or specific milieus use to secure their past. The *topoi* of shared remembrance can be actual places and concrete things but also any other conceivable reflection of yesterday and today: events and institutions as well as ideas and concepts, paintings, and other works of art such as books and documents, which allow us to read the past in the present.

Applied to the German process of dealing with the past, the term *Erinnerungsort* has divested itself of the tinge of cultural pessimism found in Nora's writings as well as the reference to establishing national identity. In today's culture of memory, the term serves the need for an unadulterated and direct encounter with the past. The *lieu de mémoire* is the counterpart to the "contemporary witness" (*Zeitzeuge*) and, like the latter, bridges the gap to a bygone era, enabling us to experience it as directly as possible while making sure it belongs to the irrevocable past. Behind both lies an epochal, characteristically Western mode of thought that, in the wake of high modernism and at the end of the postwar period, has increasingly lost its focus on progress and its confidence in the future and that, accordingly, relies ever more on its preoccupation with the past as a source of cultural self-understanding.

In the early 1980s, this paradigm shift aroused strong suspicions of nostalgia. The new yearning for the past seemed to foster an uncritical return to the "good old days" or to even consciously promote a turn to national conservatism, which sought to dispose of the darker moments of German history by consigning them to oblivion. Hindsight has shown this concern to be unfounded. The ongoing history boom of recent decades has other emphases than those contemporary critics feared, at least in the German-speaking world, where the focus is less on blind identification than on a conscious engagement with the past. This new interest in the past reacts

to the catastrophic history of the twentieth century, the age of extremes, with a dual movement of approach and distancing, which combines the recording of history with the obligation to learn from it.

This shift can be comprehended through conceptual or intellectual history. Nazi crimes against humanity were of such a magnitude that the age-old dictate of wisdom to forgive and forget—amnesty and amnesia—valid since ancient times was no longer tenable after 1945. The horrors of genocide committed in the name of Germans meant that Germany, in its endeavors for a democratic future, was under moral and political pressure not to draw a line under the Nazi breach of civilization and close the books, so to speak. This encouraged the conviction, since the 1950s, that the past should not be forgotten but must be coped with and mastered.

In keeping with this injunction, extraordinary public efforts have been made to assume the burden of the Nazi era, to see that moral justice is done, to convey a sense of historical responsibility, and to declare war on the public practice of repressing the past. And yet the term *Vergangenheitsbewältigung* ("mastering" or "coming to terms with the past") has—remarkably—seldom been applied in grappling with Germany's second major dictatorship. The expression was preempted by a term introduced by Theodor Adorno in 1959, *Vergangenheitsaufarbeitung* (working through the past). The reason for this is obvious. The term *Bewältigung* implies the hope of a final release from an awkward past, which in this day and age seems inappropriate. *Aufarbeitung*, by contrast, implies a continual engagement with the past that, despite its echoes of depth psychology, aims not at liberation from a historical burden but at nurturing its constant presence for the purpose of historical education.

The willingness in our day and age to engage in historical *Aufarbeitung* is based on the dual movement of acceptance and rejection mentioned above, which forms the core of our culture of memory in the early twenty-first century. Two tendencies converge in the powerful imperative to remember an unpleasant past: the triumph over the outrageous mentality of repressing the recent past in postwar Germany and the need to counter the "transcendental homelessness" of modernity and its all-encompassing transformative power with the affirmation of one's own roots. The paradoxical parallelism of approaching the past and distancing oneself from it has also governed our manner of dealing with the legacies of the GDR, which nowadays no longer raises the question of whether dictatorships are worth remembering at all. It is not only the fundamental difference between an essentially criminal Nazi regime and an SED regime that "merely" *committed* crimes that allows the graves of Communist Party functionaries to be revered as public memorial sites, as "places of memory," at the socialist cemetery in Berlin-Friedrichsfelde, whereas the remains of the core Nazi leadership are scattered to the four winds. Rather, the current memorial boom, regardless of the respective historical referent, contains the distinct pathos of a civil-religious authority averse to all forgetfulness, and it is precisely this that distinguishes the historical awareness after 1989 from that after 1945. The ubiquitous talk of cultures of memory expresses the self-understanding of an era that no longer grants cultural value to forgetting and knows nothing more of the "surfeit of history" that Nietzsche once warned was "hostile and dangerous to life." The willingness to remember in our day and age draws its validity from the feeling of security that comes from having the

past live alongside us as well as from having the self-assurance to refuse to forget, even when it would be more convenient to do so. Today's commemorative culture promotes dialogue with a past that we neither want to repeat nor can do without, and it is this dual nature that informs the engagement with the communist past in our democratic present.

Notes

1 Fritz Klein, *Drinnen und Draußen. Ein Historiker in der DDR* (Frankfurt am Main: Fischer, 2000), 8.

2 The term is also a play on the German word *Rechtsstaat* and might therefore be translated literally as a "state without the rule of law."

3 Ines Geipel, "Kleine, graue, miese DDR – Das Expertenpapier zur Aufarbeitung der SED-Diktatur markiert keinen Paradigmenwechsel," *Die Welt*, June 9, 2006.

4 Monika Deutz-Schroeder and Klaus Schroeder, *Soziales Paradies oder Stasi-Staat? Das DDR-Bild von Schülern - ein Ost-West-Vergleich* (Berlin: Ernst Vögel Verlag, 2008), 347.

5 Ibid., 604.

6 Marian Krüger, "Ratlose Sieger. Streifzüge durch die deutsche Erinnerungskultur," *Neues Deutschland*, January 19, 2009: 3.

Discussing the Past, or Airing the Depots: Refashioning Exhibitions of Socialism in Serbia

Olga Manojlović-Pintar and Aleksandar Ignjatović

Instead of introduction

Shortly after the October Revolution of 1917 in Russia, somewhere in the new Soviet periphery, a group of settlers established a commune that was to become a birthplace of communism and named it Chevengur. Starting a new life in the jointly achieved future, they declared "the end of the entire world's history" and promoted eternity and infinity as communal founding ideals. This is the briefest summary of Andrei Platonov's novel *Chevengur*.[1] Written in 1929, his intriguing work has never received wide public attention in the first country of socialism and for decades remained unknown to readers outside the Soviet Union.[2]

The plot begins in a time when the New Economic Policy (1921, partly liberalized market-based economic reforms) was introduced into the Soviet society and the first attempts to institutionalize the socialist state were made. For Chevengurians—who believed that revolution is a never-ending process—state interventions represented a break with revolutionary principles, a denial of the dictatorship of the proletariat, and a negation of the ideals of equality and solidarity. In an attempt to revive revolutionary ideals into the real life, they isolated themselves and eliminated those among them who were discontent with the proclaimed principles of the community. Depicting the place established "in memory of the future" and describing numerous characters and their adventures as reminiscent of Cervantes and his Don Quixote, Platonov opened one of the first artistic discussions on the utopian content of the twentieth-century ideologies. He introduced the meta-perspective that transcended the epochal and ideological myopia, and subtly recognized the shortcomings of the Soviet practice and the lack of deeper understanding among both creators and critics of the socialist reality.

Decades after Platonov wrote his novel—describing Chevengurian utopia as a nonexisting and unreachable place, which nevertheless mirrored the contemporaneous Soviet society—it still represents one of the most profound thoughts about the human imagination of the communist ideal and the attempts of its practical realization. With the passage of time and in accordance to the ideological contexts, *Chevengur* was perceived as a revolutionary but also a contra-revolutionary text, as engaged, and as

l'art pour l'artistic, labeled as Stalinist as well as Trotskyist. Frederic Jameson argued that a reason why both "Utopians and anti-Utopians can appeal alike" to Platonov's novel, lies in the fact that "two kinds of traumas that make up the arsenal of arguments against social revolution, manly violence itself, and also the repression of the nonclass 'identities' of marginality and gender" have found expression in it.[3] Jameson understood Platonov's description of oppression and cruelty in Chevengur as an unavoidable, even essential part of the Utopian text and concluded that "if one wishes to avoid thinking about suffering and misery, one must also avoid thinking about the Utopian text, which necessarily carries their expression within itself in order to constitute the wish fulfillment of their abolition."[4] For him, the Utopian vision is a reactive rather than contemplative and metaphysical, and represents "collective expression of need in the most immediate form rather than some idle conception of the perfect."[5] Finally, he found the last pages of the novel describing the faceless aggressors and the total destruction of the commune compatible with Wallerstein's interpretation of "socialist regimes in the era of the Cold War as the sum of the anti-systematic movements within the force field of a capitalist world system itself."

Opening the question of the musealization of socialism based on Jameson's reading of Platonov introduces a new interpretational framework. Constructed in order to establish the distance toward the past and at the same time to embrace it and integrate it into the state created historical continuity, museums of socialism represent constituting elements of the contemporary European societies. Although before 1989 the "death" of museums as institutions was expected and even declared, they have been revived, regaining their valuable position. Moreover, since the proclamation of "the end of history," precisely the museums of communism became the most important sites in presenting socialism as a culturally inferior "other" and, consequently, the crucial institutions in constructing the image of the past and defining the new ideological principles at the beginning of the consumeristic "regression into private life." As theorist and psychoanalyst Boris Buden has put it: "The historical project of the universal emancipation (i.e., communism) is transferred into a particular cultural identity and presented as a traumatic experience of the cultural difference." The museums of communism became spaces in which simultaneous caricature representation of the socialist past as a burlesque and as a tragedy made even further discrediting of these societies in the present possible.[6]

Numerous public narratives on socialism, ranging from ridicule and total denunciations to nostalgic memories and idealizations, and finally to its equation with fascism as two totalitarian ideologies of the twentieth century have been the product of the various memories of the socialist experience. Different interpretations were the outcome of long and complex legacies and diverse historical and political contexts in the political entity once defined as "the Eastern Bloc." Regardless the evident cultural and historical differences, which further developed during the process of social and political transformation, and disparate historical experiences were shaped within the one single ideological framework, in the same way as *Chevengur*, like "all the Soviet works of any literary quality have been filtered on their transmission to the West" and labeled as anti-communist.[7]

Contemporary proclamation of the plurality of historical discourses and perspectives seems to contradict present global hegemonic image of communism, which is crucially defining the process of the new cultural and political construction. Established social and political consensus depicted the socialist experience as a historical dead-end and an ideological cul-de-sac. Mediated by museums of communism and a variety of other mediums, generations who did not live through the communist era are instructed to remember socialism through simplified and trivialized images combining naiveté and cruelty. In the public field, socialism has been primarily described as an irrational and unproductive system ultimately destined for failure.

This chapter examines how the representational museum politics creates a system of meanings by defining socialism as the "other" in opposition to which the new collective identity is in a process of constant reconstruction after the fall of the Berlin Wall. Focusing on the work of one specific museum institution—the Museum of Yugoslavia, known as the Museum of Yugoslav History until 2016—we discuss a process of revalorizing socialism, communism, and Yugoslavia in present-day Serbia. We place the work of this specific museum in the wider institutional, historical, and artistic network of socialist Yugoslavia and contemporary Serbia.

The case study of the Museum of Yugoslav History

In May 1962, the May 25th Museum was opened as the city of Belgrade's present to Josip Broz Tito for his seventieth birthday. It was established in order to house and display gifts that the Yugoslav president received from international politicians, public figures, Yugoslav citizens, political organizations, diverse companies, and unions and soon became one of the constitutive elements of the Yugoslav socialist identity. The museum represented an important part of the symbolic topography of the socialist society. The politics of the museum, as one of the most significant institutions supporting the concept of Yugoslav identity, was based on three cornerstones: the ideology of "brotherhood and unity" (*bratstvo i jedinstvo*); a unique concept of economy, management, and social organization named "self-management" (*samoupravljanje*); and Yugoslav foreign policy defined through the active participation in the Non-Aligned Movement (*nesvrstavanje*). Maintaining and representing particular artifacts along with Tito's personal documents and the Archive of the Presidential Cabinet, the museum became one of the most important institutions displaying and symbolically reinforcing Yugoslav distinctiveness.

In a prominent place in the interior of the museum building an interesting mural was created. Rendered in a somewhat abstract manner, it depicted a grand map, a gleaming white-and-gold representation of the world. The map on the wall was, indeed, the proper context for framing the museum's collection: it depicted the world's continents, neatly named and outlined in white, and surrounded by golden-brown oceans. The map was dotted with glittering labels indicating, by year, Tito's visits to the countries of Europe, Asia, Africa, and North America up to 1962, when the museum was opened as an outstanding architectural example of Yugoslav socialist modernism.[8]

Interestingly, this representation of the world, symbolically "conquered" by the Yugoslav president, was cut off at the Equator so that only the northern hemisphere was visible. Unmistakably aimed at visually representing Tito's diplomatic journeys, the map was depicted as being open to further inscriptions, clearly indicating the developing Non-Aligned policy and the country's both coveted and actual position, as a mediator between the communist and the capitalist worlds.

From today's perspective though, the map seems intriguingly evocative of utopia: glittering gold and white represented more a transcendent world without countries and borders, much more than the usual imagery of the "real" world. The narrative of the map speaks of a territory that was not, as any other map, simply charted. Instead, it was a system of signs structured by codes of understanding that represented a space imagined in the same fashion as history spoken for time—it did not simply reflect, but rather constructed the image of the past.[9] Thus, the map epitomized the contemporaneous self-perception of Yugoslavia as having an intermediary role in a perplexed and confronted political reality of the Cold War. At the same time, it also symbolized the understanding of the world as a remote realm rapidly "getting closer" to Yugoslav citizens. The map was a political and cultural creation, an artifice of ideological self-interest and self-promotion, which was framing the Yugoslavs' new identity.

With the dissolution of the Socialist Federal Republic of Yugoslavia in 1991, the map and the world it symbolized, along with the museum it formed a central part of, was readily removed from the political realm. Five years later, the museum building, which had been neglected and marginalized for years, became the seat of a new institution—the Museum of Yugoslav History. It was formed by the fusion of two museum institutions, the Museum of the Revolution of the Yugoslav Nations and Nationalities and the Memorial Centre "Josip Broz Tito," in an attempt to rediscuss socialism and Yugoslavia—two crucial political concepts of the Western Balkans in the twentieth century.[10] The museum aimed to display, interpret, and frame the history of socialist Yugoslavia.[11] Undoubtedly, the Museum of Yugoslav History was a unique example of how the recent past has been imagined and represented in the post-socialist Serbia. Its profoundly rich holdings include over 200,000 objects divided into twenty-three collections illustrating twentieth-century Yugoslav history, with a special emphasis on the life and work of Josip Broz Tito.

In the first decade of its existence, the Museum of Yugoslav History passed through two distinctive phases. The first, ended with the year 2000 and the fall of Slobodan Milošević's regime.[12] During this period the Museum did not produce a recognizable paradigm of Yugoslav history. It was almost frozen in time and only partially reflected a general transformation of cultural values, established social and cultural norms, and historical imagination that had characterized the Federal Republic of Yugoslavia.[13] This was the period of the "discreditable," "mock" "socialism," when the terms "socialism" (in the name of the ruling Socialist Party of Serbia) and "Yugoslavia" (in the name of the Federal Republic of Yugoslavia) were both retained, while the regime effectively deconstructed their essential meanings and contents.[14]

In the second phase, which lasted until Serbia and Montenegro ceased to exist as a state in 2006, initial attempts to consolidate the museum institution were made

through several exhibitions that represented a kind of "airing out of the museum depots" and searching for the new interpretations of the past.[15] When that same year Slobodan Milošević died in the prison cell in the Scheveningen and his body was displayed for public mourning in the museum hall by government decree, the ideological bewilderment in evaluating twentieth-century heritage reached its peak. Serbian society, confused about its new post-Yugoslav and post-socialist identity, required a consensus concerning the past, just like other ex-Yugoslav republics did. In such a situation the new reorganization of the museum followed in 2007. Although its exhibiting space was further reduced, this change actually encouraged the search for new concepts and a new politics of the memorization of the past.[16] Since then, the museum has had numerous temporary exhibitions that have dealt with Yugoslavia's mainly cultural and not necessarily political heritage and its socialist past in an unconventional fashion. During the Museum's slow transformation, despite limited public influence, these exhibitions represented an important part of the process of questioning the past and taking a stance on these social and political issues.

Although the exhibitions organized in the museum were thematically heterogeneous (both in scope and significance), they represented a rare public reflection on the socialist past by Serbia's official museum institutions in that period. Given that a specific museum of communism was never established in Serbia, the exhibitions held in the Museum of Yugoslav History represented a rare reflection on that topic. In that sense, it is worth mentioning some examples of historical exhibitions where the context of Yugoslavia was undeniably connected to its socialist past and its communist identity: *Tito's New Years* (2008), *World of Silver* (2008), *Hunting Arms of Josip Broz Tito* (2009), *Death in a Treasury (A Comparative History of the Museums and the State)* (2009), *The Tito Effect: Charisma as Political Legitimacy* (2009), *Tito Photo* (2010), *Yugo—A Short Autobiography* (2010)[17], *Yoko, Lennon, Tito* (2010), *Women's Corner* (2010), *Youth, Alternative and Pop Culture in Yugoslavia from 1977 to 1984* (2011), *Poussin and the Red Star* (2012), *Comrade President's Collection of Paintings* (2012), *The Porcelain Gleam of Socialism* (2013), *Creating the Myth of Tito* (2014), *The Grand Illusion – Tito and 24 million metres of celluloid* (2014), *Design for a New World* (2015), amongst others. Conspicuously avoiding a critical and reflexive approach, the content of some of these exhibitions led visitors to diametrically opposed conclusions (in accordance with their preexisting ideological standpoints and attitudes), which significantly diminished an opportunity to provoke wider public dialogue. Nuanced with a combination of nostalgia and sarcasm, they kept the public away from raising controversial questions related both to the historical experience of Yugoslavia and socialism, as well as the history of their destruction and ideological, political and cultural legacy. This is witnessed not only by the reluctance to critically interpret the socialist and Yugoslav past but also by turning a blind eye to dubious interpretations of the Yugoslav wars of the 1990s.[18] Nevertheless, these exhibitions preempted a complete banalization and criminalization of the whole historical period of socialism, which appeared in numerous museums of communism in former socialist Eastern European countries.

At the same time, the museum hosted numerous international art exhibitions: the *October Salon*, the annual major international artistic event in Serbia; *Imperial*

Chinese Bronze (2006), an exhibition of ancient Chinese bronze art; *Parallel Stories: Masterpieces of Modern and Contemporary Art from the Collection of the Museum of Contemporary Art, Saint Etienne* (2007); *Behind the Iron Curtain: Official and Independent Art in the Soviet Union and Poland, 1945–1989* (2010); *Beijing-Belgrade: New Sights in Chinese Contemporary Art* (2013); *Neo NOB* (2014);[19] *100 Works from the Collection of the Museum of Contemporary Art* (2014); *Russian Avant-Garde in Belgrade* (2015–2016); and *Young Poland: Afterimages of History* (2016), amongst others. Some of these, although focused on a completely different set of topics, touched indirectly on the problematic legacy of the past. In that respect the most conspicuous example was the exhibition *Behind the Iron Curtain* (2012), which was organized in cooperation with the Polish Modern Art Foundation from Warsaw. Although the Polish curators' initial idea was to present the official and the independent, the representative and the forbidden art of the Soviet Union, Poland, and Yugoslavia from the Cold War era, the management and the curators of the museum asserted that Yugoslav art was never hidden behind the Iron Curtain, due to the state's specific position in the divided world. Moreover, the museum insisted that art was the main link fastening Yugoslav connections with both East and West. The museum advocated the idea of Yugoslavia as the tower on the wall created in Europe between the East and the West during the Cold War.[20] They insisted that although Winston Churchill in his famous Westminster College/Fulton speech on March 5, 1946 mentioned Belgrade among other Eastern European cities separated from the Western liberal democracies by the Iron Curtain, further political realities facilitated Yugoslavia's remarkably specific position on the international scene.

Regardless of the numerous and heterogeneous museum activities, the representation of the recent traumatic past of Yugoslav dissolution, as well as the representation of socialist history in Serbian public space stayed vague and unclear. This became obvious at the end of 2012 when the museum opened the temporary exhibition: *Yugoslavia: From the Beginning to the End*, which was structured to provide the space for discussions on the historical perceptions and interpretations of the entire Yugoslav heritage. It was defined as a "work in progress," as an exterior for the academic and political discussions on the seven-decades-long period of the existence of "two Yugoslavias." The thematic structuring of the exhibition defined six chapters, which were to represent the general framework for the debates: "Yugoslavia—Personal ID"; "Yugoslav Peoples"; "Two Faces of the Regime"; "Yugoslavia in the World, the World in Yugoslavia"; "Economy and Society"; and "The End of Yugoslavia." The authors of the exhibition established the continuity of the two regimes and social systems and opened thematic windows lightening up paradigmatic historical events and personalities. The idea to establish the museum forum and to initiate the discussions on Yugoslavia was not fully understood by the public. Rather it was perceived as the final solution only partly realized. The exhibition concept raised the critiques and the most important was that it did not represent the complexity of the Second World War and the tragic wars of the 1990s. In addition, it was stressed that the central space at the exhibition was given to the representation of terror and oppression in socialist Yugoslavia, without clearly presenting the political context during the Second World War.[21] It was perceived as mainly tracing the complex relationship between Serbia and

Croatia, its peoples and political leaders, instead of presenting the Yugoslav national diversity and cultural heterogeneity.

The official answer of the authors and curators was that the wars were excluded from the presentation as a specific chapter, since during the wars Yugoslavia did not exist. The discourses of war were to be integrated in the thematic chapters that covered the wider social and cultural phenomena. Stating that "all the memories are equal," the curators ostensibly tended to present the plurality of perspectives and the complexity of the society in the past. However, part of the academic public perceived those answers as misleading and as a relativization supporting a simplified insight into the past and a clear-cut ideological construction. The main idea of the museum, though, was to use expected heated debates on the temporary exhibition for the creation of the permanent one. The museum forum was to be opened for different dialogues on defined topic. The fact that three of the four reviewers were from different ex-Yugoslav academic centers was emphasized as the most important point in reflecting the openness and willingness of the museum staff and management to widener historical perspectives. However, the proposed solution remained without the expected resonance, because it was characterized as an inappropriate framework for deeper debate.[22]

Following the initiative to broaden the "spectre of research and musealization" toward different phenomena that "marked the Yugoslav heritage and experience," the museum changed its name to the Museum of Yugoslavia in 2016.[23] That this nominal transition meant a shift of the museum's focus from history to a more elastic and encompassing specter of research, which would justify not only the museum's highly diversified exhibition policy but also the shifting and sometimes dubious view on Yugoslav history, is yet to be seen. This decision was also the result of the years-long initiatives of the museum employees stressing that the original name did not correspond with the content of the museum funds and created a great deal of confusion with the Historical Museum of Serbia, which was established in Belgrade in 1963. Renaming the museum twenty years after its establishment represented an act of the significant emancipation of the museum curators and management who followed their own understanding of the institution, instead of accepting political decisions of the often incompetent bureaucrats and conservative historians. Since then, the Museum of Yugoslavia has invited the public to the exhibitions *Yuga, my Yuga* (2016), *Tito in Africa – picturing solidarity* (2017), and *Cities on the Move: Post-Ottoman Istanbul, Ankara, Belgrade and Sarajevo* (2017–2018). It also offered a rather private photographic experience on the dissolution of Yugoslavia with the exhibition *Lessons from '91* (2017), showing "the photographs taken on all sides of the war."[24]

Curiously enough, the Museum of Yugoslavia still has no permanent exhibition, although it has struggled to make one over the last couple of years. The work on the permanent exhibition started in 2009 with a project called the New Old Museum, which "through a series of discussion programs, initiated the process of auto reflection and redefinition of the Museum."[25] Its result was the already mentioned exhibition *Yugoslavia from the Beginning to the End* set up in 2012 and the still ongoing project curiously called the Laboratory of the Museum of Yugoslavia, initiated in May 2017. "The Laboratory" can be seen as a terminal phase of the years-long pursuit of a coherent narrative on the stunningly diverse and complex Yugoslav political, social,

and cultural experience. The thematic chapters of the future permanent exhibition defined in the laboratory are defined as: Yugoslavism, Symbols, Revolution and Anti-Fascism, Non-Alignment, Modernization and Emancipation, Democratization and the International Culture, Patriotism and the Personality Cult, and Disintegration and the Post-Yugoslav Space. Although the intention was to open the permanent exhibition in December 2018, on the occasion of the one hundred years of the establishment of the Yugoslav state, the lack of funding has prevented its realization.

The museum network and the "translation" of the historical legacy

The case of the Museum of Yugoslavia cannot be fully comprehended without considering the entire network of the museums existing in Serbia (and in Belgrade in particular). The lack of consensus about recent history among the Serbian public is buttressed by the variety of evidence available, including history discourses, which is without question the most glaring example.[26] Today, in the Serbian capital, there are more than forty museums, as officially registered. Nevertheless, the most prominent museum institutions in Belgrade, which have a long, prosperous history—such as the National Museum and the Museum of Contemporary Art—were closed for more than a decade and only recently reopened to the public. The National Museum was locked for fifteen years (2003–2018), while the Museum of Contemporary Art opened its door after a ten-year hiatus (2007–2017). Significantly, new permanent exhibitions in both museums, organized in a simple chronological fashion, are characterized by conspicuous deficiency of critical insight.[27] On the other hand, lacking either a proper exhibition space or a permanent exhibition, the most important historical museums—such as the History Museum of Serbia and the Museum of the City of Belgrade—occupy a marginal place in the public discourse. Temporary thematic exhibitions, which these museums have organized since 2000, scarcely dealt with the period framed between the years 1941 and 1991.[28] In such a context, where there is no recognizable paradigm of history and active, socially sensible and sustainable interpretation of the socialist past, major museums clearly reflect the contemporary political and ideological vacuum as regards the policy toward the history of socialist Yugoslavia. The critical political question of the undefined state borders is present as a matter of constant contention that prevents a consensus on the representation of contemporary history. The borders (in terms of political and cultural boundaries)—as the imperative objective and fairly ubiquitous form of democratic structure and political and ideological rationale—are, after two decades, still an unsolved question.[29] This fact could be understood not only as the cause but also as the consequence of an inadequate social dialogue on history and the past, which was only amplified by the resonance of the recent wars (1991–1999).

Furthermore, one cannot neglect that the museum narratives created during the socialist period constructed a strong ideological frame and cultural identity, which is difficult to deny even three decades later. In it, the role of art as the decisive element in the representation and construction of the ideology of Yugoslavism and socialism could be regarded as tremendous. Namely, the discourses of interwar

Yugoslav art as well as of art in post-1948 Yugoslavia were given very ambitious roles, as art and its musealization became inextricably coupled with the construction of Yugoslavia as a new, unique state. Especially since the early 1950s, when Yugoslav communists started implementing different forms of social, economic, and political systems related to what was perceived as "socialist democracy," art was systematically involved in the construction and legitimization of the Yugoslav version of socialism, which was presented as more authentically socialist than that of any other socialist country and more democratic than Western liberalism. Since the 1950s, art production and representation became openly exposed to all kinds of influences, but the predominant one was mainstream Western modernism, which was adopted and tailored to suit representational purposes, narrating Yugoslav socialism with a "human face."[30] To describe this developing discourse on art, the critics have coined the term "socialist aestheticism,"[31] which was initially related to post-1950s Yugoslav literature, to be later adopted and used in art and (sporadically) architectural criticism and historiography. It usually refers to an aestheticized project of art as an autonomous realm in the context of socialist Yugoslavia, allegedly beyond the influence of ideology and politics, in sharp poetic, formal, and stylistic contrast to the official representative culture of the other socialist societies, which was often essentialized as "socialist realism." At the same time, Yugoslav socialist aestheticism was understood and publicly presented as being different from mainstream Western modernism, due to its heightened aesthetic sensitivity, freedom of artistic creation, and alleged detachment from politics and ideology.

Opposite from the state-sponsored "socialist aestheticism" that became the foundation of the museum policy and of the official state and social representation, an expanding politically engaged artistic practice—although monitored, strongly criticized, and even censored by the state and party officials—had its public and political resonance as well. From the (un)successful attempt of staging the play *Waiting for Godot* in 1954 (only a year after its Paris premiere)[32] to painter Mića Popović's censored work *The Ceremonial Picture* in 1974, the prohibitions were paradoxically opening a wider space for social liberalization and democratization in Yugoslavia. "Dissident" artistic practices and the "Black Wave" in film and literature constantly challenged the elites in power. In the complex federal state, it was always possible to find an open space for unofficial interpretational practices and innovative artistic ventures in a perpetual (utopian) search for the original meanings of communism. Literature, art, performance art, and film probably have been the strongest and most recognizable buckle connecting Yugoslavia with other avant-garde and "dissident" artistic projects. Although on the margins, they crucially coined the concept of multiple identities. This interplay of the official, avant-garde and "dissident" art created a specific cultural sphere that characterized socialist Yugoslavia. A diachronic perspective may reveal how the political, cultural, and social dimensions of socialism were constructed and transformed in Serbian museums and how these features were inextricably intertwined with Yugoslavism as the most important subject of Serbian modern history. One could even assume that there was an interpretational (as well as ideological) symbiosis of socialism and Yugoslavism in public discourse, popular culture, and the academic sphere.

Artistic practices were constantly questioning Yugoslavism and socialism, perceiving them as two inextricably linked political phenomena sharing the same historical origins. A long process of the construction, dissemination, and transformation of the ideas of socialism, communism, and Yugoslavism, faced various models of representation. Essentially supplementing each other, they passed different chronological phases and competing forms of reception, continuously shaping perplexing representational policies of the past. Thus, the declaration of an authentic Yugoslav form of socialism after the Second World War was presented not only throughout the history and pre-history of the Stalin–Tito split of 1948 and the state communists' insistence on the authenticity of the Yugoslav socialist revolution and Peoples' Liberation Struggle during the Second World War, but on the specific way of the musealization of art and history. Such an ideological and cultural syncretism within the established Yugoslav cultural context was represented as one of the bolstering elements for the birth of Yugoslav self-managed socialism.

With the dissolution of the Socialist Federal Republic of Yugoslavia its recognizable history discourse and a museum policy was utterly abandoned. The wars of the 1990s crucially influenced this "silencing." The fact that apart from the Museum of Yugoslav History, the only museum opened after the dissolution of Yugoslavia has been the Museum of the Victims of Genocide represents the most notable testimony to the same phenomenon.[33] While in Europe the year 1989 paved the way for the new interpretations of communism and socialism, in the ex-Yugoslav context the crucial European watershed became the penultimate year of peace. The ensuing wars overshadowed the global aftermath of the fall of the Iron Curtain, and yet another layer was added to "the burden of the socialist past." Numerous disputes over the socialist legacy of the multinational Yugoslav society were constantly strengthening various radical political aspirations. At the same time, war trauma has given a special meaning to Yugoslav history, becoming a keystone of the new national narratives and sharply influencing the perception and interpretation of socialism and communism. One cannot neglect this substantive reason why, while the "renaissance" of European museums started in 1989, the museum practice in Serbia was unable to fit into it and stayed almost ossified for years.[34] Even the political transition of 2000, when the regime of Slobodan Milošević was toppled, did not lead to the opening of new museums, including those that would represent the state's socialist past. Instead, some of the most distinguished and renowned museums, as already mentioned, were inexplicably closed for years. Such a phenomenon suggests that Serbia only partly adopted the common post-communist paradigm in which the museological construction of identity is based on an "allegiance to Europe" and the critique of the socialist past focused on the totalitarian nature of the communist regimes.

Indeed, the Yugoslav experience of socialism, which destabilized and deconstructed the monolithic image of Eastern Europe during the world's bipolar division was transferred in a paradoxical way to the Serbian case today, tackling the dominant post-Cold War European narrative. The specificities of Yugoslav socialism testify to the heterogeneity of the socialist experience, which, as already stressed, though ideologically congruent, had different forms and content in different cultural contexts and traditions.[35] The local context in present-day Serbia is both a result of the specific

historical development and a reflection of the "whirlwind of hope and despair, possibility and frustration that characterizes political life and social worlds,"[36] and as such it contributes to a multifaceted perception and interpretation of socialism from the Baltic to Central Europe and the Balkans.[37]

On the other hand, the long-lasting process of the nationalization of history, which peaked with the attempts to nationalize the anti-fascist movements in most formerly socialist societies in Europe and in former Yugoslav republics, is legitimized in some contemporary museum exhibitions in Serbia.[38] The museum focus is transferred to the victims of the Second World War with crucial reference to their national identity. Promoting the politics of the national reconciliation the term "victim" has often been expanded to include all those members of the nation who died during the war, regardless of their ideological standpoint and military involvement. The concept of the individualization of the victims and the presentation of their suffering is misused to legitimize the new political realities produced after the break-up of Yugoslavia and the deconstruction of socialism. The victims of the Second World War are personalized in the local museums, through photographs, personal belongings, and their letters written just before the shooting. However, this concept is simultaneously used to denounce the multinational anti-fascist partisan movement and its political and military activities during the war, holding it responsible for civilians' suffering. Civilian victims of the mass killings in Serbian towns in the post-socialist war narrative were given names and faces, but the responsibility for their killings is divided between Nazis and their collaborators on the one side and communists, whose rebellious actions are treated as provocations that invited acts of revenge, on the other. The new exhibiting policies of some local museums are among the best examples of how the refashioned museum practice constructed the new historical narratives.[39]

In the same interpretational framework lies a standard, globally widespread narrative on communism as a product of a modern totalitarian mind, a kind of fascism's ideological sibling.[40] This perspective shared similar notions about the utopian character of both Yugoslavism and communism and leads to the complete denial of the value system that had been the bedrock of Yugoslavia—universalism, social justice, anti-imperialism, and global equality. Perceiving socialism as "alien to the nation" and a "historical side-track," these adverse reactions encouraged the rise of nationalism and the elite's staunch reluctance to face the recent past. The main promoters of this discourse were actually reviving the interpretation of the Second World War that made fascist collaborators into victims of communism and tragic historical figures.[41]

Finally, the third concept of the perception and interpretation of communism could be considered a part of the global phenomenon of post-communist nostalgia, opposing strong ideological equalization of communism with fascism.[42] In Serbia post-communist nostalgia is barely explored, as it is not so dissimilar to the widely spread Yugonostalgia, which further reinforces the aforementioned ideological and interpretative symbiosis of socialism and Yugoslavism.[43] Even most of the exhibitions related to socialism and Yugoslavia held in the Museum of Yugoslavia attract two main types of visitors: Yugo-nostalgics from various parts of the former Yugoslavia and foreign tourists.

Conclusion

The dissolution of Yugoslavia and the fall of socialism in Europe strengthened the revisionist historical interpretations that changed images of the past in order to constitute the new political realities in the present and to legitimize their historical roots. The museum policy in contemporary Serbia only partly follows the dominant global narratives based on the attempts to completely discredit socialist heritage. The strong legacy of the Yugoslav self-managed socialism still has a potential to deconstruct the monolith interpretation of the past. The case of the Museum of Yugoslavia discussed in this text is a glaring example of an institution that is struggling to open the forum for continuous dialogue of the dissonant historical legacy. The attempts of the Museum curators and management to constitute the original historical narrative and to revive the emancipatory politics of the socialist past are facing numerous obstacles, often being only superficial episodes that have no further influence on the frozen and silenced museum network in contemporary Serbia.

However, the highly controversial "museum question" has attracted wider public attention in Serbia in the last few years. The academic groups dealing with the phenomenon of heritology and museology have provided important analyses of this problem.[44] Simultaneously, the "platform for activist, theoretical and artistic practice that deals with the analysis and understanding of the contemporary phenomena of the (post)Fascist ideologies, politics, practices" was established in Belgrade. It organized numerous seminars and round-table discussions on the contemporary museums policy. The organizer of the project named Fascism, Musealization and Education Today was the Cultural Centre Rex. Their analysis intertwined the recent global trends in musealization of socialism with the thorough analyses of the museum narratives in Serbia.[45] The project explored various museum exhibitions in Serbia, in the region of the Western Balkans, Spain, Hungary, and Germany with the aim of understanding and explaining "the historical and current Fascisms, as well as the Fascism inclining or related ideological and political positions." The final result of the program was the publication *Political Extremism in the Museums in Serbia* that questioned the alleged ideological neutrality in the museum presentations.[46] The main idea of the project was not only to analyze the existing museum practices, but to reaffirm the neglected heritage of both Yugoslavia and socialism, to produce an alternative vision of twentieth-century history, and finally to constitute the new contemporary ideological framework that would oppose the globally dominant "There Is No Alternative" concept. Thus, discussing contemporary museum reconstructions, refashions, and revisions provided a field for the political reconstitution of the new, although completely marginal, leftist actors and agents in the political life of Serbia.

Notes

1 Andrey Platonov was the pen name of Andrei Platonovich Klimentov (1899–1951), author of several novels and stories. The most important are considered to be his novels *Chevengur*, *The Foundation Pit*, and *The Origin of the Master*. On Andrei

Platonov's work see articles in the *New Left Review*: Tony Wood, "Annals of Utopia," *New Left Review*, no. 33 (May–June 2005): 118–132; "Introduction to Platonov Screenplay," and Andrei Platonov, "Father – Mother," *New Left Review*, no. 53 (September–October 2008); "Introduction to Platonov," and Andrei Platonov, "On the First Socialist Tragedy," *New Left Review*, no. 69 (May–June 2011).

2 In 1978, the novel on Chevengurians was first published in English. A decade later, Perestroika made its integral version available to Soviet readers, shortly before the victory of liberal democracy proclaimed the end of socialism both as an utopian idea and as a political project. See Andrei Platonov, *Chevengur*, translated by Anthony Olcott (Ann Arbor, MI: Ardis, 1978).

3 Frederic Jameson, "Utopia, Modernism and Death," in *The Seeds of Time: The Wellek Library Lectures at the University of California* (New York: Columbia University Press, 1994), 104–105.

4 Ibid., 102.

5 Ibid., 101.

6 Boris Buden, "U cipelama komunizma, Nekoliko napomena o mehanizmu poskomunističke normalizacije," *Up&Underground*, no. 7/8 (2003). http://www.up-underground.com/brojevi/07-08/u-cipelama-komunizma-nekoliko-napomena-o-mehanizmu-postkomunisticke-normalizacije/ (accessed July 23, 2017).

7 Jameson, "Utopia, Modernism and Death," 114.

8 For the museum building and its functions in the political landscape of socialist Yugoslavia, see Aleksandar Ignjatović, "Otvaranje i popularizacija: Muzej 25. maj i transformacija prostora Dedinja," in Olga Manojlović-Pintar, Mile Bjelajac, and Radmila Radić (eds.), *Tito—viđenja i tumačenja* (Belgrade: Institut za noviju istoriju Srbije i Arhiv Jugoslavije, 2011), 601–614.

9 On the political invention of the historical continuity, see Larry Wolff, *The Idea of Galicia: History and Fantasy in Habsburg Political Culture* (Stanford, CA: Stanford University Press, 2010).

10 The Memorial Center "Josip Broz Tito" was established in 1982, two years after Tito's death, and included the May 25th Museum with the surrounding residential facilities and Tito's burial place in the House of Flowers, along with his birth house in the village Kumrovec and his summer and winter residences. See Vladimir Kulić, "The Land of the In-Between: Modern Architecture and the State in Socialist Yugoslavia, 1945–65" (PhD dissertation, University of Texas, 2009).

11 The Museum of Yugoslav History, founded in 1996, is a successor of the May 25th Museum (from 1982 transformed into The Memorial Center "Josip Broz Tito") and the Museum of the Revolution of Yugoslav Nations and Nationalities. Today, after the long period of social, political, and economic transition, the museum complex encompasses the building of the former May 25th Museum, the House of Flowers—Tito's burial place—and two residential palaces near the museum. See Olga Manojlović-Pintar and Aleksandar Ignjatović, "National Museums in Serbia: A Story of Intertwined Identities," in Peter Aronsson and Gabriella Elgenius (eds.), *Building National Museums in Europe, 1750–2010* (Linköping: Linköping University Electronic Press, 2011), 779–815.

12 During that period the museum became the unofficial private property of Slobodan Milošević, Yugoslav president at that time, and his family. More precisely, two residential villas, with numerous artworks and artifacts and the unique sculptures in the surrounding park, which were an integral parts of the museum, were in use by the Milošević family. Although an important part of the memorial complex and a

space for storage of museum artifacts and belongings, the villas underwent extensive renovation under the instructions of the Milošević family. The former memorial center was divided by a tall wall, which separated the new museum space from Milošević's residential area. During the NATO bombing of Yugoslavia in 1999, one of the villas, the Old Residence, was completely destroyed, and Milošević and his family moved into the Peace Villa, where they lived until March 2001, when he was arrested.

13 The Federal Republic of Yugoslavia was one of the successor states of the Socialist Federal Republic of Yugoslavia and it consisted of the two republics: Serbia and Montenegro. It existed from 1992 until 2003. It was renamed Serbia and Montenegro in 2003 and ceased to exist in 2006.

14 The artist Mrđan Bajić was among the first to delve into this issue. Between 1998 and 2000, he created *Yugomuzej* (referring to a "Yugoslav Museum"), an online art project of a virtual museum that exhibits and keeps artifacts concerning socialist Yugoslavia. Mrdjan Bajić, *Backup* (Belgrade: Cicero, 2006), http://mrdjanbajic.net/mrdjanbajic_x/backup-06.pdf (accessed September 10, 2019).

15 Some of the most visited exhibitions during the second phase were *DO, UT, DES: Archaeological Artifacts and Archival Photos from the Josip Broz Tito Collection* (2003); *Belgrade is Free: Sixty Years from the Liberation of Belgrade* (2004); *May 9th—Victory Day* (2005); and *Moving Images of the Eternity: Watches from the Museum of Yugoslav History Collections* (2005).

16 Namely, a downtown gallery once belonging to the Museum of the Revolution was withheld from the Museum of Yugoslav History and assigned to the Historical Museum of Serbia. Yet the museum's artifacts remained the property of the Museum of Yugoslav History.

17 A Yugo was a subcompact automobile built by the Zastava Corporation, a well-known model was sold even in the United States and is remembered today with a mixture of irony and nostalgia.

18 Ironically, in 2014 the museum hosted—under the patronage of the government of the Republic of Serbia—the exhibition called *Serbia through Centuries: (Un)expected Stories from the History of Serbia* (2014), which was totally unrelated to Serbia's decades-long Yugoslav experience. The exhibition was organized "to mark Sretenje, Serbian National Statehood Day," which has strong religious and political connotations that have marked recent Serbian political transitions. See Museum of Yugoslavia, "Serbia Through Centuries," 2014, https://www.muzej-jugoslavije.org/en/exhibition/srbija-kroz-vekove-2/ (accessed September 10, 2019).

19 The name of this exhibition by sculptor Ivan Fijolić referred to the National Liberation Struggle (Narodnooslobodilačka borba, NOB), while its thematic scope was dubiously connected to Yugoslav heritage, connecting what the curators have described as heroes of pop culture from Rambo to Tito, see Museum of Yugoslavia, "NEO N.O.B.," 2014, https://www.muzej-jugoslavije.org/en/exhibition/neo-n-o-b/ (accessed September 10, 2019).

20 See Predrag J. Marković, *Beograd između istoka i zapada 1948—1965* (Belgrade: Službeni glasnik, 1996).

21 The question of the repression in the socialist Yugoslavia although extensively elaborated in numerous literary and autobiographical works during the 1980s and 1990s, and in the cinema, was never presented at any museum exhibition before the exhibition in the MYH. The Museum of the History of Serbia opened such an exhibition ("In the name of the People") in the spring of 2014. The organizers and authors of the exhibition invited the public to take the active part in its preparation

in the virtual space by opening a facebook account as a forum for discussions. The answer of the leftist organizations and anti-facist activists was huge and the debate run during the whole year clearly showing the "problem of contextualization" as the biggest issue in representing this topic to the public at this specific political moment. See "U ime naroda za slobodnu Srbiju," Facebook, https://www.facebook.com/pages/U-ime-naroda-represija-u-Srbiji-44-53/521861327852518 (accessed September 10, 2019).

22 *Jugoslavija od početka do kraja, katalog izložbe, Beograd 01. 12. 2012–17. 03. 2013* (Belgrade: Muzej istorije Jugoslavije, 2013).

23 As stated in the museum's director speech, see Sonja Ćirić, "Staro i novo," *Vreme*, December 1, 2016, https://www.vreme.com/cms/view.php?id=1447185< (accessed September 10, 2019); Neven Džodan, "Muzej istorije Jugoslavije menja ime," *Blic*, December 1, 2016, https://www.blic.rs/kultura/vesti/muzej-istorije-jugoslavije-menja-ime/px0sxyp (accessed September 10, 2019).

24 Museum of Yugoslavia, "Lessons from '91," 2017, https://www.muzej-jugoslavije.org/en/exhibition/izlozba-lekcije-iz-91/ (accessed September 10, 2019).

25 Museum of Yugoslavia, "The Work on the Museum of Yugoslavia's Permanent Exhibition," https://www.muzej-jugoslavije.org/en/work-museum-yugoslavia-s-permanent-exhibition/ (accessed September 10, 2019).

26 See Aleksandar Ignjatović and Olga Manojlović-Pintar, "Muzeji Beograda i koncept suočavanja sa prošlošću," in Ana Stolić (ed.), *Muzeji kao mesta pomirenja. Zbornik radova sa 8. kolokvijuma Međunarodne asocijacije istorijskih muzeja* (Belgrade: Istorijski muzej Srbije, 2010), 129–137.

27 See Manojlović-Pintar and Ignjatović, "National Museums in Serbia," 779–815.

28 See, for instance, Jessica Greenberg, "'There's Nothing Anyone Can Do about It': Participation, Apathy, and 'Successful' Democratic Transition in Postsocialist Serbia," *Slavic Review* 69, no. 1 (Spring 2010): 41–64.

29 See, for instance, a recent scholarly article clearly identifying Serbia as standing outside the progress toward liberal democracy in post-communist Europe: Grzegorz Ekiert, Jan Kubík, and Milada Anna Vachudova, "Democracy in the Post-Communist World: An Unending Quest?," *East European Politics and Societies* 21, no. 1 (2007): 7–30. See also Ivan Čolović, *Politics of Identity in Serbia: Essays in Political Anthropology* (New York: New York University Press, 2002).

30 See Radina Vučetić, *Coca Cola Socialism, Americanization of Yugoslav Culture in the Sixties* (Budapest: Central European University Press, 2018).

31 See Lidija Merenik, *Umetnost i vlast: srpsko slikarstvo 1945–1968* (Belgrade: Fond Vujičić kolekcija i Filozofski fakultet Univerziteta u Beogradu, 2010), for the older literature on the topic.

32 The play was supposed to be staged in the Belgrade Drama Theatre. However, at the last moment it was removed from the repertoire. Nevertheless, a group of artist organized its informal premiere at the atelier of painter Mića Popović at Staro Sajmište (The Old Fairground) where the Gestapo camp functioned during the Second World War. See Pavle Ugrinov, *Tople pedesete* (Beograd: Nolit, 1990).

33 The Museum of the Victims of Genocide was founded by the Parliament of the Republic of Serbia by a special law, simultaneously with the outbreak of war in Bosnia in 1992. The main objective of the museum was to "keep a constant memory of the victims of the genocide against the Serbian people, by collecting, processing, and using data and fulfilling commitments from the International Convention on the Prevention and Punishment of the Crime of Genocide." The main focus

of the Museum of the Victims of Genocide was to represent the Second World War, particularly the victims of the Ustaša regime in the Independent State of Croatia. Importantly, the concept of the museum never equated nor even correlated communism and Nazism as two comparable totalitarian regimes. According to its founding charter and the program, the museum did not define victims of communism as victims of genocide, and it did not open a perspective where communism was perceived as a genocidal dictatorship.

34 Buden, "U cipelama komunizma."

35 John Lampe, *Yugoslavia as History: Twice There Was a Country* (Cambridge: Cambridge University Press, 2000), 265–330; Holm Sundhaussen, *Geschichte Serbiens, 19–21 Jahrhundert* (Vienna: Böhlau, 2007), 339–360.

36 Greenberg, "There's Nothing Anyone Can Do about It," 63.

37 See Péter Apor and Oksana Sarkisova, "The Futures of the Past," in *Past for the Eyes: East European Representations of Communism in Cinema and Museums after 1989* (Budapest: Central European University Press, 2008), vii–xix.

38 Kristen Ghodsee, *The Left Side of History, World War II and the Unfulfilled Promise of Communism in Eastern Europe* (Durham, NC: Duke University Press, 2015).

39 In Kragujevac and Kraljevo Nazi occupiers killed several thousands civilians including schoolchildren during October 1941. The punitive expedition of the Wehrmacht in Western Serbia was an attempt to destroy the partisan uprising. Quisling authorities presenting themselves as the protectors of civilians have developed strong anti-communist propaganda, blaming the rebels and not the occupiers of mass executions. The new exhibiting policy makes it seem as if the museums (albeit unintentionally) adopted the official war narrative, denouncing anti-fascist fighters for their struggle and trying to rehabilitate the fascist collaborators on the basis of their anti-communism. In doing so, the museums further strengthened strong contemporary anti-communism especially in the province, avoiding to critically open questions related to the recent wars and the disintegration of Yugoslavia.

The museum in Kragujevac, as part of the aforementioned Museum of the Victims of Genocide, is organized in order to preserve the memory of the victims of the genocide against the Serbian people, etc., as well as to be engaged "in collecting, processing and using information about the genocide against Jews, Roma, and members of other peoples and ethnic minorities." This broad formulation makes possible the realization of different projects remembering the victims of the wars of the 1990s as well. However, the museum is thematically framed in the Second World War period. Judging from that example, it seems difficult to answer the question: does the image of the Second World War blur the picture of the wars of the 1990s, or the situation is just the opposite, that the inability to articulate a coherent evaluation of the recent wars makes it impossible to consolidate a picture of the Second World War? See "Zakon o osnivanju muzeja žrtava genocida," in *Službeni glasnik RS*, br. 49/92, 53/93, 48/94, 101/2005. See also "Osniva se muzej genocida, "*Politika,* July 17, 1992.

40 The series of thoughts that relate totalitarian ideologies to utopian concepts (and also historical utopias) starts back in the Cold War liberalist intellectual tradition, from Hannah Arendt, Karl Popper, Isaiah Berlin, and Jacob Talmon, to Czeslaw Milosz. On interpretational relationships between utopia and totalitarianism and its ideological background, see Richard Shorten, *Modernism and Totalitarianism: Rethinking the Intellectual Sources of Nazism and Stalinism, 1945 to the Present*

(London: Palgrave Macmillan, 2012). See also Susan Buck-Morrs, *Dreamworld and Catastrophe — The Passing of Mass Utopia in East and West* (Cambridge, MA: MIT Press, 2000).

41 Although artists such as Milić de Machva and Dragoš Kalajić received wide public attention during the last two decades of the twentieth century, their influence is drastically narrowed and reduced today.

42 Maria Todorova recently explored this phenomenon. See a range of articles in Maria Todorova and Zsuzsa Gille (eds.), *Post-Communist Nostalgia* (New York: Berghahn Books, 2010). On "Yugo-nostalgia" in particular, see Mitja Velikonja, *Titostalgia: A Study of Nostalgia for Josip Broz* (Ljubljana: Mediawatch, 2008); Mitja Velikonja, "The Past with a Future: The Emancipatory Potential of Yugonostalgia," in proceedings of *Tito—vidjenja i tumačenja*, 562–581 (Belgrade: Institut za noviju istoriju Srbije, Arhiv Jugoslavije, 2011); Zala Volčić, "Yugo-nostalgia: Cultural Memory and Media in the Former Yugoslavia," *Critical Studies in Media Communications* 24, no. 1 (2007): 21–38.

43 Mitja Velikonja, *Titostalgija* (Belgrade: Biblioteka XX vek, Knjižara Krug, 2009).

44 The more detailed information on the Center for Museology and Heritology of the Faculty of Philosophy, see https://www.f.bg.ac.rs/sr-lat/instituti/CMiH (accessed September 10, 2019).

45 REX Kulturni Centar, "Fašizam: muzealizacija i edukacija danas," 2009, http://rex.b92.net/sr/REXPro/REXProjektiStrukturaKaoPages/fasizam.html (accessed September 10, 2019).

46 *Politički ekstremizmi u muzejima Srbije*, ReEX, Beograd 2018.

Life and Death of the Communist Object in Post-Communist Romanian Museums

Simina Bădică

In the spring of 1990,[1] trucks loaded with communist memorabilia of the highest quality and certified provenance shuttled back and forth in central Bucharest between the (former) History Museum of the Romanian Communist Party and the (former) History Museum of the Romanian Socialist Republic. In December 1989 the decision was taken to merge the two institutions and move them into a new building erected especially for this purpose. The decree was supposed to be signed in January 1990,[2] but by then the Romanian Communist Party, along with its leader Nicolae Ceauşescu, was already history. Yet the projected fusion was taking place in spite of its initiators' demise. The history of the Romanian Communist Party was finally becoming national history, not in the manner envisaged by the last Romanian dictator, as a fusion of party history and national history, but as an unwanted relic that national history had to accommodate.

Romanian communism has remained an unwanted relic in the basements of museums for more than twenty-five years now. First, there was a widespread consensus that it was too early to uncover the communist past. Second, when it became obvious that a discourse on the communist past was necessary, the objects the communist regime produced to represent itself were considered fake, designed to mislead the visitor and thus difficult to use in a "democratic" discourse on communism. This chapter analyzes curatorial and historical discourses on communism in post-communist museums, focusing on their use of communist objects in an overall anti-communist discourse. This chapter also analyzes the work of memory in these museums, as objects that might be useful in fostering remembering are deprived of their communicative power, surrounded with excessive texts and labeling, with the result that exhibitions on communism seem to encourage forgetting rather than remembering.

Memory in the museum: A contested relationship

The memorial function of the museum has been intensely contested, especially in connection with traumatic memory. It is precisely the traumatic memory of events in

the twentieth century that has turned museums into counter-museums and memorials into counter-memorials[3] in order to properly represent and remember what is sometimes considered un-representable or unmemorable.[4]

One of the main functions of museums of communism is their supposed capacity to remind us of what we have forgotten, acting as repositories of a memory repressed, faked, or even consciously set aside. Museums of communism are considered by their supporters and initiators as necessary in a post-communist world too eager to depart from its past. As Boris Buden put it, "if there is something to be called post-communism, its essential element—from where the name comes—is its relation with the communist past,"[5] and the best place for an analysis of this relation is the museum of communism, "an institution in which the post-communist attitude towards the communist past is programmatically constructed and exposed."[6] If Buden is right, the idea that post-communism might push the delete button on the memory-of-communism folder is improbable at best. On the contrary, post-communism constructs its identity in relation to the communist past and accordingly imagines the communist past in relation to what post-communism hopes (not) to be. In this view, museums of communism are necessary not (only) for their memorial function but as an important component of post-communist identity. As the classical period of nation-building in Europe during the nineteenth and early twentieth centuries invented national museums, post-communism constructed museums of communism. These museums seem to be there to remind the post-communist citizen what he or she is never to become again.

Most museums of communism, especially memorial museums, make intensive use of the discourse on memory, justifying their existence by pointing to the moral duty of keeping alive the memory of communism, of communist crimes, of the fight against communism, "for it never to happen again." Ana Blandiana, Romanian poet and civic activist, founder of the Sighet Memorial for the Victims of Communism and of the Resistance, clearly states in the presentation of her successful project: "The Memorial of the Victims of Communism and Resistance in Romania is a convincing affirmative answer to the question 'Can memory be relearned?'"[7]

One of the commonplaces of the discourse on communism in Eastern Europe is the much-used, much-abused, and much-paraphrased sentence that "those who cannot remember the past are condemned to repeat it."[8] Another commonplace when discussing exhibitions on communism is that they function as a reminder that might help prevent communism from being established as a social and political system in this part of the world ever again.[9] Exhibitions on communism are never just historical exhibitions. They always carry the extra burden of having to be anti-communist and thus educate the post-communist citizen on what is "never to happen again." At the opening of one such exhibition (*The Golden Era: Between Propaganda and Reality* at the National History Museum, 2007), then-Minister of Culture Adrian Iorgulescu spelled out this desire: "Romania doesn't need a museum of communism, but a museum of the fight against communism."

Museum and memory have been associated together by exceptional firmness, especially in the second half of the twentieth century, which gave birth to a specific kind of museum, the memorial museum.[10] And yet growing stronger are the voices

that claim museums are not bringing the past closer to citizens, that they are not triggering memory but rather replacing it and thus weakening it. Susan Crane believes museums are "externalizing the mental function of remembering,"[11] and archeologist Kevin Walsh goes so far as to argue that such externalizations are never benign. On the contrary, he claims, "Museums should shoulder at least some of the blame for a superficial, unquestioning portrayal of the past which ultimately separates people from an understanding of their economic, political and cultural present. As the past is presented as a complete package, it loses all relevance in our daily lives."[12]

These considerations seem all the more relevant when the past in question is a personal past and not some distant narrative of one's nation's deeds. The Gordian knot of representing communism in the museum is that it is impossible to replace the living memory of those who experienced state socialism with official narratives that often contradict the visitor's own lived experience. Thus the museum experience most often succeeds in alienating the visitor from the museum and from any further attempt at understanding and reflecting upon one's own and the country's communist past.

In the Romanian case, the musealization of communism is made even more difficult by the strong connection between public anti-communist discourse and Orthodox discourse on martyrdom and national values. In this hybrid post-communist narrative, the victims of the communist regime are martyrs of the Orthodox faith (even though many of them were of different confessions), the perpetrators were evil creatures, and the purpose of the communist regime was to erase the Romanian nation and the Orthodox faith (treated as synonymous) from the face of the earth. The visual translation of this discourse is the Sighet Memorial Museum and the hundreds of monuments spread throughout the country that were erected to the victims of the regime. The common visual element to be seen in all these monuments is the Orthodox cross. Along this strong, dichotomous narrative, assigning doom and sainthood, evil and good, a normalizing, questioning, multifaceted, and ever-changing narrative on communism is quite hard to propose. In an earlier article, Gabriela Cristea and I analyzed this Romanian phenomenon in depth and concluded: "Romanian museums often seek to imitate the convincing power of memorials and monuments. Appealing to nationalist and religious feelings and fears, memorials and monuments state one victimizing version of history. Instead of aiming at becoming agora museums, places of discussion and debate, Romanian museums dream of becoming memorials."[13]

Musealizing is a pejorative word. The objects and eras to be placed in museums are considered, even for educated visitors, long gone, and their presence in the museum is only one more confirmation of their officially registered death. As much as museum professionals would like to think that they are "bringing the past to life" in museum displays, the general public perception tends to equate museumification with mummification. When the Romanian state officially condemned the communist regime in 2006, one of the state's recommendations was the establishment of a Museum of Communist Dictatorship that, "like the Holocaust Memorial in Washington, would be both a place of memory and an affirmation of the values of the open society."[14] Reactions followed quickly. Daniel Barbu, a political scientist and later the Romanian minister of culture in charge of inaugurating a museum of communism in Romania, analyzed back in 2008 this proposal as an attempt to distance the communist past

and its implications in the post-communist present: "Romanian communism is thus thought of as a restricted object with limited access, controlled, organized, and regulated, with authorized guides and curators, which can be exhibited and contemplated but which, once immobilized in the museum, is no longer part of the present."[15]

The difficult relationship between the museum and its artifacts/subjects becomes almost impossible when the subject is communism. The conundrum is this: museums claim to grant the exhibited object an eternal life. The object in the museum thus becomes part of national memory and official representations, it is seen by thousands of people, and it is labeled, explained, categorized, and framed. And yet by these very actions the exhibited object is extracted from the context where it was alive, the milieu that constructed its meaning. The same argument goes for a wooden spoon or communist society in general. Their life, once they become museum objects, is very much the same. This article will analyze the difficulties of exhibiting communism in a post-communist country, bearing in mind that these difficulties are symptomatic for museum representations in general as well as for any public discourse on communism in the aforementioned context.

Fake objects at the Romanian Peasant Museum

The Romanian Peasant Museum in Bucharest is one of the most eloquent case studies on how the communist past is addressed in Eastern Europe. As I have already published my reading of the fascinating and thought-provoking story of the Peasant Museum,[16] I will only sketch here the summary of the transformation of a communist propaganda museum into an anti-communist, almost mystical museum of peasant art and spirituality. I then analyze two very different exhibitions organized by the museum with the objects inherited from the former communist propaganda museum.

The Romanian Peasant Museum was reestablished on February 5, 1990, barely one month after the demise of the Romanian communist regime. The building assigned to it was originally built at the beginning of the twentieth century as an ethnographic museum, the National Museum. The Museum of National Art had been removed from the building in 1952, and the V.I. Lenin-I.V. Stalin Museum (which was later renamed the Marx-Engels-Lenin Museum) moved into its place. In 1958, another propaganda museum was brought to the south wing of the building, the History Museum of the Romanian Workers' Party. The two museums functioned simultaneously until 1966, when the Marx-Engels-Lenin Museum was silently dissolved into the new History Museum of the Communist Party, of the Revolutionary and Democratic Movement of Romania, which occupied the building until 1990.[17]

The Romanian Peasant Museum constructed its identity in sharp contrast with its predecessor. It was not only a question of institutional succession; the distance to be established was between two eras, two worlds, two regimes. The team at the Peasant Museum chose to establish this distance in an innovative, original way. On a museological level, the basic concepts of dealing with the heritage of the old museum were fakery and truth. The former communist museum was considered a "fake

museum"; therefore its objects were "fake objects." The new museum was built through a dialogue with the objects, but this very dialogue was denied to the communist objects. On a discursive level, the distance taken was even sharper: the old museum was a "ghost" still haunting the building of the Peasant Museum, which needed to be exorcised. From an architectural point of view, the basement was considered the most suitable place for an exhibition on communism: the only exhibition room on communism is also the only one that requires visitors to descend underground.[18]

The metaphor of exorcising the communist ghosts is a recurring theme in the narrative of the museum, as well as of post-communist Romanian society at large. "Exorcism" became more than a metaphor when Horia Bernea decided, in the spring of 1991, to call on the Orthodox priests to chase away these spirits in a religious ceremony.

> While the dismantling took place, Horia Bernea had the idea that we needed to clean the space not only of fake walls and fake objects, but also of the bad spirits that must have sneaked in and lived among us [...]. He brought some prelates who came to sprinkle the holy water [*aghiasmă*], to clean the whole museum. They entered every storage room, every little corner; we have pictures of that. And it is interesting to see that we were all there. We were all there because we all had to be sprinkled with holy water.[19]

The permanent exhibition was inaugurated in 1996, and in the same year it received the prestigious European Museum of the Year Award. The exhibition was curated by painter and director Horia Bernea around the idea of the freedom of the object. In a non-museological manner, Bernea tried to free the museum object from the dreaded museumification/mummification process. Although not a museum professional, Bernea was an artist and was painfully aware of the shortcomings and eventually even falsifications museum exhibitions perform: "I am terrified of the exhibiting technique, the obsession for explanations, the excessive protection. They end in abolishing the object. You don't see it anymore! And if it so happens that the beauty breaks through, it is only because the object was too strong."[20] And again, "One needs good ears to hear what the object has to 'say' [...] If you have such sensibility and the courage to listen, the objects dictate the exhibiting solutions."[21] This overemphasis of the freedom of the object matches Horia Bernea's insistence on the "obedience toward the object." However, he is also the one who acknowledges that "Objects in this museum do not have the function of self-representation, of speaking about themselves; they appear as arguments in demonstrations about the characteristics of the Romanian peasant, conceived as a variant of the European medieval civilization."[22]

The museological program of Horia Bernea and his team was bold and innovative, although conservative about the image of the peasant proposed,[23] and fortunately well documented in texts written by Bernea himself. I will not develop it further, as my only intent was to contrast these principles of handling the museum object with the treatment of communist museum objects by the same team. One year after the official opening of the museum, a new room was to be added to the permanent exhibition. Irina Nicolau had envisioned this exhibition since 1990. "I was dreaming

of an exhibition set up in the technical basement, where we could isolate four small, damp rooms and a former bathroom with broken tiles, a steamy mirror, and a dirty bathtub. I imagined the bathtub filled with water in which old newspapers would float among the sunken bronze busts of Lenin, Stalin, and Gheorghiu-Dej."[24] The existing exhibition, *The Plague*, is not very far from what Irina Nicolau imagined in 1990.

The Plague—Political Installation was inaugurated in 1997, and it is to this day, in 2013, part of the permanent exhibition. It is a small room in the basement, just before one reaches the toilets. The only explanation given to the visitor is on the small notice at the entrance: "A memorial of the pain and suffering collectivization caused to the peasant world." The upper part of the room's walls are painted with red hammers and sickles, "painted in oils on a strip of blue, they still look like blood drops,"[25] while the lower part is covered with issues of the communist newspaper *Scânteia*, bearing lists of peasants imprisoned for resisting collectivization. Numerous busts of Lenin and Stalin face each other or the walls or corners of the room, and large pictures of Gheorghe Gheorghiu-Dej are squeezed in very close on the same red-painted wall. The center of the room is occupied by a huge porcelain vase inscribed: "To Comrade I.V. Stalin, a token of love and gratitude from the Romanian Association for Tightening Relations with the Soviet Union." To be able to read the inscription, one has to tour the room four times. Four huge ashtrays support the cord that surrounds the vase.

One of the strongest points of the new museographic discourse proposed by the Peasant Museum was the dialogue with the objects: letting the objects speak for themselves, letting them conquer the space and find their place in the display. Horia Bernea claims, "The Romanian Peasant Museum was born out of dialogue with the objects, an accepted, provoked, always attentive dialogue, without any preconceptions."[26] In the case of *The Plague* exhibition, he confessed, they totally ignored this freedom of the object. The objects in this exhibition used to be exhibited in the Communist Party Museum (although the exhibition makes no mention of their provenance). They were, in the curators' vision, objects of a fake past, an unreal reality. "As opposed to the dialogue with the patrimonial objects, where I forbade myself any preconceived ideas, here we absolutely need a political bias. As we couldn't exhibit the lies of the regime, we tried to exhibit its ugliness."[27] Bernea explains this political bias in a conversation with Irina Nicolau:

> Pasternak said that a talented writer should describe those years such that the blood of the readers freezes and their hair stands on end. This is the reaction we should have aimed for, but we obviously did not succeed. We could have obtained it only if we had closed visitors into the exhibition room among the objects which are all aggressively ugly and kept them there locked up without water, food, or hygiene for a week.[28]

A little sheet of paper kept and later published by Irina Nicolau makes the intentions behind the display even clearer. It contains a list of possible names for the exhibition on collectivization conceived by Bernea. *The Plague* could as well have been entitled *The Breaking of the Silence*, *Essay on Death*, *Essay on Murder*, or *The Plague—The Breaking of the Silence*.[29]

Talking about communism in 1997 was indeed "breaking the silence," as the 1990s were characterized by what I call "the black hole paradigm,"[30] a general reluctance to open the conversation over the country's communist past. The *Plague* installation is a visual translation of what Horia Bernea believed communism was:

> Communism is a disease of society and soul; it is opposed to the life-giving convention; an "ideal" stupidity, totally oriented against life; a destructive "atheist sect"; orientation against the spirit, comfortable to the lower parts of man; the exaltation of shameful evil; absolute hatred, affirmed with no reservations; an attempt to destroy the multi-millennial attempt at spiritualization; a sinister utopia.[31]

The creative team of the Peasant Museum, especially Horia Bernea and Irina Nicolau, were painfully aware of the history of the building they inherited. The permanent exhibition was a deliberate reaction to what that building used to exhibit only a few years before.[32] The *Plague* exhibition and the religious ceremonies were all attempts at exorcising and overcoming the difficult heritage of the building. However, as years went by, no one felt the need for a discourse on communism anymore, and the history of the building increasingly became the secret of a few initiates. If in the early 1990s, the knowledge of the history of the building—the fact that it used to be a symbolic place of the Romanian Communist Party—was presupposed for each visitor, twenty years later, few visitors can recall this peculiar bit of information that, in my view, is vital to understanding the permanent exhibition.

Experimenting with communist objects twenty years later

In February 2010, the 20th anniversary of the establishment of the Romanian Peasant Museum, and thus also the 20th anniversary of the dismantling of the Party Museum, a one-week experimental exhibition was offered to visitors. Some of the communist objects that had been so hastily removed from the exhibition halls twenty years before were placed back in the permanent exhibition, among the peasant objects, creating contrast or, on the contrary, imitating the display of the permanent exhibition and thus actually hiding in plain sight.[33] One object was inserted into every room of the permanent exhibition, according to the theme of the room, meaning that twenty objects in all were to be discovered by the visitor. The pottery section was most enjoyed by visitors, while the icons section triggered overt disapproval from museum researchers and curators caught unaware by the experiment.

The exhibition was opened not only on an anniversary but also at a milestone in the history of the museum, as important consolidation work was supposed to start in 2010, forcing the dismantling of the Bernea exhibition and thus posing questions about the future of this award-winning exhibition.[34] The experiment, entitled *In-Between Reconstructions*, was thus not only an invitation to reflect on the communist past of the building and Romanian society in general, but also on the history of museum buildings and the necessary succession of exhibitions, on the importance of

the context a museum artifact is placed into, and the fate of the object taken in and out of the visitors' gaze.

This 2010 temporary exhibition used the same collections[35] as the 1997 permanent *Plague* exhibition, objects that somehow escaped the transfer to the National History Museum in the 1990s. Unwanted heritage objects forgotten in inaccessible basements made it back into the spotlight of the permanent exhibition, this time not for a "discourse on ugliness" but for a memory exercise and a reminder of the fact that even if these objects, or other remnants of our communist past, have their place in most institutions and even in our private houses and lives, they are either forgotten down in the basement or hidden in plain view among other benign, ideologically neutral everyday objects.

The chosen objects took diverse forms, yet they shared a common feature: they were all created within the propaganda system, they were all meant to function as promoters of communist values and truths. They included a star-shaped *We Want Peace* metal/wood mold, a typographic mold with the inscription "The Fascist Government is Kaput!" and a 1914 *Work Calendar* (*Calendarul Muncei*) with holy days and saints alongside socialist commemorations. These were all (supposedly) created before 1945, collected and displayed afterwards in museums as proof and documents of the new communist version of history.

Most of the objects inserted in the exhibition were, however, created after 1945: plates and pottery imitating ethnographic forms but featuring political messages such as "Glory to Beloved Stalin," a photocopied postcard with Rosa Luxemburg's portrait, a lithograph of an interwar communist strike, a bust of Lenin, a small sculpture of a worker, a photograph of women dancing in national costumes on the stage of the Song to Romania festival, a painting depicting the success of collectivization, and a photograph of women sowing the fields after the 1944 liberation.

The objects in the exhibition were not easily identifiable by the visitor. On the contrary, instead of being highlighted by labels, spotlights, and showcases, they were scattered among other objects in the museum. The visitor only knew they were "communist objects," and one of the purposes of the exhibition was to invite reflection on what makes an object a "communist object," what "communism" is after all, and what its objects and images were. On the museum's blog,[36] clues on the objects were given daily in the form of images and additional information on the object inserted in the exhibition.

Visitors were invited to find at least five "Communist Party objects hidden among peasant things"; those who did would receive a small prize when exiting the museum. The invitation was a success, with more than half of the visitors reporting that they had identified the objects. Most of the identifications were correct, with objects such as a bust of Lenin, photographs of Nicolae Ceaușescu, and propaganda pottery among the most common identified "communist objects." However, Rosa Luxemburg's picture was rarely mentioned by visitors, although it stood out conspicuously from its surroundings. There were also objects belonging both to the permanent exhibition (not included in the experiment-exhibition) and to the communist era that were also identified as "hidden among peasant objects." An old radio, an alarm clock, and kitchenware used before 1989 were all identified as "party objects" by some of the visitors.

The variety of responses to this exhibition points to a still very diverse and personal relationship to the communist past in Romania. Although "communism" as an ideology and political regime was condemned as criminal in Romania (in 2006), the condemnation has not been internalized by Romanian citizens, who still refer to it as the living past. Identifying everyday objects such as alarm clocks as "communist" objects testifies to the Romanian public's reluctance to relegate communism to the political and criminal sphere and attempt to keep it as a part of their lives.

Inserting exhibitions/objects into permanent exhibitions is a museological exercise especially suited for difficult themes, subjects that some might consider impossible to exhibit. Creating layers of narration in an exhibition not only engages the visitor in a personal quest through the museum halls (thus responding to current demands to involve the visitor) but also makes a statement about reappropriating one's recent past even outside the museum walls. Discourses on the communist regime fail to meet their purpose if constructed in a didactic manner, with the authoritative voice of the museum curator speaking through labels and showcases. A more profitable discourse on the communist past—profitable in terms of triggering reflection and recognition—could be constructed through a dialogue between the museum and the visitor, both of which are owners and creators of complementary discourses on the same, elusive communist past.

Unwanted heritage at the National History Museum

The communist past is currently a major concern for the National History Museum, which kept a conspicuous silence on the subject all through the 1990s. Recent temporary exhibitions testify to this museum's concern about finding an adequate national historical representation of the communist regime. Moreover, the National History Museum is a communist creation, which makes the communist past a matter of "personal" history for the museum.

Strangely enough, Romania did not have a national history museum until 1972, and it was the communist regime, supposedly internationalist, but already in its nationalist period, that established it. A decision had been taken in 1955 to build a national history museum, but there was no follow-up, and it was only the 1968 decision of the Communist Party's Central Committee, soon after Nicolae Ceauşescu's accession to power and at his initiative, that turned the National History Museum into reality.[37] In 1970 the government endorsed the party's decision, and within only two years, 15,000 square meters representing Romanian national history became available for visiting (by comparison, the History Museum of the Communist Party had, at the same time, only 5,000 square meters).

The opening of the History Museum of the Romanian Socialist Republic, on May 8, 1972,[38] was a major event, in the presence of Nicolae and Elena Ceauşescu, who cut the ribbon and were the first visitors to the new institution.

As the regime became increasingly nationalistic, the importance of the History Museum also increased in relation to the previously symbolically representative museum, the History Museum of the Communist Party. The 1977 earthquake seriously

damaged the nineteenth-century building and led to the reorganization of the permanent exhibition, only five years after its opening. It was just another opportunity to enhance the political overtones of the exhibit. As described on the museum's site,

> This second permanent exhibition of the National History Museum was, even more than the first, the expression of the Communist Party's political will, following a much more insistent intrusion into museological creation. Furthermore, an entire section of the exhibition—with many big halls—was dedicated to *the Comrade* (nomine odiosa ...) who embodied, ever more exclusively, the Party.[39]

The text refers to the homage exhibition inaugurated in 1978 and closed in January 1990, an ever-growing exhibition whose main artifacts were the foreign and local gifts received by the Ceaușescus. The title of this particular exhibition was probably one of the longest exhibition titles in museum history: *Proof of Love, High Esteem and Profound Appreciation Enjoyed by President Nicolae Ceausescu and Comrade Elena Ceausescu, of Friendship and Cooperation between the Romanian People and Other Countries.*

The core of the National History Museum's collections on communism, the Ceausescu Collection, was based on this peculiar cluster of artifacts, around 10,000 objects coming from the socialist camp or Third World countries, gathered for twelve years in this homage exhibition.[40] The exhibition covered around 30 percent of the museum's exhibiting space—ten big halls—and as the Ceaușescus kept receiving gifts, the exhibition constantly expanded. Together with the 20 percent allotted to contemporary history, half of the History Museum of RSR was devoted to post-1945 history,[41] what the museum creators of the era named "the construction of socialism" section.

It was precisely this half of the museum, renamed the National History Museum of Romania, that was closed down in January 1990. The museum's website narrates those years: "The 1990s brought another history for the National Museum, as for the entire Romanian society. A short characterization of the period might be reduced to two words: change and confusion, for where there are many changes, there is also enough confusion."[42]

However, these objects continued to be part of the museum's collections and, together with the objects transferred from the former History Museum of the Communist Party, form the biggest museum collection in Romania pertaining to the communist past. The Ceaușescu Fund, for example, includes over 10,000 objects from the aforementioned homage exhibition, while other propaganda materials and publications have been placed in the Party Museum Fund. Under these circumstances the pressure on the National History Museum to produce a coherent exhibition on the communist past seems even greater, and thus its silence more telling.

While the contemporary history section was closed, other sections were only purged of quotations from Marxist ideology and had some new information and objects added, such as the role of the monarchy in the twentieth century or the role of political parties besides the Communist Party. However, the permanent exhibition and thus the narrative presented by the museum remained basically the same as the

one exhibited before 1989. Moreover, the museum began a major restoration in 2002, which meant closing the entire permanent display, except for the exhibition of national treasury, and interacting with the public only through temporary exhibitions.

The first temporary exhibition somewhat related to the communist era was inaugurated only in 1999 and was dedicated to the recently deceased Corneliu Coposu, former president of the National Peasant Party, an important symbol of the communist repression against interwar politicians. As the current director of the museum observed during his 2011 conference presentation, this exhibition had something of the homage style already familiar to museographers from the Ceaușescu homage exhibition.[43] Starting in 2002, with the closing of the museum for restoration, the pace of temporary exhibitions dedicated to the recent past seems to have intensified. In 2002 *Si tu ai fost urmarit* (You Too Were under Surveillance) exhibited surveillance techniques employed by the political police. In 2004 an exhibition was dedicated to the Romanian Revolution. In 2007 *The Golden Era: Between Propaganda and Reality* attempted to display "the destruction of collective mentality and identity" and the "characteristics of the communist dictatorship in the 1980s."[44]

In July 2007, a more ambitious exhibition was inaugurated—*Communism in Romania: 1945–1989*. Claiming to "impartially present a controversial period in Romania's history,"[45] the museum partnered with other institutions interested in the recent past. The result was a composite exhibition, following a comprehensive thematic but failing to convey it in a museographically vivid manner.

One of the reasons for this failure is the overuse of text and documents, of photocopies and panels, of showcases and labels, all of which can be traced back to a museography specific to the communist-era exhibitions. The practice of those years seems to have remained the same; only the ideological overtones have been rejected. Analyzing the links between museological practice before and after 1989, I conclude that exhibitions, especially those dealing with the communist regime, are quite often "the same exhibition with different labels. The narrative and methodology is the same; only good and evil are reversed. The object—as the focus of free thought— is in these museum discourses lost."[46] This fear of the object, I argue, is actually a legacy of Soviet museology, whose very rigid rules were translated and implemented in 1950s Romania. The object is considered ambiguous in Soviet museology, thus "In order to help the visitor examine the exhibits in a correct manner and to draw the correct conclusions, texts-quotations and texts by the curators are introduced into the exhibition."[47] Romanian museology has retained this uneasiness around the object, even more present in the case of the objects labeled "communist," whose mysteriously dangerous power is mitigated by excessive texts and explanations around them.[48]

Yet another of the self-imposed challenges exhibitions on communism repeatedly fail to meet is to offer an exhaustive narrative on the communist regime, a complete and definite story of the more than four decades of socialist reality. This is probably due to the chronic lack of representation of different aspects of state socialism in Romanian museums. Thus any exhibitionary attempt believes itself bound to cover all the yet unspoken aspects of the period and to represent faithfully all actors and sides of the story. Indeed, as the number of exhibitions increases yearly, the burden of the

exhaustive story seems to fade, leaving space for more nuanced representations that consciously endeavor to deal with only one fragment of the diversity of life under state socialism.

A more subtle reason for failing to properly represent communism is the didactic manner in which this exhibition was conceived. The themes of the *Communism in Romania* exhibition align perfectly with the themes of a high school history manual on the same period. Visitors to the History Museum are treated like schoolchildren who need to be taught. As pointed out above, I believe this didactic approach to be especially counterproductive in exhibiting recent history, as the aspect of this recent history that differentiates it from other histories is that it is inherently related to living witnesses. The visitors to an exhibition on communism are highly likely to have personal memories of the era or at least, for the younger visitor, to have a family narrative that is inexorably linked with the communist regime.

Unlike the exhibition projects on communism, the National History Museum pioneered an online exhibition on Romanian communism that set new standards for interactivity. The site www.comunismulinromania.ro, inaugurated in 2009, is actually an online archive revealing the physical archives (mainly photographic archives) of the National History Museum in a friendly and engaging manner, which allows the visitor to react, comment, and add her own memories to the collections of the museum, which are mainly based on official sources.

The connection between the site and the physical museum became crucial as the 2011 exhibition *70s/80s Our Youth*[49] explicitly called for visitors to the site to contribute objects to the exhibition. This appeal to anonymous donors testifies to the need to construct a new museal discourse based on objects that are currently missing from the collections of the National History Museum. As the objects created and collected by the communist regime proved insufficient and unidirectional for representing the recent past, the National History Museum is currently seeking to expand its communist collection with objects of everyday life, allegedly neutral objects with apparently no political overtones, yet whose mission is very political. They are brought to the museum collections and to the exhibition halls in order to articulate the anti-communist discourse that the curators wish to display. Everyday communist objects are usually placed in the exhibitions organized by the National History Museum as a counterpoint to the political objects inherited from former communist museums. The exhibition *70s/80s Our Youth* was actually divided into two distinct sections: on the right were official objects and documents, including *Securitate* files and practices; on the left were reconstructions of everyday life, "spaces of freedom" constructed with anonymous everyday objects and presumably challenging the official discourse presented on the right side of the exhibition.

For the National History Museum, the communist objects, which for many years seemed to have been a burden for the collections, are finally turning into an important asset. However, nowhere in the History Museum is the discrepancy between object and narrative so clear: the anti-communist discourse the museum is striving to present, according to Romania's official stand on the communist past,[50] is to be constructed with objects meant to glorify communist ideology, history, and society. The difficulties of the curators faced with this dilemma are not to be minimized. Even though they

are not so explicit as the creators of the Romanian Peasant Museum and the *Plague* exhibition in their fight with the communist object, their work actually points in the same direction: neutralizing the object, revealing the fake, the ugliness, the lie within the object. Thus the most valuable trait of a communist object in Romanian museum collections seems to be its ability to prove there is no value to communist ideology.

No objects needed: The Sighet Memorial Museum to the Victims of Communism and to the Resistance

While the abundance of communist objects seemed to overwhelm the curators of the National History Museum, the Sighet Memorial Museum to the Victims of Communism and to the Resistance faced the opposite situation. In this case, the museum started with no objects at all and only a devastated building: a former political prison. Taking into account the aforementioned difficulties of dealing with communist objects inherited by museum collections, perhaps the Sighet Memorial Museum was actually fortunate to start from zero and build its collections with the appropriate objects, objects that serve its discourse and do not challenge it, objects that are obedient and speak the message they are meant to speak.

The Sighet Memorial Museum to the Victims of Communism and to the Resistance is probably the only major Romanian museum established by civil society (more precisely, the Civic Academy Foundation). And even though it has been recognized as a *site of national importance* and subsidized accordingly ever since, it is still controlled by civil society. It is no wonder that the subject matter of the museum, the communist regime in Romania, is one that most state museums elegantly avoid dealing with. The Sighet Memorial is situated in the far north of the country, close to the Ukrainian and Hungarian borders. The narrative of the memorial museum makes a strong claim on Romanian national identity, providing a narrative of victimhood and sacrifice/ resistance.[51] Such a narrative might have seemed marginal in the early 1990s, when the museum was established, but it has recently risen to the level of an official state narrative on the communist past, with the official condemnation of communism in 2006. The contribution of the Sighet Museum and the Civic Academy Foundation to this official act of the Romanian state was of great importance; it is probably a unique case of a museum imposing its narrative on the political, and not the other way around, as proved to be the case at the other aforementioned museums.

The Sighet Prison was built in 1897 to mark the Hungarian Millennium. It functioned as a political prison for Romania's political and religious elite between 1950 and 1955. Exhibiting communism in a prison is part of a deliberate choice that reinforces the idea that during the communist regime all of Romania was a huge prison. The Sighet Memorial has two distinct phases of existence. The museum inaugurated in 1997 was mainly a museum of the Sighet Prison, a memorial to the victims of communism with a special focus on the victims who lost their freedom, and eventually their lives; fifty-two deaths were counted inside the walls of the Sighet Prison. The second stage of the museum's development, the current permanent exhibition, proposes a global discourse on Romanian communism, a proper museum of communism and not

merely a museum of the prison. After 2000, Sighet was no longer a fragment of the story of Romanian communism, a tragic account of the lives lost while establishing the communist regime in Romania; Sighet became Romanian communism as such, the black hole of Romanian history to be looked at through prison bars.

I visited the Sighet Prison museum only once, in 1997, in the first stage of its development. My analysis is thus drawn from firsthand impressions from my visit, recent visits to the museum's website,[52] a detailed virtual tour of the museum available on DVD,[53] and secondary literature. In 1997, the museum was still very much connected to the actual history of the building: acquired in 1993 by the Civic Academy Foundation, it underwent serious restoration, its interior walls were painted white, and some of the cells were transformed into museum rooms exhibiting prison furniture and the stories of famous interwar political figures, such as Iuliu Maniu and Gheorghe I. Brătianu, who were killed in the prison in the 1950s. The effect of the improvised museum, at that time, was devastating, precisely because of the lack of public debate on the legacy of the communist regime and the museum's simple and straightforward manner of telling stories of resistance and repression.[54] Nineteen ninety-seven was not only the year of the museum's official opening, on June 20, but also the year when the Romanian state finally recognized the memorial as a site of national importance and started subsidizing its existence; until 1997, the Sighet Memorial had been totally privately financed.

Ever since 1997, the museum has been striving to cover more and more aspects of the history of Romanian and Eastern European communism, with exhibition halls (actually, prison cells) on subjects as diverse as everyday life during communism, the Solidarity movement, the 1956 Hungarian Revolution, and the abusive demolitions in Bucharest in the 1980s. Although the initial focus on repression, particularly repression in the Sighet Prison, has been kept (with exhibition-cells dedicated to the victims of the prison), the prison has actually become a metaphor, a paradigm for telling the story of European communism.[55]

The official poster of the Sighet Memorial is thus very telling. Two children are peering curiously through the window of a prison cell, while the text inquires, "Do you want to understand today's Romania?" The reading of this image presupposes two commonly shared assumptions: that one cannot understand contemporary Romania without understanding communist Romania, and that the only valid point of view in understanding the Romanian communist past is the prison-cell window. This reading is congruent with the vision of the memorial's creators, the most prominent of whom is poet and civic activist Ana Blandiana. In 2011, eighteen years after the creation of the memorial, Blandiana writes,

> What makes the Memorial's loneliness in today's Romania is the capacity of this institute of memory to speak not only of the past, but also of the present. The Memorial disturbs not only, and not mainly, by unveiling and analyzing communist crimes but also—and especially—by way of pointing the conclusions of this analysis towards their residues in the society of an Euro-Atlantic integrated country. The current relevance of the Memorial is the plausible explanation for the wall of silence that is being built around it to isolate it and inoculate its loneliness.[56]

The Sighet Memorial Museum is built around a dearth of objects, yet one of the main claims of the museum is delivering authenticity[57] and proof of the criminality of the communist regime. Although the curators have tried to collect and bring original objects to the prison-cells-turned-exhibition-halls, the main object that the memorial displays is the building itself, which provides the only appropriate setting and scenography for the type of anti-communist discourse proposed by the museum's initiators. Thus even everyday objects collected and displayed in rooms such as Room 76, "Everyday Life," are framed in the prison paradigm and looked at through prison bars. It is precisely this scenography that the National History Museum has tried unsuccessfully to construct for its exhibits, a context that could tame the communist object, depriving it of any "residual power":

> After 1989, the choice of space in which the Communist past was exhibited was crucial for those seeking to condemn it. Founders of new memorial sites feared not only the residual power of Communism but were also afraid of the attraction that objects belonging to the pre-1989 era might still hold [...] They were concerned that the physical remnants of Communism should be displayed in places where their power could be contained.[58]

The Sighet Memorial Museum is a paradigmatic case for exhibiting communism in Eastern Europe and has been analyzed from a variety of perspectives: its functioning as a cultural courtroom of communism,[59] its selective authenticity claims silencing the Jewish trauma preceding the communist one,[60] and its claims on national martyrdom and the usage of Christian symbolism.[61] In this chapter, the Sighet Memorial Museum has been added as a distinct solution to the problem of dealing with the communist object. In this case, the communist object is almost absent, a chosen and telling absence, which gives voice to the victims precisely by pointing to the absence of material remnants.

Conclusions: Dead objects, living pasts

"People have a right to their past, just as they have a right to disown it." The 1996 recommendation no. 1283 of the Parliamentary Assembly of the Council of Europe on teaching history opens with this statement, which might seem outrageous to a historian and even more outrageous to a memory activist. The idea that people might have the right to renounce parts of their history seems too close to the much-condemned amnesia of Eastern European societies against which historians and civic activists have been fighting for the last twenty years. Museums, memorials, and monuments have been raised with the proclaimed purpose of not allowing the wartime and postwar eras to be forgotten. But what if the ultimate purpose of historical memory were to forget traumatic events, to make peace with troubled pasts, to recognize and thus leave behind past traumas, personal or national? Are museums constructed to help people make this peace with themselves and with others? Do museums merely provide

information on past events or also foster reconciliation, acceptance, and ultimately a way of integrating the communist story in a coherent, even if not heroic, story of the nation?

When analyzing representations of history in Soviet museums of the Stalinist era, Evgeny Dobrenko remarks, "Museumification acts as one form of destruction, in so far as the only thing that is not acceptable to Stalinism is the 'living past.'"[62] Sadly, the same might be true of historical representations in post-communist, democratic museums. The living past has nuances, the living past cannot be black and white, the living past is always under scrutiny and invites reflection. The living past can be frightening, just as it can be charming and nostalgic. The living past cannot be labeled, and it cannot be confined to showcases. It eludes museumification and wanders around museum walls and out into the streets. Are Romanian museums ready to conceive of the communist past as a living past? Are Romanian museums ready to foster remembering rather than deliver memory as a "complete package"?[63]

Paul Ricoeur dedicated a book to "happy memory" ("The effort to recall can succeed or fail. Successful recollection is one of the figures of what we term 'happy' memory"[64]), pairing it with history and "happy forgetting." Yet while writing of memory, he most often refers to the work of memory (*travail de mémoire*) stressing memory as a process, as a personal effort, memory not as a given but memory in the making.

Museum objects are to be seen as memory aids in this *travail de mémoire* the museum performs. Yet in the case of the communist object, the museum curators seem to go in the direction of neutralizing the object instead of bringing it back to life. The museum is seen as the only appropriate tombstone for the communist object, otherwise to be thrown in the garbage bin. The perverse effect of this fear of the communist object is that it lends back its power precisely through the efforts and energy put into diminishing its seductiveness. Many of the current exhibitions dealing with the communist past can be analyzed as exercises in framing museum objects to deliver the exact opposite of the message they were created to deliver. The techniques invented in order to perform this re-branding of the communist object are varied: from the absolute lack of objects, to interventions on the object, to scenographic devices creating revealing context. All these speak of the uneasiness and troubles of dealing with the past and its material remnants.

Notes

1 This chapter is part of the Museums and Controversial Collections. Politics and Policies of Heritage-Making in Post-Colonial and Post-socialist Contexts project of the Romanian National Authority for Scientific Research and Innovation, CNCS – UEFISCDI, project number PN-II-RU-TE-2014-4-2368, New Europe College, Bucharest.

2 According to Radu Coroamă, former director of the National History Museum, quoted in Vasile Surcel, "Țăranul Român a cucerit 'templul' fantasmelor comuniste" [The Romanian Peasant Conquered the Temple of Communist Phantoms], *Jurnalul National*, November 16, 2010, http://www.jurnalul.ro/acum-20-de-ani/acum-20-de-

ani/taranul-roman-a-cucerit-templul-fantasmelor-comuniste-559881.html (accessed August 29, 2019). The information is confirmed by Cornel Constantin Ilie, researcher at the National History Museum (personal conversation).

3 James E. Young, "The Counter-Monument: Memory against Itself in Germany Today," *Critical Inquiry* 18, no. 2 (Winter 1992): 267–296.

4 Nikolai Voukov, "The Unmemorable and the Unforgettable: Museumizing the Socialist Past in Post-1989 Bulgaria," in Oksana Sarkisova and Péter Apor (eds.), *Past for the Eyes: East European Representations of Communism in Cinema and Museums after 1989* (Budapest: Central European University Press, 2008), 307–334.

5 Boris Buden, "In ghetele comunismului. Despre critica discursului postcomunist" [In the Boots of Communism: On the Critique of Postcommunist Discourse], in Adrian T. Sirbu and Alexandru Polgar (eds.), *Genealogii ale postcomunismului* [Genealogies of Post-Communism] (Cluj: Idea Design and Print, 2009), 59.

6 Ibid.

7 The Memorial of the Victims of Communism and of the Resistance, http://www.memorialsighet.ro/ (accessed November 7, 2016).

8 Apparently the phrase was originally coined by philosopher George Santayana (1863–1952), but it is highly likely that most people who use the phrase have never heard of Santayana.

9 Historian James Mark argues that the concern "about Communism's residual power" was the main force behind building museums of communism in Eastern Europe. James Mark, *The Unfinished Revolution: Making Sense of the Communist Past in Central-Eastern Europe* (New Haven, CT: Yale University Press, 2010), 61.

10 See Paul Williams, *Memorial Museums: The Global Rush to Commemorate Atrocities* (Oxford: Berg, 2007).

11 Susan A. Crane, "The Conundrum of Ephemerality: Time, Memory, and Museums," in Sharon Macdonald (ed.), *A Companion to Museum Studies* (Oxford: Blackwell, 2006), 102.

12 Kevin Walsh, *The Representation of the Past: Museums and Heritage in the Post-Modern World* (London: Routledge, 1992), i (cover page).

13 Gabriela Cristea and Simina Radu-Bucurenci, "Raising the Cross: Exorcising Romania's Communist Past in Museums, Memorials and Monuments," in Oksana Sarkisova and Péter Apor (eds.), *Past for the Eyes: East European Representations of Communism in Cinema and Museums after 1989* (Budapest: Central European University Press, 2008), 302–303.

14 *Report of the Presidential Commission for the Analysis of Communist Dictatorship in Romania*, p. 639.

15 Daniel Barbu, "O istorie naturala a comunismului romanesc" [A Natural History of Romanian Communism], in Vasile Ernu and Costi Rogozanu (eds.), *Iluzia anticomunismului. Lecturi critice ale raportului Tismaneanu* [The Illusion of Anticommunism: Critical Readings of the Tismaneanu Report] (Chişinău: Cartier, 2008), 79.

16 See Simina Bădică, "The Black Hole Paradigm: Exhibiting Communism in Post-Communist Romania," in *History of Communism in Europe*, new series, vol. 1, *Politics of Memory in Post-Communist Europe*, edited by Institute for the Investigation of Communist Crimes and the Memory of the Romanian Exile (Bucharest: Zeta Books, 2010), 83–101; and Cristea and Radu-Bucurenci, "Raising the Cross," 273–303.

17 Until recently, the history of the Party Museum has attracted little attention among researchers. The one published source that briefly touches upon the

history of the building during communism records an inaccurate succession of names (Petre Popovat, "Muzeul de la Şosea" [The Museum by the Boulevard], *Martor. Supplement* 1999, no. 4, 1–140). My own research into the history of the Party Museum (Simina Bădică, "'Same Exhibition, Different Labels?: Romanian National Museums and the Fall of Communism," in Simon J. Knell, Peter Aronsson, and Arne Amundsen (eds.), *National Museums* [London: Routledge, 2010], 272–289) had to rely on printed materials (museum albums, newspapers, and the museology journals), as the archive of the former History Museum of the Communist Party is still not archived and thus unavailable for research at the Romanian National Archives. Recently, Cornel Constantin Ilie published a chronology of the Party Museum's change of names and locations that matches my own (Cornel Constantin Ilie, "Schimbarea denumirii Muzeului de Istorie a Partidului" [Changing the Name of the History Museum of the Party], *Istorie şi Civilizaţie* 2, no. 8 [2010]: 50–52).

18 For a fascinating account on the meanings of going underground during communism and post-communism, see István Rév, "Underground," in *Retroactive Justice: Prehistory of Post-Communism* (Stanford, CA: Stanford University Press, 2005), 240–303.

19 Ioana Popescu, recorded interview by Simina Bădică, Bucharest, Romania, April 26, 2004.

20 Horia Bernea, *Câteva gânduri despre muzeu, cantităţi, materialitate şi încrucişare* [A Few Thoughts on Museum, Quantities, Materiality, and Crossing] (Bucharest: Liternet, 2003), 5.

21 Ibid., 23.

22 Ibid., 5.

23 Vintilă Mihăilescu, "The Romanian Peasant Museum and the Authentic Man," *Martor: The Romanian Peasant Museum Anthropology Review* 11 (2006): 15–29.

24 Irina Nicolau and Carmen Huluţă, *Dosar sentimental* [Sentimental Dossier] (Bucharest: Ars Docendi, 2001), 58.

25 Ibid., 137.

26 Ibid., 225.

27 Ibid.

28 Horia Bernea and Irina Nicolau, "L'installation. Exposer des objets au Musée du Paysan Roumain," *Martor: The Romanian Peasant Museum Anthropology Review* 3 (1998): 224–225. The idea of keeping the visitor "prisoner" for a while, in order to make them not only understand but also feel, was implemented at the House of Terror in Budapest. For three long minutes the visitors are kept in a slowly descending elevator, watching and listening to stories about how people were hanged in that very building.

29 Nicolau and Huluţă, *Dosar sentimental*, 140.

30 Bădică, "The Black Hole."

31 Horia Bernea, quoted in Nicolau and Huluţă, *Dosar sentimental*, 140.

32 The first section of the permanent exhibition, entitled *The Cross*, was inaugurated on April 19, 1993; the French anthropologist Gérard Althabe observed that the exhibition was a "political lesson" about communism by its total lack of reference to it. Gérard Althabe, "Une exposition ethnographique: du plaisir estéthique, une leçon politique," *Martor: The Romanian Peasant Museum Anthropology Review* 2 (1997): 144–158.

33 I curated this exhibition, in close collaboration with Cosmin Manolache and Ioana Popescu, with the strong support of director Vintilă Mihăilescu. Although it is outside the purview of this chapter, it is perhaps important to note that the experiment was openly criticized by some museum staff, who called the event a profanation of Horia Bernea's original exhibition. The idea of inserting clues of the building's communist history in the current permanent display of the Romanian Peasant Museum was first suggested to me by Professor István Rév during my doctoral studies at Central European University.

34 Due to a lack of funding, these major consolidation works only started in 2016.

35 Collections inherited from the History Museum of the Romanian Communist Party, the Lenin-Stalin Museum, and the Popular Art Museum of the Romanian Socialist Republic.

36 See *Archive for the "Între Șantiere" Category* [blog], http://muzeultaranuluiroman.ro/blog/?cat=21 (accessed November 7, 2016) [site discontinued].

37 Cornel Constantin Ilie, "Regimul Comunist Si Muzeele de Istorie Din Romania" [The Communist Regime and History Museums in Romania], PhD thesis, Universitatea Valahia Targoviste, Targoviste, Romania (2012), 145–147.

38 According to current director (2016), Ernest Oberländer-Târnoveanu, the museum had two official openings. One was on May 8, 1971, on the 50th anniversary of the creation of the Romanian Communist Party (three days later the museum was closed, as it was not ready for visiting), and the second one was exactly one year later, on May 8, 1972. Ernest Oberländer-Târnoveanu, "The National History Museum," conference presentation at the First National Conference "Romanian Communism," Bucharest, Iorga Institute, March 18, 2011.

39 See Muzeul Național de Istorie a României, http://www.mnir.ro/index.php/muzeul-national-de-istorie-a-romaniei/ (accessed November 7, 2016).

40 The geographical display of the objects, themselves chosen as representative of different nations and cultures, reminds one of a *Kunstkammer*, displaying wonders of the world and the infinite power of the collector, in this case the Ceaușescus.

41 Information on the National History Museum during the communist regime mainly comes from a conference presentation held by the current director of the museum: Oberländer-Târnoveanu, "The National History Museum"; and Ilie, "Regimul Comunist Si Muzeele de Istorie Din Romania."

42 See Muzeul Național de Istorie a României, http://www.mnir.ro/index.php/muzeul-national-de-istorie-a-romaniei/ (accessed November 7, 2016).

43 Oberländer-Târnoveanu, "The National History Museum."

44 Ibid.

45 Ibid.

46 Bădică, "Same Exhibitions, Different Labels?" 288.

47 P.I. Galkina, V.K. Gardanov, I.P. Ivanitkin, K.G. Miteaev, G.A. Novitki, and N.N. Plavilscikov, *Bazele Muzeologiei Sovietice* [Bases of Soviet Museology] (Bucharest: Romanian Ministry of Culture, 1957), 177.

48 Bădică, "Same Exhibitions, Different Labels?," 279–283.

49 Inaugurated March 17, 2011, at the National History Museum.

50 On December 18, 2006, President Traian Băsescu officially condemned communism as a criminal regime: "As head of the Romanian state, I condemn explicitly and categorically the communist system in Romania, from its dictated establishment in 1944–1947 to its collapse in December 1989. Taking into account the realities

presented in the report, I state with full responsibility: the communist regime in Romania was illegitimate and criminal."

51 Cristea and Radu-Bucurenci, "Raising the Cross."

52 Fortunately, the Sighet Museum has a rich site, also proposing instructive virtual visits. See the Memorial of the Victims of Communism and of the Resistance, http://www.memorialsighet.ro (accessed November 7, 2016).

53 *Take-Away Museum*, virtual museum tour on DVD (Sighet Memorial Museum, 2008).

54 See also Cristina Vatulescu's interesting analysis of the transformation of the museum in "Prisons into Museums: Fashioning a Post Communist Place of Memory," in Julie Bucker and Emily Johnson (eds.), *Rites of Place* (Evanston, IL: Northwestern University Press, 2013), 315–335.

55 As a proper museum of communism was lacking in 1997, and is still lacking today, pressures have been made even from the outside to transform the Sighet Memorial into a Romanian museum of communism. See, for example, museum historian Ioan Opris writing in 2000 that the Sighet Memorial should encompass more and more of what communism meant for Romania, not only the repression system and in a more vivid and impressive way: Ioan Opris, "O lumânare la Memorialul Victimelor si al Rezistentei dela Sighet" [A Candle at the Sighet Memorial to the Victims of Communism and to the Resistance], *Revista Muzeelor* 1, nos. 1–3 (2000): 10–13.

56 Ana Blandiana, "Memorialul Sighet la majorat. Vreți să înțelegeți România de astăzi? [cf. p. 297, line 4]" [The Sighet Memorial Turning 18. Do You Want to Understand Today's Romania?], *Revista* 22, no. 314 (February 8, 2011), https://revista22.ro/supliment/22-plus-nr-314-memorialul-sighet-la-majorat-vre355i-s259-in355elege355i-romania-de-azi (accessed September 13, 2019).

57 Mark, *The Unfinished Revolution*, 61–92.

58 Ibid., 62.

59 Ibid., 67–69.

60 Ibid., 67–71.

61 Cristea and Radu-Bucurenci, "Raising the Cross."

62 Evgeny Dobrenko, *Stalinist Cinema and the Production of History: Museum of the Revolution*, translated by Sarah Young (Edinburgh: Edinburgh University Press, 2008), 9.

63 Walsh, *Representation of the Past.*

64 Paul Ricoeur, *Memory, History, Forgetting*, translated by Kathleen Blamey and David Pellauer (Chicago: University of Chicago Press, 2004), 28.

Part Four

Visualizing the Recent Past:
Practices of Representation

Boundary Objects of Communism: Assembling the Soviet Past in Museums and Public Spaces

Eglė Rindzevičiūtė

The last decade has seen a number of studies address the way the communist past is presented in museums and memorial sites in the Baltic States.[1] This work is an important addition to the existing studies of cultural and political nationalism in this region, as it introduces a material dimension, a crucially important world of objects, natural and man-made environments. However, this new field challenges researchers in terms of physical access, methods of data-gathering, and theoretical frameworks for interpretation. First, although new work is appearing, there is a lack of research on the development of Baltic museums and cultural policy. This lack creates difficulty for attempts to contextualize recent developments. Second, relevant museums are often spread over considerable distances, posing difficulties for comparative studies; more centrally situated museums tend to attract greater scholarly attention. For instance, comparisons of Lithuanian museums of the Soviet and Nazi occupations have typically focused on the Museum of Occupations and Freedom Fights (formerly the Museum of Genocide Victims) in Vilnius and Grūtas Statue Park, which is within an easy drive from the capital, disregarding many other alternatives. Furthermore, museums keep changing and updating their expositions, sometimes in response to academic criticism.[2] In this context, we need a fully-fledged study of the role of Baltic museums in nation-building, to consolidate the emerging materials, which so far remain fragmented and patchy.

The "boundary objects" perspective

This article adds to the development of this scholarship by introducing new cases and a new theoretical perspective into the study of museums of the communist past. While many scholars of Baltic museums draw on memory studies to analyze museums as a medium for communicating hegemonic narratives of the past,[3] I draw on an organizational theory developed by Susan Leigh Star and James Griesemer, which emphasizes that museums are under continuous construction, where meaning-making can be approached as a complex, heterogeneous, collaborative process,

which is never settled.[4] According to Star and Griesemer, meanings in museums are generated through "boundary objects." Boundary objects are material objects the meanings of which social actors articulate differently as they move between different fields of professional expertise, adjusting those meanings to institutional politics. The concept of boundary object affords "interpretive flexibility," where one and the same object points different social groups in epistemologically and organizationally different directions. Star argues that boundary objects "allow different groups to work together without consensus" as they are "temporal, based in action, subject to reflection and local tailoring."[5]

The boundary object perspective is a useful angle from which to approach museums of communism, because it allows for a simultaneous plurality of meanings: different, even quite contradictory meanings can coexist at the same time without cancelling each other out. This insight fits well with long-existing debates among museum scholars, who have argued that interpretation of a museum exposition or a heritage site is never straightforward. According to Kirshenblatt-Gimblett and Hooper-Greenhill, museum expositions are hybrid assemblages of texts, objects, and material settings, which makes their interpretation extremely complicated.[6] It is difficult to provide a thick description of a museum: messages in museums can be highly heterogeneous, internally contradictory, meaning different things to different people. Few, if any, museums can be regarded as internally consistent discourses; rather, they are hybrid, changing frameworks, shaped through negotiation among different interest groups. That said, many studies of Baltic museums that engage with the difficult past, such as communism and the Holocaust, have tended to disregard the epistemological complexity of the medium of the museum, with critical analysis often focusing on identifying hegemonic narratives that elevate an ethno-nationalist version of history at the expense of alternative narratives. To be sure, such criticisms perform an important service as they capture the many instances when Eastern European museums fail to incorporate more diverse narratives. However, such studies do not offer an explanation of the institutional and social mechanisms through which those narratives are placed in expositions, referring instead to macro processes of nation-building, which are assumed to be translated directly into the displays. To gain greater insight into the process of exposition formation, critical analysis should attune its method to the specificity of the museum as a particular medium of communication and the cultural sector as a specific institutional and organizational field.

I argue that it is in the context of comparative research into musealization and the cultural memory of communism that the concept of the boundary object can open up new vistas, because it enables us to capture the social, organizational, and material complexities involved in this process. Many museum expositions, both in East and West, are opaque rather than transparent. For instance, according to Peter Aronsson, in Sweden museum curators privilege objects over words in expositions, because this enables them to avoid addressing controversial themes head-on.[7] In those cases where explicit narrative is missing, only a visitor with sufficient cultural capital can perceive the historical meanings of the exhibited objects. Although Tony Bennett convincingly argued that history museums evolved as scientific laboratories of the past, museum

expositions are not well-argued scholarly texts, furnished with references: expositions hardly ever explicitly acknowledge doubts, lack of data, conflicts, and earlier errors.[8] History museum exhibitions typically fail to present several contrasting points of view. Conflicts remain implicit. However, the opaqueness of object-oriented exhibitions gives the visitor more freedom to seek their own narrative and explanation. In spite of the existing practice of framing opaque museum objects with labels or short narratives on displays, leaflets, catalogs, and guided tours, the traditional, professional museum prioritizes objects. According to Keršytė, even today Lithuanian museums continue to regard collection, preservation, and storage of objects as their primary task.[9] In this way, professional museum practice is first and foremost centered on objects, with an attributed value of authenticity as well as conferred significance of being either typical or unique examples of historical phenomena.

Three Lithuanian museums

To understand museum exhibits as boundary objects is to recognize that they are not readily available but are actively forged.[10] I illustrate this process by analyzing four different cases of boundary objects of communism in three museums. These museums are selected because of their different origins and strategies of framing the communist past: they were created by amateurs or cultural professionals, owned by the state or private individuals, newly built or refurbished: the Museum for Resistance and Deportations in Kaunas, the Lithuanian National Art Gallery in Vilnius, and Grūtas Statue Park near Druskininkai. These museums represent different stages of the making of communist heritage. In the early 1990s many museums began to restructure their Second World War exhibitions with support from a community of survivors of the communist terror, the Union of Political Prisoners and Deportees (UPPD), who were particularly active in that period.[11] The UPPD initiated creation of many important museums of deportations and resistance, such as the Museum of Victims of Genocide in Vilnius (established in 1992, renamed as the Museum of Occupations and Freedom Fights in 2018), the yurt from the Laptev Sea in the Open Air Museum near Kaunas as well as the Museum for Resistance and Deportations in Kaunas. UPPD also had an explicit heritage strategy.[12] However, this grassroots movement was not the only museum-builder: the other two museums addressed in this chapter had very different institutional origins and rationales as they were initiated by cultural professionals (the Lithuanian National Art Gallery, a branch of the national Lithuanian Art Museum, established in 2001 and opened in 2009) and business entrepreneurs (Grūtas Statue Park). Not all museums of the communist past are well attended: in 2011, when I did my main fieldwork, the Grūtas Statue Park received 45,496 visitors and the National Art Gallery received 45,452 visitors. However, only 1,200 visited the section for "Resistance and Deportations" in Kaunas City Museum.[13]

This study draws on ethnographic fieldwork conducted over several visits to these museums from 2010 to 2013, semi-structured interviews with museum workers and cultural policy professionals as well as published materials in Lithuanian. Several important museums, such as the Occupations and Freedom Fights in Vilnius and the

Yurt of Deportees to the Laptev Sea, are not included in this chapter because I have discussed these museums at length elsewhere.[14] In what follows, I briefly discuss the development of Lithuanian state cultural policy toward communism as heritage; the three case studies are then considered.

De-Sovietization, cultural policy reforms, and local translations

Before we proceed, some contextualization of Lithuanian museums of communism is necessary. Negotiations about the legacy of the communist past in the state cultural policy field took place in the first debates on state heritage policy reforms at the Ninth Culture Congress in Vilnius, May 18–20, 1990. Organized by the Ministry of Culture and Education, the congress assembled shortly after the declaration of Lithuania's independence. The debates took place in a highly charged political atmosphere. It was attended by some 3,000 cultural professionals, who sought to establish guidelines for a new, post-Soviet state cultural policy. While the congress proceedings condemned the communist regime, they also emphasized the importance of transforming this difficult legacy into cultural heritage. But what was the heritage of communism? The congress proposed cultural policy guidelines that called to preserve "resistance heritage," such as anti-Soviet songs, poems, stories, memoirs, photographs, the underground press, and "everyday things that became relics" of deportees and political prisoners. The rationale for collecting these different objects was framed in ethno-nationalist terms: the anti-Soviet heritage had to show "the role of national culture and religion in preserving Lithuanianness [in Lithuanian, *lietuvybė*] under hard and extreme conditions of bondage and oppression."[15]

That the Soviet past was not to be forgotten, but selectively preserved and used to shape the Lithuanian present and future, was clear for cultural professionals. However, communist heritage, regardless of its definition, never became a priority in cultural policy. The 800-page volume of the congress proceedings mentioned earlier dedicated only a few short paragraphs to the communist past; the rest were taken up by traditional cultural policy concerns with amateur folk culture and professional arts. Indeed, it was not the Ministry of Culture and Education but grassroots communities and a handful of professional cultural entrepreneurs that initiated the first presentations of the communist past in museums.

Glavlit, the Soviet censorship body that screened all printed materials, even exposition labels of museum objects, was closed in February 1990, but in fact de-Sovietization of Lithuanian museums had already been taking place since 1988. The UPPD took the lead in commemorating the communist past and lobbying the government to support the creation of new museum expositions and museums. The UPPD limited its interest to a particular set of themes, concentrating exclusively on Soviet deportations and anti-Soviet resistance, and on a particular set of materials, mainly oral history, stories narrated by deportation victims, anti-Soviet partisans, and dissidents, and objects donated by them, mainly photographs and textual documents. As a result of these efforts, about forty public, grassroots museums of deportations and

resistance were created in the 1990s, some of which eventually anchored themselves in the state-sponsored cultural sector.[16]

However, it is difficult to estimate the weight of cultural and symbolic capital that these grassroots museums of communism had in relation to the field of professional culture in Lithuania. Given that these museums were not supported by any consistent government program, few of them were organized by heritage professionals. Many of these museums were amateurish, profoundly dependent on grassroots support through volunteer aid, donations to the collections, and research. Although these UPPD museums came to occupy an important niche in the public heritage sector, which was internationally noticed and commented upon, in the domestic context they have struggled to gain economic and symbolic capital through recognition from both cultural professionals and politicians.[17] The theme of "deportations and resistance" was never acknowledged in a signature monument or museum, something that the UPPD deeply regretted.[18]

The 1990s, therefore, revealed a curious duality in dealing with the communist past on the governmental level and in cultural organizations. On the one hand, governmental officials regularly gave speeches and issued declarations about the need to come to terms with the communist past by studying it, particularly naming and shaming perpetrators of communist repressions.[19] New archives and historical research centers were established, and, as a consequence of international effort, a Commission of Historical Truth was formed in 1999.[20] On the other hand, cultural heritage was only loosely coupled with the institutionalization of the history of communism. The UPPD museums remained rather insular in their cultural niche, disseminating a narrow, ethno-nationalist version of events, while struggling to survive, crippled by shortages of funding, storage space, and professional staff. In what follows, I discuss diverse strategies of selecting and framing material objects, settings, and structures in the museums of the communist past, their choice depending on the agendas of the actors involved, and also their cultural and professional capital.

The Museum of Resistance and Deportations in Kaunas

In this section I discuss the case of a museum that was established by the UPPD and represents a particular strategy of managing boundary objects of the communist past in line with the formula established in the Cultural Congress in 1990. The Museum Department for Resistance and Deportations (DRD) was established by the UPPD in 1993, transferred to Kaunas City Museum in 2006, but closed in 2014. In 2017 the Genocide and Resistance Research Centre has taken over this exposition, planning to refurbish it and reopen in the near future. The following analysis is based on my visit to the Museum in 2011.

The DRD narrates a story of interrupted sovereignty and deportations, with a strong emphasis on the Catholic Church and religious iconography. This museum is situated in a small building on the former territory of the nineteenth-century city cemetery, now a park in central Kaunas. The site features a small memorial cemetery,

an expressionist ensemble of crosses by the prominent sculptor Robertas Antinis (1991), and a monument *For the Mother of Those Who Died for Lithuania's Freedom* (2010), a brass statue of a mourning female, adorned with wings and a crown of thorns. Initiated and funded by the UPPD, this monument blends republican and religious iconography.[21] While the wings refer to a prominent public monument in Kaunas, an angel carrying a flag (*Freedom* by Juozas Zikaras, 1921), the posture and the crown of thorns refer to a grieving Virgin Mary. There is a clear framing of the memorial site through Christian religious iconography, thus excluding the experiences of other confessional groups from the commemoration. It would be plausible to presume that this memorial site is created to appeal to cultural sensibilities of the ethnic majority of Lithuanians; however, as visitor numbers reveal, it does not seem that the ethnic majority actively engages with it.

Although the park is a pleasant green space, used as a shortcut by commuters on the way to bus and railway stations, the museum building is not the center of public attraction. I had to ring a doorbell to be admitted by a friendly member of the museum staff, who serves both as curator and receptionist. The low number of visitors (315 in 2006) is hardly surprising.[22] The exposition space is limited to one ground-floor hall that is partitioned into two parts by a reception desk. The exposition includes stands displaying photographs, both copies and originals, and objects, grouped to represent divisions of the Lithuanian Resistance Army, while other stands are dedicated to Soviet deportations and contain a wooden barrack bed, paintings by deportees, photographs, and material objects. Intentionally or not, the centerpiece above the receptionist's desk is a dazzling, somewhat kitschy painting, depicting an allegorical figure of suffering Lithuania, which waves the tricolor against a backdrop of stormy skies. As this painting, I was told by the curator, was donated to the museum by an amateur Argentinian artist, it could not be refused. This painting, indeed, is a good entry point to begin decoding this exposition as an assemblage of boundary objects, whose relevance to the museum's narrative is to be found in the circumstances of their donation rather than their content.

The UPPD largely determined both the conceptual principles of the exposition and the strategies of display at the Department for Resistance and Deportations, but the museum exhibits objects that were not proactively collected by museum curators but were instead donated by survivors. In addition to originals and copies of photographs and documents, which are used to illustrate the historical narrative, there are many examples of amateur art and craft created by deportees. While the documents speak for themselves, the traditional museum objects, material artifacts, emerge as opaque boundary objects, the meaning of which is not readily available without prior knowledge or an additional commentary. The institutional core of the museum is material objects rather than documents, which are institutionally bound to an archive. In this case, the artifacts, which are produced by survivors or, as the above-mentioned painting, by enthusiasts, are primarily sociopolitical and not aesthetic objects. It is impossible to tell if these artifacts are typical of deportees' creation or if they are exceptionally skillful, aesthetically valuable pieces: their value has been affirmed by the survivors' own community and not by cultural professionals. There is no commentary on the selection of these works available in the museum. They emerge as opaque relics of

Soviet deportations, striking in their fragile material form but speechless. Interestingly, this absence of an explicit explanatory discourse is not perceived as problematic by museum curators. The meaning of opaque relics, it seems, is assumed to be self-evident; yet we must ask, evident for whom?

Drawing on my earlier work, I propose the hypothesis that communist heritage, in this particular case, emerges through a strategy of the disclosure of Soviet repression, a strategy that was set in motion not so much by professional historians but by the self-organized survivors' community.[23] The lack of an explicit interpretative frame of the only authentic objects on display, the survivors' artifacts, I suggest, is also a clear sign of the loose coupling between history and museum practice: while the UPPD draws on the established political history narrative, it has no clear strategy of how to select, display, and integrate the material objects. Although the UPPD commission monuments featuring Christian religious iconography, they do not appear to manage actively the boundaries of everyday objects and amateur art on display. One possible explanation is that the reference frame within which these objects make sense is restricted to internal conversations in this community of survivors. Indeed, this explanation is supported by the following case, which shows that cultural professionals tend to assemble communist heritage as a very different boundary object, one whose boundaries are actively defined and managed.

The National Art Gallery

A public institution, part of the National Museum of Art, the Lithuanian National Art Gallery engages with several translations of the communist past, being very explicit about the translation strategies undertaken, which form an important part of their institutional identity. Relics of the communist past are not taken for granted here. First of all, the gallery treats its building as a memorial of the communist past. The building was originally constructed to house the Museum of the Revolution of the Lithuanian SSR, a branch of the Central Museum of the Revolution of the Soviet Union, which was established in Moscow in 1924.[24] The building was designed in 1966, but finished only in 1980, becoming a showcase of the whole Soviet Union: its image was proudly sported on the front page of an international publication on the best Soviet museums.[25] Architecturally, the Museum of Revolution was an excellent example of Soviet modernism.[26] The Museum of Revolution was closed down in the early 1990s. More than a decade later it was thoughtfully reconstructed and opened to house the National Art Gallery in 2009. To convert the Museum of Revolution into a gallery of modern art, cultural professionals employed a strategy of defamiliarization: they modernized the building fitting it to the needs of a contemporary museum, with spacious offices and areas for education and audience engagement, but they did not downplay the history of the building, turning it into an asset. The strategy of de-Sovietization as defamiliarization refers to the appropriation of those cultural, social, and political institutions that were created in the Soviet period.[27] For instance, an ex-Soviet Ministry of Culture was defamiliarized: it was reframed not as a particular institution that expresses state socialist values but as a universal institution that symbolizes modern

governance of culture. In this way the ministry as a modern institution was decoupled from the Soviet regime, which, in turn, was reduced to an ideological system. In the case of the gallery, defamiliarization has been applied to the museum building, a boundary object, a material relic of the communist past, erected to disseminate key political ideology. The Soviet-ness of the building, however, has been redefined as an expression of Soviet modernity, materialized in the architectural style of international functionalism. Furthermore, the changing external environment of the museum reinforced this reframing: being situated on the riverside, the building is located at the center of the capital city, surrounded by the growing business skyscrapers that house city administration, banking, shopping, and upmarket apartments.[28]

In contrast to the Kaunas City Museum, the UPPD did not influence the redevelopment of the Museum of Revolution. Members of the art-historical and curatorial community exercised strong autonomy in choosing how to treat the building and the Soviet art collection as boundary objects of communism. The narrative, which the gallery curators used to structure the exhibition, has nothing to do with the UPPD narrative of a struggle for sovereignty; instead, it is anchored in the disciplines of art and design history. Indeed, as early as in the late 1980s Lithuanian art history professionals posited the need to reflect on the communist past by organizing a first exhibition of socialist realist art not as a show of canonical artistic achievement but as documentation of a particular style at the Vilnius Academy of Arts. From this moment socialist realist art was reinvented as an important boundary object for the professional culture community. Socialist realist art was also defamiliarized: formerly an official idiom, it was translated into a documentation of a lack of freedom of expression but also, in some cases, as a locally significant artistic innovation.

This translation of the boundary object of socialist realist art was entrenched in the institutional design of the National Art Gallery. The gallery's exposition was based on the principle of a "universal survey," that is, an encyclopedic assembly of typical specimens.[29] The gallery curators selected for exhibition those works that fitted the historicist typology of professional art, created in the territory of Lithuania from the 1920s to the 1990s. The curators included socialist realism neither as an example of "great national art" nor as a proof of national suffering under communism, but as a representative sample of a particular period of time.[30]

Now, this is a very different translation of the boundary object of communism. Anticipating controversial readings of the socialist realist works of art on display, the gallery curators have supplied visitors with printed texts that explain the themes of each hall (unlike the UPPD museums, which count on the visitor's own historical knowledge, which also suggests that they primarily address the survivors' community). For instance, an accompanying text for the exposition "Art and Ideology," which shows the first attempts at academic socialist realism in the Lithuanian SSR in the 1940s and 1950s, emphasizes that Lithuanian artists, schooled in the modernist tradition, were not only unwilling but also professionally quite unable to implement the visual norms of socialist realism to a high standard. The reader is informed that the modernization of socialist realism in 1959 actually contributed to improving the artistic quality of Soviet Lithuanian art, allowing some room for the limited application of a modernist painting style. Here the gallery seeks to provide a more nuanced story about the

creation of Soviet art, revealing negotiations between political and professional norms. In this way, this text defamiliarized socialist realist art in Lithuania by placing it in the institutional context of professional art, saturated with its own criteria of quality and historical significance. Another exposition, entitled "The Significant Form" showcases different possibilities available for experiments in modernist painting under the Soviet regime. The accompanying text emphasizes the circulation of ideas and styles from the interwar period (1920s–1930s) as well as from Western art beyond the Iron Curtain. While this text emphasizes the Soviet artists' imagination, particularly their will to push the boundaries of official permissibility, it also made it clear that these experiments were in dialogue with the ideological canon.

In short, the National Art Gallery did not alienate the communist past, embodied in the artworks, by reducing it to a dichotomy between Soviet oppression and local resistance. Curators emphasized not so much confrontation but the importance of negotiation and mutual adjustment between artists and the communist regime, the official socialist realism, and the a-Soviet artistic modernism. Socialist realist art works are displayed in the brightly lit white space as specimens of art history to be explored: the gallery's texts encourage the visitor to engage in more nuanced intellectual thought, while its paintings and sculptures suggest that the Soviet period was not merely a world of barren gray concrete but also a world of color and improvisation. For my argument, this is an important example of using professional and cultural capital to define the meaning and value of relics of the Soviet period as artistic heritage by including them into conceptual, institutional, and pragmatic frameworks of professional architecture and art history.

Soviet statues: The Grūtas Park and the Green Bridge

Established in 2001, the Grūtas Park of Soviet Statues commanded great attention from society, scholars, and journalists and attracted high numbers of visitors (a record 124,000 in 2005, but down to 58,193 in 2017) as well as controversial evaluations in the press.[31] Its links with the professional culture field are complex, as the park is perceived as an ambivalent and semi-professional engagement with communist heritage, whereas the park's link with the UPPD is marked with tension and conflict. Starting from 1989 most public monuments to Communist Party leaders began to be taken down and were kept in warehouses belonging to the Ministry of Culture (some sculptures were stored in a barbed-wire courtyard inside the former KGB building).[32] The ministry eventually began to look for a way to exhibit those statues to the public. In 1998 the company Hesona, owned by a family of entrepreneurs, Birutė Malinauskienė and Viliumas Malinauskas, won a tender to lease these statues, which remained the property of the state, and display them in an open-air park on their property near Druskininkai, a popular spa town in Southern Lithuania.[33] Like the case of the National Art Gallery, the UPPD had little influence on this project, although they mounted several campaigns of public criticism. The UPPD accused Malinauskas's project of trivializing and commercializing the communist objects, as Grūtas Park was envisioned as a gulag entertainment park, through which a visitor would be

transported in cattle trucks. However, the local Druskininkai newspaper *Druskonis* was enthusiastic about the idea of the park and even the related controversies, seeing them as good publicity for the nearby Druskininkai spa town.[34] In response to the Grūtas Park project, the members of the national liberation movement Sąjūdis, and several other public associations, published a protest letter and demanded that Parliament ban the Soviet statue park.[35] It was proposed to form an expert group from former members of the anti-Soviet resistance and victims of repression, including the UPPD. Even the Genocide Research Center disagreed with the Ministry of Culture regarding what objects could be displayed in the park.[36]

Thanks to this controversy, the Grūtas Park became a significant reference point against which other museum builders sought to differentiate themselves, both by selecting objects and interpretative frames. While some adopted the UPPD focus on political sovereignty and repressions,[37] others searched for a new museological approach. For instance, a curator at the Museum of Occupations and Freedom Fights in Vilnius told me that they intentionally used an academic style of presentation to differentiate themselves from the entertaining and ironic style of the Grūtas Park. But the Grūtas Park also adopted some elements of the UPPD narrative in their exposition. Their website responds to its critics saying: "The exposition of Grūtas Park reveals the negative content and influence of Soviet ideology. The exposition's goal is to enable Lithuania's people, foreign guests, and future generations to see laid bare the Soviet ideology that, for many years, oppressed and harmed the spirit of our nation."[38] In addition to the statues, which are displayed alongside a path that loops through the pretty pine forest, the Park contains historical expositions housed in three specially constructed timber buildings. These expositions are a far cry from a professional museum display: they consist of a random array of Soviet propaganda artifacts, memorabilia, and some everyday objects, such as smaller furniture, telephones, and books. For example, a timber building contains an information center and an exposition of printed posters that follow the UPPD narrative of the communist past (occupations, deportations, and resistance). However, in contrast to the UPPD museum analyzed earlier, this narrative is inexplicably illustrated through a chaotic array of Soviet memorabilia, such as kitschy carpet and wooden versions of the Soviet coat of arms, busts of Lenin of various sizes, state decorations, examples of money, crockery, and random books. Another building houses a gallery of socialist realist paintings, but the selection of these works is not explained to the visitor. Moreover, this exhibition is intriguingly interspersed with a huge collection of "Misha" figurines, the Soviet Olympic mascot of 1980. Loaned from a Vilnius-based private collector, this collection of kitsch cohabits with the paintings in a rather obscure way, because socialist realist paintings were meant to be exhibited in public spaces, never at home, while such collections of souvenirs were part of private practice in the Soviet Union.

Equally opaque are the Soviet statues. Removed from urban settings into the picturesque forest, the monuments look like eccentric park sculptures. The sequence of the statues' display does not follow any particular chronological or thematic order. That they are not mere decorative fancies is testified by occasional plaques carrying brief biographical notes of the communist actors depicted. The statues do not appear to be abandoned as they are carefully placed on neatly mowed lawns, framed by lush trees.

Although transported to the woods, the Soviet statues did not lose the ability to inhabit multiple worlds: listed as heritage by the ministry, the statues also entered the creative economy. The commercial success of the Grūtas Park (earning 900,000 Litas of box income in 2012), pushed the Soviet statues into the sphere of copyright.[39] The park owner found himself entangled in the debate over whether Soviet works of art should be considered as an "authored creation," entitled to copyright laws, or as propaganda and "evidence of the crimes of communism." In 2007 law courts banned Grūtas Park from publicly showing several statues, including the famous *The Mother of Kryžkalnis* and *Four Communists* as well as a painting *Visiting a Pig Maiden Stasė Vitkienė*. The owner of Grūtas Park was obliged to compensate the artists for the use of their works. Grūtas Park was also prohibited from selling chocolate boxes that featured images of the exhibited Soviet statues.[40]

In this case Soviet statues emerged as boundary objects par excellence, as they were treated by different interest groups as propaganda, artistic heritage, intellectual property, or scrap metal. In this respect they are similar to the contemporary case of the Green Bridge statues: Soviet public monuments that were controversially removed from public spaces in central Vilnius in 2015. In 1952 four bronze statues, dedicated to the pillars of Soviet society—*Academic Youth* (sculptors Juozas Mikėnas and Juozas Kėdainis), *Guarding Peace* (Bronius Pundzius), *Agriculture* (Bernardas Bučas and Petras Vaivada), and *Industry and Construction* (Napoleonas Petrulis and Bronius Vyšniauskas)—were erected on the Green Bridge (renamed Cherniakhovskii Bridge from 1948 to 1991) in Vilnius.[41] These statues were authored by prominent Lithuanian sculptors and until recently were listed as state-protected and immobile heritage. Following the collapse of the Soviet Union, the compositions were several times reinterpreted by prominent artists. The expressive group *Agriculture* attracted the most of attention in this respect. For instance, in 1991, a photographer Remigijus Pačėsa created a photomontage with the sculptures positioned in the clouds with an ironic caption "The Green Bridge or Momentalno v more" that can be literally translated from Russian as an absurd phrase "immediately to the sea," but also sounding like *memento mori*.[42] (See Figure 10.1) In 1995, Gediminas Urbonas covered the heads of the group *Agriculture* with mirror cubes, naming the installation *Coming or Going*; this work was part of a public art project *The Language of the Everyday*, curated by Algis Lankelis. Mirror cubes returned the gaze of the passerby to her/himself, providing the reminder that the meaning of the artwork is inevitably inscribed in the present as well as in the past.

The fate of the Green Bridge statues became the focus of a struggle between the professional arts community, on one side, and the UPPD and local politicians, on the other. In 2010 the conservative mayor of Vilnius asked the heritage department to remove the Green Bridge statues from the heritage list so that they could be taken down. However, the heritage department declined this request on the grounds that the statues were listed as heritage.[43] No governmental body had the power to modify the heritage list and as long as the statues were on it, by law they had to be protected and conserved.[44] The official position of the Ministry of Culture was that the multilayered remnants of the difficult past must be preserved and that their presence in the public space strengthens the democratic foundations of society. This view was expressed in the minister of culture's letter, sent to the head of the Union of Lithuanian Freedom

Figure 10.1 Remigijus Pačėsa. The Green Bridge or *Momentalno v more*. Gelatine silver photograph, 1991. Courtesy of Gintaras Zinkevičius.

Fighters in 2012. In this letter, the minister called the attempts to erase the past "a tradition of occupational regimes," emphasizing that society must be informed and educated about the past, "however inconvenient it could appear."[45]

At the same time the materiality of the bronze statues posited a problem of safety: the condition of the figures was deteriorating (probably damaged by decades of acid rain, ironically, caused by Soviet industrialization), the statues were deemed to be unsafe to remain in their original place. A new debate if these statues should be restored and who should stand for the bill ensued. As noted by Balockaite, the Ministry of Culture announced a public tender for the conservation of the sculptures, but these were not completed due to very limited financing.[46] To complicate matters, the mayor of Moscow Luzhkov issued a statement proposing to fund the refurbishment of the Green Bridge sculptures, in this way affirming the Russian interest in keeping the remnants of Soviet culture visible in the former Soviet territories.[47] Between 2010 and 2015, when these monuments were removed, the fate of the Soviet statues became a nexus for heated public debate about the character of the Soviet regime, the boundaries of art, the civic right to public space in the city and the democratic mode of the reconciliation of different memories.[48] It is important to note that the members of the younger generation, born after the collapse of the Soviet Union, argued that the Green Bridge statues formed an important part of their own memories and that, accordingly, the meaning of these sculptures should not be restricted to the marker of the hegemony of the communist regime.

In July 2015, the brittle bronze statues were removed from the bridge. This act was presented by the Ministry of Culture as an ordinary implementation of public safety, however, for many the removal of the Green Bridge statues meant a victory in the struggle to erase the markers of the communist past. That the removal of the statues was not accompanied with a strong statement committing the Heritage Department to protect and preserve these Soviet statues in situ was seen as a grave loss by the liberal groups. Indeed, the legal status of the sculptures was changed into "transportable cultural values," which meant that although the sculptures remained under state protection as cultural heritage, their place on the Green Bridge was no longer secured.[49] Since 2015 the statues have been in storage, and in 2019 they still are awaiting repair. It was suggested that the Department of Cultural Heritage gave into societal pressure. While the cultural professional community mounted a sustained effort to keep the statues in their original place, a vitriolic public debate ensued and the translation of the statues as an inappropriate manifestation of the Soviet past prevailed in the end.[50] According to Baločkaitė, the removal of the Green Bridge statues could be interpreted as a second wave of questioning and taking down those material objects that were not singularly ideological but still represented the communist legacy, such as decorative statues and monuments to Soviet cultural actors.[51] In this case, the international geopolitical context of Russia's annexation of Crimea in March 2014 played an important role in polarizing the views on the social, political, and cultural significance of the statues. Several commentators suggested that the public debate about the destiny of the statues became a site of the informational war with Russia.[52] Nevertheless, unlike in the case of the Bronze Soldier monument in Tallinn, the removal of which prompted riots of the Russian-speaking groups in Estonia, the removal of the Green Bridge statues did not lead to any public protest from Russian speakers in Lithuania.[53]

The case of the Green Bridge statues, in this way, presents an example of the failure of a boundary object to mediate different organizational actors. In the context of strong political polarization, particularly the onset of the Russia–Ukraine conflict, the different sides could not settle upon a resolution, not to speak about a solution. Even the restoration of the statues remains a matter of controversy. However, the conflict over the meaning and destiny of the Green Bridge statues led to the proliferation of their image in public spaces. This was the first intense and wide ranging public debate about the materiality, aesthetic, and societal value of Soviet heritage in public space after 1990. Indeed, even the absence of the Green Bridge statues remains visible: the bridge remains a highly charged symbolic place. For instance, when an advertising company used one of the empty plinths that were previously occupied by the sculptures to display a new model of Audi, Vilnius inhabitants protested so actively that the car was removed within hours. The absence of the removed statues, it appears, remains meaningful, setting new boundaries for the management of public space. Furthermore, a new sensitivity to Soviet material objects and sites has emerged. Representatives of the young generation of Vilnius inhabitants have begun to make a significant claim to the stakes of managing the boundaries of the material Soviet past. This was expressed in the most recent controversy over the refurbishment of the Reformatai Park in Vilnius, a park that featured impressive flows of modernist concrete steps that were designed by prominent Soviet Lithuanian architects in 1983. Although Vilnius

City Council want to reconstruct the park by removing the crumbling, gray steps, a significant group of intellectuals and cultural figures mounted a protest that was widely communicated in the media questioning the top-down decision-making strategy of the city administration and binary interpretation of the Soviet legacy.

Boundary objects of communism

In this chapter I have analyzed how three museums have used boundary objects to present Lithuania's communist past. The branch of the Kaunas City museum initiated by the UPPD prioritized the themes of anti-Soviet resistance and Soviet repression, particularly deportations of Lithuania's population. The UPPD-style museum could best be defined as an amateur community museum. This museum relies heavily on visual and textual materials in expositions, in this way departing from the traditional focus of the museum institution on material objects. Those few material objects that were included in these expositions did not originate from the scientific interest of the museum's curators; rather, they were donated by survivors of Soviet repression. These objects are quite opaque. Their meaning is not clear to the outsider. It appears, as a result, that the communist heritage is retained as a medium that bonds the community of survivors together rather than as a discursive frame that communicates a story to the audience. Boundaries are not recognized and little explicit management is involved.

In contrast, those museums that were shaped by cultural professionals and business entrepreneurs, such as the National Art Gallery or Grūtas Soviet Statue Park, engaged with a different set of stories about the communist past, as well as different materialities, displaying objects rather than documents. Cultural professionals engaged in active management of the boundaries between the aesthetic, political, and commercial spheres that applied to "objects of communism." For instance, the curators of the National Art Gallery translated the building and the art works created during the Soviet period, with the help of the discipline of art history, which emphasized chronological and stylistic changes. In doing so, the National Art Gallery consistently applied the narrative framework of professional art history to integrate socialist realism as a boundary object between the history of art and being a relic of repressive ideological and censorship systems. The Grūtas Park case reveals the liminal nature of Soviet statues, their ability to simultaneously inhabit different conceptual, institutional, and pragmatic worlds of art heritage, leisure, entertainment, relics of the difficult past, intellectual property and commerce.

To conclude, grassroots survivors' communities, historians, and art historians mobilize different cultural, social, and political capitals in the struggle to define the meanings of boundary objects of communism, integrating them in their own pragmatic frameworks. Studies of communist heritage, therefore, should map and analyze these different social groups, assessing their rationales and roles in different contexts. Only by tackling this complexity, assessing the ways in which boundary objects of communism are framed in the wider field of culture, both professional and amateur, can we gain a better understanding of the social mechanisms through which the communist past

is presented to the public. Future studies should go beyond the reductionist view of museum expositions as a consensual outcome of the linear, top-down dissemination of the official views endorsed by the governing elites, instead approaching museums and objects of communism as boundary objects and infrastructures, where different social groups compete over their meanings and purpose.

Acknowledgments

I want to thank Constantin Iordachi and Péter Apor for their comments on earlier versions of this chapter. This chapter is a revised version of an article "Boundary Objects of Communism: Assembling the Soviet Past in Museums and Public Spaces," which was published in *Ethnologie française* 170, no. 2 (2018): 275–286.

Notes

1 This body of literature is growing. See, for instance, Agnieszka Mrozik and Stanislav Holubec (eds.), *Historical Memory of Central and East European Communism* (London: Routledge, 2018); Eglė Rindzevičiūtė, "Hegemony or Grassroots Movement? The Musealization of Soviet Deportations," in Tomas Balkelis and Violeta Davoliūtė (eds.), *Narratives of Exile and Identity: Soviet Deportation Memoirs from the Baltic States* (New York: Central European University Press, 2018), 147–174; Eva-Clarita Pettai and Vello Pettai, *Transitional and Retrospective Justice in the Baltic States* (Cambridge: Cambridge University Press, 2015); Eva-Clarita Pettai, "Negotiating History for Reconciliation: A Comparative Evaluation of the Baltic Presidential Commissions," *Europe-Asia Studies* 67, no. 7 (2015): 1079–1101; Eglė Rindzevičiūtė, "The Overflow of Secrets: The Disclosure of Soviet Repression in Museums as an Excess," *Current Anthropology* 56, no. 12 (2015): 276–285; Eglė Rindzevičiūtė, "Institutional Entrepreneurs of a Difficult Past: The Organisation of Knowledge Regimes in Post-Soviet Lithuanian Museums," *European Studies* 30 (2013): 65–93; Georges Mink and Laure Neumayer (eds.), *History, Memory and Politics in Central and Eastern Europe: Memory Games* (Basingstoke: Palgrave Macmillan, 2013); Aro Velmet, "Occupied Identities: National Narratives in Baltic Museums of Occupations," *Journal of Baltic Studies* 42, no. 2 (2011): 189–211; Mark James, *The Unfinished Revolution: Making Sense of the Communist Past in Central-Eastern Europe* (New Haven, CT: Yale University Press, 2010); Maria Mälksoo, "The Memory Politics of Becoming European: The East European Subalterns and the Collective Memory of Europe," *European Journal of International Relations* 15, no. 4 (2009): 653–680; Paul Williams, "The Afterlife of Communist Statuary: Hungary's Szoborpark and Lithuania's Grutas Park," *Forum for Modern Languages Studies* 44, no. 2 (2008): 185–198; Stuart Burch and Ulf Zander, "Preoccupied with the Past: The Case of Estonia's Museum of Occupation," *Scandia* 74, no. 2 (2008): 53–73; Nikolai Vukov, "The 'Unmemorable' and the 'Unforgettable': 'Museumizing' the Socialist Past in Post-1989 Bulgaria," in Oksana Sarkisova and Péter Apor (eds.), *Past for the Eyes: East European Representations of Communism in Cinema and Museums after 1989* (Budapest: Central European University Press, 2008), 307–334; Gediminas Lankauskas, "Sensuous (Re)



24 *Museums in the USSR* (Moscow: USSR Central Museum of the Revolution, 1989), 52, 50.

25 Ibid.

26 Darius Linartas, "Sovietinio laikotarpio architektūros konkursų raidos apžvalga," *Urbanistika ir architektūra* 33, no. 1 (2009): 39–47; Marija Drėmaitė, Vaidas Petrulis, and Jūratė Tutlytė, *Architektūra sovietinėje Lietuvoje* (Vilnius: VDA, 2012).

27 Rindzevičiūtė, "From Authoritarian to Democratic Cultural Policy."

28 Linara Dovydaitytė, "Post-Soviet Writing of History: The Case of the National Gallery of Art in Vilnius," *Studies on Art and Architecture* 19, nos. 3–4 (2010): 105–120.

29 Carole Duncan and Alan Wallach, "The Universal Survey Museum," *Art History* 3 (1980): 447–469.

30 In July 2019, the gallery reorganized the part of the exhibition that presents art from the 1940s to the post-Soviet period. The present version of the exhibition contains many more works of art that were created in response to the Holocaust, Soviet deportations and Soviet and Nazi occupations. The following analysis is based on the exhibition that was displayed in the National Gallery from 2009 to 2019.

31 "Muziejų lankomumas," *Lietuvos muziejai* 2 (2007): 48; The Lithuanian Ministry of Culture, *Muziejų statistika 2017*. The Museum of Occupations and Freedom Fights attracted 83,339 visitors in 2017.

32 Interview with anonymous heritage expert from the Ministry of Culture, Vilnius, 2011.

33 The other bidders were the European Center Park, the Center for Sculpture and Stained Glass at the Lithuanian Artists' Union, and Kaunas District Municipality. "Dvylika leninų Grūto miške," *Druskonis* 42 (October 1998).

34 "Dvylika leninų Grūto miške."

35 "Dėl sovietinio režimo propagandinių paminklinių skulptūrų ekspozicijos Varėnos rajone, Grūto miške," Lithuanian Parliament, sixty-fourth session (July 7, 1999).

36 Ibid.; "Dėl sovietinio režimo propagandinių paminklinių skulptūrų ekspozicijos Varėnos rajone, Grūto miške," Lithuanian Parliament, fifty-third session (June 17, 1999).

37 In 2010, a group of private individuals suggested establishing a historical and patriotic park. As they put it, "in contrast to" the Grūtas Park, they would focus on fighters for Lithuania's freedom on the grounds of a manor of the last interwar president. (The proposed project involved erecting new monuments to the nineteenth-century nation-builders, constructing post-Second World War partisan bunkers, and presenting materials about deportations.) "Atsvara Grūtui – patriotinis parkas A. Smetonos tėviškėje?," *Delfi.lt*, November 27, 2010.

38 See Grūto Parkas, www.grutoparkas.lt (accessed August 29, 2019).

39 The Lithuanian Ministry of Culture, *2012 m. muziejų statistika*.

40 Dainius Sinkevičius, "Grūto parkui uždrausta prekiauti ir saldainiais," *Delfi.lt*, September 13, 2007; Dainius Sinkevičius, "Teismas Grūto parkui nurodė sunaikinti kalendorius su sovietinėmis skulptūromis," *Delfi.lt*, July 8, 2011.

41 Agnė Narušytė, "Dislocation: The Conflict of Photographic and Cinematographic Representations of War in Soviet Lithuania," *Art History and Criticism*, published online ahead of print, December 13, 2017, doi:10.1515/mik-2017-0004.

42 Narušytė, "Dislocation," 48.

43 BNS, "Paveldosaugininkai: Kol stovės Žaliasis tiltas, tol stovės ir skulptūros," *Delfi.lt*, May 19, 2010.

44 Daiva Citvarienė, "Ideologiniai viešojo diskurso konstruktai ir atminties politika posovietinėje Lietuvoje," *Darbai ir dienos* 49 (2008): 165–195.
45 Letter from Arūnas Gelūnas, the minister of culture of Lithuania, to Jonas Burokas, the chairman of the Freedom Fighter's Union (2012), http://www.llks.lt/pdf/del%20 Zaliojo%20tilto%20skulpturu1.pdf (accessed August 29, 2019).
46 Rasa Baločkaitė, "Sovietinis paveldas vidurio rytų Europoje: antroji revizionizmo banga," *Kultūros barai* 2 (2016): 18–22.
47 Ibid., 19.
48 Valentinas Mitė, "Žaliojo tilto skulptūros – išplautos istorinės atminties simbolis," *Delfi.lt*, November 22, 2010; Lina Žigelytė, "Paminklai: Lietuvoje dabartis tapo spiritizmo seansu," *Delfi.lt*, August 10, 2011.
49 Angelė Čepėnaitė, "Social Value of Cultural Heritage: Lithuanian Case," in Bogusław Szmygin (ed.), *How to Assess Built Heritage? Assumptions, Methodologies, Examples of Heritage Assessment Systems* (Florence: ICOMOS, 2015), 97–111.
50 Giedrė Jankevičiūtė, "Apie Žaliojo tilto skulptūras ir mūsų santykį su sovietiniu paveldu," *Bernardinai.lt*, 2015; Skaidra Trilupaitytė, "Monuments, Memory, and Mutating Public Space: Some Initiatives in Vilnius," *Lituanus* 60, no. 2 (2014): 24–41.
51 Baločkaitė, "'Sovietinis paveldas vidurio rytų Europoje," 2.
52 Ibid., 20–21.
53 Martin Ehala, "The Bronze Soldier: Identity Threat and Maintenance in Estonia," *Journal of Baltic Studies* 40, no. 1 (2009): 139–158; Karsten Brüggemann and Andres Kasekamp, "The Politics of History and the 'War of Monuments' in Estonia," *Nationalities Papers* 36, no. 3 (2008): 425–448.

Canons of Civilization and Experiments of Spectacle: Exhibiting Contemporary History in Hungary

Péter Apor

Disorder in the museum

In the room of the Soviet advisers at the House of Terror Museum in Budapest, a key component of the original display concept was a can of pickles.[1] Only an observant visitor would be able to recognize the pickles among a strange set of objects: paintings of Stalin and Red Army soldiers on the wall, files, stationery, and an old telephone piled atop a desk, a bookshelf full of various books and prints, a uniform hanging on a rack, and various bas-reliefs, red stars, and USSR emblems chocked up to the desk. The room, a fairly small one on the museum's second floor, is a mock-up of an office of Soviet advisers before they fled at the outbreak of the 1956 Revolution (a calendar on the wall shows the date is October 23, 1956). The space is packed with the apparently haphazardly generated collections, thus creating the impression of disorder as the outcome of an unsystematic collection and random display.

Visually, the room of the Soviet advisers strikingly resembles the image of another room exhibiting collectibles, one painted by Charles-Caius Renoux, the French Romantic painter, in 1825. His *L'Antiquaire* depicts the founder of the Musée de Cluny in Paris, Alexandre du Sommerard, sitting in his Cabinet of Antiquities, surrounded by his collections. Du Sommerard was an avid collector of historical objects, artifacts, and works of art from the Middle Ages and the Renaissance, which he originally used to set up a salon for artists. After he purchased the former town house of the Abbots of Cluny, however, du Sommerard decided to put his collections on public display in order to authentically recreate the atmosphere of the Middle Ages. Renoux's painting, which shows the collector's apartment before his move to the Gothic Cluny buildings, represents the genuine entropy of objects, creating the impression of random collecting practice. "The portrait of *L'Antiquaire* shows a chaotic assemblage of objects crammed into a small space with armour and fire-arms invading the carpet," Stephen Bann noted.[2]

Renoux's painting evoked the images of chambers or cabinets of curiosities, which were ridiculed and unfavorably compared to modern museum practices. The cabinet of curiosities, typically assembled by many European princely and elite families during the sixteenth and eighteenth centuries, used to display objects to represent the totality and total order of the world, an objective that motivated owners to collect a broad variety of individual objects. This order, however, was not encyclopedic by any standard: the ability of representation was associated with the power of uniqueness and the capacity to astonish visitors in order to explore the borders of nature. Material was therefore selected for its perceived distinctiveness and strangeness. Display in the cabinets of curiosities represented their objects as being located on the boundaries of the known world, as possible gateways to an exotic and inherently alien world that was waiting to be deciphered.[3] The chaotic-looking display of objects in the room of Soviet advisers in Budapest has a similar aim. Although the object itself was not easy to find in the abundance of other exhibition material, the curators argued in an interview that for those who had memories of Russian officers' eating habits, the pickles evoked a profound context, a rich and complex cultural experience of occupation, socialism, and the life in the Soviet bloc.[4] The disorder of objects and the chaos of the exhibition room thus refer to an imagined world that is different, strange, and exotic: that of the Soviets.

The original can of pickles, later replaced by a vodka bottle—perhaps to invoke in a didactically more effective way conventional wisdom concerning Russian drinking habits—signals a desire of the curators more important than to simply represent the Soviets as exotic. In fact, it signals an epistemological claim. Neither the original can nor the subsequent bottle claims any sort of historical authenticity. There is no explanation informing the visitor of their status: they could be originals, replicas, or any random can or bottle. Apparently, the curators attribute no significance to establishing the authenticity of their exhibition material: it can be original, found, facsimile, or fictive scenery. In some cases, as with the Soviet tank in the entrance hall, the visitor is aware that what he or she is seeing is an original historical object. However, in most cases the status of exhibition material is fairly ambivalent. For instance, in the room that depicts forced labor in the USSR, the spectator encounters a few vitrines containing various objects placed above the rug shaped like a map of the Soviet Union and surrounded by screens on the walls showing documentary footage featuring witnesses of the gulag. The placement makes it seem as if the visitor is being invited to scrutinize objects from the gulag whose function and history are explained by the visual framework of the exhibition. However, the truth is different: the objects are connected neither to the background material nor to each other. More importantly, there is virtually no explanation attached to them. In some cases, the visitor is informed that the object is either a gift or comes from the estates of various unidentified people. However, as it is unclear whether these people were prisoners in the camps, the authenticity of the exhibited objects remains unresolved. Moreover, there are objects in the display cases, such as the felt boots, that look too unused to be original. However, as there are no inscriptions attached to them, the reason for and purpose of their display remains an enigma.

The room of confessions is a prime example of this practice. Entering the room, the visitor notices a huge cross lying on the floor—in fact, beneath the floor, as if it had just

been excavated after many years of being concealed from the communist secret police. However, as the spectator is not informed whether the display is a museum restoration of an original setting or a replica of the original or only contextual scenery, its status is highly ambiguous. Similarly, the walls contain small glass vitrines displaying objects that in some cases are labeled as gifts or donations or the original property of persons identified only by name, without biographical notes. Whereas in some cases these unidentified objects give the impression that they originated in labor camps—thus being authentic evidence of the persecution of the clergy—in some other cases they do not reveal such connections except to identify their former status as church property, thus providing only loose illustrations of some vaguely defined metanarrative. Besides the cross, the biggest objects on display are the two priestly garments—one Catholic and one Protestant—hanging on the wall framing the entrance to the room. Above each garment is the name of a priest: one died in a labor camp, while the other was persecuted but survived. Nevertheless, the inscription does not clarify whether the two robes used to belong to them or if they are original clerical robes from the period at all. Considering their fairly good shape and condition, one might instead conclude that these robes are new, and possibly even made for the exhibition.

The House of Terror Museum offers a curious mixture of original, unidentified, replica, and decorative objects throughout its exhibition rooms. In general, the exhibition displays three different categories of objects. The first group covers the truly authentic historical material, the second consists of copies of original articles, and the last includes objects from contemporary everyday life whose role, meaning, and place remains unclear in the context of the exhibition. The museum typically uses its authentic materials in a way that further increases uncertainty concerning their interpretation. Typically, there is so little information attached to even authentic objects that it is often very difficult to decide whether these are the genuine remnants of an actual historical moment or simply objects that might represent a historical interpretation authentically if contextualized properly. In addition, the museum constantly blurs the distinction between real and fabricated objects, since it displays them in the same way and eschews further explanation.

However, this disorder reflects more than the apparent uncertainty concerning the role, function, and status of original exhibition material. In addition to du Sommerard's own collection, the Cluny museum included the collections of another collector, Alexandre Lenoir. Lenoir obtained French antiquities during the revolution mostly made available by the confiscation of church property. Yet he used these objects not only to make his fortune but to make them visible to the broader public. His principles for exhibiting, however, were radically different from those of du Sommerard. Lenoir divided his collection mechanistically into chronological sections, hoping he would be able to trace and represent the differences of various centuries. To make these differences more conspicuous, the French collector completed his exhibition with newly fabricated busts imitating the alleged style of each century.[5]

The scandalous mixture of authentic objects with archaizing artificial works of art made du Sommerard see Lenoir's collections as being in a state of disorder. For Lenoir the actual historical authenticity of objects counted little in the creation of the atmosphere of a period, which he substituted instead with the spatial juxtaposition of

visually similar material. Du Sommerard, by contrast, invited the visitors to perceive the illusion of historical totality by the carefully designed charming spectacle of historical originals. The chaotic assemblage of objects in du Sommerard's pre-Cluny apartment appeared as a problem to be sorted out, a disorder to be overcome, and a transition to be made. It represented a collection of artifacts in a random state before adequate order was imposed on them in the proper museum. The exhibition rooms in the Cluny museum displayed authentic objects as a restoration of their original function and place. For instance, tables were covered with objects belonging with tables, such as books or gaming dice; suits of armor were carefully reassembled, and the material was cautiously selected from one period. The Cluny museum made du Sommerard's dream come true: it recreated the authentic experience of the totality of an age using exclusively original objects.[6] For its founder, the Musée de Cluny represented the restoration of historical authenticity and the overcoming of the unbearable disorder triggered by historical inaccuracy.

In the early nineteenth century a shift occurred concerning the ordering of collections of objects from the past. Private collections of antiquities, which were meant to demonstrate the plenitude and richness of both the collection and collector, began to be conceived as in a state of chaotic disorder due to careless management, as with the collection Johann Wolfgang von Goethe visited in Bonn in 1813. For Goethe the display and storage of objects the owner was proud of was a shocking experience and a cultural scandal to be quickly abolished, as he reported to the Prussian government in Berlin:

> The chaotic condition in which the priceless objects of nature, art, and antiquity lie is unthinkable: they lie, stand, and hang all over and under each other. He [the owner] guards these treasures like a dragon but without at all sensing that day by day something exquisite and worthy is losing through dust and dry rot, and through being shoved and rubbed and stuffed together.[7]

Goethe would have preferred a radically different placement and management of these objects of the past. Following his visit to another collector's residence two years later, Goethe recommended completing an educated and systematic collection with a similarly careful arrangement of objects according to a chronological-temporal sensitivity that could bring order to the chaos by enabling the perception of temporal trajectories: history. Early-nineteenth-century intellectuals and the broader middle-class collectors' culture of historical awareness called for reshaping objects of the past previously considered targets of antiquarian curiosity as means of making visitors experience history, as historical objects.[8]

The modality of spectacle represents epistemological claims in both the Musée de Cluny and the House of Terror. As du Sommerard based the access to the past in his museum on the carefully arranged display of authentic original historical objects, implicitly rebuking Lenoir's practice as an expression of improper and unfounded knowledge, the curators of the House of Terror considered their exhibition a critique of historical knowledge based on objects. They regard the recent past as a period poor in conventional historical evidence, especially for museum exhibits. In general, there

are few objects from the period, explains the House of Terror's ethnologist-curator interpreter, so the curators had to experiment with new ways of accessing the past.[9]

Memory in the museum

Similar to the antithesis of du Sommerard's or Goethe's historical museum, rigorous historical accuracy was not the main concern of the designers of the House of Terror Museum in Budapest. As Sándor Fábry—a television host and one of the initiators of the museum—critically remarked, the historical narrative in the exhibition was not without gaps. Specifically, he noted that resistance to the Hungarian Soviet Republic in 1919 and the subsequent White Terror were omitted, and the 1956 Revolution was not given enough significance.[10] However, given the curators' wider ambitions to create an ethnographic-style exhibition focusing on ways of life, which tried to depict historical periods in their totality, the minute reconstruction of historical details appeared less important.

The curators considered their museum a reaction against conventional historical exhibitions, which, they believed, employ too much text and too few visuals, usually resulting in boring displays unable to maintain interest and attract the young. In fact, they argued that traditional historical museums actually failed to get their message across. The main designer of the exhibition, Attila Ferenczffy-Kovács, claimed it was difficult to precisely express historical events such as the persecution of religious institutions and persons. An accurate explanation, he said, would have resulted in incomprehensible guidelines reducing the richness of interpretation, which was more faithfully and effectively mediated by the complex experience of the multimedia installation. As Ferenczffy-Kovács explained, the main objective was to achieve visual intensity. He stressed the importance of turning each room into a visual surprise to maintain visitors' interest. The former stage designer described his concept of representing the past in the exhibition rooms as fictional projections of the ways that he understood various historical episodes to be imagined currently. András Szalai, one of the architects of the House of Terror, similarly emphasized their focus on the visuals of the museum identified with the evocative power desired.[11]

There are virtually no inscriptions in the House of Terror, and only brief explanatory notes supplementing each room that try to provide a cursory overview of the context of events represented. Instead, the museum is full of carefully designed, spectacular, visually appealing sceneries using new media technology. The visitor entering the House of Terror is immediately embraced by the totality of the atmosphere created by the concerted efforts of visuals and sound effects. Opening the fairly ordinary small door, the visitor is abruptly struck by the sight of the twin memorial commemorating the victims of the communist and Arrow Cross tyrannies. The carefully lit, red and black memorial is in the visual focus of the narrow gloomy stairway. Its material (marble) and the accompanying sound (dark gothic-like melodies) creates a shocking impression, as if the visitor had entered a mortuary. The exhibition in the House of Terror capitalizes on a shocking and depressing atmosphere of violence, starting immediately with the entrance hall, whose dark, mystical design weighs heavily on the visitor.

This gloomy vision is usually the spectator's first crucial impression. The inner courtyard of the building is dominated by a Soviet-made tank and a huge board displaying a vast selection of photographs of the victims of Soviet terror. The brutal shape of the former Soviet T-64 tank, stuffed in a relatively tiny courtyard surrounded by black, gray, and white backgrounds, guides the visitor toward the staircase to the main exhibition rooms. In a similar manner, the corridor leading to the Arrow Cross room is dominated by black, while the visitor is physically forced into a tiny space between two walls. Typical in this respect is the room of the communist deportations. In the early 1950s, Hungarian authorities, like their counterparts in all other Soviet-bloc countries, forcibly dispossessed alleged "class enemies"—members of the interwar middle class and administration—and deported them to labor camps. The design intended to evoke this event produced another version of the mortuary atmosphere: with dark music in the background, the spectator is invited to contemplate a black curtained box in the middle of the room. Behind the curtains a black Pobeda—the car associated with the Hungarian communist secret police in the 1950s—stands patiently, as if waiting to take the visitor away. Clearly, the purpose of the display is to produce general experiences and impressions and to discourage systematic interpretation of the events referred to.

For the average visitor a crucial part of the visiting experience is a depressing descent in an elevator. The unsuspecting museumgoer is suddenly hit by the sound of a video installation that starts from behind: an old man—once a janitor who had been present during executions—describes in detail how hangings were carried out. The elevator stops in the museum's cellar, where a torture chamber of the communist secret police has been reconstructed. The gloomy image of death accompanies the spectators as they leave the elevator only to arrive in black, industrial-style empty cellar corridors emulating the scenery of horror movies.

The House of Terror creatively uses visual techniques such as the multiplication of images, modeled on successful television advertising techniques to mediate messages. The room of occupations, designed to begin the narrative of the exhibition by depicting the horrific consequences of the Nazi and Soviet invasions of Hungary, is based on a set of complementary video installations. The monitors fixed on two opposing sides of a wall dividing the room into two equal halves repeat on an endless loop shocking images of atrocities such as documentary footage taken in Nazi concentration camps or in the gulag. The exhibition, however, does nothing but repeat these iconic pictures of atrocity and violence while refusing to provide any explanatory context for the moving images. Thus the room itself remains nothing but a repetitive hammering of the message about the horrors of occupations.

Modern museums in the nineteenth century were indeed born as spectacles—the rational counterparts of the disorderly amusement of fairs. Museums offered things to be seen and learned and invited visitors to be subjects of new visual knowledge and encouraged them to transform themselves into civilized and cultured citizens.[12] However, the House of Terror's approach, dominated by audiovisual spectacle and the disorderly mixture of original and replica, authentic artifact and staged scene, also claims to be the pertinent approach to a new type of epistemological modality—a new procedure for experiencing the past. The House of Terror Museum claims the

authority of its representation on the past as an institution preserving and displaying collective memory. It seeks to justify its mission by the necessity of performing an adequate memory work. As its website states:

> Although what should never have been allowed to happen did happen, in 2002 the site of common remembrance, the community and exhibition space, came into being, touching the wounds of Hungarian historical memory like fresh air. Following the decades of silence, a place was born that, like a living memento, calls the participants in our common history, victims and perpetrators alike, by their name. Without speaking what seems unspeakable and naming what seems unnamable, there can be no regeneration.[13]

The Budapest House of Terror considers itself a modern memorial museum, one of the institutions currently cropping up around the world that combine the production of historical knowledge on violence with the intention to commemorate the victims of atrocities.[14] Indeed, the staff of the Budapest institution saw it as a successful attempt to express academic content in visual language. For them, the building and exhibitions created a sacral site of memory to commemorate the victims of dictatorships in Hungary. It was meant to be a place triggering catharsis and emotional reactions. Curators believed they faithfully respected the pertinent practice of contemporary memorial museums such as the Washington Holocaust Museum or Jerusalem's Yad Vashem, and they were admittedly influenced by the model of an Eastern European counterpart, the Museum of Genocide Victims in Vilnius, which seeks to commemorate the victims of both the Nazi and Soviet occupations.[15]

In fact, several observers remarked soon after its opening, the House of Terror seemed like a legitimate attempt to represent the past in a form radically different than conventional history museums. While criticizing the institution for failing to accomplish its mission due to ideological confines or misconceived aesthetics, such critiques typically accept its claim to be a special (postmodern) institution where the authenticity, credibility, and power of the representation of the past do not rest on accuracy, argument, and interpretation but on commitment, participation, and passion.[16] It is as if history and memory were two isolated distinct areas: history would be a neutral technical activity of carving out facts and data, whereas memory would be the value-laden morally committed relationship to the past leading to respecting sacrifice and drawing lessons. It is as if history and memory required two markedly different and independent methods: while historical interpretation would be based on textual descriptions, memory would be based on visual experience, cultural imagination, and the persistence of cultural images. It appears to be possible to construct memory by the sweeping power of the new audiovisual media and to neglect the mean requirements of historical accuracy: it appears to be possible to separate spectacle and evidence.

By the early 1980s, the concept of memory had indeed started to claim something similar. In social psychology, sociology, and anthropology the notion of memory has increasingly begun to refer to a particular set of collective capacities that shape the image of the past in various communities and groups.[17] Memory is typically

understood as a process where the representation of the past is largely independent of historical accuracy or evidence. Memory appears as a process where the preservation of the knowledge of the past and the construction of linkages with the past are secured by radically different means: by social frames of communication, by the formation of communities, by canons of cultural genres and meanings, by framing identities, and by the implications of power and dominance.[18] Memory seems to be not only a distinct sociocultural practice concerning the past but, perhaps more importantly, a remarkably distinct methodology to access the past.[19] Museums in particular appear to be the places where the representation of the past occurs in different modalities than in conventional academic history. Museums seem to be the places where by capacity the past is recreated through spectacle; places where memory is being constructed; places where memory can be learned; places where the past is accessible through memory.[20]

Representing a secret history

Nevertheless, there is something more that memory can offer. The prime minister of the Hungarian government at the time—the radical anti-communist liberal turned radical anti-communist conservative party Fidesz-Magyar Polgári Párt, also known as Fidesz-MPP (Fidesz-Hungarian Civic Party)—inaugurated the House of Terror on February 25, 2002. It was claimed that this museum was built to commemorate the victims of dictatorial rule in the country. The museum's spectacular opening ceremony took place just two months before the general elections and was part of the electoral campaign of the ruling conservative party. The prime minister's personal presence and inauguration speech, the appointment of his personal consultant in "historical matters," Mária Schmidt, and the establishment of a public foundation from huge state subsidies to manage the museum clearly indicated that the event was considered a highly important political step. In his address, the prime minister stressed the importance of eventually realizing a true representation of the history of the twentieth century in Hungary that would teach future generations the meaning of the fight for freedom.[21] The House of Terror immediately became the subject of fierce criticism. Public intellectuals, including many respected historians, pointed out the ambiguity of historical interpretation in the museum, the controversial nature of the comparison of fascism and communism, the insufficient distinction between victims and perpetrators, and the failure to address the longer-term historical roots of political terror and violence in Hungary.[22]

The House of Terror in Budapest was inaugurated on the Day of the Victims of the Communist Dictatorships. This commemorative day was created on June 16, 2000, when the Hungarian Parliament passed Resolution 58 of 2000. There were 201 "yes" votes, 24 "no" votes, and 87 abstentions. With this decision, Parliament set aside a particular day in Hungarian high schools to commemorate the victims of the communist dictatorships.[23] On February 25, 1947, the Soviet Red Army seized Béla Kovács, the general secretary of the Smallholders' Party, one of the harshest critics of the communists' aspirations of power. In 1947, this violent act clearly marked the limits of Hungarian democracy: the Hungarian communists could count on the support of

the Soviet military forces to resolve crucial political conflicts. June 16—the day the Parliament passed the decision in 2000—was the same date as that of the execution of Imre Nagy in 1958. In 1989, the reburial of the prime minister of the 1956 Revolution on the anniversary of his death constituted the core symbolic event of the demise of the communist regime. This parliamentary act depicted a continuity of communism from the takeover in 1947 through its fundamental crisis in 1956 to its fall in 1989. The communist dictatorship was portrayed as a state of undifferentiated repression. The resolution showed historical facts in isolation and blurred the personal fate of the communist prime minister who had remained true to his convictions, consciously accepting the death penalty, as well as that of the persecuted smallholder oppositionist politician who had become a member of the Parliament in 1958 in the post-revolution Kádár regime. The history of communism was represented as an abstract entity identified with political terror.

The Hungarian Parliament's decision to establish a memorial day for the victims of communism marked the first post-1989 commitment toward a systematic politics of commemoration related to the communist past in the country. The anniversaries of the October 1956 revolution were celebrated annually with remarkable pomp and publicity and bore the mark of the contemporary daily political context. Nevertheless, they failed to express any coherent intention to systematically interpret the history of the communist dictatorship. Although the members of the first conservative government (1990–1994) demonstrated considerable interest in historical matters and did not decline to make statements on particular historical questions, these remained individual manifestations rather than parts of a comprehensive political will to remember. Immediately after 1989, the general disorientation of history produced a variety of interpretations, yet the first socialist-liberal coalition (1994–1998) prioritized the current economic and social problems and appeared rather disinterested in and indifferent to issues of the past. The socialists, who at that time were mostly former communists, found it extremely inconvenient to face their fairly dubious late-communist legacy. Liberals considered questions of historical identity secondary to the pressing need to restructure the economy and public administration.

However, the second conservative government (1998–2002), led by Fidesz-MPP, managed to formulate a strongly historically oriented conservative-nationalist ideology. In the struggle for votes in the post-communist elections, Fidesz-MPP realized the importance of identity politics, embedded in an imaginary history of the nation. In its campaign the party emphasized its intention to "give back Hungarians their national self-esteem." And immediately after its victory in the general elections, the party began to bombard the electorate with historical interpretation.[24] Fidesz decided to build "national pride" on a voluntaristic and mythical series of *grandeur et gloire* connected to the history of the Hungarian state and (Christian) church(es). The first element of this politics of history was the establishment of the new Ministry of National Cultural Heritage, which was commissioned to define aspects of cultural heritage considered worthy of integration into the imagined historical-national identity.[25] This initiative culminated in two controversial events. The first of these was the centrally organized celebration of the 1,000-year anniversary of the foundation of the Hungarian state in 2000. Common historical understanding held

that on Christmas of 1000, Stephen, the apostle of the Magyars, was crowned as the first king of Hungary. This millennium was clearly modeled on a previous 1,000-year anniversary in 1896, when the modernizing Hungarian state celebrated the conquest of the Carpathian Basin by Magyar tribesmen. In 1896, national pride had been embedded in the achievements of civilization and modernity in which the state was actively involved, whereas in 2000 the millennium provided an opportunity for the government to distill a historical continuity of the Hungarian state grounded in a Christian-clerical historicization and national distinctiveness.[26] The intention to set the point of departure of the modern Hungarian state's history in the symbolic founding of the medieval kingdom was demonstrated by the transfer of the Holy Crown from the National Museum to the Parliament building. The sacred crown of Saint Stephen started to be considered the ultimate representative of the Hungarian political body in the late Middle Ages and early modern times. This was closely related to the fact that the country's actual ruler resided outside the territory of the kingdom, in Vienna. The crown had been taken by the US Army at the end of the Second World War and given back to Hungary in 1978. It was kept in the National Museum until 2000, when the Fidesz-led government decided to place it in the hall of Parliament as the symbol of Hungarian statehood and thereby declared the contemporary Hungarian state the subject of the supra-personal Holy Crown.[27] Thus the subject of this particular Hungarian history—the Christian state—became an ahistorical and eternal abstraction whose essence was not subject to temporal change but remained the deepest desire of the nation.[28]

The museum of communism plays a special role in this politics of commemoration of national pride. The politics of history in contemporary Hungary, which includes the interpretation of the communist dictatorships, represents the nation as an eternal entity, a set of virtues and values, whose history is described as a success story of the realization of these qualities. Shameful periods of national history are regarded as regrettable historical accidents caused by various external forces. Representing the communist regime exclusively as a terrorist rule generated by such external forces and maintained solely by violence is a crucial means of implementing this concept-rooted historicist understanding of nationalism. If the communist dictatorships in these countries can be successfully isolated as events of non-national history, it becomes possible to claim that a range of resilient qualities and features characterize the nation and that these remained unchanged despite communism. On this basis it is possible to state that there is an eternal national identity despite temporal change and that this identity manifested itself in the periods of genuine national history.[29]

In this conception, communism indeed occurred, but somewhere else; perhaps on a different plane of existence, but not within the mythical and mystical space of real national history. In this perspective, the Arrow Cross regime and German occupation appear only as a prelude to genuine dictatorship: these obtain meaning as the overture of the core story of communism. The attempt to quarantine them as non-national history is intended to demonstrate that ideological dictatorships are alien to the real essence of the nation. The Holocaust in Hungary, social exclusion, or an alliance with the Third Reich did occur in some mundane, down-to-earth historical reality. Nevertheless, in the higher History of the Nation, these are never-ever-happened events.

It seems as if the creators of the House of Terror took seriously the notion of historical authenticity held by the Marxist philosopher and communist activist György Lukács. The most important criterion of authentic historical interpretations, as Lukács claimed in his treatise on the historical novel published in Russian in 1937, then in Hungarian in 1947, was that they were able to represent the tendencies of development that shape the present. The Marxist philosopher expected historical novels to demonstrate how society came to take its contemporary form and which historical processes determined its contemporary state.

> Without a felt relationship to the present, a portrayal of history is impossible. But this relationship, in the case of really great historical art, does not consist in alluding to contemporary events, but in bringing the past to life as the prehistory of the present, in giving poetic life to those historical, social and human forces which, in the course of a long evolution, have made our present-day life what it is and as we experience it.[30]

Lukács believed that precisely because the purpose of historical representations was to detect processes leading to the present, many historically relevant tendencies revealed only a retrospective gaze into the past. Numerous components of the historical development remained hidden for contemporaries, which nevertheless became recognizable to subsequent observers. Lukács, however, was searching for more than simply the relevance of historical explorations as tools to understand the present. The Marxist philosopher argued that since the genuine essence of historical reality was made of those processes that led toward the present, this reality became accessible through an adequate assessment of the present. The appropriate understanding of the historical process depended on the correct moral-political commitment and cultural-ideological consciousness of the observer-interpreter of the past. The purpose of authentic historical representation was thus to document the process of historical necessity as understood in retrospect. "Measured against this authentic reproduction of the real components of historical necessity, it matters little whether individual details, individual facts are historically correct or not [...] Detail is only a means for achieving the historical faithfulness here described, for making concretely clear the historical necessity of a concrete situation."[31]

The theory of socialist realism teaches that to represent reality faithfully, one must depict the hidden essence of things. The hidden, but real, essence of history or reality reveals itself in its typical manifestations. However, to recognize and understand the typical, one must practice a certain form of self-discipline: one must learn not to trust his or her eyes. The eyes, according to socialist realist criticism, reflect only the objects as they appear; they tell little about the truly important factors of human consciousness and cognition, which is accessible only by thought. The visible, observable qualities of objects—facts—are only part of the truth. More precisely, they are raw material that genuine representation must learn to use, and even use creatively, in order to discern the unessential and the typical. But how is it possible to establish what is important and what is not? The typical, according to the theory of socialist realism, is not marked by its regular appearance or prevalence. The typical is instead the crucial process that

is just emerging to determine the further course of history. Therefore, reality is to be recognized not by considering the visible and the observable but by contemplating the still-invisible and still-hidden. Obviously, a certain element of prediction and fortune-telling is involved in this process, which could make faithful representation impossible if there were no guiding light in seeing the future. If it is the political center, the party that shapes the future, launches processes to emerge, and defines what the typical is, then true representation must understand, depict, and follow political visions and objectives.[32]

The visual design of the exhibition in the House of Terror is dominated by typical (neo)constructivist elements: geometrical forms of the cube, globe, and circle and (neo)avant-garde techniques of visual representation such as photomontage or the total audiovisual experience of sounds and moving images. Attila Ferenczffy-Kovács, the main designer, was a member of a Budapest network of (neo)avant-garde artists in the 1980s and regularly cooperated with (neo)constructivist architects László Rajk and Gábor Bachmann. The House of Terror is not the first appearance of (neo) constructivist design and avant-garde modernism in a historical exhibition.[33] The Mostra della rivoluzione fascista (Exhibition of the Fascist Revolution), opened by Benito Mussolini in 1932, recruited thirty-four of the best Italian contemporary artists, including modernist painter Mario Sironi and rationalist architect Guiseppe Terragni, to set an unprecedented, innovative, novel visual experience. Fascist modernism, which regarded conventional nineteenth-century historical realism and the corresponding modalities of museum representations as lifeless, empty formalism and essentially "bourgeois," sought to replace the former experience with new spiritual and mobilizing perceptions of history. The avant-garde genres and techniques of photomontage, constructivist design, functionalist architecture, expressionist theater, and experimental film created a form of representation where history is felt rather than reasoned and which dissociated the visual depiction of fascism from all earlier eras, thus making Mussolini's dictatorship a novel, formative, "historic" event.[34]

The modernist Italian artists were impacted largely by their personal experiences of the early twentieth-century Russian avant-garde. Sironi, who designed the Italian pavilion at the 1928 International Press Exhibition in Cologne, witnessed El Lissitzky's constructivist Soviet architecture there. Terragni, in turn, was influenced not only by German Dadaism but most importantly by Soviet futurist-constructivist architecture and photomontage-based exposition and agitation art.[35] Yet the purpose of constructivist art, at least in Russia, was not to create new, attractive forms to redirect attention toward undiscovered aspects of reality. The leading artists of the Russian avant-garde, Malevich, Melnikov, and El Lissitzky, sought instead to eliminate, deconstruct, erase, and reduce all forms—everything that had been constructed before. Nevertheless, this idea was not driven by some sort of abstract passion to destroy the old, conventional structures of society and culture but rather by the desire to detect the true but hidden inner structure of reality. The Russian avant-garde was motivated by the conviction that the direct, ordinary experience of reality merely concealed the other, more real structure of reality. Consequently, in order to reveal and unpack this inner reality, everything that hid and masked it needed to be destroyed. The constructivist project was based on a constant and deliberate distancing from the

mundane and the visible in order to create the opportunity for another, nightly vision: to demonstrate the hidden invisible construction of reality.[36]

The curators and designers of the House of Terror see their museum as a theater-like institution dominated by spectacle, where the overall visual design and the resulting emotional reactions are believed to guarantee the authenticity of the experience of the past, irrespective of the authenticity of individual objects. The museum is a typical manifestation of modernist exhibitionary art that sought to capture the secret structure of reality not revealed to ordinary eyes. The creators of the exhibition longed for a virtual reality in which representations could convince the audience of the hyperreality, the "more real reality" of the construction. Three-dimensional design and multimedia projections are used to build simulacra, the hyperreality of representations that establishes itself as reality.[37]

Conventional historical museums bound to objects of ordinary reality have proved to have difficulty representing the other, secret reality. After interviewing three of the designers, the ethnologist-curator Éva Szacsvay interpreted their method thus: the House of Terror generated a new world different from the concept of previous exhibitions, which had been based on data provided by objects. The House of Terror had to meet a different sort of challenge. It needed to confirm an idea using objects; it needed to adjust the objects into a preexisting, ready-made conceptual frame. In this concept, objects are not expected to inform their spectators; instead, their duty is to evoke various contexts for those who possesses memories about them. As a consequence, systematic collection is not a necessary prerequisite for setting up a museum. Instead, a careful selection of a limited number of isolated objects from other museums and collections seems sufficient. (The House of Terror staff searched, in particular, through the collections of the National Museum and the Military History Museum for appropriate material.)[38] This imaginary new museum would mediate a prefabricated concept after locating appropriate objects or, if there is little such material, creating them.

However, this is exactly what an influential contemporary idea of memory offers. This discourse of memory promises access precisely to "realities" allegedly hidden beneath the surface of visible details. The concept of "memory" not only recalls the socially constructed and culturally shaped nature of historical knowledge but also appears as a special approach that provides authentic access to the past by forgetting the concrete and the detail but invoking visual codes and cultural narratives. The study of memory has become a revelation—as if the scrutiny of individuals' minds and the cultural practices of collectivities enabled the scholar to unveil another secret reality hidden behind the visible signs of ordinary culture. Memory seems to be able to break through what conceals the visible and reach toward the invisible. Memory has emerged as a distinct field of inquiry that promised to provide access to the fundaments of human existence. If memory is shaped by collective mental, cultural, and political processes, then the study of remembering is a means of obtaining crucial knowledge of the organizational principles of social structure, the underpinnings of cultural systems, the decisive stakes of political power regimes, and even the depths of the human mind. Memory has matured into a concept to represent or even replace what structure used to mean for sociologists, culture for anthropologists, the soul for psychologists, narrative traditions for literary critics, and ideology for political scientists and historians.[39]

The epistemology of emptiness

Nevertheless, what occurs in the House of Terror is by no means experiencing the past, because the past is simply not there. Contrary to the illusion, the exhibitions do not employ actual historical figures. Communists, whom one would expect to be the main actors in the drama, appear only in the abstract, typically as objects of socialist realist propaganda art. The room designed to represent the climate of political surveillance and indoctrination refers to the political culture of the period by displaying portraits idealizing Communist Party leaders such as Stalin or Hungary's Mátyás Rákosi. Proper explanation of who these people actually were and what their role was in 1950s politics is not provided; they appear only as the object of the political cult of party leaders, not as real once-living historical figures along with their actual historical context. Similarly, in the room made up to resemble a former secret-police office—allegedly the office of commander Gábor Péter—two monitors on the wall show a few recurring portraits: one in ordinary black-and-white, the other one in blurred gray-and-black shadowy texture. The curators claim to be visually representing the frequent shifting of roles from perpetrator to victim within the communist secret-police apparatus. Nevertheless, the portraits are not identified and not linked to actual life trajectories, which makes the exhibition nothing but an allegorical reference to the fragility of human existence.

In general, the House of Terror is a highly depersonalized institution. Although the curators creatively employed the scenery of mourning and sorrow in connection with ideologically motivated persecution, it is difficult to obtain information on the precise identity of the victims. None of the rooms devoted to displaced persons, forced labor, or the post-revolutionary repression in 1956 to 1957 link the abstract atmospheres to actual individual life-narratives that could have situated the general statements in concrete historical contexts and could have turned these into tangible and comprehensible realities. The images of the victims in the reconstructed prison cells are not accompanied by proper explanations to give the visitor an understanding of who these persons were and the reasons for their destiny. The Arrow Cross perpetrators make an appearance only as symbolic icons: they are represented by a set of empty uniforms hanging on the wall and a blurred plastic-faced figure of Szálasi (leader of the party).

The fact that the curators' intention was to evoke general emotional atmospheres rooted in doom, fear, and anger is clearly demonstrated in the room dedicated to the post-1956 repressions. Here the visitor faces six identical gallows (the multiplied visual effect is a typical practice of the House of Terror), which apparently represent the executions following the suppression of the revolution in 1956. Yet instead of identifying the actual victims and turning the story of 1956 into a tangible historical experience by displaying a few individual fates, the room actually disorients the visitor, who finds on some of the gallows the sentences of people who were actually executed between 1945 and 1949.

Thus the exhibition does not refer to 1956 as an actual event of the past: it omits its historical context, conflates it with other events, and abuses it to evoke abstract allegorical meanings. A room made up to look like a courtroom, said to represent

the hollow formality of communist jurisprudence, immediately follows the secret-police office, creating the impression that it was intended to depict the show trials of the 1950s. Nevertheless, a wide-screen monitor broadcasts the original propaganda film of the trial of Imre Nagy, the prime minister affiliated with the 1956 revolution. The room, however, does not clarify the reason why this installation immediately follows the secret-police office, which eventually absorbs the meaning of 1956 as a real event with causes and consequences and connections to other events into a mishmash of communist terror.

Although the museum occupies the building of two terror organizations, the Hungarian fascist Arrow Cross Party and the communist secret police, respectively, it fails to firmly connect the representation of the past to the actual historical site provided by the physical location. On the one hand, the exhibition does not represent the building as the concrete locus of concrete organizations. It is difficult to understand what the communist secret police in the 1950s was, what its tasks and mandate were, what sort of activities it managed from the Andrássy Street building, and how the terror of the 1950s related to the persecutions during the late socialist period. On the other hand, the House of Terror blurs the concrete reality of the building by the constant display of an unclassified mixture of atrocities committed in other locations.

Furthermore, the exhibitions ignore instances of injustice and violence also connected to the building. The history of the house did not begin with the Arrow Cross. Originally it was the property of Budapest upper-middle-class Jewish businessmen. The successor of one of these families, the painter Izsák Perlmutter, who became the building's sole owner in 1930, declared in his last will that he wanted the building to be used to house a future Jewish art museum. Nevertheless, this museum was never realized, and the successors decided to rent out the apartments. Paradoxically, the Hungarian fascist Arrow Cross Party became the main tenant in the building, probably starting in 1937; they took advantage of the situation and did not pay rent. Until 1951 Perlmutter's widow and family formally remained owners of the building, which in fact the communist security police had already been using since 1945, when it was nationalized and officially maintained by various state companies. Neither the family nor the Israelite Community of Budapest—the intended beneficiary of the would-be Jewish Museum—have ever been compensated for any losses.[40]

The intention of the House of Terror is not to present an interpretation of history but to dismantle the reality of the past. The impressive use of new media does not lead the visitor closer to compassion for past victims and an understanding of their fate (the objectives of commemoration) but effectively distances them from the reality of the past in order to throw them into the surreality of the present. The simultaneously flooding, multiplied, and overlapping noises, voices, images, and moving images create a cacophony of experiences that disorients and puzzles the visitor. In the middle of the exhibition, the room on forced collectivization guides the spectator through a labyrinth of plastic bricks shaped like old-fashioned cubes of pork fat, referring to the confiscation of goods from the peasantry. The labyrinth is virtually empty of exhibition material, except for a few small monitors screening documentary footage. Deprived of signs and information, the visitor feels lost, and when the route abruptly ends in a space filled with sizable images and videos, the visitor feels thrust into a David Lynch

movie, wandering hopelessly in between reality and surreality, or simply in between different layers of unreality. The feeling, familiar from thrillers, of being hopelessly lost is what haunts spectators when they finish their descent to hell, to the level of underground prison cells whose appearance has been taken from the empty cellar corridors of Hollywood horror movies.

The House of Terror in this respect appears to share the epistemological skeptical conviction of the Mostra della rivoluzione fascista (Exhibition of the Fascist Revolution) opened on October 28, 1932, in Rome. The exhibition attempted a painstakingly minute reconstruction of the atmosphere of the period of Mussolini's March on Rome, the Italian Fascist Party's 1922 seizure of power. The organizers, led by Dino Alfieri, emphasized the focus on an "objective, faithful, chronological reconstruction" and put great efforts into securing considerable documentation for this purpose. Local party activists were mobilized to research and collect original evidence, photographs, medals, postcards, and other artifacts, in order to tangibly demonstrate the historical origins of fascism.[41] Nevertheless, it was precisely the overwhelming abundance of objects that prevented the audience from appropriately assessing the historical events displayed in the exhibition. The visitors encountered a flood of images, artifacts, symbols, signs, and documents, which overwhelmed them with information and contributed to their complete disorientation, confusion, and loss of focus. The exhibition consciously mixed objects of art with original historical evidence, blurring the distinction between fiction and investigation, aiming at the denial of critical distance necessary for the establishment of rational appropriation but cultivating emotional reactions among the audience.[42]

The innovative audiovisual technology and the abundance of spectacle ultimately simply conceal that there are virtually no objects in the exhibition area of the House of Terror. The entire museum thus resembles an installation referring to an imagined world rather than any representation of an actual historical period. The exhibition uses its objects to refer to previously established abstract ideological tenets, to illustrate and hence evoke these allegorical meanings.[43] The House of Terror thus represents no alternative model to approach the past and no competing interpretation of history to be debated. It simply denies epistemological foundations; it denies the possibility of obtaining knowledge of the past via investigation and evidence in order to persuade its audience about the credibility of its historical fiction. The House of Terror offers nothing to remember; instead it articulates and visualizes a political message.

The epistemology of memory, in fact, is rooted in enchantment and practices of magic. Pierre Nora recalled how he was inspired by Frances Yates's work on the art of memory when he conceived the term *lieu de mémoire* as a reflection of the classic concept *loci memoriae*.[44] Yates, however, was interested chiefly in the process through which the tradition of the art of memory, from the Middle Ages onwards, acquired thorough mystical meanings based on Platonic concepts. Although Plato himself devoted no treatise to memory, he was convinced that knowledge of the ultimate truth was latent in human memory. Medieval memory treatises concerned with Christian religious concepts were intended to reveal the secrets of heaven, hell, and the fall of man through remembering. The *Rhetorica Novissima*, written by Boncompagno

in 1235, drew a distinction between natural and artificial memory, considering the former the gift of nature and the latter something manufactured by human beings. While natural memory required no artificial aid, its artificial counterpart was only an auxiliary of natural memory. Notwithstanding their difference, both were directed toward a comprehension of the Creation. Although men and women possessed the ability to remember Paradise naturally, after the Fall they required the assistance of natural memory.[45]

In Renaissance Italy some scholars attempted to create places of memory—the theaters of memory—which were believed to evoke memory that would reveal the final order of the universe. Guilio Camillo (1480–1544) designed a theater to represent the order of eternal truth. He expected to remember the universe through the organic association of all its parts by comparing the microcosm to the macrocosm. Giordano Bruno (1548–1594) hoped to detect the Hermetic secret by a sophisticated use of the art of memory. He even believed that he possessed the Great Key of the universe, which was the ultimate means to reveal the essence of the Creation. For Renaissance thinkers the detection of places of memory was an act of magic that could reveal the Great Key of the universe—an act that could enable the magician-scholar to recognize the secret hidden truth.[46]

The idea of memory as a potential way to ignore the particular and to get behind the facade of reality, and its practice in institutions such as the House of Terror, suppresses the fact that memory, museum, spectacle, and evidence were originally assembled in a different manner. Renaissance museums or theaters of memory, which sought to visually represent the order of things in the universe, considered themselves solutions to the problems of knowledge. The visual display of objects in such museums that were believed to correctly imitate the original or natural order of the universe, however, was not only imagined as an appropriate means of mediating this knowledge; the collected objects, if arranged according to a proper method, were also expected to generate new and original knowledge.[47] Cabinets of curiosity were considered places that satisfied the desire to know, "and the cabinet was intended to open the mind to the wonders of the world equally as much as it was intended to further study." Curiosity involved not only the interest in the rare, exceptional, or exotic but also the intellectual activity to discover or learn unknown things. For the Enlightenment, "museum" meant a place for display, study, and discussion alike.[48] Museums were born as institutions that treat, represent, and construct their objects as both evidence and spectacle.

Notes

1 Éva Szacsvay, "A látvány anatómiája. Beszélgetés a Terror Háza Múzeum kiállításának alkotóival" [The Anatomy of Spectacle: An Interview with the Designers of the Exhibition of the House of Terror Museum], *Magyar Múzeumok*, Summer 2003: 12.

2 Stephen Bann, *The Clothing of Clio: A Study of the Representation of History in Nineteenth-Century Britain and France* (Cambridge: Cambridge University Press, 1984), 80.

3 Lorrain Daston and Katherine Park, *Wonders and the Order of Nature 1150–1750* (New York: Zone Books, 1998), 260, 272–273; Susan A. Crane, "Curious Cabinets and Imaginary Museums," in Susan A. Crane (ed.), *Museums and Memory* (Stanford, CA: Stanford University Press, 2000), 64–69; Eilean Hooper-Greenhill, *Museums and the Shaping of Knowledge* (London: Routledge, 1992), 88–89.
4 Szacsvay, "A látvány anatómiája," 12.
5 Bann, *The Clothing of Clio*, 84.
6 Ibid., 87.
7 Crane, "Curious Cabinets," 76–77.
8 Susan A. Crane, *Collecting and Historical Consciousness in Early Nineteenth-Century Germany* (Ithaca, NY: Cornell University Press, 2000), 109–111.
9 Szacsvay, "A látvány anatómiája," 11.
10 Ibid., 13.
11 Ibid., 13–14.
12 Tony Bennett, *The Birth of the Museum: History, Theory, Politics* (London: Routledge, 1995), 69–75.
13 For an introduction to the House of Terror Museum, see http://www.terrorhaza.hu/en/museum (accessed September 10, 2019).
14 Paul Williams, *Memorial Museums: The Global Rush to Commemorate Atrocities* (New York: Berg, 2007), 3–25.
15 Szacsvay, "A látvány anatómiája," 9–10.
16 Sándor Radnóti, "Mi a Terror Háza?" [What is the House of Terror?], *Magyar Múzeumok*, Summer 2003: 6–9; András Rényi, "A retorika terrorja. A Terror Háza mint esztétikai probléma" [The Terror of Rhetoric: The House of Terror as a Problem of Aesthetics], in *Az értelmezés tébolya. Hermenutikai tanulmányok* [The Madness of Interpretation: Studies in Hermeneutics] (Budapest: Kijárat, 2008), 215–231.
17 Jeffrey Olick and Joyce Robbins, "Social Memory Studies: From 'Collective Memory' to the Historical Sociology of Mnemonic Practices," *Annual Review of Sociology* 24 (1998): 105–140.
18 The approaches of social psychology are provided by David Middleton and Derek Edwards, *Collective Remembering* (London: Sage, 1990). For sociological perspectives, see Iwona Irwin-Zarecka, *Frames of Remembrance: The Dynamics of Collective Memory* (New Brunswick, NJ: Transaction Publishers, 1994). For an overview on anthropology, see Jacob J. Climo and Maria G. Cattel, *Social Memory and History: Anthropological Perspectives* (Walnut Creek, CA: AltaMira Press, 2002).
19 Pierre Nora, "Between Memory and History: Les Lieux de Mémoire," *Representations* 26 (Winter 1989): 7–25; Jacque LeGoff, *History and Memory* (New York: Columbia University Press, 1992); Jaclyn Jeffrey and Glenace Ecklund Edwall (eds.), *Memory and History: Essays on Recalling and Interpreting Experience* (Lanham, MD: University Press of America, 1994); Geoffrey Cubitt, *History and Memory* (Manchester: Manchester University Press, 2007).
20 Susan A. Crane, "Memory, Distortion, and History in the Museum," *History and Theory* 36 (December 1997): 44–63; Crane, *Museums and Memory*, 1–16; Lorena Rivera-Orraca, "Are Museums Sites of Memory?," *New School Psychology Bulletin* 6, no. 2 (2009): 32–37; Margaret Williamson Huber (ed.), *Museums and Memory* (Knoxville, TN: Newfound Press, 2011).
21 For the prime minister's speech, see berrnuli, "Orbán Viktor megnyitja a Terror Háza Múzeumot 2002-ben," [Video] YouTube, June 29, 2012, https://www.youtube.com/watch?v=DAQpHYU3m3s (accessed September 3, 2019).

22 The following study provides a thorough analysis of the inauguration and the reception of the House of Terror: Zsófia Frazon and Zsolt K. Horváth, "A megsértett Magyarország. A Terror Háza mint tárgybemutatás, emlékmű és politikai rítus" [Offended Hungary: The House of Terror as a Demonstration of Objects, Memorial, and Political Rite], *Regio* 13 (Winter 2002): 303–347. The article contains an extensive bibliography on the debate as well.

23 "Resolution 58/2000: Establishing the Day of the Victims of the Communist Dictatorships," *Magyar Közlöny* 66 (2000): 3360.

24 The context of this politics of history in historiography proper is described in Balázs Trencsényi and Péter Apor, "Fine-Tuning the Polyphonic Past: Hungarian Historical Writing in the 1990s," in Sorin Antohi, Balázs Trencsényi, and Péter Apor (eds.), *Narratives Unbound: Historical Studies in Post-Communist Eastern Europe* (Budapest: Central European University Press, 2007), 45. On conservative-nationalist historical ideas in Hungary, see László Karsai, "A múltnak kútja. A mai magyarországi jobboldal történelemszemléletéről" [The Well of the Past: On the Historical Culture of the Contemporary Hungarian Right Wing], *Élet és Irodalom* 51 (November 16, 2007): 2–3.

25 Péter Erdősi, "A kulturális örökség meghatározásának kísérletei Magyarországon" [Attempts to Define Cultural Heritage in Hungary], *Regio* 11 (Winter 2000): 26–44.

26 András Gerő, *Képzelt történelem. Fejezetek a magyar szimbolikus politika történetéből* [Imagined History: Chapters in the History of Hungarian Symbolic Politics] (Budapest: Eötvös Kiadó and PolgArt Kiadó, 2004), 181–199. As a matter of fact, the determination that the year of the millennium was 1896 was made fairly pragmatically. The government commissioned the Hungarian Academy of Sciences to establish the exact date of the Magyar conquest; nevertheless, the professionals could only identify the period between 888 and 900 as the most likely date of the event. The government then set the date of the millennium for 1895. However, when the preparations could not be finished in time, the authorities postponed the celebrations by one year. See Gerő, "The Millennium Monument," in *Modern Hungarian Society in the Making: The Unfinished Experience* (Budapest: Central European University Press, 1995), 204.

27 Sándor Radnóti, "Az üvegalmárium. Esettanulmány a magyar korona helyéről" [The Glass Cupboard: A Case Study on the Place of the Hungarian Crown], *Beszélő* 6 (November 2001): 36–68.

28 "Ranke did not concern himself with useless speculations on the origins of churches and states or the manner in which they were constituted at the beginning. The *generally* beneficial character of these two institutions he took to be a *fact* of history, a truth established not only by historical reflection but also by quotidian experience. He was privately convinced that these institutions had been founded by God to impose order on a disorderly humanity; and he thought that a dispassionate study of history would confirm the generally beneficent role played by these two institutions in human life, which might suggest to the pious their divine origin. But it was necessary to believe in their divinity to appreciate their ordering function in the lives of peoples. They constitute the sole ordering principles in historical time; it is through them that a 'people' can direct its spiritual and physical energies toward the constitution of itself as a 'nation.'" Hayden White, *Metahistory: The Historical Imagination in Nineteenth-Century Europe* (Baltimore, MD: Johns Hopkins University Press, 1973), 169.

29 On the formation of historical identity of nations, see George L. Mosse, *The Nationalization of the Masses: Political Symbolism and Mass Movements in Germany from the Napoleonic Wars through the Third Reich* (New York: New American Library, 1975), esp. 47–99.

30 Georg Lukács, *The Historical Novel* (Boston, MA: Beacon Press, 1963), 53.

31 Ibid., 59.

32 Boris Groys, *The Total Art of Stalinism: Avant-Garde, Aesthetic Dictatorship, and Beyond* (Princeton, NJ: Princeton University Press, 1992), 50–54.

33 István Rév, *Retroactive Justice: Prehistory of Post-Communism* (Stanford, CA: Stanford University Press, 2005), 294–298.

34 Marla Susan Stone, *The Patron State: Culture and Politics in Fascist Italy* (Princeton, NJ: Princeton University Press, 1998), 128–142; Claudio Fogu, *The Historic Imaginary: Politics of History in Fascist Italy* (Toronto: University of Toronto Press, 2003), 132–164.

35 Stone, *The Patron State*, 148; Rév, *Retroactive Justice*, 296–297.

36 Boris Groys, "A konstruktivizmus filozófiája" [The Philosophy of Constructivism], in *Az utópia természetrajza* [The Nature of Utopia] (Budapest: Kijárat, 1997), 13–15.

37 Jean Baudrillard, "Simulacra and Simulations," in *Selected Writings* (Cambridge: Polity Press, 1988), 166–184, and *Symbolic Exchange and Death* (London: Sage, 1993), 51–86; F.R. Ankersmit, "A Phenomenology of Historical Experience," in *History and Tropology* (Berkeley: University of California Press, 1994), 188–194.

38 Szacsvay, "A látvány anatómiája," 11–12.

39 This is a concept Kerwin Lee Klein called "structural memory": Klein, "On the Emergence of Memory in Historical Discourse," *Representations* 69 (Winter 2000): 131. Wulf Kansteiner also warns about the dangers of turning memory into a meaningless concept: Kansteiner, "Finding Meaning in Memory: A Methodological Critique of Collective Memory Studies," *History and Theory* 41 (Summer 2002): 179–197. Contemporary anthropology appropriates the notion of memory to preserve the image of coherent cultures, which, however, is conducive to simply replace the earlier usage of "culture" with that of "memory": David Berliner, "The Abuses of Memory: Reflections on the Memory Boom in Anthropology," *Anthropological Quarterly* 78 (Spring 2005): 203–205. An important example of how historians adapted the study of memory in political and cultural history is John R. Gillis (ed.), *Commemorations: The Politics of National Identity* (Princeton, NJ: Princeton University Press, 1994). The literary history of postwar Europe has been reconsidered in terms of memory: Helmut Peitsch, Charles Burdett, and Claire Gorrara (eds.), *European Memories of the Second World War* (New York: Berghahn Books, 1999).

40 Gábor Vas, "Múzeumot álmodók" [Dreamers of Museums], *Élet és Irodalom* 46 (February 22, 2002): 2.

41 Simonetta Falasca-Zamponi, "Of Storytellers and Master Narratives: Modernity, Memory, and History in Fascist Italy," in Jeffrey K. Olick (ed.), *States of Memory: Continuities, Conflicts, and Transformation in National Retrospection* (Durham, NC: Duke University Press, 2003), 57–61.

42 Stone, *The Patron State*, 131–162.

43 Frazon and Horváth, "A megsértett Magyarország," 311–325; Rév, *Retroactive Justice*, 278–290.

44 Nora, "Between Memory and History," 25.

45 Frances Yates, *The Art of Memory* (Chicago: University of Chicago Press, 1966), 58–70.

46 Ibid., 138–172, 211–216.

47 Paula Findlen, "The Modern Muses: Renaissance Collecting and the Cult of Remembrance," in Crane, *Museums and Memory*, 162–163; Hooper-Greenhill, *Museums and the Shaping of Knowledge*, 30–33.

48 Crane, "Curious Cabinets," 68–69; Crane, *Collecting and Historical Consciousness*, 107.

Museums of Socialism from Below: Local Representations of the Socialist Past in Contemporary Bulgaria

Rossitza Guentcheva

Until 2011, Bulgaria was one of the very few former Eastern bloc countries that had not established some sort of a national museum of socialism.[1] So far, the main tropes through which the debate about the socialist past in Bulgaria developed, writes Svetla Kazalarska, have been the tropes of silence, belatedness, and lagging behind.[2] In his 2005 article entitled "The absent museum," Bulgarian writer Georgi Gospodinov blames the lack of reflexivity for this deficiency: the need of "at least one step distance" from that past on the part of the Bulgarian society; the opposite would mean to "make a museum of the museum, in the museum."[3] Reflecting on why the socialist regime is neither represented nor interpreted in Bulgarian museums—and thus has remained a "blank period"—Nikolai Vukov uses the term "unmemorable," meaning units that are well known, not forgotten, retained in memory, but prevented from display, "present in mind, but hidden from view."[4]

In the absence of a separate national museum of socialism in Bulgaria, scholars' interest was attracted by the limited number of regional museums that have either permanent or temporary exhibits on the pre-1989 period. Kazalarska has paid brief attention to the History Museum in Dimitrovgrad, which was created in the late 1940s as the first new exemplary socialist town in Bulgaria, as well as to the activity of the Regional History Museum in Rousse, which sponsors temporary expositions related to the socialist period.[5] The museum in Dimitrovgrad was discussed also by Radostina Sharenkova, who remarked that nowadays it is empty and even avoided by visitors due to its old-fashioned exhibition and non-refurbished space.[6]

Nikolai Vukov has turned his attention to the scant efforts to represent the socialist past within the space of particular museums, most of all history museums.[7] These efforts were conditioned more by a desire to complete a historical narrative about the nation (the national museums) or a city (the regional museums). In this plot, socialism in Bulgaria was embedded in an evolutionary trajectory—its artifacts logically follow those from the Thracian times, the Middle Ages, the Ottoman period, and the Age of capitalism. This chronological perspective rested on an "ideological vision of 'the

progressive development from prehistoric times until the socialist victory,"[8] where the presence of communism is imminent and impending, as if defying reflection and slipping out of thorough understanding. In this vision, the time of socialism smoothly—just too easily, even somehow automatically and non-reflexively—followed the time of capitalism, and the displays—wherever they existed at all—respected the already pre-given narrative order, setting, and design.[9]

This chapter will focus on post-1989 instances of "museumizing" socialism in Bulgaria from bellow, namely on the efforts of local communities and even individuals to establish museums of socialism in the country, outside and beyond the system of national and regional museums. So far such initiatives have been described quite scarcely and are generally conceived as scattered, random, and disjointed, because they neither attempt nor succeed in offering systematic, well-justified interpretations and representations of the socialist past. Thus Kazalarska has mentioned passingly the First Private Museum of Socialism in the city of Pleven (announced in 2006 but never actually founded), the Red Attic in the city of Turnovo, the Museum of Communism in Garvan village, the house of Krassimir Kozlev in the town of Liaskovets, and the collection of the Elias Canetti Society in the city of Rousse as well as three restaurants in Sofia, Sandanski, and Sunny Beach resort.[10] Probably the single exception here is Nikolai Vukov's discussion of the museum in the house of former communist leader Todor Zhivkov in his birthplace, the town of Pravets, which he has interpreted as a nostalgic move on the part of the local community—"an expression of nostalgia for the days when the town was at the top of the scale of symbolic importance during the socialist era."[11]

The present text will try to take local museumizing initiatives seriously, in spite of their small scale, lack of professional curators, proper buildings, adequate resources, and clear legal status. It will shun away from perceiving these endeavors as not museums per se, as incomplete, unfinished, insufficient, and somehow deficient entities, or simply exotic local curiosities. They are worth studying not only in a context where there is no national museum of socialism that could be explored, hence as a second-best substitute for an official, national, and monolithic interpretation and representation of the socialist past. Grassroots museumizing enterprises deserve being constituted as a legitimate object of research in their own sake, for a multitude of reasons.

First, they represent a truly grassroots attempt to come to terms with the socialist past, which have sprung from the local community and private audiences. These projects demonstrate the social action of lay, ordinary people who are not only trying to grasp the meaning of socialism but also to represent and display it. Thus one has the opportunity to observe the memory wars of larger and often marginal social strata that normally do not participate in the curatorial work behind a museum exhibit with all its vicissitudes, hesitations, and detours. Second, at a time when the museum as an institution is widely perceived to be in crisis, when the very notion of a museum is attacked from a variety of perspectives and even classical museums strive to go out on the streets, outside of officially sanctioned exhibition spaces, focusing on the way distinct publics perform the museum locally could add to the debate on what a museum really is.

Last but not least, in the context of missing dominant discourse on the memory of socialism in Bulgaria, local actors have no hegemonic model to emulate and are

compelled to elaborate and objectify their intrinsic understanding of socialism and the meaning of the memory thereof. Approaches "from below" normally go hand in hand and in juxtaposition with approaches "from above" and are more than regularly interpreted through the prism of reception of—and reaction to—central, top-down policies and discourses. That is why most of the time they are instrumental in elucidating how a particular dominant policy or discourse has been negotiated, redefined, twisted, domesticated or subverted on the local level. On the contrary, when no such discourse is available, local publics are forced to work from scratch in order to formulate and make explicit their own interpretations and representations of socialism. Their anxieties and insecurities about how to arrange their exhibitions are less a proof of insufficient professional expertise than a ground zero from which to produce, build, and develop the local perceptions of the pre-1989 years.

The chapter investigates four such initiatives from below. Two of them were established in the 2000s: the museum of socialism in Garvan village in northeastern Bulgaria and the museum of communism created by a young librarian from the city of Veliko Turnovo (central Bulgaria), in the attic of his house. The other two existed before 1989 and continue to function in the twenty-first century: the museum in Vrabevo village (central Bulgaria) and the museum in Skrebatno village (southwestern Bulgaria). My fieldwork took place in 2010 and is based on participant observation and in-depth interviews with the persons who were instrumental in organizing and maintaining these initiatives as well as with people who contributed to the collection of objects and the elaboration of the expositions' design.

The Museum of Socialism in Garvan village: Lived socialism

Garvan village is situated in Silistra district in northeastern Bulgaria, 4–5 kilometers from the Danube river. According to statistics, it has 390 inhabitants,[12] yet some of them are economic migrants who work abroad and rarely return home. Previously a rich village with extensive vineyards and sheep farms, Garvan now relies solely on its agricultural cooperation, which produces tobacco, corn, wheat, and pumpkins. The kindergarten, which during pre-1989 years provided daily care for about sixty children, has been closed for a decade, as has the village school. The closure of these institutions would prove instrumental in providing materials for the Museum of Socialism: large posters, slogans, statues, and sculptures, which once adorned the rooms and corridors of the school, as well as various documents from its archives became part of the artifacts exhibited in the local museum.

I visited Garvan village on April 16–18, 2010. During this trip, I made in-depth interviews with five local people who were actively engaged in the museum's design and maintenance. The museum itself opened in May 2009, in the framework of the traditional public meeting of people from Garvan village, who have migrated from the village over the years. Yet the idea to establish such a museum dates back to the summer of 2007, when a young woman from the village saw the busts of Lenin and Georgi Dimitrov, the first communist leader of post-Second World War Bulgaria, thrown in the basement of the municipal building and decided they needed to be preserved. After

consultations with people from the village, then with the municipality in Sitovo, and the district authorities in Silistra, a decision was taken to establish a District Museum Collection on Socialism in Garvan. In the first half of 2008, the mayor of Sitovo granted a municipal house—in the center of Garvan village, next to the cultural house—where the museum was to be located (Figure 12.1). The regional governor in Silistra helped reconstruct and refurbish it, providing materials and finding a sponsor among the local construction firms. In the second half of 2008, there began the collection of materials from among the personal belongings of Garvan villagers. "90% of the local people in Garvan know what socialism is. This regime is a fact for them … they can neither reject it nor forget it … this is history … this is their history—which they have lived and on whose scene they have been the real actors," says the then-mayor of Garvan village.[13] Former school and kindergarten teachers, but also young people—above all women— were among the most active supporters and curators of the museum.

Since the museum is not permanently open, the visitor must first find the mayor in order to get the key. My visit happened to coincide with the annual meeting of the local agricultural cooperation and the election of its new governing board. In the afternoon, people who came for this meeting took the opportunity to visit the museum as well. Foreign guests, such as the volunteers from EU and non-EU countries who come regularly during the summer months to the village under a foreign-sponsored project, are among its greatest fans.

The most difficult part in the process of founding the museum was the exhibition's design. The women activists were unanimous in describing their predicament and difficulty in deciding how exactly to arrange the artifacts. Initially the mayor sought

Figure 12.1 District museum collection on socialism in Garvan. Photograph: Rossitza Guentcheva.

help from local and regional museums, but none provided assistance or advice. Thus Garvan villagers gathered together and contrived the organization of the display themselves. When opening the front door of the museum, one sees a giant photo of former leader Todor Zhivkov under the coat of arms of the Bulgarian socialist state.

The main exhibition, located in one room on the right, starts with the kindergarten, the first material object to be displayed being a blue kindergarten uniform. There follow a school desk covered with children's socialist literature and school uniforms—for the primary school, the so-called "Cheta Chavdarche," with their characteristic blue ties, and for the grown-up pupils, the so-called "Pioneers," with their red ties.

The next corner of the wall is dedicated to the youths, with pictures from the student years of the mayor's daughter and the villagers themselves, combined with pictures of famous young Bulgarian communists who died for the homeland.

Further, a big table is reserved for the rubric "The Party," featuring membership cards for various organizations and clubs, which belonged to Garvan villagers, as well as scripts and scenarios for official feasts celebrating the Communist Party or national holidays. Between the busts of Lenin and Dimitrov, which had prompted the very idea of establishing a museum of socialism, there stands a poster celebrating communist women—with photos of Liudmila Zhivkova and Tsola Dragoicheva, prepared especially for the museum by the village women.

After "Childhood," "School," "Youth," and "The Party," the rubric "Entertainment" follows, represented by old-fashioned radios, tape recorders, and musical plates as well as communist books (ideology and fiction) and newspapers from the 1980s. The last rubric in the exhibition is dedicated to "Work," especially work in the local agricultural cooperative, which is represented by photos and printed public advice to villagers how to maintain their stock and homes. The display ends with a red flag that belonged to the son of one of the women activists. It was covered with badges coming from different countries—Bulgaria, Romania, the USSR, Czechoslovakia, Cuba—and commemorating different features or events, including the Moscow Olympic games, historical castles in Kiev, Bulgarian rose oil, etc.

In this way, the principles underlying the display at the museum in Garvan are different from already existing post-1989 approaches to presenting socialism in the country. One the one hand, Bulgarian historians and historiographers of the socialist past tend to narrate the history of political events and party congresses, thereby replicating the concepts of socialist historiography itself. On the other hand, there is a vision challenging these dominant stances, which is to be found in the *Inventory Book of Socialism* (2006). The book's editors, Yana Genova and Georgi Gospodinov, have presented a catalog of artifacts from socialist light industry—photos of candies, domestic appliances, detergents, etc.—with the attempt to create a visual archive of the everyday material culture of socialism, which is usually "not described and put in museums." Aiming at exhibiting "the unconscious collective memory for the taste of socialism," Genova and Gospodinov have approached socialism through a "refined archaeology of the material sphere" and have shown the "banality of quotidian life and its visual cliché." Thus they have aligned themselves with contemporary oral historians, who try to see how "'History with a capital H' is being transformed, interpreted, and interiorized in personal biographic narratives."[14]

The Garvan Museum of Socialism is remarkably different from both abovementioned perspectives, because it shows how the personal biographic narratives of Bulgarian villagers can accommodate—and continue to accommodate—the grand narratives of the socialist regime, centered around the party, public participation, discipline, and work. This is all the more noteworthy, since it has happened at a time when the market has revived some of the socialist material objects (most of all foods), allowing nostalgia to be easily expressed through everyday material culture. Garvan villagers continue to represent their own lives under socialism through books and literature conceptualized as part of entertainment, rather than through the tempting sweet taste of "Chernomorets" candies or "Golden Autumn" biscuits. Their representation of socialism features two novel modes of display: first, it is based on the life cycle that coincides with the system of socialist organizations responsible for public mobilization: "Cheta Chavdarche," "The Pioneers," "The Komsomol," and "The Party." These former socialist institutions now give Garvan villagers the possibility to narrate their own biographies through the history of these official organizations. Second, as Gerald Creed has remarked, when exhibiting their nostalgic memory of socialism, the villagers in fact comment on the present.[15] The museum thus contains evidence of vibrant social activities, such as the agricultural cooperative or official socialist festivities that are lacking in present-day rural Bulgaria. Finally, Garvan villagers' effort to museumize socialism is a genuine grassroots endeavor to break the "unmemorable" and give voice to alternative interpretations of the socialist past.

The museum in Skrebatno village: Socialism frozen

Skrebatno village is situated in southwestern Bulgaria, in the hills of the Rhodope mountain, near the Greek–Bulgarian border, and has 298 inhabitants, the majority of whom are Bulgarian Muslims (Pomaks), while the rest are Orthodox Bulgarians. The main activity of the villagers, tobacco growing, has remained a remarkably persistent source of subsistence throughout the whole twentieth century, uprooted neither by the advent of the socialist regime after 1944, nor by its collapse in 1989. Yet nowadays the implementation of the EU policy on phasing out tobacco subsidies has prompted the villagers to start thinking of alternative livelihoods. Some of them reluctantly consider substituting tobacco production with that of raspberries; others envisage investing in family tourism in the context of rapidly developing tourism businesses in the whole region, based on the nearby winter ski resorts around the town of Bansko and the ever more fashionable spa destinations in the vicinity of Skrebatno. Yet some of the villagers have embarked on migration abroad, going mainly to the United States (for good) and to Spain (for seasonal circular work in the agricultural and the care sectors).

When I visited Skrebatno on August 10–20, 2010, the village was bursting with life, despite that this was the time of Ramadan, the holy month of fasting for Muslims. Many of the migrants have returned for their summer vacation, bringing their children (called by the locals the "little Americans" and the "little Spaniards"). There were also the wealthy newcomers, who have bought and restored traditional houses in the village,

drawn both by the beauty of the landscape and by the opening of the Ilinden–Exohi border crossing with Greece (in 2005), which made the Adriatic sea within an hour's drive. My visit also coincided with a summer school for music held there for a week, and a classical guitar concert in the village cultural house, which also had attracted foreigners from the nearby towns: Peace Corps volunteers and their US friends, Italian businessmen working in the construction sector in southwestern Bulgaria, and Greek tourists. Some of them also visited the village museum, inscribing their impressions in the museum guest book.

The museum in Skrebatno village is situated in its center, on the premises of the one-time primary school (Figure 12.2) that was abandoned in 1954, when a larger school building was erected with the help of voluntary labor from the local villagers.[16]

It borders on the private ethnographic museum established recently by a local musician (a newcomer, a guitarist); in its vicinity are the cultural house, the local pub and store, and also the village mosque. I was taken to the museum by the village mayor, with whom I had numerous informal conversations on the museum's history and fate, and who also let me take out and photocopy the museum guest book, maintained scrupulously and continuously from 1978 until August 2010. The museum has two floors: the first contains an ethnographic exhibition of local agricultural tools, everyday objects, and colorful textiles, while the second is dedicated to the history of Skrebatno from the seventeenth through to the twentieth century.

It is this second floor that features the exhibition on the socialist past, which is of interest here not only because it contains the actual materials on the socialist period but also because the whole museum exhibition was designed and set in 1978, and has

Figure 12.2 The museum in Skrebatno village. Photograph: Rossitza Guentcheva.

been carefully maintained ever since. It is not enough simply to say that the museum has existed from 1978 until 2010; what is more remarkable is that its expositions have been preserved intact and virtually unaltered, especially those on the second floor, displaying the socialist interpretations not only of the socialist past but also the standard socialist vision of the entire history of Bulgaria, represented and narrated through the history of Skrebatno village.

The museum was founded in 1978 with an official status of a "museum collection," under the auspices of the Regional Museum of History in the city of Blagoevgrad. A tablet in the second floor's entrance lists the names of twelve villagers—"the committee"—under whose initiative the museum was established.[17] It states that the main part of the exhibited materials has been gathered by Alexander Botev, the exhibition curator (*urednik*) for more than twenty years. Yet their interpretation has been assisted by a booklet, issued in 1978 by the regional historical museum in Blagoevgrad, which narrates Skrebatno's history from antiquity until the late twentieth century and provides the socialist viewpoint on crucial events of the last two centuries, represented on the museum walls.

The second floor consists of four rooms, the first dedicated to the seventeenth to early twentieth century—the time when Skrebatno was under Ottoman rule—the second to the first half of the twentieth century, and the third and fourth to the socialist period. Upon opening the front door, one is greeted by the portraits of Dimitur Blagoev and Georgi Dimitrov' the first was the founder of the organized socialist movement in Bulgaria in the late nineteenth century, and the second was the most prominent Bulgarian communist and the first post-Second World War Bulgarian prime minister until his death in 1948.

The rooms were arranged chronologically, starting with a document from 1660, a graphic picture of a massacre, and a caption explaining the "second mass Islamization of the region" and the imposition of Islam on an otherwise Christian population by the Ottoman Empire. Recounted were the activities of the "Turkish oppressors [...] who exploited the Bulgarian population," but a conclusion stated that "during the years of the Turkish yoke, Skrebatno villagers earnestly fought against the attempt at forced assimilation." The labels highlighted the fact that "the vigour to preserve the Bulgarian national consciousness has lasted for decades, owing to which the assimilators never reached complete success in the village." The exhibited guns, powder pouches, and knives were accompanied by photos of national and local figures of the Bulgarian Revival, and a photo of the construction of the Christian Orthodox church in the village. The intransigent and combatant spirit of the Skrebatno villagers was the chief accent of the period 1878–1912, when the region remained outside of the newly liberated modern Bulgarian state, and within the territory of the Ottoman Empire. This period was narrated through the prism of armed resistance and struggle for liberation against Ottoman domination, while the early twentieth century was presented as the time when the first socialist ideas reached Skrebatno village.

Thus, following the socialist template for narrating the Bulgarian history, the history of socialism in the Skrebatno museum began as a prehistory of the socialist regime stretching back to the first years of the twentieth century in the village. In the second museum room, the decades until the Second World War were narrated

as a time when new revolutionary traditions were set, owing to the constant fighting of the village communists—and even workers—against the political and economic terror of the capitalist state. The period was presented through the pictures of key activists in the "creation of a sound united front of all progressive forces against the bourgeois state."

The third museum room was dedicated to the partisan struggle in Skrebatno village beginning in 1942, the establishment of the socialist regime, and the early post-Second World War years. The exhibition here almost entirely consisted of pictures and text, with the sole material objects being two guns used by Skrebatno guerrilla fighters, a typewriter for printing underground literature, and numerous medals, received later by the "active fighters against fascism," a category officially instituted by the Bulgarian socialist state. A scheme of the itineraries and battle sites of the local partisan unit was drawn on the wall, next to a multitude of faces—of political prisoners, partisans, partisans' assistants (*iatatsi*), and helpers (*pomagachi*), men and women, young and elderly.

The first socialist years were narrated, again, through a series of photos: of a meeting of Soviet soldiers and progressive Skrebatno youths (from 1945), of a youth brigade for the planting of trees, of agricultural workers photographed during harvest in the framework of the local agricultural cooperative, of a border guard unit "that contributed to the strengthening of the people's power," of a male musical band, of a volunteers' day of the members of the village Communist Party organization (from 1945), of the youth choir in the local cultural house (from 1946), and of youths celebrating a socialist feast with flags and slogans.

The fourth and final room was dedicated to "mature" socialism, and—in addition to the plaster head of Georgi Dimitrov—contained a red tablet with pictures of then-party and state leader Todor Zhivkov, delivering speeches and meeting Soviet and North Korean communist leaders as well as communists from West Berlin. There was also a photo of Leonid Brezhnev, addressing a Bulgarian audience during a visit to Bulgaria. The 1978 exhibition ended with a caption highlighting the importance of the 10th Communist Party congress of 1971 for the Bulgarian people's development.

Thirty years after its establishment, this exposition was surprisingly unedited. Changes consisted most of all in additions and not revisions of the socialist period's meaning. A red flag commemorating the 60th anniversary of the establishment of the local Communist Party unit in 1921 was hung there in 1981. A tablet with the photos of former school teachers in Skrebatno was also added, as were a couple of recent paintings—village landscapes, including one of the museum itself.

The mayor of Skrebatno, who was delighted to tell at length the story of each photo and object in the museum, expressed his regret that some of the pictures—those from the 1970s—had their edges curbed and that the glue on their labels had dried out, causing pictures to fall down and leaving holes in the coherent story about the past. When asked whether some of Skrebatno villagers objected to this exhibition, he said "yes," telling a story about how in the 1990s some people from the village tried to privatize the building and turn it into a club. Local politics and feuds over property rather than a conscious desire to preserve the socialist exposition appear to have saved the museum at that time.

The most notable local dispute, connected to the museum, revolved around its ethnographic part. Recently, the old bells (*chanove*) displayed on the first floor were stolen, seemingly with the idea to sell the whole collection to Greek dealers in antique objects. And while the bells were replaced with similar ones, the village population has remained dissatisfied with what it perceived as the museum exhibit's forced modification. Again, this indignation was conditioned not so much by concerns about authenticity but by discontent with the greed of the local thieves. The mayor of Skrebatno has expressed his sorrow that no institution helped him maintain the museum, neither the regional historical museum in Blagoevgrad, which has not given money for a technical face-lift of the exposition, nor the police who were unable to apprehend the thieves. Corroborating his account, the regional historical museum in Blagoevgrad has denied any connection to the exhibition and its representatives claimed they were unaware of its existence.

Yet the exhibition enjoys popularity, as the long museum guest book testifies. From the first entry (October 20, 1978) to the last one (August 2010), the reviews are unanimous in their praise of the museum expositions. And as the pre-1989 visitors have been impressed by the village's heroic past and the revolutionary tradition of resistance and struggles for liberation, so were the post-1989 visitors, none of whom had voiced disagreement with the exhibition's message and content. "Fighting for the homeland is a sacred thing. I was here and felt it. GENS UNA SUMUS," wrote an anonymous visitor on February 23, 2004. "[We] must do everything in order to preserve our history," wrote T. Tsvetanov on June 1, 2008, while K. Hadzhiev, visiting the museum on the same day, added: "Let us have more places like this so that I could feel I am Bulgarian."

Whereas references to the "development of our socialist country, the People's Republic of Bulgaria" have disappeared, the book's pages were filled with references to the Bulgarian "development and civilization." Writing in Arabic in July 2003, Rezki Asus noted that the museum contained materials that "symbolise that country's culture and reflect its history—symbol of the country's civilization and development." In April 2010 the Georgiev family from the neighboring town of Gotse Delchev wrote: "We were delighted by what we saw. For a short moment we were transferred back in time, in village history." On June 15, 2010, a group of pupils aged 11–13 also from Gotse Delchev left several entries: "Nice museum, nice pictures!," "Super-museum!," "The museum is terrific!," "I liked it a lot. It's superb!," "Unique!," "The perfect museum!," "Wonderful museum!," "Bulgaria forever!," and "REVOLUTION!."

For the relatives of Skrebatno villagers the exhibition provided a frame for observing and reflecting on their own lives. On June 28, 2010, Slaveika Koemdzhieva visited the museum and was happy to see her grandmother's kin represented there; other relatives of Skrebatno villagers called the museum a "modest sanctuary," a "relic," a "treasury." The guest book's last entries belong to a group of Americans, who wrote: "Very beautiful and so helpful! Thank you for preserving the past!" (Amberly Rosen from Eugene, Oregon), "Lovely museum & very interesting house!" (Arlene Imagawa from California), "Hi and thank you!" (Shannon Wells from San Francisco).

The museum in Vrabevo village: A postmortem reproduction of socialism[18]

Vrabevo village is located in central Bulgaria, in the foothills of the Stara Planina mountain, and has 748 inhabitants. It is an unusually well-off Bulgarian village, for it is the location of a branch of one of the biggest industrial enterprises in the country, Sopharma Pharmaceuticals. The village population is insufficient to supply the entire 350-persons strong workforce of the plant, thus Vrabevo has become a commuting destination for workers living in the nearby towns and cities, such as the municipal center of Troyan and even the district center of Lovech. Besides the Sopharma company's branch, the village has an agricultural cooperative and a lift-repairing factory.[19] Private entrepreneurs have embarked on reconstructing the village's traditional houses, planning either to use them for family tourism or to sell them to foreigners, especially British citizens who had already started buying property for a second home in the area. Some members of the top Sopharma management have their private summer homes in the village, including the company's CEO, and these illustrious buildings serve as a potent symbol of local well-being.

I visited Vrabevo on July 16–17, 2010, and was introduced to the museum by its curator, Valia,[20] who was also chairwoman of the local cultural house and deputy-chairwoman of the village pensioner's club. A former teacher of Bulgarian literature, she was also wife of the former village mayor, and mother of the then-current mayor. I held several informal talks about the museum and its place in the village with Valia and members of her extended family.

At first glance Vrabevo might seem like a place absorbed by contemporary neoliberal social and economic processes. This notwithstanding, mobile labor, global capital, and Western presence share space in the village with visible signs of the pre-1989 epoch—street names and slogans dating from socialist time, clean and well maintained. In a similar fashion to Skrebatno, the museum has also survived, virtually intact and unaltered since the 1980s, when it was created. Like the exhibition in Skrebatno, the Vrabevo exposition narrated the village history in the twentieth century, placing particular emphasis on the socialist period. To extend the parallel further, this museum has also become the site of new practices of experiencing the exposition post-1989, engendering a peculiar local memory about the socialist regime and giving rise to novel forms of reflection on the socialist past.

On our way to the museum, we first walked on Georgi Dimitrov Street, then passed along 9th September Street and, under the socialist inscription "Clean courtyard—healthy family," found the museum on Lenin Street. A major difference with the Skrebatno museum appears immediately upon unlocking the front door. The Vrabevo museum is located in the house where one of the top Bulgarian communist leaders, army general Dobri Dzhurov (1916–2002), was born. (Figure 12.3)

Unlike the Skrebatno exhibition, the Vrabevo materials were organized around this dominant key figure, who was long-time minister of defense (1962–1990) and member of Politburo of the Central Committee of the Bulgarian Communist Party (1977–1990). The fact that the village history was told through the personal history—the actual biography—of Dobri Dzhurov, explains why the representation of village

Figure 12.3 The museum in Vrabevo. Photo: Rossitza Guentcheva

history started exactly in the 1910s, despite that a note on the wall clarified that the Thracians were the first people to have inhabited the land of Vrabevo. The single document from an earlier period—a tax sheet from 1882—did not undermine the representation of Vrabevo as a "red," revolutionary village grafted onto the omnipresent figure of its most renowned communist.

Following the Skrebatno exhibition pattern that became hegemonic in the 1970s and the 1980s,[21] the Vrabevo museum exposition opened up with an ethnographic section, containing wooden, iron, and brass household utensils and tools, some of which had belonged to Dobri Dzhurov's family. Then, spread on two floors, is the historical exhibition, covering the interwar and the socialist periods, with the staircase between the two serving as a visual symbol of socialism's advent in 1944.

It began with pictures of pupils from the village school dating from the late 1920s, when Dobri Dzhurov himself was a pupil there. Exhibited were some handbooks of that time, which were most probably the type of textbooks Dzhurov himself used in his classes in mathematics, natural sciences, and history of the ancient world. The story continued with the establishment of the local workers' party group that became politically active in 1913, and its electoral successes in 1919 and 1932, when the two Vrabevo communes were proclaimed. Following photos of young unionized workers and excerpts from the leftist press of the 1930s, was the first picture of Dobri Dzhurov himself, as a member of the youth workers' organization at the Woodworking School in the town of Teteven, from 1935. Three more pictures from Dzhurov's secondary school years hang next to them. The written protest of the Vrabevo communists against the Leipzig trial of Georgi Dimitrov in 1933 was showcased on the wall. The interwar history of Vrabevo was further represented through photos of organized youths—the

cooperative union, the anti-alcohol society, the village brass band, the football and the Esperanto clubs, while a label indicated that the Communist Party used all of them to spread its influence on the local level. A picture documented Dzhurov's internment in 1942 because of his leftist activities; the names of other political prisoners from Vrabevo were also listed. The pre-1944 exposition concluded with five more photos showing Dzhurov as the leader of the famous "Chavdar" partisan brigade from September 1944, of which the long-time Bulgarian communist leader Todor Zhivkov was also a member.

The socialist period's representation was done entirely through pictures, after the initial inscription on the wall declared that: "The Vrabevo population greeted the victory on 9th September 1944 with exceptional joy and, guided by the Fatherland Front and the Bulgarian Workers' Party (communists), participated actively in the establishment and strengthening of the democratic people's power."

Starting with a long list of Vrabevo villagers who took part in the last phase of the Second World War from 1944 to 1945, it continued with photographs of Vrabevo women, celebrating March 8, 1946, of the Vrabevo population celebrating the "first free May 1" in 1945, of a meeting in the village on the occasion of the referendum for the establishment of a people's republic in 1946, of members of a working brigade constructing a train line in 1948, of the activities of the Fatherland Front in the village in 1948, and of the children in the first kindergarten in the village in 1945. Several photographs showed the construction of the agricultural cooperative's building in the village in 1950, as well as villagers depicted in different stages of agricultural work in the 1950s. The exposition finished with a large panel entitled "Vrabevo throughout the last years," which contained unlabeled pictures of groups of people, village buildings, animals, and the landscape. A poem dedicated to Vrabevo was the last museum object.

At the time of my visit to the museum, it still bore the traces of a recent refurbishment. The walls were freshly painted and new glass exposition cases had been brought in. The renovation was sponsored by Sopharma, which gave 5,600 leva (around 2,800 euros) to the museum. According to Valia, the museum needed an additional 2,000–3,000 leva in order to complete all of the envisaged transformations, yet no other institution was ready to help. She complained that she did not know how to arrange the glass cases and that she had the desire and energy but no ideas about how to incorporate new materials in the exposition. Officially, the museum's status was of a "museum collection" subordinated to the municipality of Troyan, which, however, "does not help in any way," as Valia stated. At the start of 2010 Valia went to the municipality to seek assistance and discovered the municipal authorities were not aware of the Vrabevo museum's existence. After her plea for support—for money and know-how—the Troyan municipality sent four experts to inspect the museum before deciding what kind of aid to offer. Valia was proud that upon entering the museum the specialists were astonished by how "such beauty could remain unknown." They gave advice on what to change: the experts found the lighting of all rooms inadequate: light that was coming only from the windows had to be replaced with artificial light, from an appropriate angle, so that the materials did not fade quickly. They also gave advice on

how to improve electricity. The specialists saw nothing wrong with the exhibit's content and did not prescribe anything relating to it.

However, Valia considered reform in the exposition inevitable. She showed me diplomas and pictures of young communists from the 1960s, 1970s, and 1980s, which she had acquired from the village school upon its closure in 2006. Valia thought they should be exhibited in the museum, yet felt that putting them in the existing glass cases would cause "overcrowding." The museum exposition has, indeed, been complemented after 1989 and this curatorial interference is more than symptomatic for the memory and representation of communism in the village. At the start of the exhibition, the visitor is greeted by color pictures of the village church, which contrast sharply with the rest of the black-and-white photos on the first floor. One of them features a high-ranking church leader with a woman, who is the daughter of Dobri Dzhurov, Professor Dr. Axinia Dzhurova, a leading Bulgarian scholar in the field of Byzantine studies.

One of the glass cases contained a 1994 article entitled "Church painters in the Troyan monastery," which in addition to displaying Professor Dzhurova's picture again, also was written by her. Thus what appeared to be a symbolic crack within the pre-1989 exposition, in fact turned out to be a continuation of it: rather than displacing the accent from the revolutionary struggle against capitalism and fascism to contemporary religious and artistic matters, the new additions in the museum emphasized Dobri Dzhurov's kin as central to the village even after 1989.

The last transformation has affected the museum's courtyard. Sopharma Pharmaceuticals has bought the second house that stood next to the museum within the same garden. Beautifully restored, it served as a hotel for Sopharma's guests. On the porch between the museum and the hotel, next to the open fireplace and at the huge wooden table, Sopharma's corporate parties shared space with the revolutionary past of Vrabevo's heroes. Towering above all, and overlooking from behind, was the mosaic portrait of socialist Bulgaria's first prime minister Georgi Dimitrov, transferred from the Sopharma plant in the village and built within the museum wall at the beginning of twenty-first century.

The museum of communism in the city of Turnovo: Socialism individually appropriated

Veliko Turnovo, a picturesque city located in north-central Bulgaria, is inhabited by 73,443 people. The historical capital of the medieval Second Bulgarian Kingdom, it boasts a medieval fortress and an old marketplace from the nineteenth century. Being a popular tourist destination, Turnovo presents a wealth of museums, all of them subdivisions of the Regional Historical Museum: the Archaeological museum, the Museum of the Bulgarian Revival and Constituent Assembly, the museum in the old prison, and a host of museum-turned-houses of prominent Bulgarian politicians, writers, and fighters for independence from Ottoman rule, who were born in Turnovo. The city even has a museum of modern and contemporary history, which, however, places the accent on the late nineteenth century and the "wars for Bulgarian national

unification, from 1885 to 1918."[22] The period of the socialist regime does not form part of its exhibition.

The museum of communism described here is an entirely private initiative, lacking any official status. It is located in the attic of the apartment of Nikolai Kolev, a 38-year-old librarian working in a local branch of the Regional Public Library in Turnovo. The flat is situated on the fifth floor of a residential building (Figure 12.4) in the Buzludzha district of the city: a district built in the 1980s as a "new socialist quarter" and consisting almost entirely of concrete blocs of flats.[23] I visited the attic and spoke with Nikolai on October 30, 2010, after having spent a great deal of time in trying to find it.

In 1989 Nikolai was 16 years old and recalled succumbing to the mass rejection of everything "communist": he literally threw out everything that linked him to that period, "even my Komsomol papers." A few years later, in 1994 to 1995, "upon growing up," Nikolai decided that the memory of communism had to be kept alive and started gathering flags, portraits, books, and other objects from the socialist period. Nikolai studied history at Turnovo University and relied on the help of a young local professor to locate objects from the time before 1989. Because of his leftist leanings, this professor was contacted by people from Turnovo and the region, who gave him communist materials, which Nikolai thought had disappeared long ago. For more than a decade, Nikolai gradually enriched his collection, until a 2006 visit to the Museum of Communism in Prague prompted him to display his belongings in the form of an exhibition and to set up his own museum of communism.

Figure 12.4 The block of flats hosting a private museum of communism, Turnovo. Photograph: Rossitza Guentcheva.

Nikolai believed the most important requirement for a successful museum was entertainment and he acknowledged that at this point his personal museum did not live up to this ideal vision. Simply displaying objects from the socialist period would not be sufficient, he said, because "the tourist needs attraction, he must be immersed in the atmosphere that had enveloped the exhibited objects." Thus, rather than simply displaying the objects, Nikolai would instead recreate the practices they engendered, such as the very rituals of acceptance in the children's communist organizations, "Pionerche" and "Chavdarche," and in the Komsomol, the youth communist organization, "with the whole seriousness of the existing procedures." He acknowledged embracing that idea after having read about a museum of communism in Berlin, where a workers' canteen was staged "with all the tablecloths and meals from those times." He recalled a visit to a Turnovo school, where he was invited to speak about communism and where the pupils seemed unable to understand what communism was about, because it was "too abstract" for them. "We need to demonstrate how things happened then, so that the students will be able to grasp their meaning," concluded Nikolai.

Yet, although imperfect in his own eyes, Nikolai regarded his museum exactly as a museum. He did not charge a fee for entrance to the attic – known since the late 1990s as the "Red Attic"—but asked the visitor to bring an object from the recent past: a Communist Party ticket, a copy of the Komsomol charter, a pioneer's red tie, or a box of Fenix cigarettes.[24] When reflecting on his attic, Nikolai thought of it as a museum: "The museum is not my main priority. I myself have not been persistent enough. The museum needs a proper campaign and this would mean for me to leave my job, for making a museum requires a lot of efforts and dedication." Nevertheless, he has pondered about the best place for a museum of communism in Turnovo and has considered several options. He thought about a former bunker (turned into a former club) near the University of Turnovo, because the place had been related to the Cold War. He also thought about the medieval Tsarevets fortress: a place proposed by some Turnovo citizens and even discussed with the regional historical museum's director; yet Nikolai was rather opposed for "we come back to the idea of linking socialism to feudalism, which is incorrect." Ideally, he would establish the museum in the Gabrovski park, named after the co-founder of the first socialist party in Bulgaria in the late nineteenth century; yet he regretted the park was away from the chief tourist routes in Turnovo, which made it an unsuitable alternative.

Nikolai also seemed at ease with his status as a local celebrity and museum founder. He accepted an invitation to become a member of the History Teachers Club in Turnovo. He recounted minutely the instances when he was interviewed by representatives of the media, for the local *Yantra Today* newspaper (on the 20th anniversary of the fall of communism in Bulgaria), for the national BNT and BTV televisions, and for a film about the post-1989 changes in Bulgaria, made by Reuters. He has advised a Dutch student writing an essay about communism in Bulgaria (although he did not inquire about the grade). Nikolai was confident that his ideas about a museum of communism were widely supported in the city and quoted local people often asking him when the museum would open. Thus Nikolai acted as a museum entrepreneur[25]—a veritable entrepreneur of memory who used his initiative to museumize communism as an instrument of gathering social capital and maintaining numerous connections and networks.

Yet for the moment, Nikolai's collection was confined to his attic, which was about 10 square meters but housed materials that could normally be displayed in a much larger space.

Nikolai's impulse to collect socialist artifacts stemmed from his conviction that the past should not be forgotten: "We, the Bulgarians, are a peculiar tribe, we easily smash and destroy our past. Those are 50 years under these conditions, this is the life of 2–3 generations." There is a further rationale behind Nikolai's attempt to preserve the memory of communism: he was convinced that communism's forgetting served ignoble political aspirations in the present. Far from being nostalgic, he accused the Bulgarian Socialist Party (the former communists) of putting a veil on the past while trying to persuade the population how good it was to live before 1989. "They make us forget what they have been forcing people to do, all the crimes they committed along their effort to consolidate the communist fate, and this is so stupid and fake," said Nikolai. In his words, he had not met a single person who would oppose his initiative, even among the most intransigent post-1989 anti-communists, for they too had a stake in the museum. The new democrats had relatives persecuted and repressed by the communists and the lack of a museum of communism meant, in fact, forgetting about them as well. "Every person could find something for themselves in such a museum: those on the left will say how good it was then, and those on the right will see only the bad things," concluded Nikolai, who conceived of his museum as a *tabula rasa*—a ground zero—on which anyone was allowed to build their own interpretation.

Nikolai's inclination to preserve the past has led him in two rather unusual directions. A notable accent of the collection is on objects dating from the period of the personality cult of the early 1950s, thus on artifacts quite difficult to find even before 1989. One of Nikolai's paramount concerns was to uncover and preserve these personality cult objects that were forgotten even during socialism, made obsolete not only by the passage of time but also by conscious physical and ideological destruction. Several pictures and drawings of Stalin were hung on the walls, next to a plaster head of Stalin. There was also a picture of Mao, while one of the biggest—and quite rare—portraits represented Vulko Chervenkov, leader of the Bulgarian Communist Party and prime minister at the time of the personality cult (1949–1956). Propaganda posters hailed Stalin, placing him together with Marx, Engels, and Lenin, with a lesser-known quote from Georgi Dimitrov.

A Russian map of Bulgaria, dating from the 1950s, displayed the name Stalin for the present-day city of Varna. A ticket from a visit to the mausoleum of Lenin and Stalin from April 20, 1954, was also preserved. Books written by Stalin and translated into Bulgarian formed part of the collection as well as a book bearing Stalin's autograph in red ink. One of the quite rare books, featuring a portrait of Vulko Chervenkov, was *The Experience of the Exemplary Workers* that contained the speeches of the delegates to the national conference of the exemplary workers of agricultural cooperatives, which took place in November 1951.

A second noteworthy emphasis in Nikolai's collection was on objects containing the personal "marks" of their producer or user and which displayed erasures, orthographical mistakes, fusion, and irony. Nikolai has acquired a portrait of Soviet leader Mikhail Gorbachev with the famous birthmark on his forehead obliterated in an attempt to embellish his outward appearance.

One of the most valuable objects in his collection was a replica of the former coat of arms of the USSR, whose inscription had been misspelled by an anonymous Bulgarian who had obviously not mastered the Russian language and had not understood entirely what he had been writing and sculpting.

One of the posters in the Red Attic featured communist leaders Vasil Kolarov and Georgi Dimitrov, the latter wearing a coat with a fur collar. Nikolai explained that this poster was unusual in its depiction of the communist leaders as "fat bourgeois with thick necks" and credited its author with the ability to shrewdly embed a dissident message in an otherwise communist propaganda picture. A statue of Buddha, which Nikolai acquired in a neighboring village, featured the face of communist leader Todor Zhivkov and was another example of an anonymous sculptor, who produced an ironic and playful commentary on the political system, subverting its official images of power.

In addition, Nikolai's manner of exhibiting and arranging his material often bore the traces of his own ironic verdict on the socialist regime. The largest item in his attic, a plaster bust of Georgi Dimitrov, wore the insignia of Doctor Honoris Causa, by which Nikolai wanted to stimulate the viewer to reflect on the communist leader's poor education and the overt persecution of intellectual elites during the previous regime.

With all these artifacts, Nikolai underscored lay people's individual agency during the socialist period and proposed to commemorate their personal everyday resistance through transformations of and laughter at iconic socialist objects and images.

The multiple facets of memory work

The four cases of local museums of communism unambiguously demonstrate the variegated itineraries and trajectories that memory work on socialism from below has taken in Bulgaria in the last decades. Individuals and communities in the villages and towns analyzed above have different conceptions of socialism, distinct stakes in preserving the memory thereof as well as different ideas about how to best visualize and museumize it. They have selected specific features as worth remembering and have used a multitude of varying artifacts to display their memory. Their memory of socialism is multilayered and multivocal, firmly embedded in the local context and social expectations.

The villagers of Garvan have presented a case of lived socialism, inscribing their personal lives and the lives of their families in the grand narrative of the socialist state. In their museum they have narrated the autobiography of their generation, with socialism providing the common stages it passed through and the shared frames of its experience and remembrance. The librarian in Turnovo, who is interested in how people even before 1989 have used and reformulated the meaning of symbols of power, has also exhibited lived socialism, but in his version socialism is individually lived, through active daily appropriation and reformulation. His approach to the socialist regime emphasizes the ingeniousness of brave, although anonymous, local artists and citizens and is an apotheosis of the individual creativity of ordinary people. Part of the irony of the whole undertaking rests in the fact that Nikolai's memory of communism attempts to fight against the socialist regime's own memory politics, namely against

the oblivion, disparagement, and erasure it performed against its own early period of the cult of personality. Since Nikolai's initiative is a private endeavor and because of his fascination with the everyday resistance of lay people, his collection remains eclectic, fragmented, and unfinished, without a coherent narrative about socialism. Anybody could bring what they deem fitting to Nikolai's museum project without it ruining the overall composition, which makes the Red Attic fragile and fluid, yet remarkably open and an invite for new interpretations.

While Nikolai is contesting socialism's own memory politics by restoring the memory of the personality cult years, which the socialist regime tried to suppress and bury, the Skrebatno village community presents a socialism frozen, neither challenged nor securely constrained through visual mechanisms or novel narratives. For this community of Bulgarian Muslims what seems more important is to defend and preserve museumized socialism from privatization and plundering rather than rewriting the nationalist and essentially anti-Muslim pre-1989 interpretation of their village history. Further, although Vrabevo's case appears as a mirror image of Skrebatno due to the continued exploitation and resuscitation of museums built during the late regime, it exemplifies a different configuration of remembering socialism. The Vrabevo villagers' approach shows a *postmortem* reproduction of socialism through the symbolic procreation and expansion of its exemplary communist kin within the local museum. In this way, the Vrabevo museum also differs from the museum in Garvan, in that the village community keeps identifying through a dominant communist family, whose history and representation span both the socialist time and the periods preceding its advent and following its demise. Seemingly an inherited socialist institution, the museum in Vrabevo is not an ossified relic from previous historical periods but a product of contemporary economic, cultural, and social processes, determining the frames of local memory. Yet Vrabevo and Garvan are similar in that both have been able to mobilize larger local networks for supporting their versions of the memory of socialism—the former enlisting the help of a thriving business, while the latter that of district and regional authorities. It is also noteworthy that attracting larger social strata—and especially businesses—to the museum initiatives has not led to the local museums' commercialization; the desire for interactive entertainment or selling of souvenirs are completely absent.

Yet probably the most important thing here is the fact that all four figures of memory of socialism go beyond the traditional debate on this historical period in Bulgaria in the last couple of years, namely the clash between a "totalitarian approach" to museumizing socialism (with an accent on its crimes, victims, and repressions) and an "everyday material culture approach" (the so-called industry of experiencing socialism), the latter accused of normalizing the socialist regime. Whereas alternatives to that debate— classic not only for Bulgaria but for all ex-socialist countries—exist on a global level,[26] the four local initiatives discussed here demonstrate that steps beyond this traditional dichotomy are possible on a local level as well, when looking at the local manifestations of memory work. However, despite the divergences in these local visions of socialism, they are similar in their principal motivation: designing these museums is not meant to glorify socialism and represent nostalgia but rather to create an image that could attract foreign tourists, conceived as a key priority for local development.[27] Packaging

socialism as a tourist product might prove to be the only common denominator behind the grassroots attempts to exhibit and museumize socialism in Bulgaria. Remembered, museumized socialism represents a symbolic capital for the local community: an asset able to attract foreign visitors in the competition over financial resources with neighboring municipalities in the same vein as in pre-1989 Bulgaria, when proving a link to the "communist past" meant allocation of more funds to a particular location. At the same time, conceiving of socialism as part of cultural heritage displaces the debate on its essence to its contemporary functions, uses, and advertisement.

On September 19, 2011, the first national museum of socialism was solemnly inaugurated in Sofia, at a ceremony led by the Bulgarian prime minister, the minister of culture, and the minister of finance. Located far from the center and away from the main tourist itineraries, it is, in fact, a museum of socialist art, featuring one room with paintings and a garden with several sculptures. It is interesting to observe how this novel endeavor to remember socialism will affect the grassroots, scattered, and widely diverging approaches of local publics to displaying and exhibiting the recent past. How will the already officialized, centralized, and nationalized memory of socialism interact with the local memories of socialism? Will the local actors get access to Central European or global models of commemorating socialism, bypassing the Bulgarian capital altogether? Or will they find a path to form a local network and to exchange their experiences and concerns? In any case, museums of socialism are already conceptualized as symbolic capital of the local communities, thus conditioning the future memory work of multiple local publics.

Notes

1 A shorter version of this text appeared as Rossitza Guentcheva, "Napravi si sam muzei na sotsializma" [DIY Museum of Socialism], in Natalia Hristova (ed.), *Sotsializmut v muzeia na postsotsializma* [Socialism in the Museum of Postsocialism] (Sofia: Nov Bulgarski Universitet, 2015), 198–221; and in *Seminar BG*, no. 8 (2013), https://www.seminar-bg.eu/spisanie-seminar-bg/broy8/item/374-napravi-si-sam-muzei-na-sotzializma.html (accessed August 30, 2019).

2 Svetla Kazalarska, *Muzeiat na komunizma mezhdu pametta i istoriiata, politikata i pazara* (Sofia: Universitetsko izdatelstvo "Sv. Kliment Ohridski," 2013), 261.

3 Georgi Gospodinov, "Lipsvashtiiat muzei," *Literaturen vestnik*, no. 3, January 26, 2005: 1. See also chapter 9 of Kazalarska's *Muzeiat na komunizma*, entitled "'The Absent' Museum of Communism in Bulgaria."

4 Nikolai Vukov, "The 'Unmemorable' and the 'Unforgettable': 'Museumizing' the Socialist Past in Post-1989 Bulgaria," in Oksana Sarkisova and Péter Apor (eds.), *Past for the Eyes: East European Representations of Socialism in Cinema and Museums after 1989* (Budapest: Central European University Press, 2008), 307–334. Still, Vukov acknowledges and also analyzes some local instances in museumizing socialism. For a comprehensive review of pre- and post-1989 efforts to museumize the socialist past in Bulgaria, see his comparative text, Nikolai Vukov, "Visualizations of the Past in Transition: Museum Representations in Hungary, Romania and Bulgaria after 1989," *CAS Working Paper Series*, no. 2 (2009), http://www.cas.bg/uploads/files/Nikolai%20Vukov.pdf (accessed August 30, 2019).

5 Kazalarska, *Muzeiat na komunizma*, 274.

6 Radostina Sharenkova, "Forget-Me(-Not): Visitors and Museum Presentations about Communism before 1989," *History of Communism in Europe*, 1 (2010): 63–80. For an account on the closing down of socialist memorial museums in the initial euphoria following 1989, see Gabriela Petkova-Campbell, "Bulgarian Museums in the Post-communist Period," *Museum Management and Curatorship*, 3 (2010): 277–290.

7 Vukov, "The 'Unmemorable' and the 'Unforgettable.'"

8 Ibid.

9 On the rare occasions where socialism was displayed in the framework of national history museums, the curators have struggled to insert a break in the narrative— either symbolic or physical—and to present it as an aberration from historical time, thus simultaneously denying it a place in national history (as in Riga or Budapest). See James Mark, *The Unfinished Revolution: Making Sense of the Communist Past in Central-Eastern Europe* (New Haven, CT: Yale University Press, 2010), 87–90.

10 Kazalarska, *Muzeiat na komunizma*, 275.

11 Vukov, "The 'Unmemorable' and the 'Unforgettable.'"

12 http://www.grao.bg/tna/tab02.txt (accessed September 15, 2011), data as of September 15, 2011. All statistics in the chapter come from this site and from that date.

13 Kazalarska, *Muzeiat na komunizma*, 276.

14 *Visual Seminar*, January–June 2004, 2.

15 Gerald Creed, *Domesticating Revolution: From Socialist Reform to Ambivalent Transition in a Bulgarian Village* (University Park: Pennsylvania State University Press, 1998).

16 K. Vodenicharov, M. Tashkov, and S. Vodenicharov, *Selo Skrebatno. Isotricheski ocherk* (Blagoevgrad: Okruzhen istoricheski muzei – Blagoevgrad, 1978), 41.

17 Some of them were members of the local Communist Party organization and the others were people from Skrebatno who lived in the village, in Sofia, and in other Bulgarian cities. See ibid., 45.

18 I am grateful to Aliki Angelidou for introducing me to Vrabevo village, the Vrabevo village museum, and its present caretaker. For more information on Vrabevo village, see Aliki Angelidou, "Transformations sociales et recompositions de l'identité locale en Europe du Sud-est: le cas de Vrabevo, un village bulgare post-socialiste" (PhD dissertation, École des Hautes Études en Sciences Sociales, Paris, 2005).

19 It had been closed shortly before my visit there in July 2010.

20 This is a pseudonym.

21 Prior to 1989, in fact since 1969, museums in Bulgaria had to be organized following a three-tiered structure, containing a historical section, a "building of socialism" section, and "natural history" section, with ethnographic and archaeological collections coming under the first section. See Gabriela Petkova-Campbell, "Communism and Museums in Bulgaria," *International Journal of Heritage Studies* 5 (2009): 403. Post-1989 museums smoothly reproduce this tiered structure, displaying unproblematically ethnographic material together with socialist artifacts.

22 The Regional Museum of History – Veliko Tarnovo, http://museumvt.com/en/museum-of-contemporary-history/#secondPage (accessed August 30, 2019).

23 Completed in 1986, the building was constructed after French architectural plans. Prior to moving there, Nikolai's family had shared an apartment with another family, each of them being allocated two rooms. The two families had struck a deal so as to avoid the common use of the non-separable spaces: the other family pledged not to use the terrace, while Nikolai's family promised not to use the shower.

24 Ivan Purvanov, "Bibliotekar suzdade Muzei na komunizma," v-k *Monitor*, July 24, 2009: 16–17.
25 I am grateful to Daniela Koleva who suggested this notion to me.
26 James Mark gives as an example South Africa, which still fights over the memory and representation of apartheid in a manner similar to the way the former socialist countries in Central and Eastern Europe are attempting to deal with the memory of socialism. One of the emblematic places of memory in South Africa, the prison on Robben island where many of the anti-apartheid fighters were held, including Nelson Mandela, was made into a museum with an accent not on demonization of those responsible for the apartheid but as a place with a difficult past that was successfully overcome. And while pain and suffering have been acknowledged and exhibited, the visitor's attention is drawn not to victimization and repression but to the nation's ability to surmount the violence and discrimination of the previous regime. In the same manner, the concentration camps from the Anglo-Boer war from the late nineteenth and the beginning of the twentieth century are turned into places of interethnic reconciliation—into shared *lieux de mémoire*, where both black and white South Africans were oppressed by the British monarchy. Mark, *The Unfinished Revolution*, 91–92.
27 For a different relationship between remembering communism and tourism, see Duncan Light, "Gazing on Communism: Heritage Tourism and Post-communist Identities in Germany, Hungary and Romania," *Tourism Geographies* 2 (2000): 157–176. See also Duncan Light, "An Unwanted Past: Contemporary Communism and the Heritage of Communism in Romania," *International Journal of Heritage Studies* 2 (2001): 145–160.

Conclusion. Memorializing Recent "Pasts" in Eastern Europe: Comparative Perspectives

Constantin Iordachi and Péter Apor

This volume offers fresh perspectives on museum representations of the recent past in contemporary Eastern Europe, against the background of European-wide debates on history, memory, and politics. Our endeavor differs from existing publications in its dual focus on museums of the Second World War and of communism, and in its comparative scope and systematic approach, combining detailed case studies with regional perspectives. We regard museums as complex institutions that are at the center of a vast array of political, institutional, economic, and epistemological processes. We argue that museums have greatly shaped the image of the communist past in Eastern Europe; they have used a wide selection of media tools, visual tactics, and commercial strategies in order to substantiate ideological approaches to the past and to shape public opinion.

Without ignoring broader global perspectives, the volume treats museums of communism as an outcome of the specificities of post-communist societies in Eastern Europe. The chapters focus, comparatively, on a wide variety of case studies, pointing out similarities and differences, and accounting for transnational patterns of remembrance at a national, regional, and European levels. They identify important common themes that connect most museums of communism in the region: their claims to represent the history and identity of the respective nation, their implicit or often manifest comparison between communism and fascism, their transnational links and networking, their engagement with nostalgia for communism (be it in a positive or a negative way) as well as their innovative use of media technology. At the same time, the contributors warn against the tendency to treat the development of museums of recent history in Eastern Europe as a homogeneous process. Instead, the volume highlights important differences in the chronology, institutional background, and genres that have shaped museums of the recent past in Eastern Europe.

The assessments of the national cases covered in the volume enable us to advance new comparative insights. First of all, it should be noted that, from a chronological perspective, museums of communism emerged in several waves, closely connected to larger sociopolitical transformations. In the first post-communist decade, museums of communism were rather rare, being the exception rather than the rule. By the mid-

2000s, such museums were established in Lithuania, Latvia, Hungary, Romania, and the former GDR. Until recently, there were no such institutions in Bulgaria, Slovakia, Poland, or Serbia.[1]

That was because the communist period was not regarded as equally important for all of the societies concerned. While Hungarian or Romanian elites and public opinions considered the post-1945 decades as crucial in understanding the history of their nation, in Poland or in the successor states of Yugoslavia the emphasis was laid on the experience of occupation during the Second World War and on processes of national liberation. More recently, however, museums of recent history have gradually become paramount institutions in the articulation of national identity, often replacing conventional national museums. Traditionally, national museums in the region, be they historical, art-historical, or ethnographic in orientation, used to convey master narratives on the history and core features of their respective national communities. After 1989, many of them lost importance, partly because of lack of funding but also because their conventional view of the nation was less successful in mobilizing political identities than the combatant, polemic rhetoric of new museums of the Second World War and of communism.

Second, museums of communism differ in their institutional history and legal status. In the Baltic States, museums of communism originated as private initiatives run by non-governmental organizations led by former political dissidents or persons persecuted by the Soviet authorities. Likewise, the first museum devoted to communism in Romania was initiated by a civic association of former anti-communist dissidents, which later on managed to gain state support as well. In Germany, the numerous institutions that deal with the communist period in the GDR combine public and private funding. In contrast, the House of Terror Museum in Budapest, Hungary, was initiated by the central government and is funded mostly from the state budget. Differences in legal status, donors and sponsors might also account for differences in historical interpretations.

Third, the dominant interpretative paradigm of exhibiting the communist period is that of totalitarianism, focusing on the communist takeover, the process of Sovietization, the establishment and consolidation of one-party rule and of the system of organized repression. Yet this paradigm is not the only way in which the history of communism has been approached. The history of everyday life, reified in objects of private consumption, household and leisure activities, is particularly well represented in the GDR as well as in Serbia, Romania, and Hungary. These two approaches have been largely antithetic, resulting in an interpretative schism (see Chapter 2).

Fourth, the volume explores the close links between museums of occupations and museums of communism. This issue brings to the fore various modes of comparing fascism and communism, revolving mostly around the legacies of the Holocaust and the Gulag. This value-loaded comparison functioned often as a form of anti-communism, as a way of demonizing communist regimes by placing them on a par with the ultimate evil in history, fascism (and Nazism in particular). But this mode of representation is also a way to reduce the importance of fascism as a political phenomenon, presenting it—following in the footsteps of Ernst Nolte—as a legitimate if extreme, reaction to Bolshevism and thus not an independent, self-sustainable political phenomenon. The

history of the two forms of totalitarianism have been explicitly linked together in the Baltics States but also in Hungary and Poland, in order to represent ideological extremes that allegedly fell outside the confines of the history of the respective nations.[2] In other countries, they are rarely connected in such a manifest, ideologically driven way. Moreover, in many Baltic museums older exhibitions have been recently refurbished and the totalitarian paradigm relativized in order to also address the participation of national communities in the maintenance of fascist and communist dictatorships and to integrate these into the larger theme of the fight for freedom. These changes in patterns of representation are intrinsically linked to the ways in which political elites try to reshape national identities and to either distance themselves from or integrate into dominant European narratives of civic, multicultural, and multiethnic citizenship.

Fifth, it is particularly important to investigate the transnational networks that tie these museums. Recently, several museums of contemporary history formed the transnational Platform of European Memory and Conscience, which has developed strong links to the European Parliament. The network builds on earlier transnational linkages actively constructed by Eastern European museums in the past two decades and incorporates a pan-European group of actors. Nonetheless, not all new museums of the recent past represented in this network subscribe to the European consensus concerning the condemnation of dictatorships from the standpoint of a democratic value system. Often orchestrated by anti-liberal politicians—rather than museum personnel—conservative-nationalist or revisionist museum narratives aim to undermine the central role of the Holocaust in the post-1945 European regime of remembrance and to replace it with the framework of "unitotalitarianism," equating communism with fascism.[3] Museums of the recent past have been often used by post-communist elites to establish and promote such historical narratives based on victimhood nationalism. The contributors to this volume reiterate the fact that while it is obvious that both forms of totalitarianism have to be condemned, their abuses and atrocities should be exposed by confronting them with a democratic system of values and not in the name of nationalist-authoritarian values. It is apparent that, thirty years after the collapse of communism, the most virulent anticommunist discourses are not meant to educate the general public about the history of the defunct communist regimes but are demagogically used as tools to delegitimize the (so-called) contemporary 'left,' which, in an untenable conceptual overstretch, is defined as encompassing communists, social democrats, but also center-right liberal politicians.

Sixth, the volume has tried to identify and socially locate feelings of nostalgia toward former communist regimes. Many contributors have pointed out that nostalgia is not just an innocent recollection of the "Good Old Days" of youthhood but is rather an attempt to place the period of the socialist dictatorships into temporal distance and to turn that period into a distinct yet still "familiar" historical period by exoticizing that "strange world" once experienced. Such temporal distancing may often be on a par with representations of violence in exhibitions on communism. The display of the brutality of communism or of the Second World War in Eastern Europe turns socialist dictatorships into alien entities, both in time and space as violent events usually function as a symbolic borders separating political regimes. Exhibiting atrocities renders communism into a distinct yet also recognizable Cold War geo-cultural area, that of "Eastern Europe" for many travelers from the West.

In terms of techniques of display, museums of communism tend to diverge from conventional history museums. While the former are typically saturated with historical documents, objects, and photographs framed by textual explanations, most museums of the recent past aim to provide a full audiovisual "experience." To this end, they employ new media technologies consisting of computer interfaces, audiovisual installations, posters, and life-size reconstructions of historical interiors. Museums of the recent past have thus served as laboratories for experimenting with new techniques of visual and material representation. While making such multimedia artifacts directly accessible to visitors, many museums of contemporary history thereby distance their visitors—consciously or unconsciously—from the historical evidence—represented by archival materials, oral history, or documentary footage—in favor of an artistic representation of the "spirit" of the times. As such, they often face a lack of credibility, authenticity, and factuality of their historical representations. It remains the task of the visitors—be they "consumers" of public history or survivors of traumatic historical events—to endorse or contest dominant historical representation by filtering them through the prism of their own personal memories.

Museum professionals have made efforts to meet the challenges posed by the use of attractive audiovisual and digital technologies by reflecting on the nature of historical and museum evidence and the relationship between multimedia and conventional textual, archival, and object-based exhibition items. In this context, the new museums of the recent past, in particular, have become sites where broader epistemological issues—such as the criteria and conditions of the authenticity and credibility of historical narratives—are questioned or 'negotiated' on a wide social level. Our volume points out that museums of the recent past in Eastern Europe tend to be at times very vague about the criteria used to verify their historical statements. The contributors to the volume confront narratives in museums of the recent past—and more broadly of historical representations—with contemporary paradigms of historical truth and evidence. They seek to understand what sort of images of the past are selected and presented as authentic and how museums today can operate meaningful distinctions between the manipulation of evidence and the multilayered interpretation of historical facts. As far as museum practices are concerned, several contributors to the volume advance the idea of a "laboratory museum" as an experiment that can bridge the analysis of the official ideology and practices with the subjective social experience of a multitude of "actors" who lived under the communist rule in Eastern Europe.

Overall, it is our conviction that the comprehensive study of the history and main features of museums of the recent past in Eastern Europe can offer a more nuanced understanding of post-communist political developments as well. Political scientists often define post-communism as a region-specific regime of transition determined largely by a similar or even uniform evolution from the communist rule to democracy. This book demonstrates that national contexts and historical traditions have greatly shaped, in various ways, societies, cultures, and politics after the fall of communism. In addition, the contributions to this volume set the post-communist evolution of Eastern Europe in a pan-European framework.[4] They point out that museums of the recent past have been often the result of an international cooperation involving a multitude of actors such as national institutions, museum curators, politicians and public

intellectuals, European institutions, and private funding bodies from Europe or across the world. Therefore, while emulating international trends and borrowing templates from Western Europe or North America, East European museums have also generated specific regional or continental debates that have reshaped the ways we understand the legacy of dictatorship, oppression, and violence on a global level.

Notes

1 See, for instance, Nikolai Vukov, "The 'Unmemorable' and the 'Unforgettable': 'Museumizing' the Socialist Past in Post-1989 Bulgaria," in Oksana Sarkisova and Péter Apor (eds.), *Past for the Eyes* (Budapest: Central European University Press, 2008), 307–334; and Sara Jean Tomczuk, "Contention, Consensus, and Memories of Communism: Comparing Czech and Slovak Memory Politics in Public Spaces, 1993–2012," *International Journal of Comparative Sociology* 57, no. 3 (2016): 105–126.

2 Ieva Zake, "The Exempt Nation: Memory of Collaboration in Contemporary Latvia," in Péter Apor, Sándor Horváth, and James Mark (eds.), *Secret Agents and the Memory of Everyday Collaboration in Communist Eastern Europe* (London: Anthem Press, 2017), 59–79.

3 Zoltán Dujisin, "Post-Communist Europe: On the Path to a Regional Regime of Remembrance?," in Michal Kopeček and Piotr Wciślik (eds.), *Thinking through Transition: Liberal Democracy, Authoritarian Pasts, and Intellectual History in East Central Europe after 1989* (Budapest: Central European University Press, 2015), 553–586.

4 Konrad H. Jarausch and Thomas Lindenberger (eds.), *Conflicted Memories: Europeanizing Contemporary Histories* (New York: Berghahn, 2007).

Select Bibliography

Apor, Péter. "An Epistemology of the Spectacle? Arcane Knowledge, Memory and Evidence in the Budapest House of Terror." *Rethinking History: The Journal of Theory and Practice* 18, no. 3 (2014): 328–344.

Aro, Velmet. "Occupied Identities: National Narratives in Baltic Museums of Occupations." *Journal of Baltic Studies* 42, no. 2 (2011): 189–211.

Aronsson, Peter, and Gabriella Elgenius, eds. *National Museums and Nation-Building in Europe 1750–2010: Mobilization and Legitimacy, Continuity and Change.* London: Routledge, 2015.

Ash, Timothy Garton. "Trials, Purges and History Lessons: Treating a Difficult Past in Post-communist Europe." In *Memory and Power in Post-War Europe: Studies in the Presence of the Past*, edited by Jan Müller, 265–282. Cambridge: Cambridge University Press, 2002.

Bădică, Simina. "The Black Hole Paradigm: Exhibiting Communism in Post-Communist Romania." *History of Communism in Europe*, new series, no. 1 (2010): 83–101.

Bădică, Simina. "'Same Exhibition, Different Labels': Romanian National Museums and the Fall of Communism." In *National Museums: New Studies from around the World*, edited by Simon J. Knell, Peter Aronsson, and Arne Bugge Amundsen, 272–289. London: Routledge, 2010.

Bakiner, Onur. "Between Politics and History: The Baltic Truth Commissions in Global Perspective." In *Transitional Justice and the Former Soviet Union: Reviewing the Past, Looking toward the Future*, edited by Cynthia M. Horne and Lavinia Stan, 155–176. Cambridge: Cambridge University Press, 2018.

Balbier, Uta A., Cristina Cuevas-Wolf, and Joes Segal, eds. *East German Material Culture and the Power of Memory.* Washington, DC: German Historical Institute, 2011.

Bann, Stephen. *The Clothing of Clio: A Study of the Representation of History in Nineteenth-Century Britain and France.* Cambridge: Cambridge University Press, 1984.

Barnes, Amy. *Museum Representations of Maoist China: From Cultural Revolution to Commie Kitsch.* Burlington, VT: Ashgate Publishing Company, 2014.

Beattie, Andrew H. *Playing Politics with History: The Bundestag Inquiries into East Germany.* New York: Berghahn Books, 2008.

Ben-Naftali, Aya. "Collaboration and Resistance: The Ninth Fort as a Test Case." In *Collaboration and Resistance during the Holocaust: Belarus, Estonia, Latvia and Lithuania*, edited by David Gaunt, Paul A. Levine, and Laura Palosuo, 361–382. Bern: Peter Lang, 2004.

Bennett, Tony. *Pasts Beyond Memory: Evolution, Museums, Colonialism.* London: Routledge, 2004.

Bernhard, Michael, and Jan Kubík, eds. *Twenty Years after Communism: The Politics of Memory and Commemoration.* New York: Oxford University Press, 2014.

Blaive, Muriel, Christian Gerbel, and Thomas Lindenberger, eds. *Clashes in European Memory: The Case of Communist Repression and the Holocaust*. Innsbruck and Vienna: StudienVerlag, 2011.

Blandiana, Ana. "Memorialul Sighet la majorat. Vreți să înțelegeți România de astăzi?." *Revista* 22, no. 314 (February 8, 2011). Available online: https://revista22. ro/supliment/22-plus-nr-314-memorialul-sighet-la-majorat-vre355i-s259-in355elege355i-romania-de-azi (accessed April 20, 2019).

Bodenstein, Felicity, and Dominique Poulot. "From Politics to Policy: Two Decades of National Museum Development in France (1989–2012)." In *Museum Policies in Europe 1990–2010: Negotiating Professional and Political Utopia*, edited by Lill Eilertsen and Arne Bugge Amundsen, 13–42. Linköping: Linköping University Electronic Press, 2012.

Boyle, Joe. "China's 'Red Tourism' Stopover." BBC News, May 14, 2008. Available online: http://news.bbc.co.uk/2/hi/asia-pacific/7401223.stm (accessed August 27, 2019).

Bren, Paulina. *The Greengrocer and His TV: The Culture of Communism after the 1968 Prague Spring*. Ithaca, London: Cornell University Press, 2010.

Bren, Paulina, and Mary Neuburger, eds. *Communism Unwrapped: Consumption in Cold War Eastern Europe*. Oxford: Oxford University Press, 2012.

Buck-Morss, Susan. *Dreamworld and Catastrophe — The Passing of Mass Utopia in East and West*. Cambridge, MA: MIT Press, 2000.

Burch, Stuart, and Ulf Zander. "Preoccupied with the Past: The Case of Estonia's Museum of Occupation." *Scandia* 74, no. 2 (2008): 53–73.

Buzalka, Juraj. "Post-peasant Memories: Populist or Communist Nostalgia." *East European Politics and Societies and Cultures* 20, no. 10 (2017): 988–1006.

Carson, Cary. "The End of History Museums: What's Plan B?." *Public Historian* 30, no. 4 (Fall 2008): 9–27.

Cento Bull, Anna, and Hans Lauge Hansen. "On Agonistic Memory." *Memory Studies* 9, no. 4 (2016): 390–404.

Cesereanu, Ruxandra. "The Final Report on the Holocaust and the Final Report on the Communist Dictatorship in Romania." *East European Politics and Societies* 22, no. 2 (2008): 270–281.

Clarke, David. "Understanding Controversies over Memorial Museums: The Case of the Leistikowstraße Memorial Museum, Potsdam." *History and Memory* 29, no. 1 (2017): 41–71.

Clarke, David, and Paweł Duber. "Polish Cultural Diplomacy and Historical Memory: The Case of the Museum of the Second World War in Gdańsk." *International Journal of Politics, Culture, and Society* (2018): 1–18.

Conway, Brian. *Commemoration and Bloody Sunday: Pathways of Memory*. Basingstoke: Palgrave Macmillan, 2010.

Crane, Susan A. *Collecting and Historical Consciousness in Early Nineteenth-Century Germany*. Ithaca, NY: Cornell University Press, 2000.

Crane, Susan A. "Curious Cabinets and Imaginary Museums." In *Museums and Memory*, edited by Susan A. Crane, 64–69. Stanford, CA: Stanford University Press, 2000.

Crane, Susan A. "Memory, Distortion, and History in the Museum." *History and Theory* 36 (December 1997): 44–63.

Crowley, David, and Susan Reid, eds. *Pleasures in Socialism: Leisure and Luxury in the Eastern Bloc*. Evanston, IL: Northwestern University Press, 2010.

Crowley, David, and Susan Reid, eds. *Style and Socialism: Modernity and Material Culture in Postwar Eastern Europe*. Oxford: Berg, 2000.

Crownshaw, Rick, Jane Kilby, and Antony Rowland, eds. *The Future of Memory*. Oxford: Berghahn, 2010.

Cubitt, Geoffrey. *History and Memory*. Manchester: Manchester University Press, 2007.

Daston, Lorrain, and Katherine Park. *Wonders and the Order of Nature 1150–1750*. New York: Zone Books, 1998.

Dejung, Christof. "A Past That Refuses to Pass: The Commemoration of the Second World War and the Holocaust." *Journal of Contemporary History* 43, no. 4 (2008): 701–710.

Denton, Kirk A. *Exhibiting the Past: Historical Memory and the Politics of Museums in Postsocialist China*. Honolulu: University of Hawaii Press, 2014.

Deutz-Schroeder, Monika, and Klaus Schroeder. *Soziales Paradies oder Stasi-Staat? Das DDR-Bild von Schülern - ein Ost-West-Vergleich*. Stamsried: Vögel, 2008.

Digan, Katie. "Space and Place of Memory: The Case of the Haus am Großen Wannsee." In *Erinnerungsorte: Chancen, Grenzen und Perspektiven eines Erfolgskonzeptes in den Kulturwissenschaften*, edited by Stefan Berger and Joana Seiffert, 56–58. Essen: Klartext Verlag, 2014.

Dobrenko, Evgeny. *Stalinist Cinema and the Production of History: Museum of the Revolution*, translated by Sarah Young. Edinburgh: Edinburgh University Press, 2008.

Dovydaitytė, Linara. "Post-Soviet Writing of History: The Case of the National Gallery of Art in Vilnius." *Studies on Art and Architecture* 19, nos. 3–4 (2010): 105–120.

Drakulić, Slavenka. *A Guided Tour through the Museum of Communism*. New York: Penguin, 2011.

Eilertsen, Lill, and Arne Bugge Amundsen, eds. *Museum Policies in Europe 1990–2010: Negotiating Professional and Political Utopia*. Linköping: Linköping University Electronic Press, 2012.

Ekiert, Grzegorz, Jan Kubík, and Milada Anna Vachudova. "Democracy in the Post-Communist World: An Unending Quest?." *East European Politics and Societies* 21, no. 1 (2007): 7–30.

Emden, Christian, and David Midgley, eds. *Cultural Memory and Historical Consciousness in the German-Speaking World since 1500*. Bern: Peter Lang, 2004.

Etges, Andreas, Irmgard Zündorf, and Paweł Machcewicz. "History and Politics and the Politics of History: Poland and Its Museums of Contemporary History." *International Public History* 1, no. 1 (2018). doi:10.1515/iph-2018-0006.

Evans, Martin. "Memories, Monuments, Histories: The Re-Thinking of the Second World War since 1989." *National Identities* 8, no. 4 (2006): 317–348.

Faulenbach, Bernd, and Franz-Josef Jelich, eds. *Asymmetrisch verflochtene Parallelgeschichte? Die Geschichte der Bundesrepublik Deutschland und der DDR in Ausstellungen, Museen und Gedenkstätten*. Essen: Klartext Verlag, 2005.

Faulenbach, Bernd, and Franz-Josef Jelich, eds. *Probleme der Musealisierung der doppelten deutschen Nachkriegsgeschichte*. Essen: Klartext Verlag, 1993.

Fulbrook, Mary. *The People's State: East German Society from Hitler to Honecker*. New Haven, CT: Yale University Press, 2005.

Geyer, Michael, and Sheila Fitzpatrick, eds. *Beyond Totalitarianism: Stalinism and Nazism Compared*. Chicago: University of Chicago Press, 2009.

Ghodsee, Kristen. *The Left Side of History, World War II and the Unfulfilled Promise of Communism in Eastern Europe*. Durham, NC: Duke University Press, 2015.

Ghodsee, Kristen. *The Red Riviera: Gender, Tourism and Postsocialism on the Black Sea*. Durham, NC: Duke University Press, 2005.

Ghodsee, Kristen. "Tale of 'Two Totalitarianisms:' The Crisis of Capitalism and the Historical Memory of Communism." *History of the Present: A Journal of Critical History* 4, no. 2 (Fall 2014): 115–142.

Giustino, Cathleen M., Catherine J. Plum, and Alexander Vari, eds. *Socialist Escapes: Breaking Away from Ideology and Everyday Routine in Eastern Europe, 1945–1989.* New York: Berghahn Books, 2013.

Godis, Nataliia, and Jan Henrik Nilsson. "Memory Tourism in a Contested Landscape: Exploring Identity Discourses in Lviv, Ukraine." *Current Issues in Tourism* 21, no. 15 (2018): 1690–1709.

Guentcheva, Rossitza. "Past Contested: The Museum of Socialist Art in Sofia." In *National Museums and the Negotiation of Difficult Pasts,* edited by Dominique Poulot, José María Lanzarote Guiral, and Felicity Bodenstein, 123–136. Linköping: Linköping University Electronic Press, 2012.

Halbwachs, Maurice. *La mémoire collective,* rev. edn. Paris: Albin Michel, 1997.

Hloušek, Vít, and Lubomír Kopeček. "Cleavages in the Contemporary Czech and Slovak Politics: Between Persistence and Change." *East European Politics and Societies* 22, no. 3 (2008): 518–552.

Höglund, Maria. "European Union Approaches to Museums 1993–2010." In *Museum Policies in Europe 1990–2010: Negotiating Professional and Political Utopia,* edited by Lill Eilertsen and Arne Bugge Amundsen, 157–188. Linköping: Linköping University Electronic Press, 2012.

Hooper-Greenhill, Eilean. *Museums and the Interpretation of Visual Culture.* London: Routledge, 2000.

Huener, Jonathan. *Auschwitz, Poland, and the Politics of Commemoration, 1945–1979.* Athens: Ohio University Press, 2003.

Jarausch. Konrad H. "Conclusion: Nightmares or Daydreams? A Postscript on the Europeanization of Memories." In *A European Memory?. Contested Histories and Politics of Remembrance,* edited by Małgorzata Pakier and Bo Stråth, 309–320. Oxford: Berghahn Books, 2010.

Jarausch, Konrad H., ed. *Dictatorship as Experience: Towards a Socio-Cultural History of the GDR.* New York: Berghahn Books, 1999.

Jeffrey, Jaclyn, and Glenace Ecklund Edwall, eds. *Memory and History: Essays on Recalling and Interpreting Experience.* Lanham, MD: University Press of America, 1994.

Jõesalu, Kirsti. *Dynamics and Tensions of Remembrance in post-Soviet Estonia: Late Socialism in the Making.* Tartu: University of Tartu Press, 2017.

Jõesalu, Kirsti. "'We Were Children of Romantic Era': Nostalgia and the Non-ideological Everyday through a Perspective of 'Silent Generation.'" *Journal of Baltic Studies* 47, no. 4 (2016): 557–577.

Jõesalu, Kirsti, and Ene Kõresaar. "Continuity or Discontinuity: On the Dynamics of Remembering 'Mature Socialism' in Estonian Post-Soviet Remembrance Culture." *Journal of Baltic Studies* 44, no. 2 (2013): 177–203.

Jõesalu, Kirsti, and Raili Nugin. "Reproducing Identity through Remembering: Cultural Texts on the Late Soviet Period." *Folklore. Electronic Journal of Folklore* 51 (2012): 15–48.

Jolles, Adam. "Stalin's Talking Museums." *Oxford Art Journal* 28, no. 3 (2005): 431–455.

Jones, Sara. "Staging Battlefields: Media, Authenticity and Politics in the Museum of Communism (Prague), The House of Terror (Budapest) and *Gedenkstätte Hohenschönhausen* (Berlin)." *Journal of War & Culture Studies* 4, no. 1 (2011): 97–111.

Kaminsky, Annette, ed. *Orte des Erinnerns. Gedenkzeichen, Gedenkstätten und Museen zur Diktatur in SBZ und DDR*, 2nd rev. edn. Berlin: Ch. Links Verlag, 2016.

Kirshenblatt-Gimblett, Barbara. *Destination Culture: Tourism, Museums and Heritage.* Berkeley: University of California Press, 1998.

Knell, Simon J., Peter Aronsson, and Arne Bugge Amundsen, eds. *National Museums: New Studies from around the World*. London: Routledge, 2010.

Knigge, Volkhard, and Ulrich Mählert, eds. *Der Kommunismus im Museum: Formen der Auseinandersetzung in Deutschland und Ostmitteleuropa*. Cologne: Böhlau Verlag, 2005.

Knischewski Gerd, and Ulla Spittler. "Memorialization of the German-German Border in the Context of Construction of Heimat." In *Memorialization in Germany since 1945*, edited by Bill Niven and Chloe Paver, 318–328. Basingstoke: Palgrave Macmillan, 2010.

Kopeček, Michal, and Piotr Wciślik, eds. *Thinking through Transition, Liberal Democracy, Authoritarian Past, and Intellectual History in East Central Europe after 1989*. Budapest: Central European University Press, 2015.

Kõresaar, Ene. "The Notion of Rupture in Estonian Narrative Memory: On the Construction of Meaning in Autobiographical Texts on the Stalinist Experience." *Ab Imperio*, no. 4 (2004): 313–339.

Kõresaar, Ene. "World War II Remembrance and the Politics of Recognition: An Outline of the Post-1989 Mnemohistory of Estonian 'Freedom-Fighters.'" In *War, Revolution, and Governance: The Baltic Countries in the Twentieth Century*, edited by Laxar Fleischman and Amir Weiner, 165–193. Boston, MA: Academic Studies Press, 2018.

Kovács, Éva. "Limits of Universalization: The European Memory Sites of Genocide." *Journal of Genocide Research* 20, no. 4 (2018): 490–509.

Kovanič, Martin. "Institutes of Memory in Slovakia and the Czech Republic: What Kind of Memory?." In *Secret Agents and the Memory of Everyday Collaboration in Communist Eastern Europe*, edited by Péter Apor, Sándor Horváth, and James Mark, 81–104. London: Anthem Press, 2017.

Kunicová, Jana, and Monika Nalepa. "Coming to Terms with the Past: Strategic Institutional Choice in Post-Communist Europe." Working Paper, December 2006. Available online: http://www.sscnet.ucla.edu/polisci/cpworkshop/papers/Kunicova.pdf (accessed May 20, 2019).

Kurvet-Käosaar, Leena. "Voicing Trauma in the Deportation Narratives of Baltic Women." In *Haunted Narratives: Life Writing in an Age of Trauma*, edited by Gabriele Rippl, Philipp Schweighauser, Tiina Kirss, Margit Sutrop, and Therese Steffen, 129–151. Toronto: Toronto University Press, 2013.

Kuusi, Hanna. "Prison Experiences and Socialist Sculptures – Tourism and the Soviet Past in the Baltic States." In *Touring the Past: Uses of History in Tourism*, edited by Auvo Kostiainen and Taina Syrjämaa, 105–122. Discussion and Working Papers. Savonlinna: MAVY, 2008.

Kuutma, Kristin, and Paavo Kroon. "Museum Policy in Transition from Post-Soviet Conditions to Reconfigurations in the European Union." In *Museum Policies in Europe 1990–2010: Negotiating Professional and Political Utopia*, edited by Lill Eilertsen and Arne Bugge Amundsen, 69–90. Linköping: Linköping University Electronic Press, 2012.

Landsberg, Alison. *Prosthetic Memory: The Transformation of American Remembrance in the Age of Mass Culture*. New York: Columbia University Press, 2004.

Langwagen, Kerstin. *Die DDR in der Vitrine*. Berlin: Metropol Verlag, 2016.

Lankauskas, Gediminas. "Sensuous (Re)Collections: The Sight and Taste of Socialism at Grūtas Statue Park, Lithuania." *Senses and Society* 1, no. 1 (2006): 27–52.

Lebow, Katherine. *Unfinished Utopia: Nowa Huta, Stalinism, and Polish Society, 1949-1956.* Ithaca, NY: Cornell University Press, 2013.

Lebow, Richard Ned, Wulf Kansteiner, and Claudio Fogu, eds. *The Politics of Memory in Postwar Europe.* Durham, NC: Duke University Press, 2006.

LeGoff, Jacque. *History and Memory.* New York: Columbia University Press, 1992.

Light, Duncan. "Gazing on Communism: Heritage Tourism and Post-Communist Identities in Germany, Hungary and Romania." *Tourism Geographies* 2 (2000): 157–176.

Light, Duncan. "An Unwanted Past: Contemporary Communism and the Heritage of Communism in Romania." *International Journal of Heritage Studies* 2 (2001): 145–160.

Lindenberger, Thomas. "Governing Conflicted Memories: Some Remarks about the Regulation of History Politics in Unified Germany." In *Clashes in European Memory: The Case of Communist Repression and the Holocaust,* edited by Muriel Blaive, Christian Gerbel, and Thomas Lindenberger, 73–87. Innsbruck: StudienVerlag, 2011.

Lindenberger, Thomas, ed. *Herrschaft und Eigen-Sinn in der Diktatur: Studien zur Gesellschaftsgeschichte der DDR.* Cologne: Böhlau Verlag, 1999.

Logge, Thorsten. "Public History in Germany: Challenges and Opportunities." *German Studies Review* 39 (2016): 141–153.

Lücke, Martin, and Irmgard Zündorf. *Einführung in die Public History.* Göttingen: Vandenhoeck und Ruprecht/UTB, 2018.

Lüdtke, Alf, ed. *The History of Everyday Life: Reconstructing Historical Experiences and Ways of Life.* Princeton, NJ: Princeton University Press, 1995.

Luthar, Breda, and Maruša Pušnik, eds. *Remembering Utopia: The Culture of Everyday Life in Socialist Yugoslavia.* Washington, DC: New Academia Publishing, 2010.

Macdonald, Sharon, ed. *A Companion to Museum Studies.* Oxford: Blackwell, 2006.

Macdonald, Sharon. *Memorylands: Heritage and Identity in Europe Today.* London: Routledge, 2013.

Machcewicz, Paweł. "I Wanted to Include the East European Experience into the Western Narrative about WWII [interview]." *TRAFO – Blog for Transregional Research,* August 28, 2018. Available online: https://trafo.hypotheses.org/12372 (accessed August 27, 2019).

Mälksoo, Maria. "'Memory Must Be Defended': Beyond the Politics of Mnemonical Security." *Security Dialogue* 46, no. 3 (2015): 221–237.

Manojlović-Pintar, Olga, and Aleksandar Ignjatović. "National Museums in Serbia: A Story of Intertwined Identities." In *Building National Museums in Europe 1750-2010,* edited by Peter Aronsson and Gabriella Elgenius, 779–815. Linköping: Linköping University Electronic Press, 2011. Available online: http://www.ep.liu.se/ecp_home/index.en.aspx?issue=064 (accessed May 20, 2019).

Mark, James. *The Unfinished Revolution: Making Sense of the Communist Past in Central-Eastern Europe.* New Haven, CT: Yale University Press, 2010.

Mateoniu, Maria, and Mihai Gheorghiu. "Theories and Methods of Studying Everyday Life. Everyday Life during Communism." *Martor,* no. 17 (2012): 7–18.

McKenzie, Sheena. "This Holocaust Museum Cost Millions and Still Hasn't Opened. But That's Not What Worries Historians," CNN International Edition, 2018. Available online: https://edition.cnn.com/interactive/2018/11/world/holocaust-museum-hungary-cnnphotos (accessed December 10, 2018).

Message, Kylie. *New Museums and the Making of Culture*. Oxford: Berg, 2006.

Michalska, Julia. "Outcry over Polish Government's Changes to Second World War Museum." *The Art Newspaper*, no. 296, December 21, 2017. Available online: https://www.theartnewspaper.com/news/outcry-over-polish-government-s-changes-to-secondworld-war-museum (accessed August 27, 2019).

Miller, Alexei, and Maria Lipman, eds. *The Convolutions of Historical Politics*. Budapest: Central European University Press, 2012.

Mink, Georges, and Laure Neumayer, eds. *History, Memory and Politics in Central and Eastern Europe: Memory Games*. New York: Palgrave Macmillan, 2013.

Müller, Jan-Werner. *Memory and Power in Post-War Europe: Studies in the Presence of the Past*. Cambridge: Cambridge University Press, 2002.

Nedelsky, Nadya. "From Velvet Revolution to Velvet Justice: The Case of Slovakia." In *After Oppression: Transitional Justice in Latin America and Eastern Europe*, edited by Vesselin Popovski and Mónica Serrano, 390–417. Tokyo: United Nations University Press, 2012.

Neumayer, Laure. *The Criminalisation of Communism in the European Political Space after the Cold War*. London: Routledge, 2019.

Nora, Pierre. *Les Lieux de mémoire*, vols. 1–3. Paris: Gallimard, 1984.

Oberländer, Erwin. "Soviet Genocide in Latvia? Conflicting Cultures of Remembrance of Stalin's Policy." In *Forgotten Pages in Baltic History: Diversity and Inclusion*, edited by Martyn Housden and David J. Smith, 239–260. Amsterdam: Rodopi, 2011.

O'Brien, Paraic. "Polish Government Accused of 'Cultural Purge' in World War Museum Row." 4 News, November 22, 2018. Available online: https://www.channel4.com/news/polish-governmentaccused-of-cultural-purge-in-world-war-museum-row (accessed August 27, 2019).

Ochman, Ewa. "Soviet War Memorials and the Re-Construction of National and Local Identities in Post-Communist Poland." *Nationalities Papers: The Journal of Nationalism and Ethnicity* 38, no. 4 (2010): 509–530.

Ochsner, Jeffrey Karl. "Understanding the Holocaust through the U.S. Holocaust Memorial Museum." *Journal of Architectural Education* 48, no. 4 (1995): 240–249.

Offe, Sabine. "Sites of Remembrance? Jewish Museums in Contemporary Germany." *Jewish Social Studies* 3, no. 2 (1997): 77–89.

Osęka, Piotr. "The Polish Debate on the Core Exhibition of the POLIN Museum of the History of Polish Jews." *Cultures of History Forum*, November 9, 2015. doi:10.25626/0045.

Pakier, Małgorzata, and Bo Stråth. "A European Memory?." In *A European Memory?. Contested Histories and Politics of Remembrance*, edited by Małgorzata Pakier and Bo Stråth, 1–20. Oxford: Berghahn Books, 2010.

Palhegyi, Joel. "National Museums, National Myths: Constructing Socialist Yugoslavism for Croatia and Croats." *Nationalities Papers*, 45, no. 6 (2017): 1048–1065.

Peifer, Douglas C. "New Books on Memory, History and the Second World War." *Contemporary European History* 18, no. 2 (2009): 235–244.

Pence, Katherine, and Paul Betts, eds. *Socialist Modern: East German Everyday Culture and Politics*. Ann Arbor: University of Michigan Press, 2008.

Penn, Shana, and Jill Massino, eds. *Gender Politics and Everyday Life in State Socialist Eastern and Central Europe*. Basingstoke: Palgrave Macmillan, 2009.

Petkova-Campbell, Gabriela. "Bulgarian Museums in the Post-Communist Period." *Museum Management and Curatorship* 3 (2010): 277–290.

Petkova-Campbell, Gabriela. "Communism and Museums in Bulgaria." *International Journal of Heritage Studies* 5 (2009): 399–412.

Petkova-Campbell, Gabriela. *Five Essays on Bulgarian Museums and Communism*. Paris: Harmattan, 2015.

Poulot, Dominique, Felicity Bodenstein, and José María Guiral, eds. *Great Narratives of the Past: Traditions and Revisions in National Museums*. Linköping: Linköping University Electronic Press, 2012.

Přibáň, Jiří. "Politics of Public Knowledge in Dealing with the Past: Post-Communist Experiences and Some Lessons from the Czech Republic." In *Law and Memory: Towards Legal Governance of History*, edited by Uladzislau Belavusau, and Aleksandra Gliszczynska-Grabias, 195–215. Cambridge: Cambridge University Press, 2017.

Radonić, Liljana. "Post-Communist Invocation of Europe: Memorial Museums' Narratives and the Europeanization of Memory." *National Identities* 19, no. 2 (2017): 269–288.

Radonić, Ljiljana. "Slovak and Croatian Invocation of Europe: The Museum of the Slovak National Uprising and the Jasenovac Memorial Museum." *Nationalities Papers* 42, no. 3 (2014): 489–507.

Radtchenko, Daria. "Simulating the Past: Reenactment and the Quest for Truth in Russia." *Rethinking History* 10, no. 1 (2006): 127–148.

Rhiannon, Mason. "National Museums, Globalization, and Postnationalism: Imagining a Cosmopolitan Museology." *Museum Worlds: Advances in Research* 1, no. 1 (2013): 40–64.

Ricoeur, Paul. *Memory, History, Forgetting*, translated by Kathleen Blamey and David Pellauer. Chicago: University of Chicago Press, 2004.

Rindzevičiūtė, Eglė. "From Authoritarian to Democratic Cultural Policy: Making Sense of De-Sovietisation in Lithuania after 1990." *Nordisk kulturpolitisk tidskrift* 12, no. 1 (2009): 191–221.

Rindzevičiūtė, Eglė. "Gifts from the Past and the Present: Assembling Soviet Deportations in Lithuanian Museums." In *Maps of Memory: Trauma, Identity and Exile in Gulag Testimonies*, edited by Tomas Balkelis and Violeta Davoliūtė, 153–177. Vilnius: LII, 2012.

Rindzevičiūtė, Eglė. "Institutional Entrepreneurs of a Difficult Past: The Organisation of Knowledge Regimes in Post-Soviet Lithuanian Museums." *European Studies* 30 (2013): 65–93.

Rivera, Lauren A. "Managing 'Spoiled' National Identity: War, Tourism, and Memory in Croatia." *American Sociological Review* 73, no. 4 (August 2008): 613–634.

Rivera-Orraca, Lorena. "Are Museums Sites of Memory?." *New School Psychology Bulletin* 6, no. 2 (2009): 32–37.

Rosenfeld, Gavriel D. "A Looming Crash or a Soft Landing? Forecasting the Future of the Memory 'Industry.'" *Journal of Modern History* 81, no. 1 (2009), 122–158.

Rothberg, Michael. *Multidirectional Memory: Remembering the Holocaust in the Age of Decolonization*. Stanford, CA: Stanford University Press. 2009.

Sabrow, Martin. "Die DDR erinnern." In *Erinnerungsorte der DDR*, edited by Martin Sabrow, 11–27. Munich: C. H. Beck, 2009.

Sabrow, Martin. "The Post-Heroic Memory Society: Models of Historical Narration in the Present." In *Clashes in European Memory: The Case of Communist Repression and the Holocaust*, edited by Muriel Blaive, Christian Gerbel, and Thomas Lindenberger, 88–98. Innsbruck: StudienVerlag, 2011.

Sabrow, Martin, Rainer Eckert, Monika Flacke, Klaus-Dietmar Henke, Roland Jahn, Freya Klier, Tina Krone, Peter Maser, Ulrike Poppe, and Hermann Rudolph, eds. *Wohin treibt die DDR-Erinnerung? Dokumentation einer Debatte*. Göttingen: Vandenhoeck und Ruprecht, 2007.

Sarkisova, Oksana, and Péter Apor, eds. *Past for the Eyes: East European Representations of Communism in Cinema and Museums after 1989*. Budapest: Central European University Press, 2008.

Scheunemann, Jan. "Gehört die DDR ins Museum? Beobachtungen zur Musealisierung der sozialistischen Vergangenheit." *Gerbergasse* 18 (2009): 34–37.

Segal, Joes, and Uta A. Balbier. "Introduction." In *East German Material Culture and the Power of Memory*, edited by Uta A. Balbier, Cristina Cuevas-Wolf, and Joes Segal, 5–12. Washington, DC: German Historical Institute, 2011.

Sharenkova, Radostina. "Forget-Me(-Not): Visitors and Museum Presentations about Communism before 1989." *History of Communism in Europe* 1 (2010): 63–80.

Sharon, Jeremy. "Hungarian Minister: 'Holocaust Revisionist Historian Not Involved in Museum.'" *Jerusalem Post*, June 19, 2019. Available online: https://www.jpost.com/Diaspora/Hungarian-minister-Holocaust-revisionist-historian-not-involved-in-museum-593035 (accessed August 27, 2019).

Shorten, Richard. *Modernism and Totalitarianism: Rethinking the Intellectual Sources of Nazism and Stalinism, 1945 to the Present*. London: Palgrave Macmillan, 2012.

Silke, Arnold-de Simine. *Mediating Memory in the Museum: Trauma, Empathy, Nostalgia*. Basingstoke: Palgrave Macmillan, 2013.

Skramstad, Harold. "An Agenda for American Museums in the Twenty-First Century." *Daedalus* 128, no. 3 (1999): 109–128.

Snyder, Timothy. "Poland vs. History." *New York Review of Books*, May 3, 2016. Available online: https://www.nybooks.com/daily/2016/05/03/poland-vs-history-museum-gdansk/ (accessed August 27, 2019).

Snyder, Timothy. *The Reconstruction of Nations: Poland, Ukraine, Lithuania, Belarus, 1569–1999*. London: Yale University Press, 2003.

Sodaro, Amy. *Exhibiting Atrocity: Memorial Museums and the Politics of Past Violence*. New Brunswick, NJ: Rutgers University Press, 2018.

Spragens, Thomas. *Civic Liberalism: Reflections on Our Democratic Ideals*. Lanham, MD: Rowman and Littlefield Publishers 1999.

Stan, Lavinia. *Transitional Justice in Eastern Europe and the Former Soviet Union*. London: Routledge, 2009.

Stan, Lavinia. "Truth Commissions in Post-Communism: The Overlooked Solution?." *Open Political Science Journal*, no. 2 (2009): 1–13.

Struve, Kai. "Eastern Experience and Western Memory: 1939–41 as a Paradigm of European Memory Conflict." In *Shared History - Divided Memory: Jews and Others in Soviet-Occupied Poland, 1939–1941*, edited by Elazar Barkan, Elizabeth A. Cole, and Kai Struve, 43–66. Leipzig: Leipziger Universitätsverlag, 2008.

Sturken, Marita. *Tourists of History: Memory, Kitsch, and Consumerism from Oklahoma City to Ground Zero*. Durham, NC: Duke University Press, 2007.

Šuligoj, Metod. "Warfare Tourism: An Opportunity for Croatia?." *Economic Research-Ekonomska Istraživanja* 30, no. 1 (2017): 439–452.

Teitel, Ruti G. *Transitional Justice*. Oxford: Oxford University Press, 2000.

Than, Krisztina. "Hungary's New Holocaust Museum Divides Jews, Faces 'Whitewash' Accusations." Reuters, October 19, 2018. Available online: https://www.reuters.com/article/us-hungary-holocaustmuseum/hungarys-new-holocaust-museum-divides-jews-faces-whitewash-accusations-idUSKCN1MT1QQ (accessed December 16, 2018).

Tinning, Katrine. "To Survive Ravensbrück: Considerations on Museum Pedagogy and the Passing on of Holocaust Remembrance." *Museum and Society* 14, no. 2 (2016): 338–353.

Tismăneanu, Vladimir. *The Devil in History: Communism, Fascism, and Some Lessons of the Twentieth Century*. Berkeley: University of California Press, 2014.

Tismăneanu, Vladimir, and Marius Stan. *Romania Confronts Its Communist Past: Democracy, Memory, and Moral Justice*. Cambridge: Cambridge University Press, 2018.

Todorova, Maria, ed. *Remembering Communism: Genres of Representation*. New York: Social Science Research Council, 2010.

Todorova, Maria, and Zsuzsa Gille, eds. *Post-Communist Nostalgia*. New York: Berghahn Books, 2012.

Todorova, Maria, Augusta Dimou, and Stefan Troebst, eds. *Remembering Communism: Private and Public Recollections of Lived Experience in Southeast Europe*. Budapest: Central European University Press, 2014.

Tomczuk, Sara Jean. "Contention, Consensus, and Memories of Communism: Comparing Czech and Slovak Memory Politics in Public Spaces, 1993–2012." *International Journal of Comparative Sociology* 57, no. 3 (2016): 105–126.

Törnquist-Plewa, Barbara. "Local Memories under the Influence of Europeanization and Globalization: Comparative Remarks and Conclusions." In *Whose Memory? Which Future?: Remembering Ethnic Cleansing and Lost Cultural Diversity in Eastern, Central, and Southeastern Europe*, edited by Barbara Törnquist-Plewa, 208–226. New York: Berghahn Books, 2016.

Törnquist-Plewa, Barbara. "Cosmopolitan Memory, European Memory and Local Memories in East Central Europe." *Australian Humanities Review* 59 (2016): 136–154.

Truc, Gérôme. "Memory of Places and Places of Memory: For a Halbwachsian Socio-Ethnography of Collective Memory." *International Social Science Journal* 62 (2011): 147–159.

Velikonja, Mitja. *Titostalgia: A Study of Nostalgia for Josip Broz*. Ljubljana: Mediawatch, 2008.

Verdery, Katherine. *What Was Socialism and What Comes Next?* Princeton, NJ: Princeton University Press, 1996.

Volčić, Zala. "Yugo-nostalgia: Cultural Memory and Media in the Former Yugoslavia." *Critical Studies in Media Communications* 24, no. 1 (2007): 21–38.

Vukov, Nikolai. "Visualizations of the Past in Transition: Museum Representations in Hungary, Romania and Bulgaria after 1989." *CAS Working Paper Series*, no. 2 (Sofia, 2009). Available online: http://www.cas.bg/uploads/files/Nikolai%20Vukov.pdf (accessed May 20, 2019).

Walsh, Kevin. *The Representation of the Past: Museums and Heritage in the Post-Modern World*. London: Routledge, 1992.

Watson, Sheila. "The Legacy of Communism: Difficult Histories, Emotions and Contested Narratives." *International Journal of Heritage Studies* 24, no. 7 (2018): 781–794.

Weekes, Lorraine. "Debating Vabamu: Changing Names and Narratives at Estonia's Museum of Occupations." *Cultures of History Forum*, April 25, 2017. Available online: http://www.cultures-of-history.uni-jena.de/debates/estonia/debating-vabamu-changing-names-and-narratives-at-estonias-museum-of-occupations/ (accessed May 20, 2019).

Williams, Paul. "The Afterlife of Communist Statuary: Hungary's Szoborpark and Lithuania's Grutas Park." *Forum for Modern Languages Studies* 44, no. 2 (2008): 185–198.

Williams, Paul. *Memorial Museums: The Global Rush to Commemorate Atrocities*. New York: Berg, 2007.

Williamson, Margaret, ed. *Museums and Memory*. Knoxville, TN: Newfound Press, 2011.

Winter, Jay. "Public History and Historical Scholarship." *History Workshop Journal* 42 (1996): 169–172.

Young, James E. "The Counter-Monument: Memory against Itself in Germany Today." *Critical Inquiry* 18, no. 2 (Winter 1992): 267–296.

Yurchak, Alexei. *Everything Was Forever, Until It Was No More: The Last Soviet Generation.* Princeton, NJ: Princeton University Press, 2006.

Zhurzhenko, Tatiana. "The Geopolitics of Memory." *Eurozine*, May 10, 2007. Available online: www.eurozine.com (accessed May 20, 2019).

Zombory, Máté. "The Birth of the Memory of Communism: Memorial Museums in Europe." *Nationalities Papers* 45, no. 6 (2017): 1028–1046.

Zubkovych, Alina. *Dealing with the Yugoslav Past: Exhibition Reflections in the Successor States.* Stuttgart: Ibidem, 2017.

Zubrzycki, Geneviève. *The Crosses of Auschwitz: Nationalism and Religion in Post-Communism Poland.* Chicago: University of Chicago Press, 2006.

Zubrzycki, Geneviève. "History and the National Sensorium: Making Sense of the Polish Mythology." *Qualitative Sociology* 34, no. 1 (2011): 21–57.

Zündorf, Irmgard. "Contemporary History and Public History." *Docupedia-Zeitgeschichte*, March 16, 2017. Available online: http://docupedia.de/zg/Zuendorf_public_history_v2_en_2017 (accessed May 20, 2019).

Zündorf, Irmgard. "DDR-Museen als Teil der Gedenkkultur in der Bundesrepublik Deutschland." In *Jahrbuch für Kulturpolitik tome? 9: Erinnerungskulturen und Geschichtspolitik*, edited by Bernd Wagner, 139–145. Essen: Klartext Verlag, 2009.

Contributors

Péter Apor is a research fellow at the Institute of History of the Hungarian Academy of Sciences. Between 2003 and 2011, Apor was a research fellow at the Central European University, Budapest, and an associate researcher at the University of Exeter (2008–2009). In 2012, he was a Fellow at the Imre Kertesz Kolleg, Jena. His main research interest includes the politics of memory and history in post-1945 East-Central Europe, the social and cultural history of the socialist dictatorships, and the history of historiography. He is the author of *Fabricating Authenticity in Soviet Hungary: The Afterlife of the First Hungarian Soviet Republic in the Age of State Socialism* (2014).

Simina Bădică is curator at the House of European History, Brussels, and teaches museum studies at the National School for Political and Administrative Studies, Bucharest. Previously, she worked as researcher and then Head of Ethnological Archives at the Romanian Peasant Museum, Bucharest, and served as editor of the journal *Martor*. Bădică earned her PhD in history from the Central European University, Budapest. Her publications include "'Forbidden Images'? Visual Memories of Romanian Communism before and after 1989," in *Remembering Communism: Private and Public Recollections of Lived Experience in Southeast Europe* (2014), and the co-edited special issue "Curating Change in the Museum" of *Martor*, vol. 23 (2018).

Rossitza Guentcheva is an assistant professor at the Department of Anthropology, New Bulgarian University, Sofia. She received her PhD in history from the University of Cambridge (2001), MA in history from the Central European University in Budapest (1995), and MA in history from the University of Sofia (1992). She was a junior research fellow at the Open Society Archives in Budapest (1995–1996), fellow of the Wissenschaftskolleg zu Berlin (2003–2004) and the Centre for Advanced Studies in Sofia (2004–2005). Her recent publications include "Block No. 18, Auschwitz," in *Entangled Histories of the Balkans*, vol. 4, *Concepts, Approaches, and (Self)-Representations* (2017).

Aleksandar Ignjatović is an associate professor at the University of Belgrade where he teaches architectural, art, and cultural history. His most recent publications include "*Translatio Imperii* Revisited in the Balkans: Interpretation of Serbian Past and Imperial Imagination" in *Inventio, Absentia Imperii: From the Roman Empire to Contemporary Imperialism* (2018); "Affecting Consonance, Striving for Dominance: Scholarship and Politics at the Congresses of Byzantine Studies in the Balkans, 1924–1934," in *Journal of Balkan and Near Eastern Studies* (2018); and "Byzantium's Apt Inheritors: Serbian Historiography, Nation-Building and Imperial Imagination, 1882–1941," in *Slavonic and Eastern European Review* (2016).

Constantin Iordachi is Professor of History at the Central European University, Budapest, co-editor of the peer-reviewed journal *East Central Europe* (2006–), and President of the International Association for Comparative Fascist Studies. Prof. Iordachi also serves as a member of the Academic Committee of the House of European History, Brussels. He has published widely on comparative history in Central and South-Eastern Europe. His publications include *Liberalism, Constitutional Nationalism, and Minorities: The Making of Romanian Citizenship, c. 1750–1918* (2019); *Charisma, Politics and Violence: The Legion of the "Archangel Michael" in Inter-war Romania* (2004); and "Fascism in East-Central and South-Eastern Europe: A Reappraisal," *East-Central Europe*, vol. 37 (2010). He is editor or co-editor of over sixteen collective volumes, including *Fascist Studies: New Perspectives* (2010, 2011; Romanian edn. 2014; Turkish edn. 2015).

Kirsti Jõesalu is a research fellow and lecturer at the Department of Ethnology, University of Tartu. She defended her PhD thesis on remembering "late socialism" in 2017. Her main fields of research are social memory of socialism, study of socialist everyday life, and oral history. She is interested in the relationship of public and private remembering. Currently she is researching how the history of the twentieth century is displayed in Estonian museums. She has published on memory of late socialism in various journals.

Ene Kõresaar is an associate professor of ethnology at the Institute of Cultural Research, University of Tartu. Her research interests include social memory and mnemohistory of communism and the Second World War in the Baltics, oral history and life writing, anniversary journalism, and museum studies. She has edited and co-authored several books on post-socialist cultural and autobiographical remembrance, most recently *Baltic Socialism Remembered: Memory and Life Story since 1989* (2017).

Martin Kovanič is a postdoctoral researcher at the Department of Political Science, Faculty of Arts, Comenius University, Bratislava. In 2016, he was a research fellow at the Vienna Center for Societal Security. His main research interests include transitional justice, politics of memory, and politics of surveillance in the post-communist context. He is an author of several publications in these fields.

Olga Manojlović-Pintar is a senior research fellow at the Institute for Recent History of Serbia, Belgrade. She gained her PhD in 2005 at Belgrade University. She is a participant in numerous international projects and a regular contributor at international interdisciplinary conferences and round-table discussions. Manojlović-Pintar has published numerous articles and edited three collective volumes: *Transnational Experiences of the Yugoslav History* (2019); *Tito: Visions and Interpretations* (2011); and *History and Memory, Studies of the Historical Consciousness* (2005). She authored the book *The Archaeology of Memory: The Monuments and the Identities in Serbia 1918–1989* (2014).

Vjeran Pavlaković is an associate professor at the Department of Cultural Studies, University of Rijeka, Croatia. His most recent publications include "The Controversial Commemoration: Transnational Approaches to Remembering Bleiburg," in *Politička misao* (2018), and "How Does This Monument Make You Feel? Measuring Emotional Responses to War Memorials in Croatia" (with Benedikt Perak), in *The Twentieth Century in European Memory: Transcultural Mediation and Reception* (2017). He is also the lead researcher on the project "Framing the Nation and Collective Identity in Croatia: Political Rituals and the Cultural Memory of 20th Century Traumas" funded by the Croatian Science Foundation (HRZZ).

Eglė Rindzevičiūtė is an associate professor at the Department of Criminology and Sociology, Kingston University, London. She received her PhD in Culture Studies in 2008 from Linköping University, Sweden, and has published articles on cultural policy and political history of science and technology in the Soviet Union and East–West circulation of scientific knowledge in such journals as *Modern Intellectual History*, *Slavic Review*, and *Current Anthropology*. Her most recent books include *The Power of Systems: How Policy Sciences Opened Up the Cold War World* (2016), and *The Struggle for the Long-Term in Transnational Science and Politics: Forging the Future* (2015), co-edited with Professor Jenny Andersson.

Martin Sabrow is Director of the Zentrum für Zeithistorische Forschung Potsdam and Professor of Contemporary History at the University of Potsdam and at the Humboldt University Berlin. He obtained his PhD in 1993 at the University of Freiburg with his dissertation on the political murder of Walther Rathenau, and in 2000 studied the historiography of the GDR at the Freie Universität Berlin. In 2017 he was awarded the Golo Mann Prize in History. His recent publications include *Erich Honecker. Das Leben davor. 1912–1945* (2016).

Irmgard Zündorf is a research associate for university cooperation and knowledge transfer at the Centre for Contemporary History Potsdam (Zentrum für Zeithistorische Forschung, ZZF), a role that includes responsibility for the cooperation between the ZZF and museums and memorial sites. She coordinates the master's program on Public History at the Freie Universität Berlin. In 2005/6 she assisted the expert-commission founded by the German government to consider the future of the GDR commemoration culture. Since 2008, her academic work has focused mainly on museum and public history, and on German contemporary history. Her most recent publications include, with Martin Lücke, *Einführung in die Public History* (2018).

Index

CPSIA information can be obtained
at www.ICGtesting.com
Printed in the USA
LVHW080236200821
695744LV00002B/35

9 781350 103702